From High Places

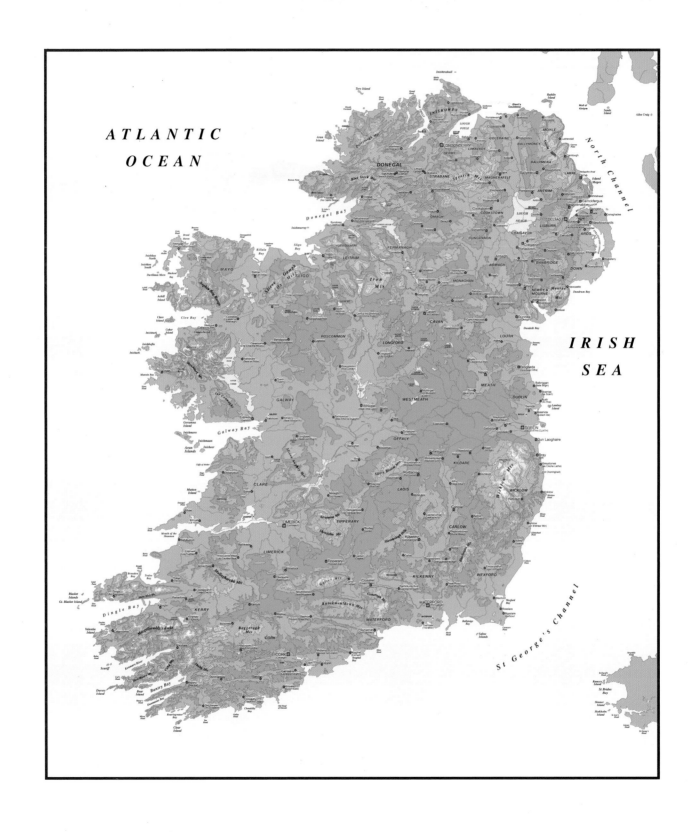

From High Places

A Journey through Ireland's Great Mountains

Adrian Hendroff

The
History
Press
Ireland

In memory of my mother and grandmother
who have surmounted more difficult mountains than I have.

Previous page Above the clouds: Looking west on to the Dingle coastline from the summit of Brandon Mountain.

© MAPS IN MINUTES™ (2007)

First published 2010

The History Press Ireland
119 Lower Baggot Street
Dublin 2, Ireland
www.thehistorypress.ie

© Adrian Hendroff, 2010

The right of Adrian Hendroff to be identified as the Author
of this work has been asserted in accordance with the
Copyrights, Designs and Patents Act 1988.

British Library Cataloguing in Publication Data.
A catalogue record for this book is available from the British Library.

ISBN 978 1 84588 989 0

Typesetting and origination by The History Press
Printed in Great Britain

CONTENTS

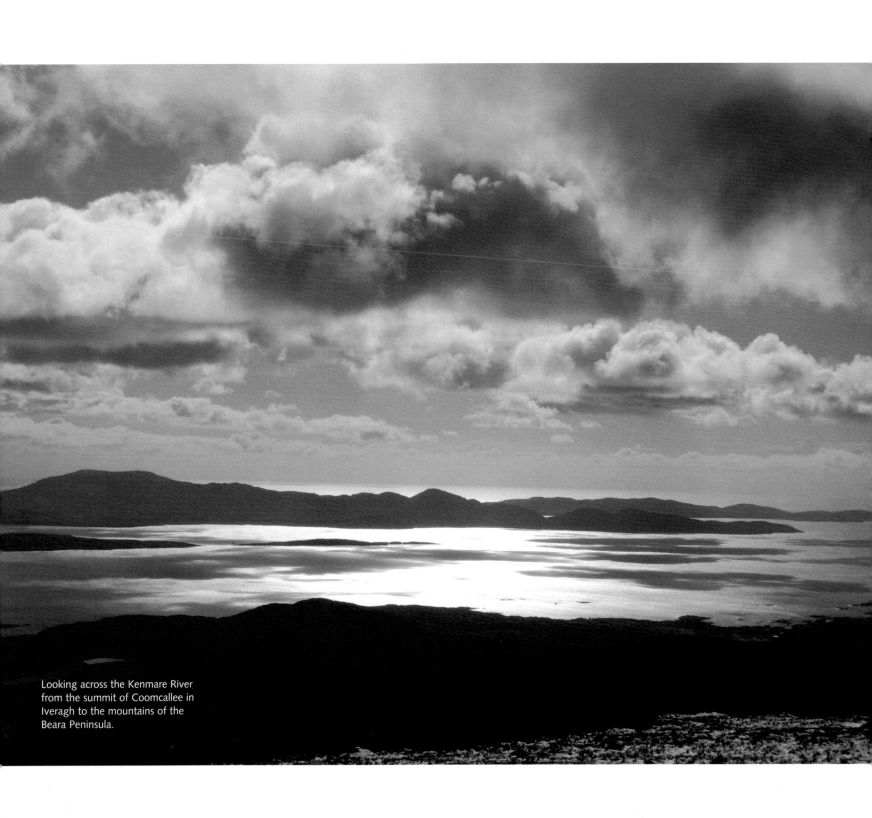

Looking across the Kenmare River
from the summit of Coomcallee in
Iveragh to the mountains of the
Beara Peninsula.

FOREWORD

The first Irish mountain I climbed was Knocknarea in Sligo. My old half-inch map credits it with being 1,078ft high, which sounds much better then the miserable 327m of the modern 1:50,000 sheet. I was six at the time and wasn't concerned about the height, or the view which sweeps from Ben Bulben round to the Ox Mountains, but rather with my mother's refusal to let me climb the big stone cairn, generally held to be the tomb of Queen Maeve, heroine or villainess of the *Tain Bó Cualaigne*, depending on which province you come from.

In another pre-war summer holiday in Ireland, we stayed with an uncle near Moycullen. We drove north one day through Glen Inagh, the road dominated by the masses of the Twelve Bens to the west and the Maumturks to the east, both looming over the Glen exactly as they do in the nineteenth-century prints.

My next visit to the West was in Spring 1948, when I went to stay with my aunt in her cottage near Tully Cross in north Connemara. Her bay window looked north over a panorama from Mweelrea to Achill Head, but I was looking in the other direction towards the big hills. Just behind the cottage was Benchoona, which I climbed then, and innumerable times since, but more importantly, I got two long walks in the Twelve Bens, and fell in love with their steep crags of white quartzite.

On the way back home, I stayed in Dublin with Bill Perrott, a friend I'd made in India, who took me rock-climbing at Dalkey and Ireland's Eye. Thanks to the generosity of the British government, I was about to start at university, so why not at Trinity College in Dublin? By the end of 1948, I was settled in Dublin, studying Engineering at Trinity, and with Bill, had founded the Irish Mountaineering Club. There were sixty members at the first meeting, now *Mountaineering Ireland* is the national body for walkers and climbers in both the Republic and Northern Ireland, with more than 10,000 members.

Naturally, there was soon discussion amongst club members of the Munros, the Scottish mountains of 3,000ft or over. Should we have an Irish list? 3,000ft didn't

seem appropriate – there would hardly be ten of them – how about a 2,000ft list? I became involved (I usually do) and began to work on it. The only available maps for most of the country were half-inch to the mile with 100ft contour interval. Wicklow and Kerry had one-inch maps, but the contour interval above 1,000ft changed to 250ft. It was at this point that the Rev. C.R.P. Vandeleur, Canon of Salisbury Cathedral offered his help. He hadn't lived in Ireland for many years, but he came from a Limerick family and was a phenomenal source of information. I would get letters that began, 'When I was in the National Library twenty years ago I noticed…'.

Of course there was no grid; we picked an important summit like Carrauntoohil and described other summits as, say 2¼ miles north-west of the important summit. Just as in Scotland we divided the summits into Main Peaks and 'Tops'. With my Dublin-born wife, Nora, whom I'd met in the IMC, I prepared an original and three carbons, all of which seem to have disappeared. However, when in the '70s I prepared a revised edition of Claude Wall's *Mountaineering in Ireland*, I included the list.

Then along came 1:50,000 maps with heights in metres and a 10m contour interval. It seemed sensible to change the list to 600m instead of 609.60m, the exact equivalent of 2,000ft. This worked satisfactorily for the Peaks, but some of the Tops were doubtful, and walkers are still checking them with GPS. I've only gone into this detail about the 600m list because Adrian Hendroff himself notices it and readers may be interested in its history.

Adrian asked me to write a foreword to *From High Places: A Journey Through Ireland's Great Mountains* some months ago, and gave me the sections he had completed in draft, together with photographs. By chance (or purpose?) he gave me Connemara and Mayo, and I revelled in the text and photographs of my favourite mountains. There was Benchoona, there were all the Bens (it is arguable

which are actually the Ten) and the Turks. He mentions Carrot Ridge, of which I made what I thought was the first ascent – it was the third actually, but we named it because my second reckoned he got up it because I kept telling him there was only one more pitch, which was like enticing a donkey with a carrot. It's our family climb – Nora, my son, my daughters, my son-in-law, my grandsons have all climbed it.

But I must not keep drooling over my favourite mountains. The author has brought us to the most beautiful and the best walking areas of Ireland, and then provided us with excellent photographs to remember them by. They combine clear foreground detail, often of rocks or streams, with mountain and valley backgrounds. Two stand out especially in my memory. One is the Bens reflected in Lough Derryclare – this is much the best of all the many shots I've seen of this view. The other is a winter view of snow-capped hills from the summit of Lugnaquillia – hard horizontal lines between snow and dark hillside and even the clouds are straight-edged to match. A figure whose red anorak is backed by a black hillside completes a picture which could easily be a painting.

Enough; except to say what a pleasure it has been to write the foreword to this inspirational book.

Joss Lynam

INTRODUCTION

Under a full moon, Carrauntoohil sparkles on a winter's night,
Above clouds of Killary, Mweelrea emerges to a spring delight,
Tower, trig point and cairn on Donard catch the summer's light,
Sky orange and red blaze on Lug: truly an autumnal sight.

These four mountains safeguard provinces of Erin's soil,
Four out of hundreds in corners of Eire they stand tall,
All blessed with beauty, charm and grandeur to enthrall;
These high places decorate Ireland like an embroidered shawl.

Adrian Hendroff

I often hear that Ireland's mountains are dull, flat lumps that reflect the low-lying plains of its midlands. There is also a common perception that Ireland only has a handful of mountains, like those in the MacGillycuddy's Reeks and Croagh Patrick. This book is written with the hope of dispelling those myths.

There are, in fact, hundreds of mountains. Paddy Dillon, in his book *The Mountains of Ireland*, lists 212 summits over 2,000 feet. The Vandeleur-Lynam list as per www.mountainviews.ie currently has a count of 268 summits over 600m. I am fortunate to have completed both those lists in recent years, an endeavour that has taken me to the corners of Ireland that I would have otherwise never thought of visiting. While climbing them, I have found these mountains to be neither flat nor dull. Although they do not come close to rivalling the Alps in height or the Scottish Munros, Corbetts and Grahams for quantity, the mountains of Ireland are rather special.

I love the Irish mountains for a variety of reasons; there are distinctive qualities that make them unique. These high places are mostly trackless wildernesses: no signposts, no paths and with landscapes both barren and rugged. They form a ring of coastal mountain ranges on the Western fringe of Europe. This intimate blend of mountains and the sea possess a charm that inexorably draws one back.

I find there is always somewhere new to visit in Ireland's high places, like a remote valley, a secluded lake or an untrodden summit, allowing me to escape from an increasingly rushed and weary world. I've often wandered in these mountains without meeting a soul, a rare commodity to be found in those of Snowdonia or the Lake District, for instance. This feeling of isolation on Irish hills can be strangely liberating, and in some ways gives a sense of pioneering spirit, and sometimes remoteness, to the lone explorer.

I've visited mountain ranges around the world – in the highlands of Scotland, the interior of Iceland and the heights of Romania, amongst many others. But at the end of the day I always think of the Irish mountains as home. This book was not created overnight, but rather borne out of a wealth of time spent climbing these mountains. They have given me so much, so it is time I give something back, by revealing some of their secrets to a wider world.

I wanted to deliver a book on Ireland's mountains that is inherently different. I wanted to present these mountains in a style that has not quite been done before, in a manner that would appeal to all, and not just to hill-walkers and mountaineers. I wanted to do these mountains justice, to give them the recognition they deserve.

Photography is a powerful tool and a picture paints a thousand words. I have a library of hundreds of images amassed from my time exploring Ireland's mountains. On selecting the book's final images, I have placed an emphasis on shots taken from the very core of these high places – rare views seldom seen. I don't see myself up there with the ranks of Colin Prior, Art Wolfe or Bill Birkett; these people are proven professionals in the art of mountain and landscape photography. However, I do hope the images in this book will both surprise and

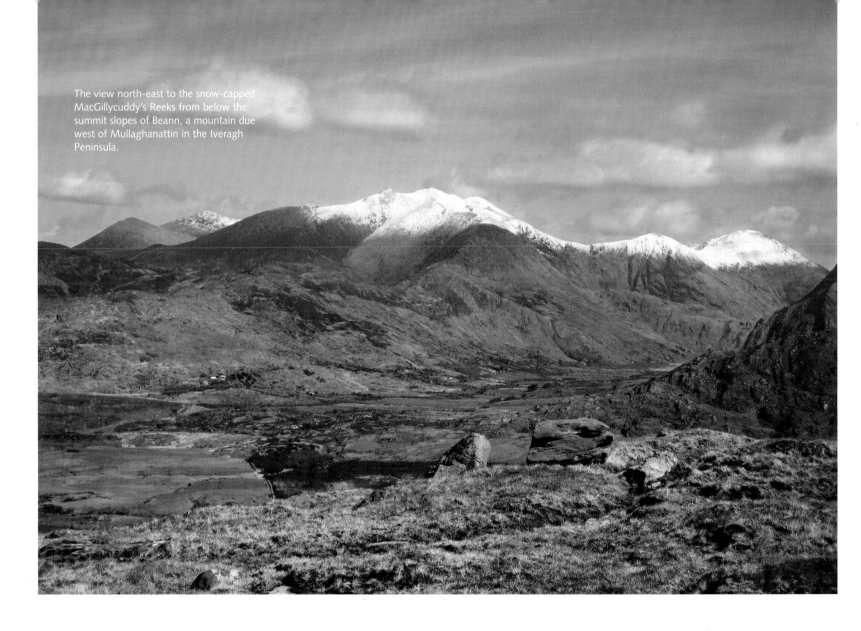

The view north-east to the snow-capped MacGillycuddy's Reeks from below the summit slopes of Beann, a mountain due west of Mullaghanattin in the Iveragh Peninsula.

inspire, and perhaps serve as a catalyst to embark on your personal voyage of discovery. If anything, it also proves that it doesn't always rain in Ireland!

There are aspects of the Irish mountains that cannot be presented in the form of photography. This is where words are important, for without them, the soul of these mountains will be forgotten. There are tales of folklore, echoes of history, feats of individuals and richness of place names associated with these mountains that simply cannot be ignored. I have tried to blend these with my own personal journey through these mountains.

The journey begins in the peaks of Connemara, and then works its way clockwise around Ireland's mountains, before ending on the MacGillycuddy's Reeks, home to some of its highest summits. I would also like to note that several pages of material have been dropped, with some of the lower mountain ranges like the Slieve Blooms, Ballyhoura Mountains and Ox Mountains not covered. This is not intentional, but rather because the book would take up several volumes if I included them all!

I hope you like the book, and will, like me, take the road less travelled up to Ireland's great mountains.

Adrian Hendroff

one

JEWELS OF CONNEMARA

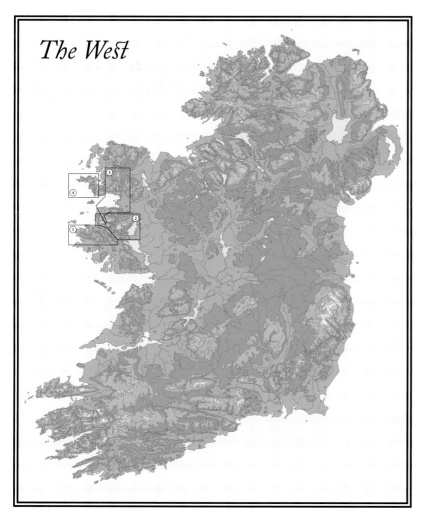

The West

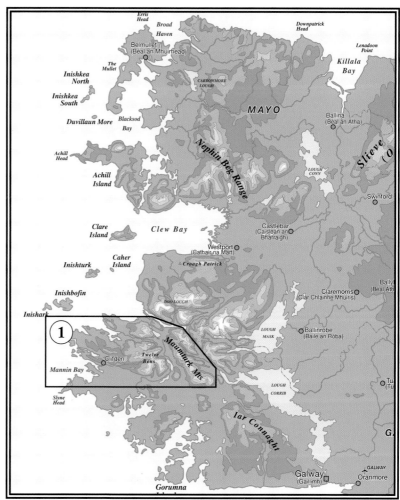

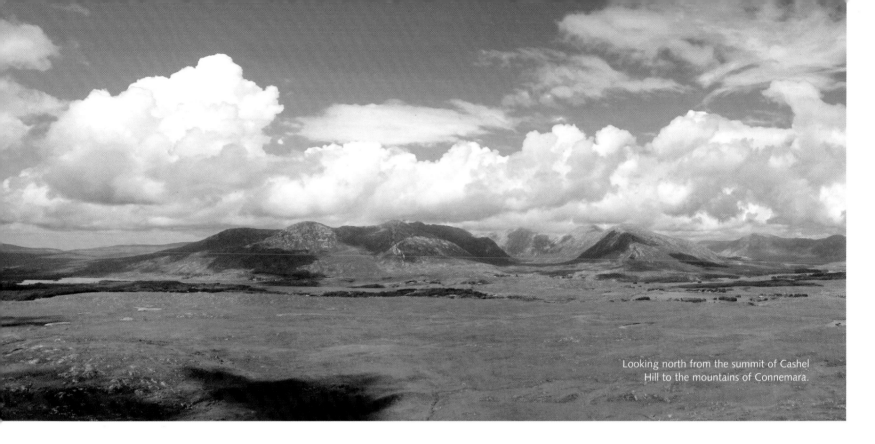

Looking north from the summit of Cashel Hill to the mountains of Connemara.

The Bank has no fortune of mine to invest
But there's money enough for the ones I love best;
All the gold that I want I shall find on the whins
When I'm in Connemara among the Twelve Pins.
Down by the Lough I shall wander once more
Where the wavelets lap lap round the stones on the shore:
And the mountainy goats will be wagging their chins
As they pull at the bracken among the Twelve Pins.

William Percy French

The N59 Galway to Clifden road always fills me with expectancy and anticipation as I approach the crossroads of Maam Cross. Nestling in the shadows of Lackavrea (396m/1,299ft) and surrounded by beautiful lakes both large and small, Maam Cross leads to the four corners of Connemara, a part of Ireland where the wind and rain is cleansing, and where spirits are lifted by sunlight filtering through layers of cloud scudding through valleys, painting its skies with rainbows.

On passing Maam crossroads, the view on the right is filled with a conical beehive-shaped mountain rising steeply from the bog. Beyond it, two more summits loom, one grey-green, the other rising like a great peak and completing the sweep of this mountainous stretch. The silvery ribbon of road leads further west pass Recess and then takes several bends before the contrast between glittering lakes on the left and rugged mountain summits on the right appears sudden and dramatic. These are some of the oldest mountains in the world, the quartzite peaks of *Beanna Beola*, also known as the 'Twelve Stakes' as seafarers of old used to call them, or by its commonly used name, the Twelve 'Bens' or 'Pins'.

The Irish for Connemara is *Conmhaicne Mara*, meaning 'people of the sea'. These people were a branch of the Conmhaicne, an ancient tribal grouping that had a number of clans located in different parts of Connacht. When traversing high-level ridges and rugged mountain tops in the wilderness of Connemara, perhaps like the Conmhaicne, the proximity of the sea and beauty of the landscape fills me with a spirit of wanderlust and peaceful contentment.

In the northern corner of the Twelve Bens, from the summit of Knockpasheemore (412m/1,352ft), the Glen Inagh River can be seen winding its way along the broad valley floor. The river twists and turns for several kilometres, and on wet days its many tributaries gush down rocky slopes into its main stem. South of this river, steep mountainsides soar upward ominously, complete with buttresses and crags, ending on its upper ranges to form a rugged massif of roller coaster ups and downs. It is

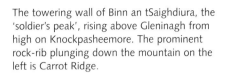

The towering wall of Binn an tSaighdiura, the 'soldier's peak', rising above Gleninagh from high on Knockpasheemore. The prominent rock-rib plunging down the mountain on the left is Carrot Ridge.

Bencorr and Bencollaghduff from Derryclare Mountain. The rugged ridge forms the eastern end of the Glencoaghan Horseshoe, one of the classic high-level routes in Connemara. The col in the far left is Maumina, a remote area surrounded by peaks.

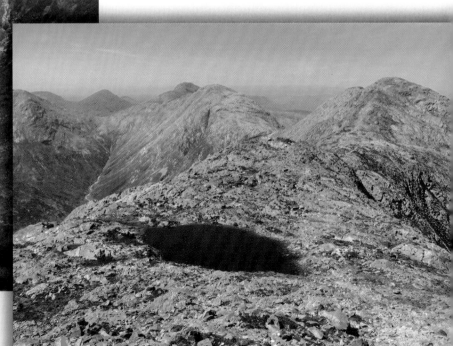

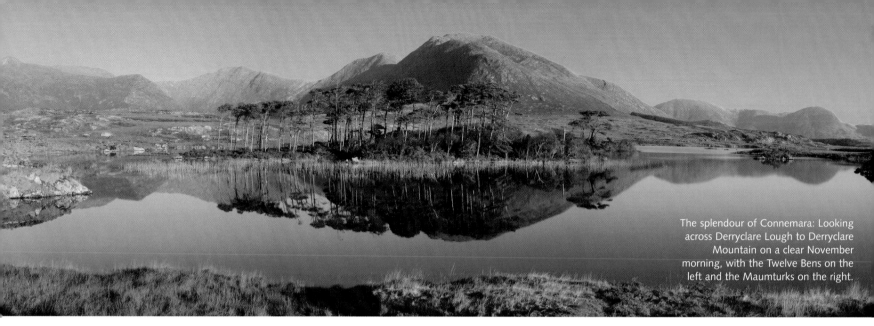

The splendour of Connemara: Looking across Derryclare Lough to Derryclare Mountain on a clear November morning, with the Twelve Bens on the left and the Maumturks on the right.

a fascinating view, dominated by a formidable finger of rock plunging down from the mountain's upper reaches in a curved arc. This nose of rock, known in climbing circles as Carrot Ridge, measures some 274m/899ft long and is an exhilarating rock-climb. At the end of the final pitch of this climb, a scramble up rock-slabs leads to its crest, and a final stiff pull south-east culminates in *Binn an tSaighdiura* (653m/2,142ft), the 'soldier's peak', named, according to local legend, because a soldier assisting with survey duties plummeted off this summit and perished. Looming higher above this is yet another summit, Bencorr (711m/2,333ft), which boasts a supporting cast of bare rocky terrain, rugged quartzite peaks and extensive views, which is probably why it was used as the primary triangulation point of the Ordnance Survey in the 1830s.

Bencorr is in fact the highest point of a fine circuit – perhaps *the* finest walking circuit in Ireland – the Glencoaghan Horseshoe. Encompassing a distance of 16km/10miles and approximately 1,500m/4,921ft of total ascent, it is a challenging high-level ridge walk, taking in some of the most outstanding mountain scenery in Ireland, while traversing the following tops: Derryclare (677m/2,221ft), Bencorr, Bencollaghduff (696m/2,283ft), Benbreen (691m/2,267ft), Bengower (664m/2,178ft) and Benlettery (577m/1,893ft).

It is a route I've done several times, but it is my first visit to these mountains that is forever etched in my memory. There was not a cloud in the sky then, as I weaved my way up a steep slope of rock and heather to arrive at Derryclare's summit. The view on that fine summer's day was one that exceeded expectations. To the west and north-west, the entire horseshoe from Bencorr to Benlettery, its rocky quartzite peaks gleaming greyish-white in the morning sun, could be traced over continuous rising and dipping terrain. To the east, the sprawling

Maumturk range loomed above the cobalt-blue waters of Lough Inagh. To the south-east, Derryclare Lough and other lakes dotted the green plains, with the brownish-green triangular knob of Cashel Hill (310m/1,017ft) rising beyond. At that moment, I fell in love with Connemara.

Derryclare Lough is a lake of legends. In days past, a ferocious ruler of the O'Flaherty clan commanded his men to annihilate a local village. Strangely, O'Flaherty's men did not return. So the chief rode out to investigate, and upon meeting his men, discovered that they had spared the locals taking refuge in the village's church. O'Flaherty was outraged, and challenged the Almighty to drown him on the spot if he failed to execute all the villagers in the church. He exclaimed this as he stood with his men beside a stream in a deep and narrow valley. However, without warning, the stream imploded into a gushing flood, drowning the ruthless ruler and his men, and forming Derryclare Lough.

Aside from its formidable peaks, one of the highlights of the Glencoaghan Horseshoe is the col at Maumina, the lowest and mid-point of the route. This col is in the heart of the Bens, remote and surrounded by a fortress of peaks in all directions. On the western end of the horseshoe are the summits of Benbreen, possibly named after a man called Braoin; Bengower, the 'mountain of the goat'; and Benlettery, the 'mountain of the wet hillside'. There is an interesting tale connected to Benlettery. The Irish historian Roderick O'Flaherty wrote that the summit, 'hath standing water on top of it, wherein they say if any washes his head, he becomes hoar'. Being in close proximity to the roadside, Benlettery can be climbed on its own from its namesake youth hostel. I once stood on its summit late in the day and watched as the sun dipped down the western horizon. As the final rays of golden sunlight gleamed over Ballynahinch Lake, I descended

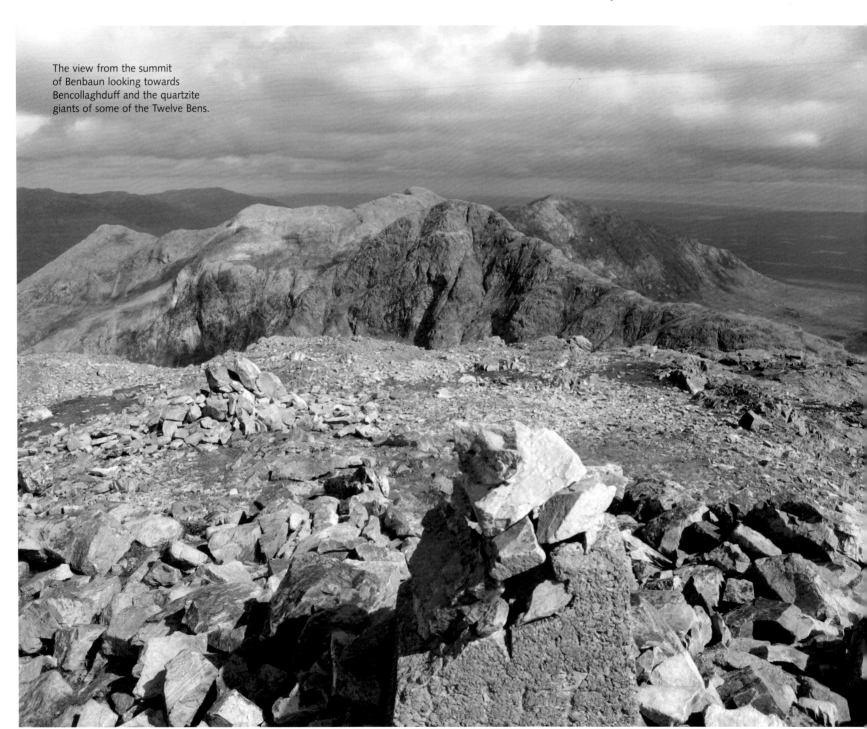

The view from the summit of Benbaun looking towards Bencollaghduff and the quartzite giants of some of the Twelve Bens.

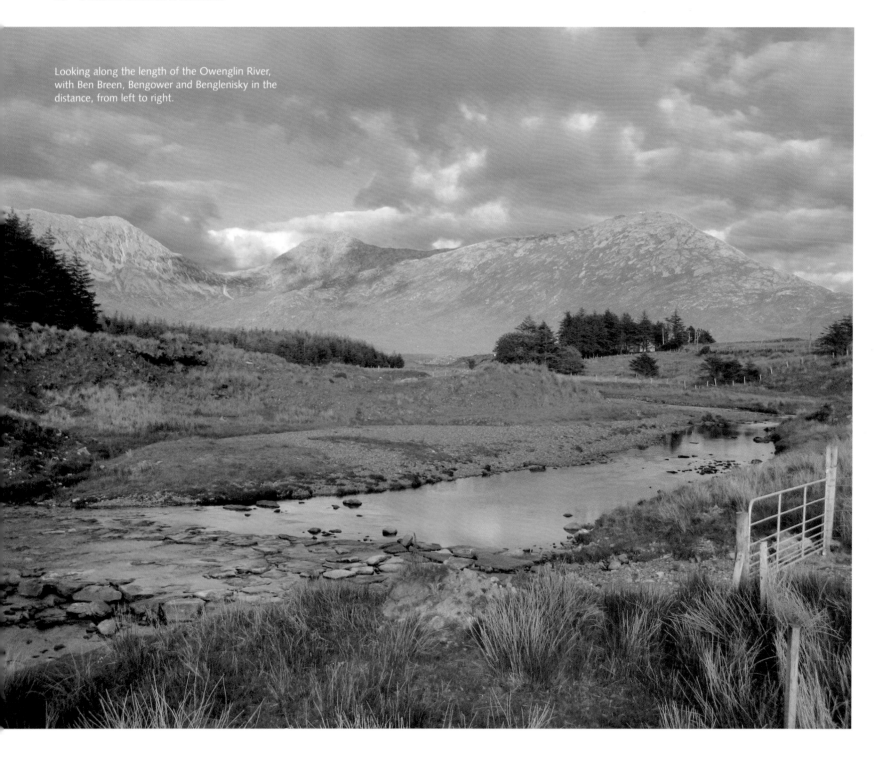

Looking along the length of the Owenglin River, with Ben Breen, Bengower and Benglenisky in the distance, from left to right.

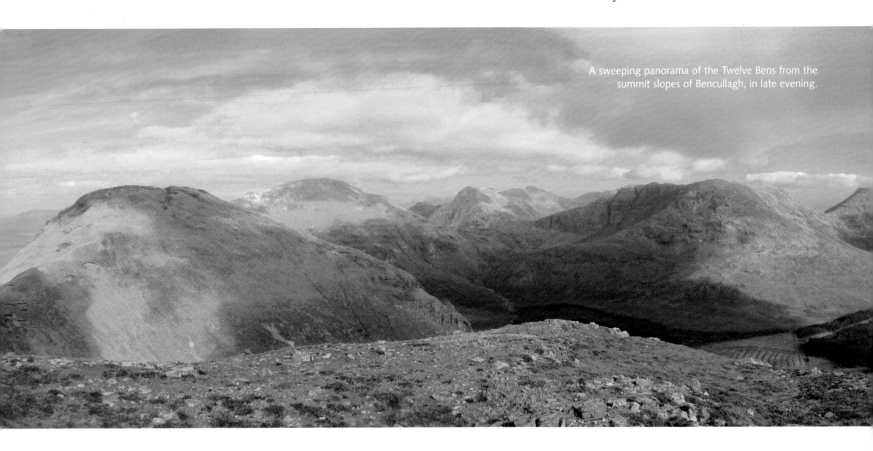

A sweeping panorama of the Twelve Bens from the summit slopes of Bencullagh, in late evening.

its wet and boggy southern slopes, while observing the intricate lake-strewn outlines of Roundstone Bog and the distant bump of Errisbeg (299m/981ft) fade in the distance.

The next day I set out to do the Owenglin Horseshoe. I parked my car by a forest entrance just after a bridge over the Owenglin River. It was pre-dawn as I walked south-east on tarmac before striking eastward across blanket bog toward the col between Benbreen and Bengower. I felt insignificant as I trudged across the dry bog, picking a route along the wide valley floor, as the morning fog cleared to reveal mighty peaks rising in front of and around me. It was strangely silent save for the intermittent call of the cuckoo. After negotiating the scree slope of Ben Breen and its dog-leg ridge, I ascended the unremitting treadmill of Benbaun to its summit – at 729m/2,392ft, the highest of all the Bens. All the main ridges of the Bens unfolded before me, together with Roundstone Bog, islands, sea inlets and faraway hills. After Benbaun, I ventured westward, without meeting a soul, and ascended four other delightful summits – grassy Benfree (638m/2,093ft), schisty

Muckanaght (654m/2,146ft), stony Bencullagh (632m/2,073ft) and its satellite peak Maumonght (602m/1,975ft). I arrived completely fulfilled just before nightfall at my car near the Owenglin River, the calm waters of which now reflected the pastel colours of an inspiring evening sky – a sky decorated with rolling clouds that cast bewitching shadows on the valley floor and the face of the Bens.

East of the Bens is the R344, a minor road that meanders along the edge of picturesque Lough Inagh, a long stretch of water lying in a broad flat valley flanked by the Bens and Maumturks on either side. Halfway along this road is a bohereen leading uphill, away from the lake and gradually intersecting the Western Way, a long-distance way-marked trail. Dotted along this section of trail are remnants of old ruined farm dwellings, outlines of small fields and cultivated ridges – a stark reminder of the Great Famine of 1845 to 1849. On my first visit to Connemara many years ago, I drove along this bohereen to investigate potential starting points for future forays in the Maumturks. It was a changeable sort of day, on which the clouds cast eerie shapes over Lough Inagh. The mist gradually peeled

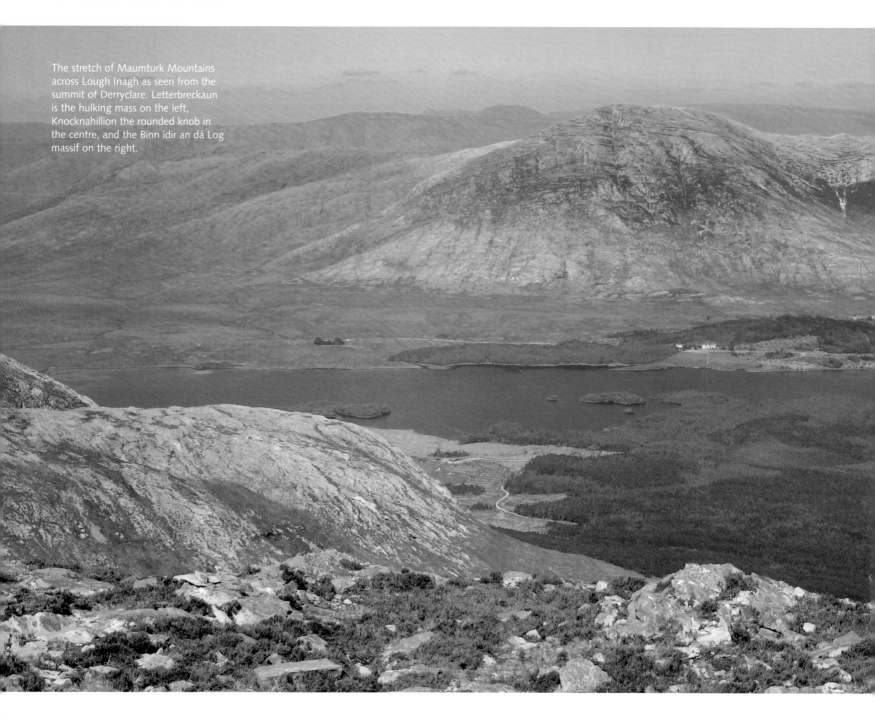

The stretch of Maumturk Mountains across Lough Inagh as seen from the summit of Derryclare. Letterbreckaun is the hulking mass on the left, Knocknahillion the rounded knob in the centre, and the Binn idir an dá Log massif on the right.

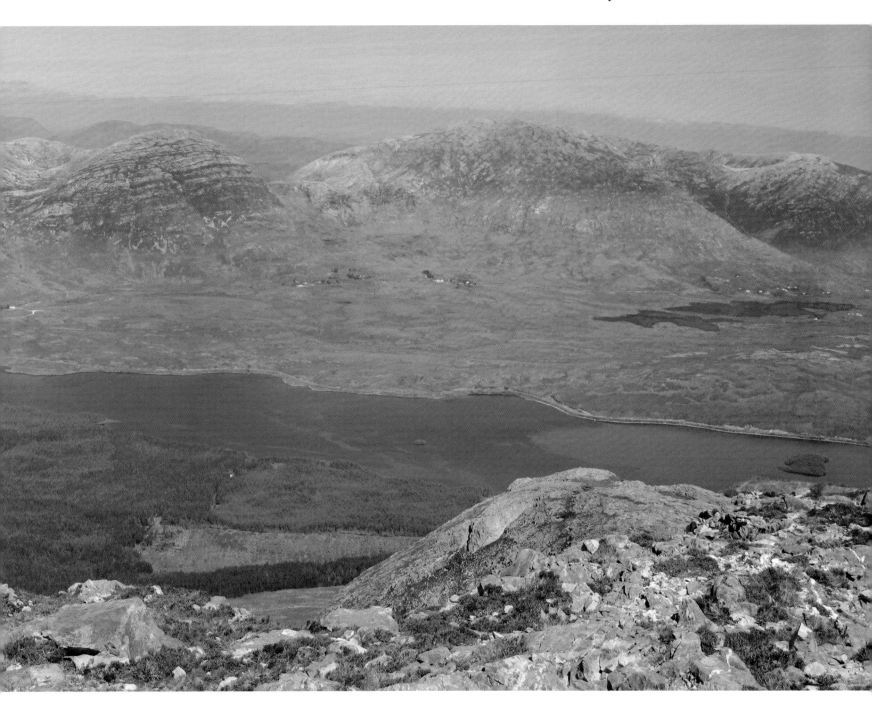

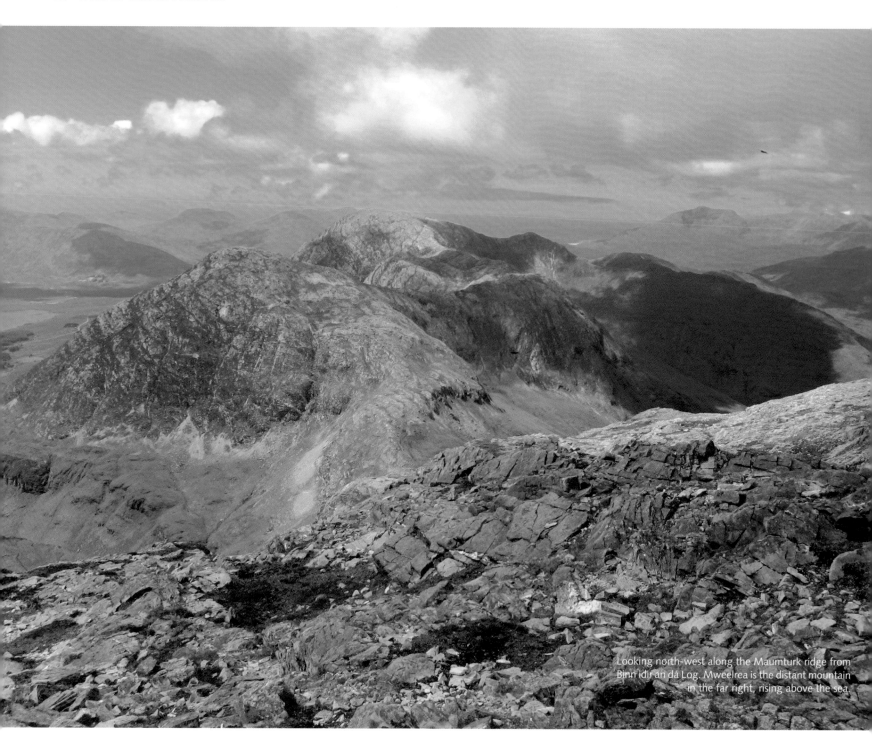

Looking north-west along the Maumturk ridge from Binn idir an dá Log. Mweelrea is the distant mountain in the far right, rising above the sea.

away to reveal steep slopes and searing gullies of the nearer Maumturks and the chameleon-like silhouettes of farther-away Bens. The experience was overpowering to the senses. Since then, I've frequented this stretch of road several times, over peaches of days and gloomy mornings, but never ceasing to be overwhelmed by its immediate surroundings.

I think of the Maumturks as the Twelve Bens 'smoothed out and stretched in a single line' with some hair-pin bends in between. Its complex terrain is possibly one of the roughest in the country and should always be treated with respect. There is an annual marathon walk, which traditionally takes place in spring, taking in the entire length of the Maumturks from Maam Cross to Lennaun. It is a challenge of epic proportions, covering over 24km/15miles of mountainous terrain and a total ascent of approximately 2,400m/7,874ft. It is no surprise then, that of the hundreds who started in 1995, only about a quarter completed the route. In 1997 and 1998, a helicopter had to evacuate injured walkers to safety, and in 1999 there was even a fatality reported. The highlight of the walk is the Col of Despondency, a low point of the route near the end, where walkers would have to slog up a final slope for about 350m/1,148ft to eventually descend to Leenaun.

My first taste of the Maumturks saw me walking to a gap at Maumeen, the 'pass of the birds'. A Christian missionary by the name of St Patrick was said to have reached this place on a windy day around AD430. According to legend, instead of crossing the pass, St Patrick blessed the mountains and turned back. From a small chapel, I could see why; steep, trackless mountain crags loomed above in two directions. A stiff pull uphill in a north-west direction leads to a rough ridge, the highest point of which is *Binn idir an dá Log* (702m/2,303ft), the 'mountain between two hollows', also the highest in the Maumturks. Below the summit, steep cliffs guard the deep-blue corrie lake of Lough Maumahoge, itself sitting in a hollow slightly above a lower gap. The descent to the lake is steep, with the mass of Knocknahillion (607m/1,991ft) towering like a giant moth ahead. Maumahoge is the mountains' closely guarded secret, where nature's soul connects with that of man.

One autumn, I spent a night in the Maumturks. Under the elbow-shaped shadow of Knocknahillion, I hand-railed the eastern bank of a steeply cut river, its waters gurgling in loud tones, a product of the previous night's downpour. As I climbed higher, heather gave way to rock, and after several bends in the river, I entered an amphitheatre of sheer rock. My line of vision decreased as I climbed higher, the fog thickened, and there was no wind. When the river branched, I followed its right-most tributary, up to a wild tarn, then skirted above another, amidst rocky scenery composed of different shades of grey. Climbing again, I weaved between rocks, and then trudged along a stony plateau, later

decorated by dark pools, until I touched the cold summit cairn of Letterbreckaun (667m/2,188ft). Under such conditions, there is bold wildness about mountains – untamed and unforgiving. I was alone, until I noticed a lone Blackface sheep standing on a rocky knoll, curiously observing me. The sound of a plane's engine suddenly droned above, unseen in the mist, and then gradually dissipating to leave an eerie silence. Leaving the summit, I edged across the wet quartzite, the rocky terrain soon giving way to wet grass and moss, descended to the 'pass of the boar', then up to Maumturkmore, before finally dropping to camp by a river below some crags at Gleniska.

Away from the forbidding mountains of the Bens and Maumturks is a cluster of hills north of Kylemore Abbey. Beyond the abbey, a hill called Doughruagh (526m/1,726ft) rises steeply above woodlands, tangled growths of rhododendron and the statue of the Sacred Heart. The summit of Doughruagh is a broad top splattered with small lakes and composed of rocky outcrops, mainly *gabbro* – dark, coarse-grained, igneous rock with magnetic properties that affect compasses.

North-east of Doughruagh is Benchoona (581m/1,906ft), a lovely little mountain whose summit offers magnificent views in all directions. Out on the Atlantic, the island of Inishturk sits proudly, along with rocky islets and an intricate peninsula. To its north-east, Lough Muck appears like a blue dwarf compared to Killary Harbour. To the east, Lough Fee sweeps the foreground with a string of peaks completing a mountainous backdrop. And to the distant south and south-east, the majestic mountains of Connemara are a sight to behold.

Robert MacFarlane wrote of Benchoona in his book *The Wild Places*:

Around noon, I reached the summit: a rough broken tableland of flat rocks, perhaps a quarter of an acre in area, and planed smooth by the old ice. There was a single small cairn, and on its top sat a horned sheep's skull. I picked up the skull, and as I did so water streamed from its ragged nose-holes in sudden liquid tusks, and ran on to my hand and up my sleeve. I put it back on the cairn top, having turned it so that it faced eastward and inland, looking over miles of empty land glinting with lakes, on which thousands of wild geese over-wintered each year. The sun came out, breaking fitfully through the clouds and warming my hands and face.

South of Benchoona is the bald summit of Garraun (598m/1,962ft). From there, a grassy spur tumbles steeply south-east as a series of platforms, always close to Lough Fee far below. Eventually the road is reached – the N59 again. It leads north-east, then eastward in one direction, toward the beautiful village of Leenaun.

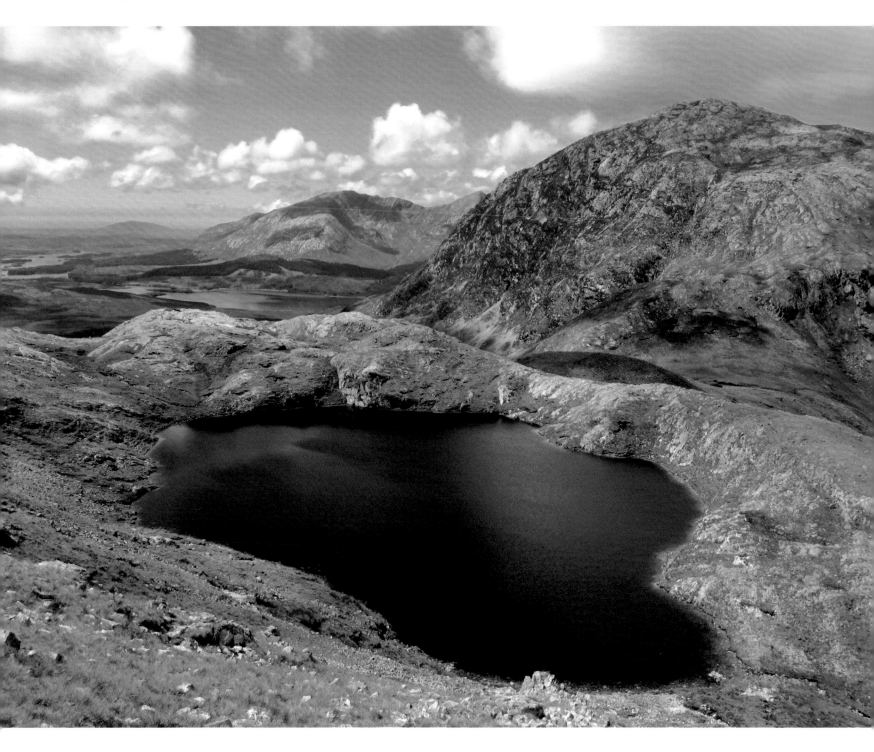

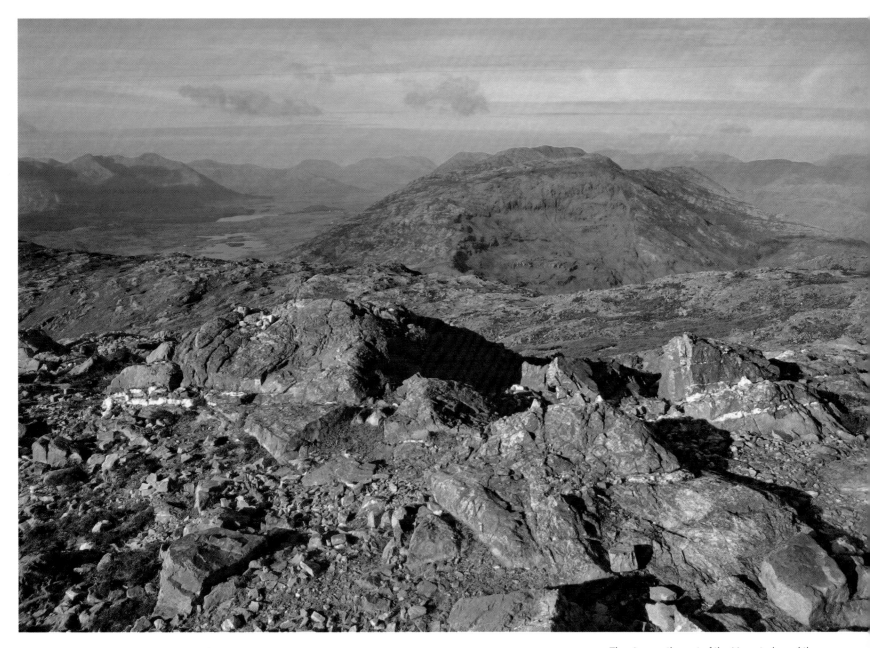

The view north-west of the Maumturks and the distant Connemara mountains from near the summit of Binn Mhór.

Opposite The corrie lake of Lough Maumahoge, sitting on a rugged col in the Maumturks. Knocknahillion towers behind it.

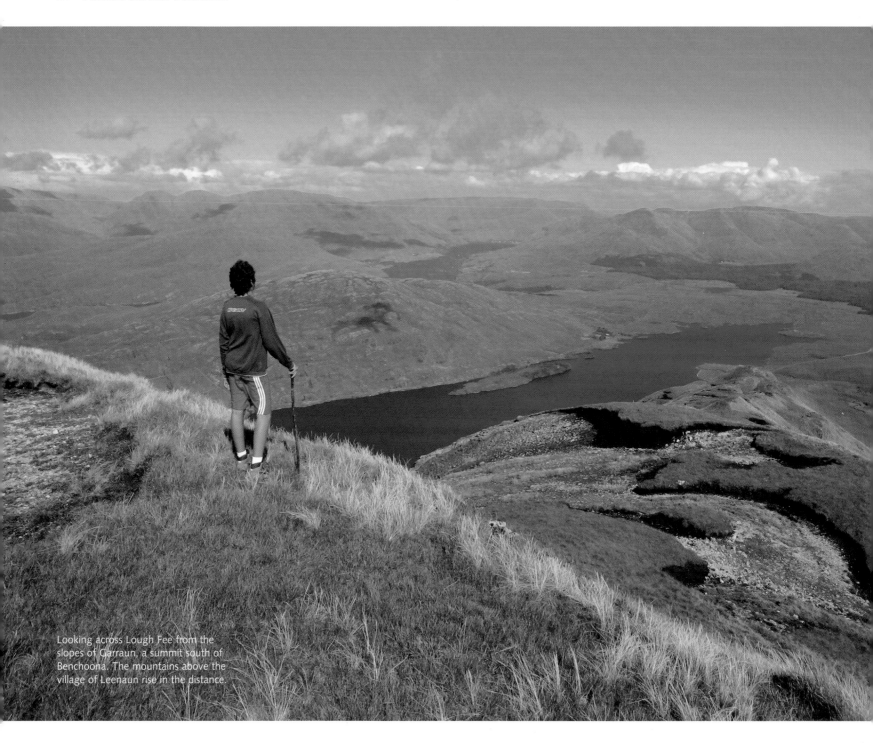

Looking across Lough Fee from the slopes of Garraun, a summit south of Benchoona. The mountains above the village of Leenaun rise in the distance.

DESTINATION LEENAUN

Too lonely for the traffic of the world:
Body and soul cast out and cast away
Beyond the visible world.

William Butler Yeats

There is a magical charm about Leenaun. Its village is a nestled hamlet where three roads meet; its singular stretch of road on its main street is dotted with a compact line of dwellings facing the head of an immense sheet of water. Opposite a café, I stand with my eyes closed as a zephyr-like wind blows across the harbour, humming a gentle melody. The wind dies down and only the sporadic call of gulls and curlew breaks the silence. I gaze westward; the aquamarine waters of the harbour seem to stretch out forever. At the opposite end of the water-bank, almost a kilometre away, yellow-green slopes soar upwards to meet a sweeping ridgeline. I trace my eye in a clockwise direction, and now the view is filled by high hills in different shades of green that rise alluringly from the bottom of things.

Around Leenaun one is spoilt for choice, as there is such a large number of mountains to climb. However, if the selection criterion is based purely on a mountain whose name has a 'ring' to it, then one would stand out. Towering above the Glennagevlagh valley, north-east of Leenaun, is a mountain called Devilsmother (645m/2,116ft). The Irish for it, as marked on the Ordnance Survey Ireland (OSi) map, is *Magairlí an Deamhain*. Interestingly, the Irish for 'mother' is *máthair* and 'devil' is *diabhail*, nothing quite resembling *Magairlí* or *Deamhain*, so something does not quite add up. According to a friend fluent in the Irish language, the direct translation of *Magairlí an Deamhain* has an even better 'ring' to it. *Deamhain* literally means 'demon', and *magairlí*, put bluntly, translates to 'testicles'. Collectively then, the peak in question would translate as 'the devil's testicles' in its purest form, but they couldn't put that on the map, could they?

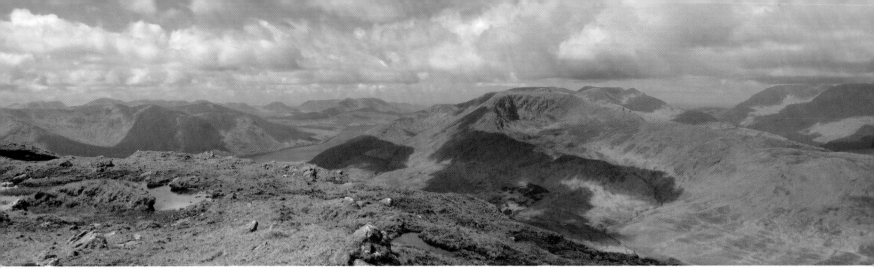

The magnificent mountains of Leenaun: The northern end of the Maumturk range on the left; while Ben Gorm, Mweelrea and the Sheeffry Hills rise on the right.

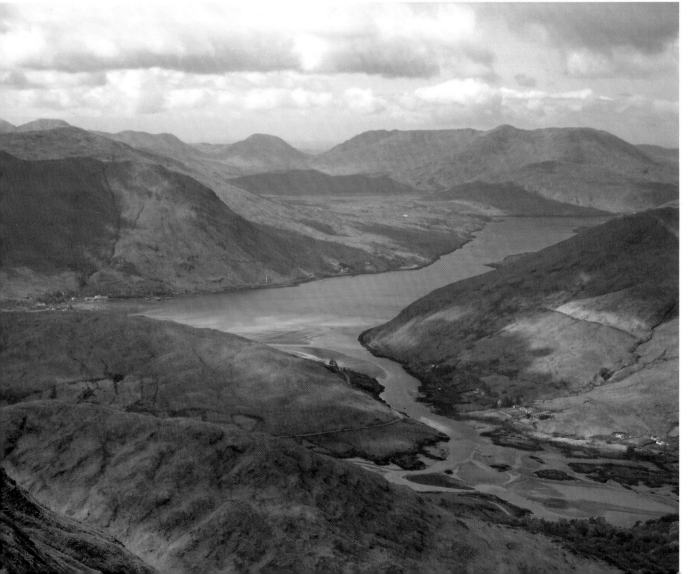

Looking down on Killary Harbour, the nestled hamlet of Leenaun and its backdrop of mountains from the summit ridge of Devilsmother.

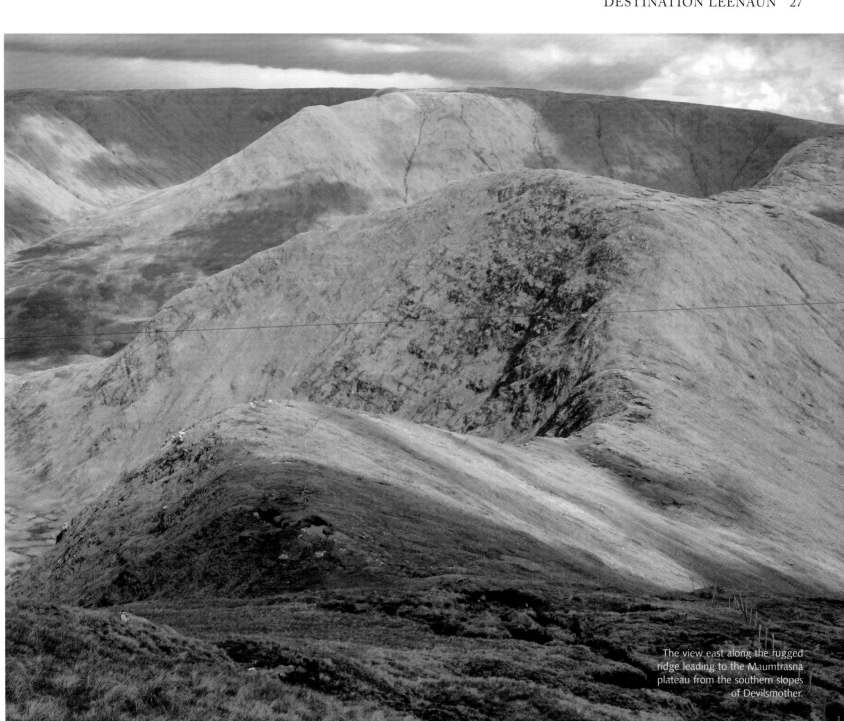

The view east along the rugged ridge leading to the Maumtrasna plateau from the southern slopes of Devilsmother.

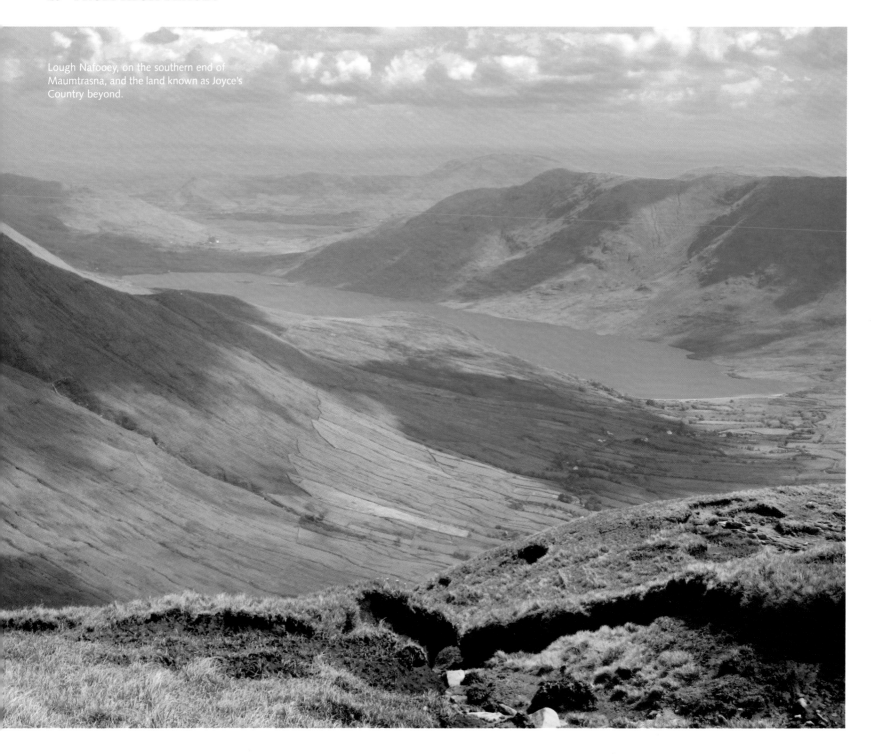

Lough Nafooey, on the southern end of
Maumtrasna, and the land known as Joyce's
Country beyond.

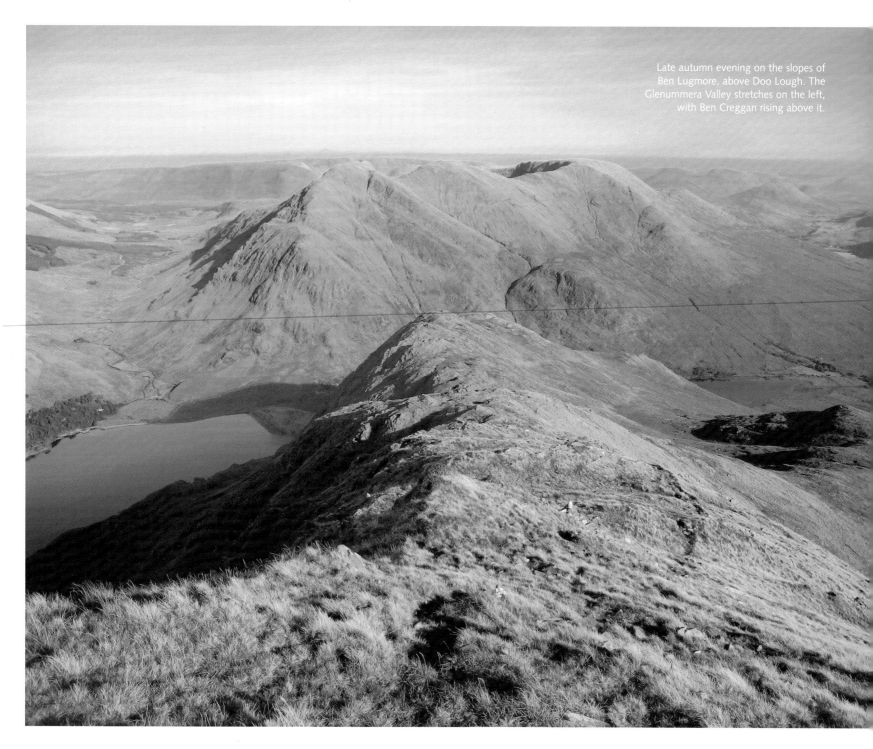

Late autumn evening on the slopes of Ben Lugmore, above Doo Lough. The Glenummera Valley stretches on the left, with Ben Creggan rising above it.

Mistranslation or otherwise, Devilsmother is a hill with a remarkable vantage point. One biting cold spring dawn, I was dropped off near a metal gate, west of Glennacally Bridge. When a brief interlude on a path came to an end, I was then faced with a steep incline littered with rough moor-grass and rocky outcrops. The ground eventually flattened, but then steepened again. I glanced back at the way I came; the Erriff River winds its way far below along greenish-brass plains toward a clump of trees. East of the river's silver glints, a road twists like a vertically elongated 'W' and rising above this road are the brooding Luga Kippen crags. A few more paces uphill and I arrived at a lichen-strewn cairn on the northern end of the hill. I walked toward the edge of the spur and stood in silence, for I was beguiled by beauty. Out westward, the land, water and mountain is intimately woven and extends for miles beyond, intoxicating like a powerful cocktail. The village of Leenaun looks insignificant from up here, tucked in the far-left corner with its namesake hill towering above it. Beyond that, distant mountains protrude as various humps and bumps. To the north-west, the Mweelrea massif peeps behind the craggy recesses of Ben Gorm, whose cliffs glint like blue under cotton-wool clouds.

But the view that dominates the eye is the stretch of water curving in a graceful arc below these mountains. It is long and narrow, and its sinuous sandy expanses give it a slightly reddish tint. This sea inlet is known as Killary Harbour; it in fact extends some 16km/10miles from its head to its mouth, near the island of Inishbarna. It is deepest in the centre, as deep as 45m/148ft; but its average depth is around 15m/49ft, a result of glacial forces carving, gouging and scouring the ice thousands of years ago. I once took a cruise along its fjord-like length, passing various rafts and barrels floating along the surface of water, housing mussel beds and salmon cages for the aquaculture consortia. Steep mountainside plunges down relentlessly from the heights of Mweelrea above; these craggy walls paint an evocatively haunting scene, and the shadows darken the blue waters of Killary below.

On that same day on Devilsmother, my ambition prevailed and I decided to link it with a walk up to Maumtrasna, a plateau that rises up to 682m/2,238ft eastward. After a slight detour to the true summit of Devilsmother, I found myself on a rugged ridge, dropping, rising, dropping and then rising again to its midway point, Knocklaur (518m/1,699ft). The boggy, boulder-strewn ridge twists like a slow-moving Mexican wave, narrow at first, then broadening after Knocklaur. I slowly inched my way up the barren plateau. It is a desolate area; an extensive tableland of bare conglomerated rock, bog, pools of water and deceptive crests. I had come to seek wilderness, and I found it here in abundance. This is no place to be in mist, I thought. I counted the amount of 1km by 1km squares on my map: a total of eleven in all. How many soccer pitches is that? The edges of the plateau fall away like tentacles of an octopus, some sweeping for miles, with fearsome gullies and buttresses guarding its sides. These spurs are adorned with names such as Leynabricka, Skeltia, Binnaw and Buckaun and extend down the eastern side, an area of unsurpassed beauty. Streams plunge from the top of the plateau, tumbling like waterfalls down crags and breaking into a symphony of cascades, the vein-like tributaries flowing into a main-stem until finally reaching its home in wild corries lakes.

Maumtrasna's beauty is not to be underestimated, as I and some friends discovered one autumn in late October. Beauty then turned into a raging beast: the west-wind howled, the rain lashed a horizontal frenzy and the sleet stung like venom on our faces. We staggered up the Skeltia spur, and struggled to remain upright as grey gales tore fiercely, beating against body and rucksack. Surf waves and twisters of water skated across the surface of Lough Nafooey, hundreds of feet below. A wall higher up the spur offered some protection from the gales, but only momentarily, as we were once again battered with the devilish rain after the wall ended. There was no lull whatsoever. It took us over twice as long to cover ground, every step a struggle. The exposure to the elements only intensified as we climbed higher; the flat plateau would offer no respite to the horrendous conditions. There was only one option, and we took it, and that was back down our ascent route to the safety of the road.

But this wildness, this savagery, does not compare to the events that transpired on 17 August 1882, south-east of the mountain range, in the townland of Maumtrasna. South-west of Lough Mask's lonely shores on OSi Sheet 38 map are the words 'Joyce's Country' printed in bold. During that time, there were a lot of Joyces in this part of the land, almost all of them related. Irish was the common language, English almost non-existent. It was an enclosed society, with the entire local population living poorly in straw or mud cabins with their cows and poultry. This seclusion from society was to change one morning when a neighbour discovered the massacred bodies of John Joyce and five members of his family sprawled on the floor of the cabin, their heads and limbs broken, their flesh littered with bullet wounds. John Joyce, his mother, his wife and his daughter lay dead. His elder son died the following day; only the youngest son survived.

The entire district rushed to the crime scene, except for ten men. Ironically, these men, nearly all Joyces or Caseys, were arrested by the police based on information provided by an Anthony Joyce, his brother and his son. On the night of the brutal slayings, Anthony was awakened from his slumber by the barking of his dog. He claimed he saw a group of men passing, who increased in size to ten. He roused his brother and they followed these men to the cabin of John Joyce where the savage butchery was witnessed. Was there truth in this? Truth or not, these accused men were transferred to Dublin to face an English-speaking court

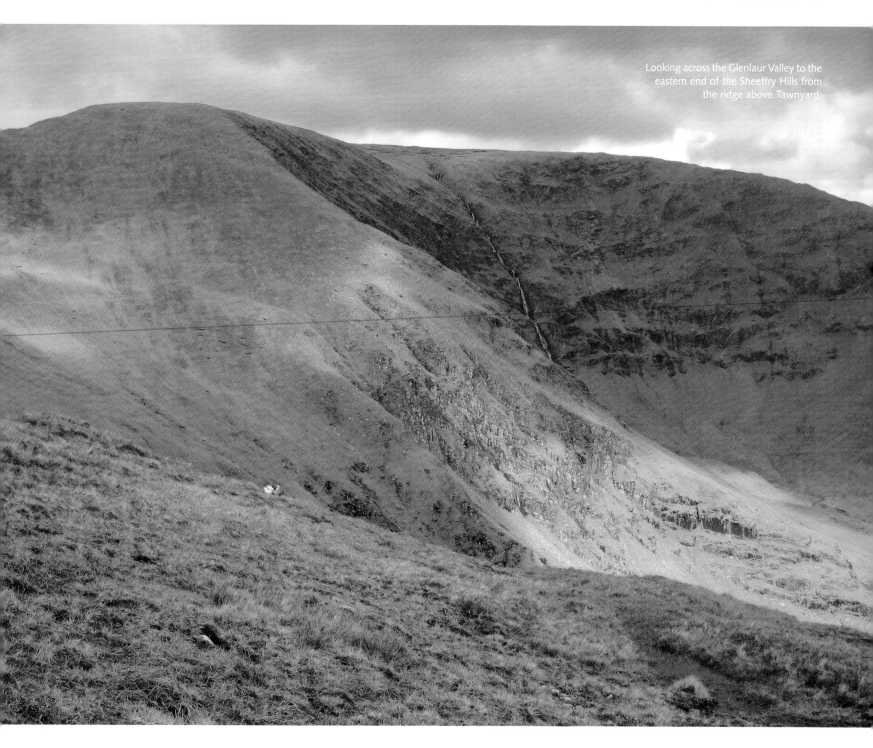

Looking across the Glenlaur Valley to the eastern end of the Sheeffry Hills from the ridge above Tawnyard.

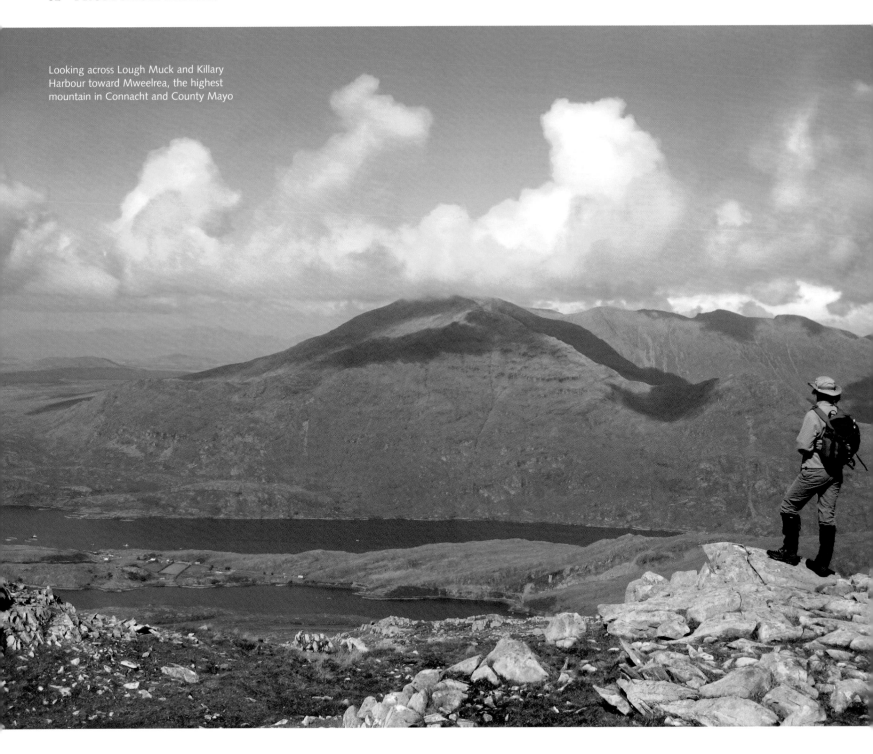

Looking across Lough Muck and Killary Harbour toward Mweelrea, the highest mountain in Connacht and County Mayo

of Crown lawyers and a mainly unionist and middle-class jury. An interpreter was used but to what extent? The court credited Anthony Joyce's tale, but the story also goes that they persuaded two of the accused to turn state evidence. The end result was that three of the accused were hanged, including one who was innocent, and five jailed for life.

West of Maumtrasna is a delightful group of hills. Rising like a swallow in flight from the creamy-white spray of Aasleagh Falls are the Ben Gorm (700m/2,297ft) and Ben Creggan (693m/2,274ft) mountains. They tower like mighty sentinels; steep unassailable-looking slopes soar heavenwards on its west side, moraine-filled valleys decorate its eastern fringes. North of this range, a picturesque road winds its way along the valley floor, the Glenummera River a close companion as its waters twist and turn along the roadside. At Tawnyard, the road rises steadily, overlooking a lovely lake, and gradually levels off as it reaches a bend. It then winds its way down an incline, almost touching the gaunt crags at Barnaderg, until it meets a section of the Western Way near Sheeffry Bridge. This stretch of the Western Way meanders northward, up to a peaty plateau overlooking the remote bowl-shaped Lough Lugacolliwee. A range of hills slithers westward from here for almost 8km/5miles – these are the Sheeffry Hills. For most of the way, its uppermost reaches is a broad crest, with the exception of a narrow pinch on its western end before Barrclashcarne (772m/2,533ft).

But none of these hills rise higher than western neighbour Mweelrea. For most of the year its bald top is shrouded in cloud, lending a grey tint to this colossal grit and sandstone mountain massif. Nowhere in Connacht is higher than the summit of Mweelrea (814m/2,671ft) itself. There are no easy routes up this mountain; its contorted ridge also consists of two other summits, Ben Bury (795m/2,608ft) and Ben Lugmore (803m/2,635ft). I've climbed it several times, twice starting from the mountain resort at Delphi. On the first occasion I decided to climb the trio of summits in an anti-clockwise direction. After an initial plod through squelchy bog and high tussocks, it was onward and upward until I crested the top of the spur. I felt a change in the weather as I climbed, soon clouds descended and I was shrouded in mist. I felt an awful drop to my right as I negotiated the ridge, catching only occasional glimpses of the black abyss below. The narrow ridge was a tunnel of mist. I used map and compass, and hand-railed, progressing cautiously to the summits of Ben Bury and Mweelrea. I must return in good weather, I promised myself.

I did just that on a glorious autumn day two years later. However, on this occasion I tackled the horseshoe in reverse. It was pleasant walking through dry bog; the valley was like a boiling pot under the bright yellow sun, not a breath of wind stirred the air. It became unpleasantly hot, and the urge to have a dip in the stream below Lough Lugaloughan prevailed. The sun's rays dried me almost immediately as I stepped out of the stream. The summit of Mweelrea gazed down on me, electric ultramarine blue skies behind, and not a cloud in sight. I climbed; a joyous staircase to heaven filled with imposing views down a fearsome corrie lined with glowering cliffs that traced a vertical line to the summit of the highest mountain in Connacht.

I reached its cairn on a peaty top. The extensive views included the Atlantic Ocean, Killary Harbour and all the distant ranges of Connemara. Moments later, I felt free as a bird as I tore down easy-angled rock slabs to a broad gap. The ground rose again gradually, with more stones and boulders underfoot, before culminating at the summit cairn of Ben Bury. I could see as far as the distant Croagh Patrick (764m/2,507ft) and the Nephin Beg range from here. But my attention was grabbed by the narrow ridge ahead, the same one that engulfed me in mist two years previously, with the distinct tooth-shaped peak adorning its mid-length. I continued to descend a gap to look down an enormous hollow on my left, a hanging corrie ringed by crags and of jagged walls soaring up hundreds of feet to the heavens above.

A mountain rises above this deep hollow, Ben Lugmore, and it was below its crags that I camped one evening on yet another occasion. As darkness fell, I descended into the corrie, down a steep ramp. Upon reaching a stream, the cloudy sky above turned ink-black. I pitched my tent somewhere in these dark depths and later, as the clouds parted, I looked up at a catalogue of stars twinkling in the night sky. It was a calm, peaceful night that trickled into dawn. Before sunrise the next day, I descended to the valley below, with the waters of its lake, Doo Lough, still silhouetted in black shadows under a milky pre-dawn sky.

I thought I heard voices, but it was probably the wind, except there was none.

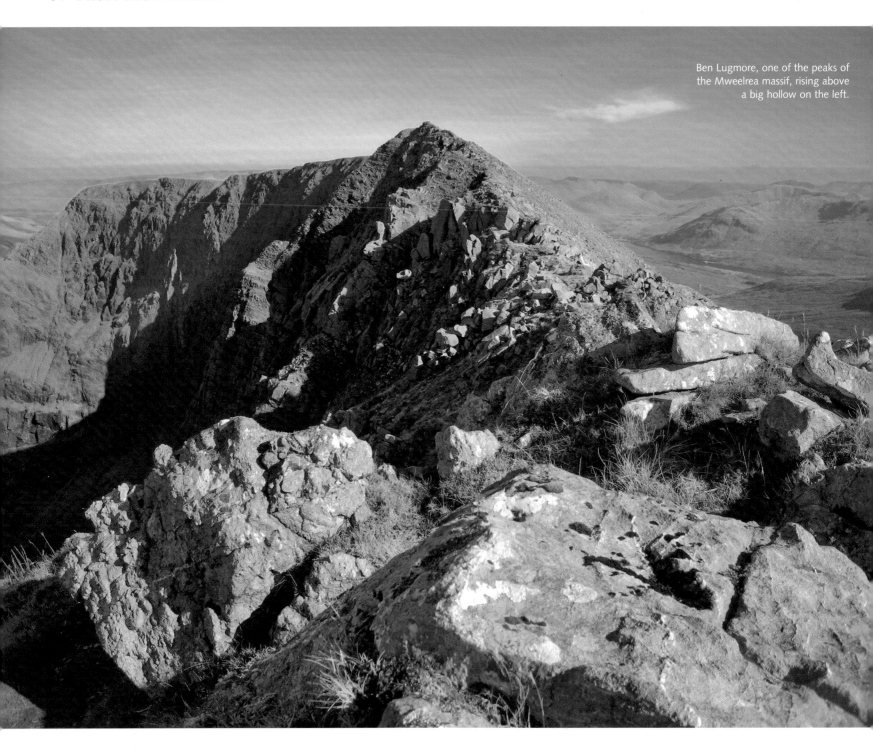

Ben Lugmore, one of the peaks of the Mweelrea massif, rising above a big hollow on the left.

three

SPACE, SUMMITS, STILLNESS

Sitting on a high, naked peak, surveying an immense region, I can say to myself: here you are on ground which stretches to the bowels of the earth – no more recent layer, no piles of ruins, have come between you and the primeval world; you do not walk over a continuous grave as in those fertile valleys. These peaks have produced nothing living and have devoured nothing living; they are before all life and above all life.

Johann Wolfgang von Goethe

Mayo, 1847. The smell of death filled the air on that cold spring dawn in Louisburgh. Hundreds of malnourished, ragged and semi-naked corpses lined the damp streets near the Relieving Officer's House. Hundreds more barely survived the rain-drenched night. These famished souls, impoverished and barely alive, were told to go and apply to guardians at Delphi Lodge. The starving men, women and children set off south; they walked barefoot over wild terrain, toward the lodge, which was nearly ten miles away. There were no roads in those days, and the goat tracks were almost imperceptible. Soon they reached a river. Here, at the Glankeen, these peasants waded arduously through turbulent waters, then near Doo Lough they negotiated a steep pass, and later more swollen streams. By luck or curse, they arrived in a near-hypothermic state at the lodge, as some collapse dead among the pines. Hours later, the guardians emerged, but with devastating news. 'There's to be no relief or tickets here today, you'll all have to return', the guardian announced. Hope for these homeless souls was now utterly vanquished.

Dejected and full of despair, they begin to stagger northward along the same route, back toward Louisburgh. The approaching darkness brought with it a biting-cold north-west wind. Storm clouds gathered and soon the night sky littered hailstones. They waded through rivers again, the now ice-cold waters stiffening their cadaverous limbs. Dozens fell dead. The ones still alive were faced with the

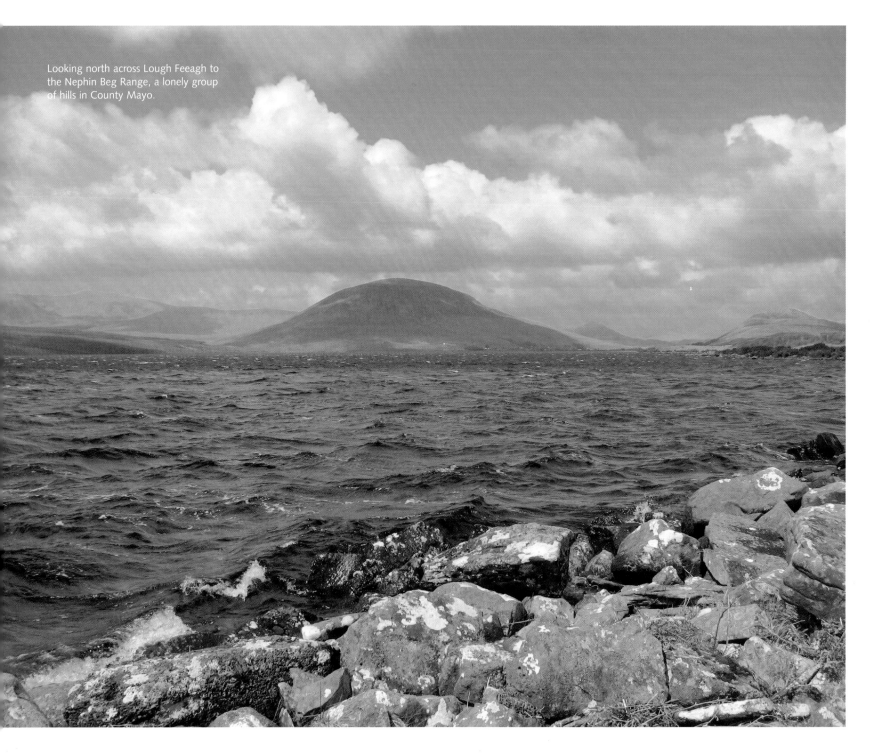

Looking north across Lough Feeagh to the Nephin Beg Range, a lonely group of hills in County Mayo.

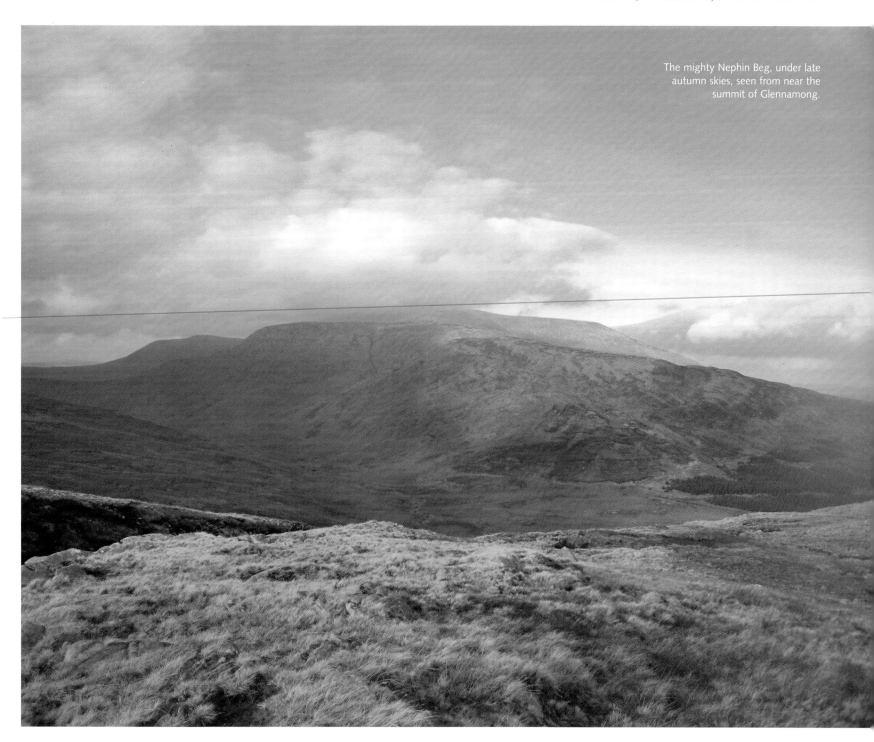

The mighty Nephin Beg, under late autumn skies, seen from near the summit of Glennamong.

climb back up the steep pass. Hundreds of frostbitten toes and hands struggled up the slope. When they reached the top of the pass, tragedy befell. The north wind, now a squally gale, blew dozens back down the slope, and many of them were storm-tossed to their deaths into Doo Lough. Today, a simple plaque on the side of the road at Doo Lough, the black lake, commemorates the dead of this tragedy.

In Mayo, hundreds of thousands of people perished of starvation and epidemics during the Great Famine of the 1840s, and many more emigrated. Kay Mullen, an American poet, wrote these touching lines of poetry to honour her late husband, A.J. Mullen:

I return to Mayo County
to walk in the steps of your fathers,
the ones who wove the threads of love
for you through years of famine and faith
long before you were born. I have come
to honor you and your name
imbedded in every cell of my bones.
It is the passage that counts,
what's left behind, the migrations,
the breath of God in the going,
always the sounds of dancing,
of laughter and Irish songs in the wind.

According to A.J.'s collected writings, his great-grandparents married in 1863 in the parish of Crossmolina in County Mayo, and shortly after that they left for America, joining the millions who emigrated due to evictions and harsh living conditions. Ms Mullen relates that throughout A.J.'s lifetime, his Irish ancestors, 'conveyed to him an ardent love of life through song, dance, the music of mountains and a deep faith'. These uplifting words are testimony to the tradition passed down the generations, despite the hardships of that time and uncertainty of the future. A life centred on song, dance, mountains and faith must have been a pillar of hope for the men and women of that generation.

Mayo is derived from the Irish *Maigh Eo*, or 'plain of the yew trees'. Ironically, along the N59 from Crossmolina to Bangor, trackless bog, and not yew trees, is the main feature of this desolate 31km/19mile stretch of road. The bog envelopes the flat plains like a blanket, extending for hundreds of square kilometres north and south of the road, its wet spongy moss-like surface a habitat for insectivorous plants like sundew and butterwort. To the faraway south, worlds away from the barren sea of bog, rises a band of heather-clad brown bare hills, its plateau-like tops separated by miles of uninhabited wilderness. These lonely hills, sequestered from civilisation and wedged in on all sides by vast boglands, belong to the Nephin Beg range.

Robert Lloyd Praeger in his classic book, *The Way That I Went*, describes the Nephin Beg hills as such:

I confess I find such a place not lonely or depressing but inspiriting. You are thrown at the same time back upon yourself and forward against the mystery and majesty of nature and you may feel dimly something of your own littleness and your own greatness; for surely man is as great as he is little: but the littleness is actual, and the greatness largely potential.

I once tramped a cumulative distance of approximately 87km/54miles in five days in order to climb these mountains. One of these, Slieve Carr (721m/2,365ft), is a beast of a hill, accessible only by walking a long distance on the Bangor Trail. The others – the rocky spike of Birreencorragh (698m/2,290ft), mighty Nephin Beg (627m/2,057ft), remote Glennamong (628m/2,060ft) and shapely Corranabinnia (716m/2,349ft), with its serrated rocky ridge connecting its two tops – were just as hard, often soul destroying, but ultimately rewarding.

Glennamong is in the middle of it all; the mighty peaks of Slieve Carr and Nephin Beg tower to its north, the shapely tops of Nephin (806m/2,644ft) and Birreencorragh rise in the east, the inviting horseshoe of Bengorm (582m/1,909ft) and Corranabinnia due south, and a sweeping fold of brown bog envelopes its western plains. The mountain is known in Irish as *Gleann na Mhóin*, which strangely translates to 'glen of the bog'. I often wonder if it should rather be more appropriately named 'the mountain that overlooks the glen of the bog'? I stood on Glennamong's summit cairn one cold November evening, greeted by Atlantic winds wailing like a banshee in the lower slopes. Through gaps in the encircling mist, I saw drifting views of two massive corrie lakes to its south-west. As the mist lifted, I became fully aware of the tremendous sense of scale and space around me. The wind died down, and then the resulting silence was absolute. The evening light robed the mountain tops in enchanting shades of chrome yellow, burnt orange and forest green. The space around me was seemingly limitless, bringing with it a peculiar feeling of remoteness, of utter desolation.

A great depression separates Glennamong and Birreencorragh to the east; another similar depression separates Birreencorragh and Nephin further eastward. I've climbed Birreencorragh twice, once via its southern spur and on another occasion completing a fine horseshoe from its northern end near the Deel River. Its summit trig point area is stony, almost like a rugged little pin. The view is extensive, one of sweeping spurs and fine vistas of the Nephin Beg range and the solitary Nephin, towering like a sentinel watching over the Mayo plains. But it is a mountain

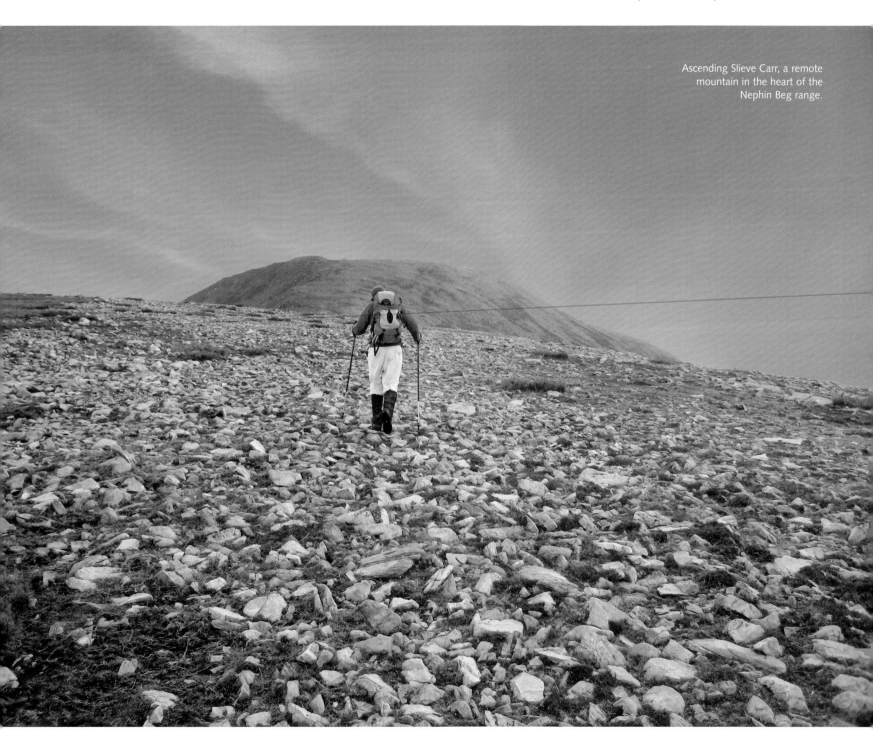

Ascending Slieve Carr, a remote mountain in the heart of the Nephin Beg range.

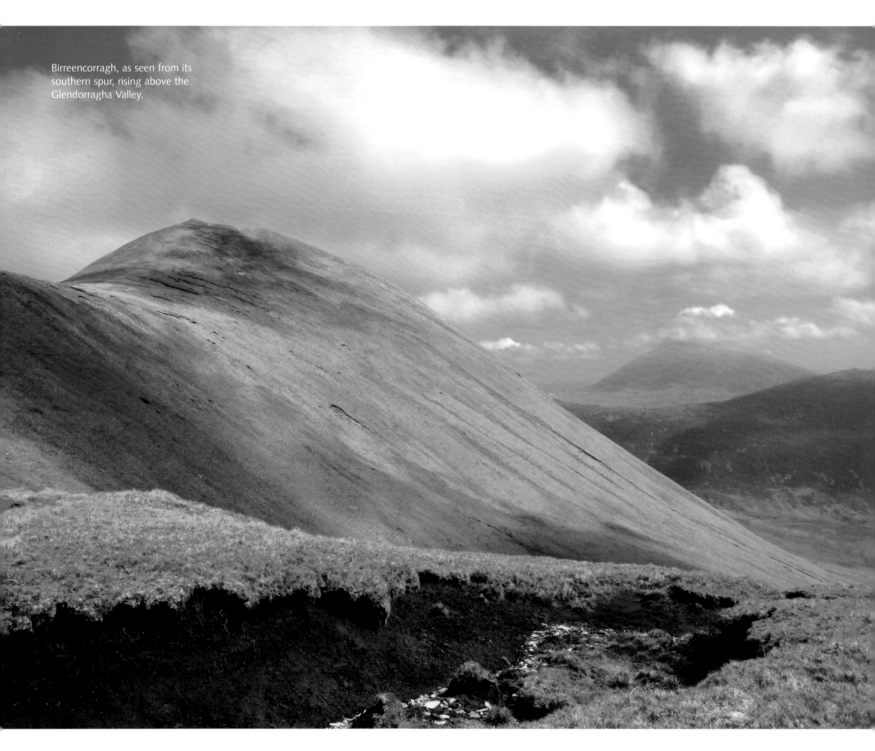

Birreencorragh, as seen from its southern spur, rising above the Glendorragha Valley.

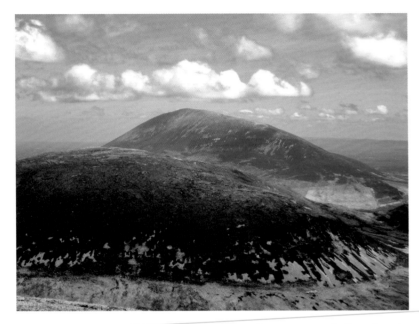

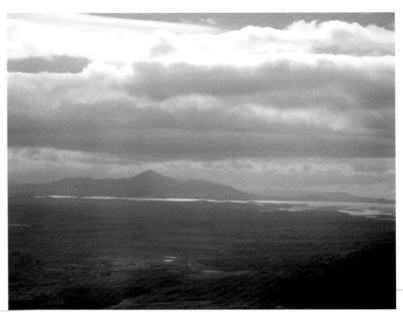

Looking across Knockaffertagh to the towering sanctuary of Nephin, a solitary mountain rising above the Mayo plains.

The view south-west from Nephin's slopes is dominated by a single mountain, Croagh Patrick, whose summit is the apex of a conical dome.

due south-west of Birreencorragh, beyond the Skerdagh Valley and across Clew Bay that dominates; a quartzite mass forming a long east-west ridge, its summit the apex of a conical dome.

In ancient times this mountain used to be known as *Cruchán Aigli* or 'mount of the eagle'. In those times, on the first day in August, women would climb to the summit and spend a night on its upper slopes. It is said that childless women would conceive soon after that act of pilgrimage. This act is part of a Celtic harvest festival called *Lughnasadh*, celebrated in thanksgiving to Crom Dubh, a Celtic deity of fertility and abundance who made the summit his abode. A pagan god of dark complexion, Crom Dubh was said to have descended from the Fomorians, a mythic sea-pirate tribe of African origins who arrived in Ireland around 1800BC. With the onset of Christianity, such pagan worship was suppressed and Crom Dubh went on to be depicted as an evil god who postulated human sacrifices in return for a good harvest. During Lent around AD441, a saint by the name of Patrick braved his way to the dwelling place of Crom Dubh on the heights of *Cruchán Aigli*, and brought with him a white metal bell. Here, it was said, a showdown ensued between the Celtic deity and Christian saint. Written records by medieval monks, written centuries after St Patrick's death, provide a clue to what events transpired.

After fasting for forty days and nights, weeping, encountering angels and battling demons on the summit, St Patrick finally descended the mountain. As he descended, mighty birds flew about him. The saint held the bell in his hand, which was now tainted black due to the battles St Patrick had with 'snake-like demons' on the mountain. With the help of his bell, he banished them to the sea. The pagan mountain now became a holy mountain, known as Croagh Patrick (764m/2,507ft), or locally referred to as the Reek.

In the centre near Murrisk, at the northern base of Croagh Patrick, I once saw a striking aerial photograph of thousands of flickering lights that stood out in the night sky and dazzled the flanks of the dark mountain. These days, such midnight pilgrimages have ceased to occur. However, during the last Sunday in July, Reek Sunday, tens of thousands of pilgrims climb Croagh Patrick, maintaining an annual tradition practised for the past 1,500 years. It is believed that many do so in their bare feet. In 2006, the winds tore savagely and torrential rain ravaged the land. Even so, around 20,000 people participated in the climb. It was a year of statistics, as Civil Defence volunteers carried out a survey of 11,000 of these pilgrims. Interestingly, out of this total, only 2 per cent ascended the mountain in their bare feet. Also, two thirds of pilgrims were men, one third women, 5 per cent lived

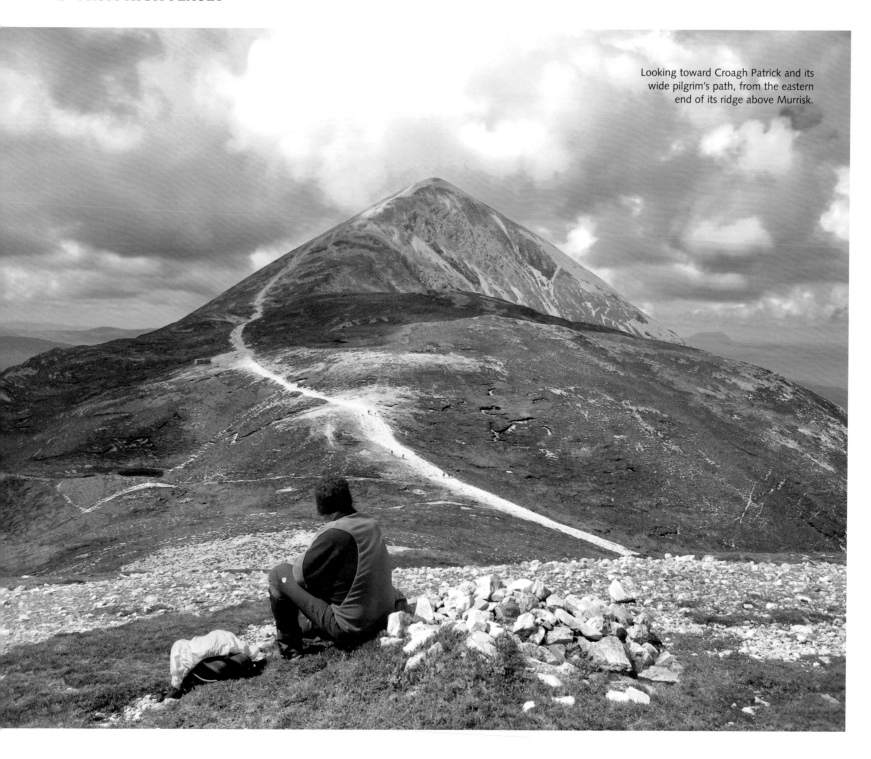

Looking toward Croagh Patrick and its wide pilgrim's path, from the eastern end of its ridge above Murrisk.

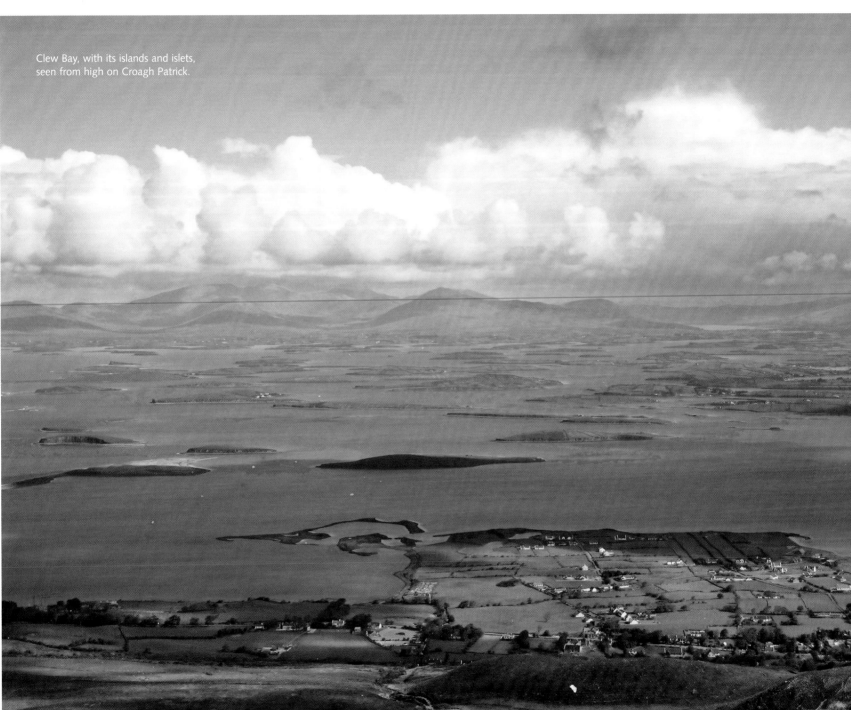

Clew Bay, with its islands and islets,
seen from high on Croagh Patrick.

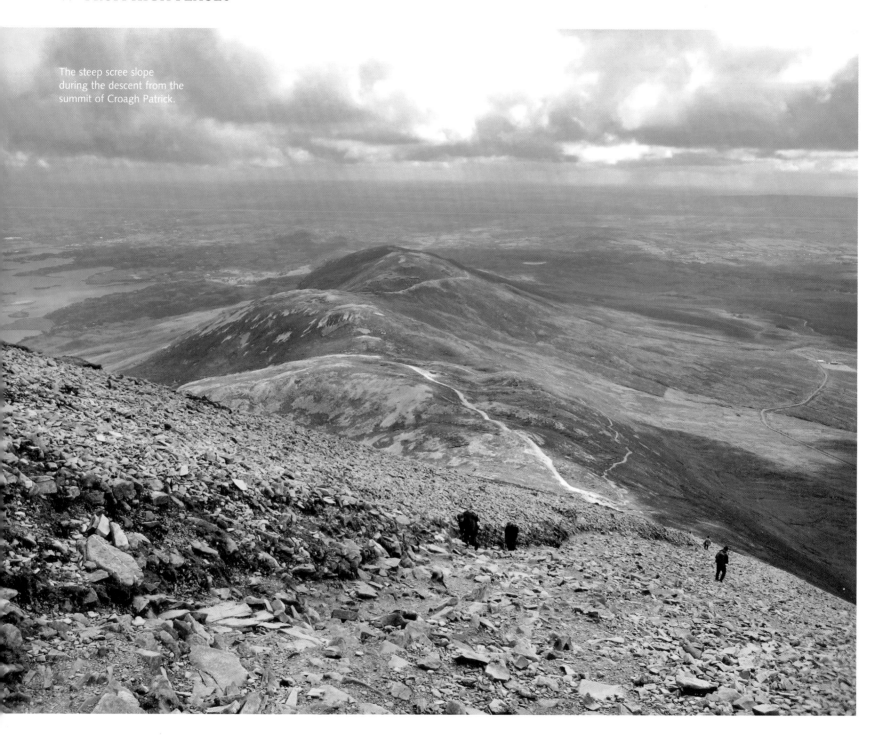

The steep scree slope
during the descent from the
summit of Croagh Patrick.

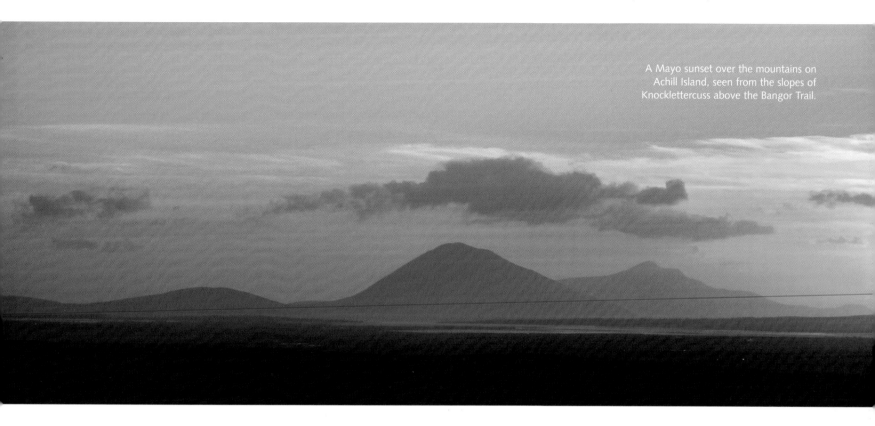

A Mayo sunset over the mountains on Achill Island, seen from the slopes of Knocklettercuss above the Bangor Trail.

abroad and twenty-three people were stretchered off or airlifted with injuries or illnesses. To these pilgrims, such a climb would be a leap of faith in itself, as many of them may have never set foot on a mountain before. However, all this dwarfs the feat accomplished in 2005 by adventurer Ian McKeever, who ascended and descended Croagh Patrick seven times in just over seventeen hours.

I've climbed Croagh Patrick several times in recent years. At the start of the Murrisk path there is a sign that says, 'When climbing the mountain keep strictly to the path. Do not climb on wet foggy days.' On each return, the broad, stony path to the mountain's upper reaches sadly appear to be increasingly eroded. I plod up its final grey-white scree slope of quartzite rock to gain the summit. The chapel here was built in 1905. It is normally locked. Locals say that hundreds of 3kg cement bags where wheeled to the base of the mountain and dedicated men carried these to the summit.

I've never climbed Croagh Patrick on Reek Sunday; following throngs of people is not my thing. I normally opt to ascend early or late in the day. On days like these, I am glad to be alone on the mountain. The view is stunning – Clew Bay with its archipelago of harlequin-green drumlin-studded islands decorates the peaceful waters to the north. They say there is an island here for every day of the year; indeed there are many. Mountains and plains grace the horizon to the north and south. I look out to Clare Island, intrigued by its 462m/1,516ft summit of Knockmore, and beyond that, to the north-west, the cliffs and mountains of Achill rise from the sea.

four

NEXT STOP, AMERICA

I sit on a stone after noon and consider the glow
Of the sun through mist, a pearl bulb containedly fierce;
A rain-shower darkens the schist for a minute or so,
Then it drifts away and the sloe-black patches disperse.

Derek Mahon

A light breeze brushed my cheeks in the warm sunshine. I closed my eyes and soaked up the atmosphere. Alone, amidst gloriously spacious views, serenity beckoned. Eyes back open, I slowly began to savour and trace the unending circular panorama. The cobalt-blue waters of Blacksod Bay to the north with Belmullet in the distance. An endless vista back to the mainland due east dominated by the distant Nephin Beg range. To the south-east, the hilly Corraun peninsula, and Croagh Patrick farther away still. To the south, the unmistakable outline of Clare Island and its highest point, Knockmore. Then the prominent Menawn Cliffs and inviting Trawmore strand closer at hand. The still calm waters of Keel Lough and the sprawl of holiday homes at Keel closer still. Finally, before a complete circle was traced back along the delightful coastline returning to Blacksod Bay, the eyes stop, transfixed on the massive bulk of Croaghaun, a vertiginous stack perched at the edge of the world dominating the view west of Slievemore's 671m/2,201ft summit where I stood.

Indeed, on a fine day, the view from the top of Slievemore is probably the most spectacular and commanding in all of Achill's 148sq.km/57sq.mile spread of island. The name Achill was said to have originated from the Gaelic word *Acaill*, meaning 'eagle'; it was also mentioned in *The Annals of Loch Cé*, under the year 1235, as Eccuill or Eagle Island. Leaving the eagle's-eye view from the summit, I descended its slopes, reversing the route of my ascent. But there is much more to Slievemore than its summit.

Along its southern slopes, around the 70m/230ft contour line, sits the haunting and evocative remnants of an abandoned village. Consisting of about a hundred

Looking down on Keel Lough,
Trawmore strand and the
Menawn Cliffs from the summit
of Slievemore.

The view across Blacksod
Bay to Croaghaun from the
western slopes of Slievemore.

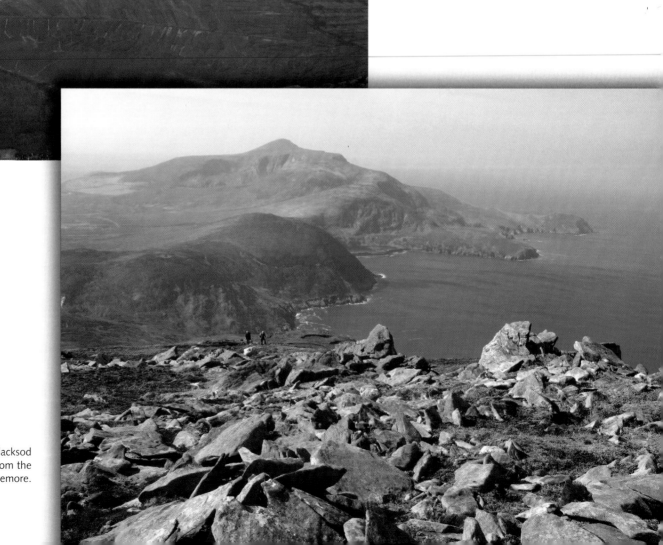

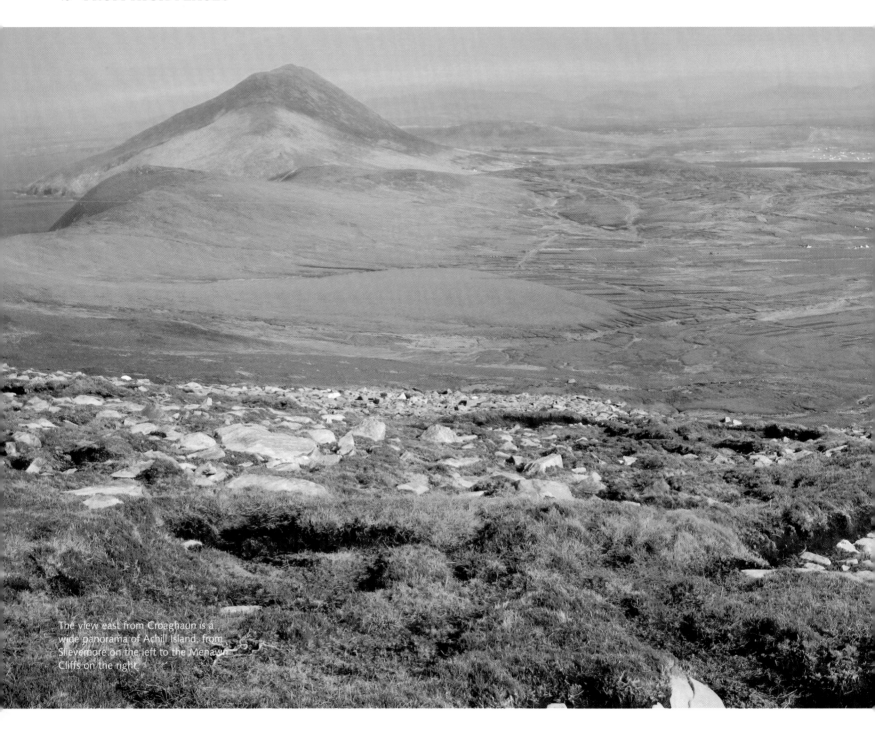

The view east from Croaghaun is a wide panorama of Achill Island, from Slievemore on the left to the Menawn Cliffs on the right.

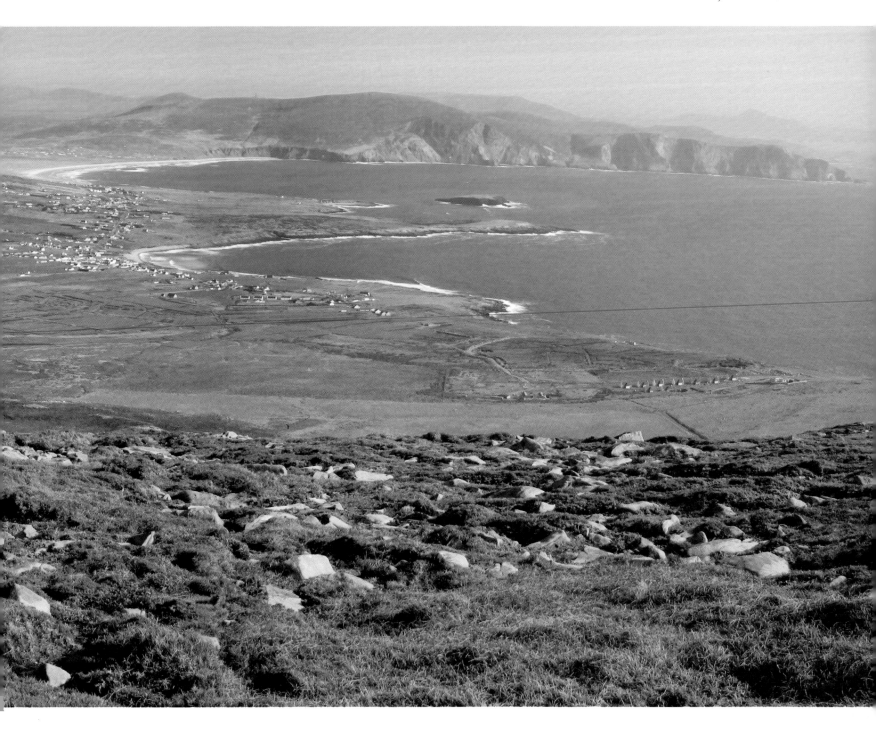

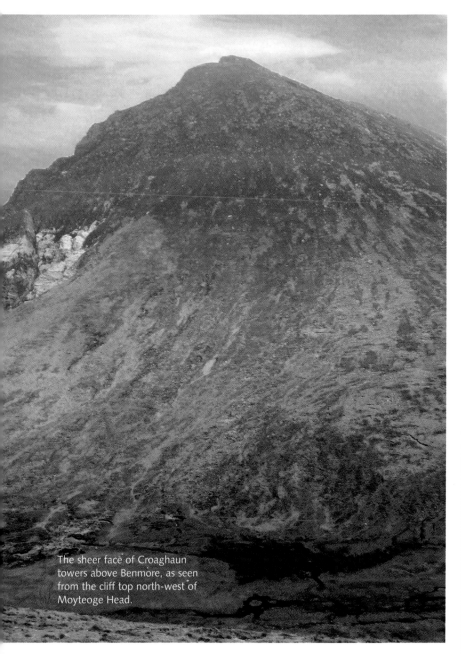

The sheer face of Croaghaun towers above Benmore, as seen from the cliff top north-west of Moyteoge Head.

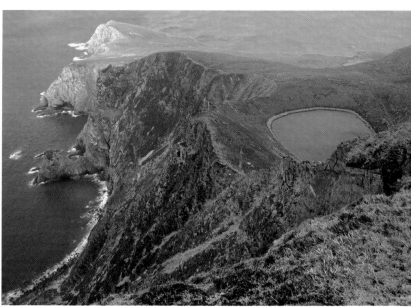

Above Croaghaun summit from its south-west top.

Right Bunnafreva Lough West, a corrie lake perched precariously above sea cliffs at Saddle Head, seen from the north-east reaches of Croaghaun.

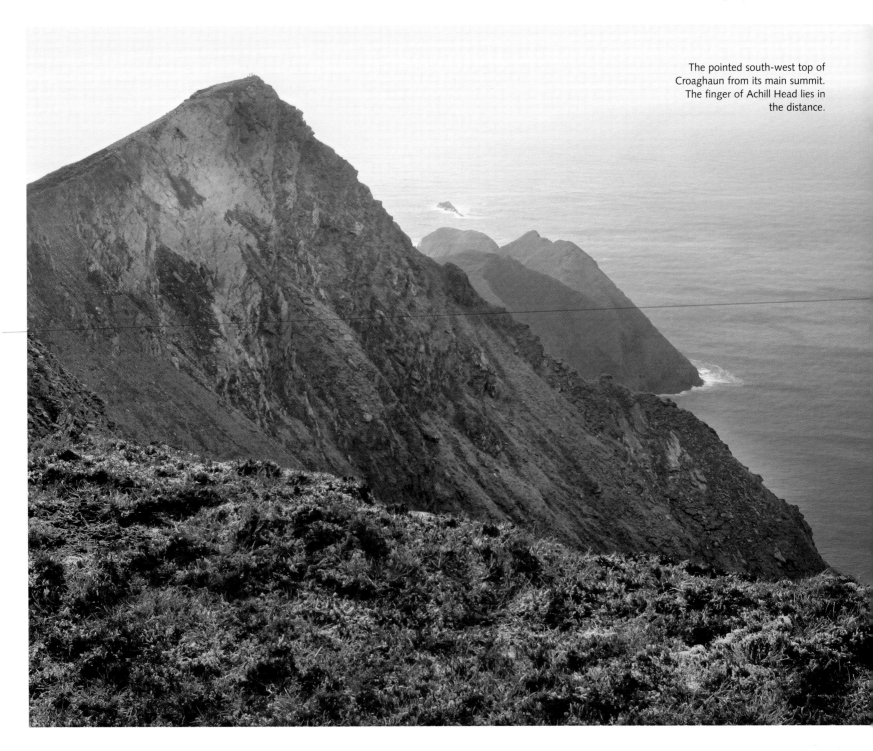

The pointed south-west top of
Croaghaun from its main summit.
The finger of Achill Head lies in
the distance.

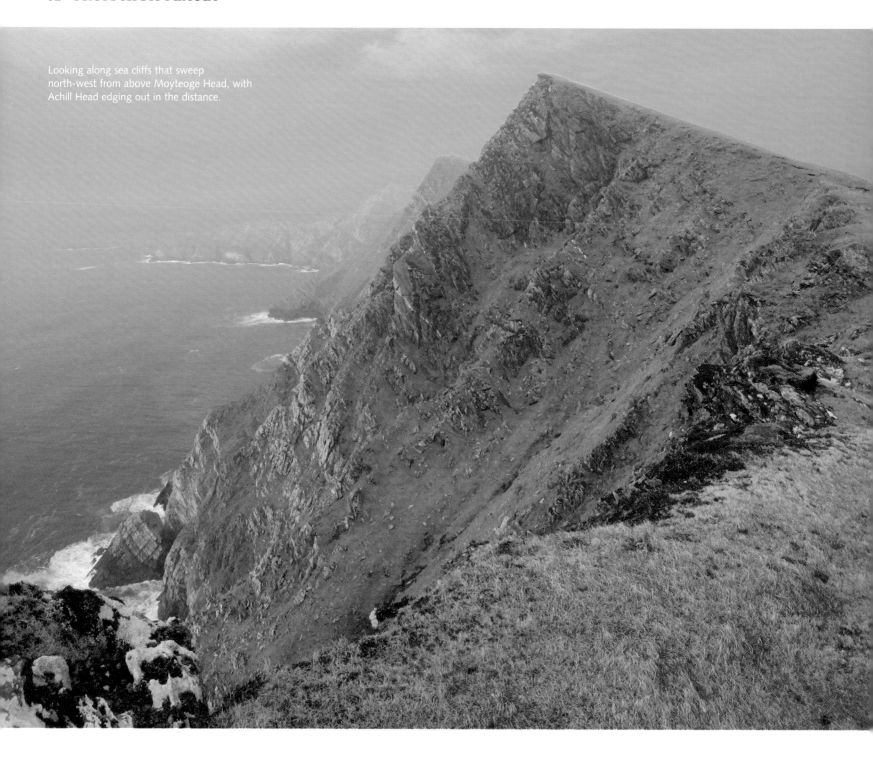

Looking along sea cliffs that sweep
north-west from above Moyteoge Head, with
Achill Head edging out in the distance.

now-roofless stone dwellings, this deserted village is a powerful reminder of the traumatic period in the island's history, the Great Famine of 1845 to 1849, the proximate cause of which was a potato disease known as the Potato Blight. Like ghosts from the Famine, voices echoed a silent lament as I walked past these ruined dwellings. Some partitions were windowless. There are stone slabs inside, cold to the touch; these were probably covered in rushes or heather and used as seats or beds once. There are also stone shelves built into the walls. During the time of the Famine, tenants were unable to pay their rent and suffered a series of harsh evictions. Families were ejected from the homes of their forefathers, where they had lived all their lives.

There are horrid tales of the manner in which these evictions took place. At the fishing village of Keel, James Hack Tuke, a Quaker from York, had seen landlord Sir Richard O'Donnell's agents evict some twenty wretched families during the Famine. Crowds of men, women and children were on their knees pleading, weeping, bewailing. A feeble old grey-haired man carrying his bedridden aged wife in his arms limped unsteadily to Tuke. He placed her down at Tuke's feet; with immeasurable anguish he pointed in agony to her, and then to the scorched timbers of his now roofless house. Another family, a widow and her four young children, had their only earthly possession, a lamb, confiscated and sold for five shillings.

The hardship led to a subsequent wave of emigration. But even emigration was not to be a ticket to salvation. Tales of coffin ships were prevalent. These were crowded and disease-ridden ships that carried emigrants across the Atlantic. Many never made it to land on the other side. The Atlantic became the Famine Graveyard for countless men, women and children.

Even in light of the projected development in post-Famine Achill, tragedy was not far behind. A study of OSi Sheet 30 reveals an old dismantled railway ending at Achill. This extension of a railway from Westport to Achill in 1894 brought some hope to this already depopulated region. However, as fate would have it, the first train brought home the bodies of the Clew Bay drowned; victims of a tragic incident where a vessel crossing from Achill to Westport overturned, with 35 of its 110 occupants perishing. Eventually, in 1937, after many profitless years, the railway company decided to discontinue the service. However, due to a blaze at Kirkintilloch, the line was forced to reopen, and the final train arrived with the ghastly burned corpses of workers who were trapped in its bothy that was engulfed in flames. Even more chilling is the notion that this was prophesised by an Achill man, Brian Rua O'Cearbháin, in the seventeenth century. O'Cearbháin vividly saw in a dream corpses carried to Achill on iron-wheeled carriages emitting smoke and fire at the beginning and end of a new epoch of transport.

This sombre mood and eerie lament was what probably encapsulated my feelings during my first visit to the island many years ago. The rain was unceasing, with blanketing grey mist, wild crashing waves and katabatic winds as we drove across the Michael Davitt Bridge from Achill Sound to Keem Strand. On the final stretch of road there were mountains sensed but not seen, which offered an impetus to return.

Subsequent visits felt like a curse lifted. Robert Lloyd Praeger describes Achill as having a 'strange charm which everyone feels but none can fully explain'. Under the warmth of the afternoon sun and cloudless sky, the settled weather revealed another side of Achill to me, one of silvery-white cliffs, velvety mountains, purple heathlands and the deep blue sea. On days like these I would imagine that among the islanders of centuries past the hope of better days lived on. Even among the majority of islanders today, a modest existence prevails and has its own attractions different to those of the the cluttered cities on the mainland.

From Slievemore's upper slopes, I was continuously intrigued by the sight of Croaghaun to the west, rising gracefully like an eagle in flight, so elegant in shape that it compelled me to climb it on the same day. Not long after leaving the deserted village I found myself at the eastern end of Lough Acorrymore, admiring the rugged, precipitous corrie walls that lined the back of it. Wispy cirrus clouds lined the blue sky, and the breeze grew in intensity as I progressed westward and upwards to Achill's highest point on the edge of the sea. As I reared up toward the 688m/2,257ft summit cairn, the gentle breeze transformed into propeller force winds that muted all intelligible conversation. The westward drop to the ocean below seemed endless; in fact it plunges vertiginously for over 2,000 feet. Despite the wind, time seemed to stand still at the summit. Up to 1912, sightings of golden white-tailed sea eagles were reported on these lofty heights. An uninterrupted panorama of the entire island revealed itself. Blacksod Bay curves to the west, with Slievemore rising above it, followed by vast brown moorlands that decorate the land among patches of green fields. White dwellings dot the eastern fringes near Dooagh Strand and Trawmore, and the Menawn Cliffs sprawl like a dragon cresting the sea in its far eastern end. The wind subsided, so I traversed Croaghaun's curved ridge westward to its fin-shaped subsidiary summit. Minutes later, I arrived at its lichen-strewn summit rocks; the views of reptilian Achill Head and back toward the main summit astounded me. I lingered.

The next day I drove westward along the R319. Toward the cul-de-sac at Keem Strand, the road loses about a hundred metres of height and takes several tight bends, where tarmac, cliff and sea seem to meet. Keem Strand is a delightfully secluded bay, tucked in a nook between the slopes of Moyteoge Head and Croaghaun's southern slopes. It was said that amethysts were discovered here in the 1960s when the road leading down to it was built. For quarter of a century and up to the mid-1970s, four-ton basking sharks of up to 12m/39ft in length were captured in nets secured to Keem Cliffs and killed by harpoons from canvas-covered

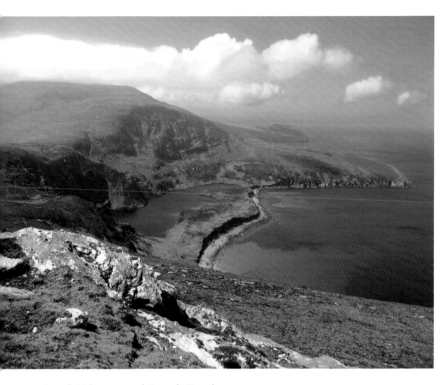

Lough Nakeeroge and Annagh Strand
from high ground above Blacksod Bay.

wooden-framed currachs. This industry thrived due to demand for liver oil and sharks fin at the time.

From the golden sands at Keem Strand, I followed a stream uphill, the ground rising above me on both sides. Lulled by the stream's murmuring, I meandered deeper into the valley and up a flat expanse to pass some small tarns. A bit farther on, I encountered the ruins of some stone buildings. These were once dwelling stables and stores of Captain Charles Boycott, a land agent of an absentee landlord in the 1850s. Captain Boycott leased 7,000 acres of land around Lough Acorrymore. In 1880, he evicted protesting tenants from their land after they had demanded a rent reduction. Urged by the founder of the Irish Parliamentary Party, Charles Stewart Parnell, the local people stopped dealing with Captain Boycott. His servants quit work in the house, stables and fields; local tradesmen ceased trading with him; and even the local postman refused to deliver his mail. The only silver lining for the Captain was that the word 'boycott' entered the English language soon after.

I stepped up a green slope toward the ridge-top and headed west. Croaghaun rose majestically behind me, its sheer western face of schist and quartzite towered like a volcano. On the ridge-top, I felt closer to the ocean than ever before. Wanting to get closer still, I edged my way, one step at a time, as far out the narrow length of Achill Head as I could, until prevailing winds strengthened, and I decided to go no further. As I stared out into the Atlantic beyond, I realised that if I possessed superhuman ability to swim the seas, I would eventually end up on American soil. I imagined the wanderings of men of centuries past, due to curiousness or necessity, reaching this point whereupon they wondered what lay beyond the horizon. My thoughts drifted back to Slievemore graveyard and I recalled reading in *The Mayo News* that a team of archaeologists led by Theresa McDonald found something there which gave an insight into the Famine and emigration. In a recent correspondence with Theresa, she noted, 'This man, Patrick Mangan, must have gone to America but came back to erect a grave slab to commemorate his father's death in 'Black '47'. The inscription read:

Lord have mercy on the soul of
Michael Mangan who departed
this life 8 Nov 1847
In the 49th year of his age
Erected by his son Patrick
AMERICAN CITIZEN
Remember friends as you pass by,
As you are now so once was I
As I am now so you shall be
Think of death & pray for me.

"AMERICAN CITIZEN' is in capital letters, so he must have taken great pride in the fact that he went to America and came back with sufficient money to erect this fine stone in memory of his father', Theresa continued. 'It is these types of discoveries which continue to surprise.'

I stared at the sea, and in that moment I knew that somewhere out there America was staring back at me.

five

YEATS COUNTRY AND CUILCAGH

The North-West

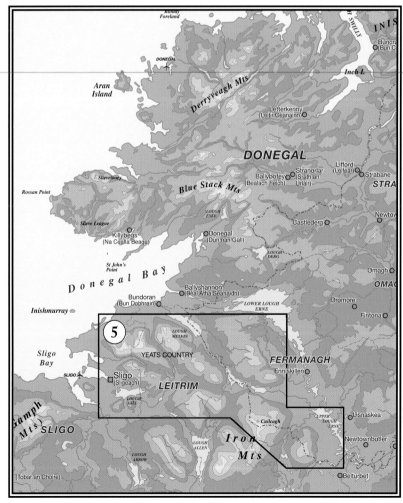

Evening light illuminating
Benbulbin's northern ramparts.

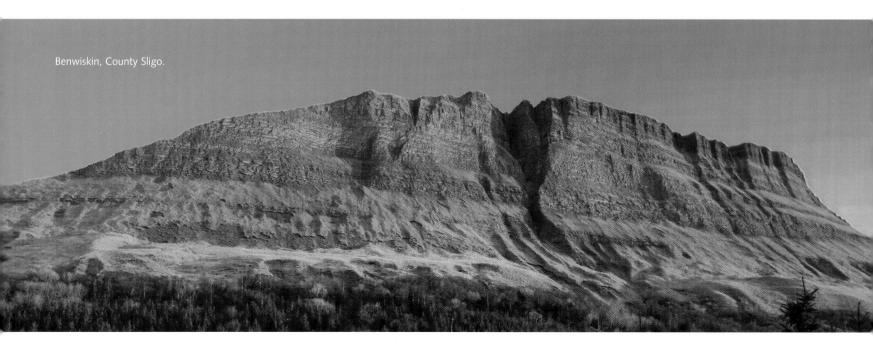

Benwiskin, County Sligo.

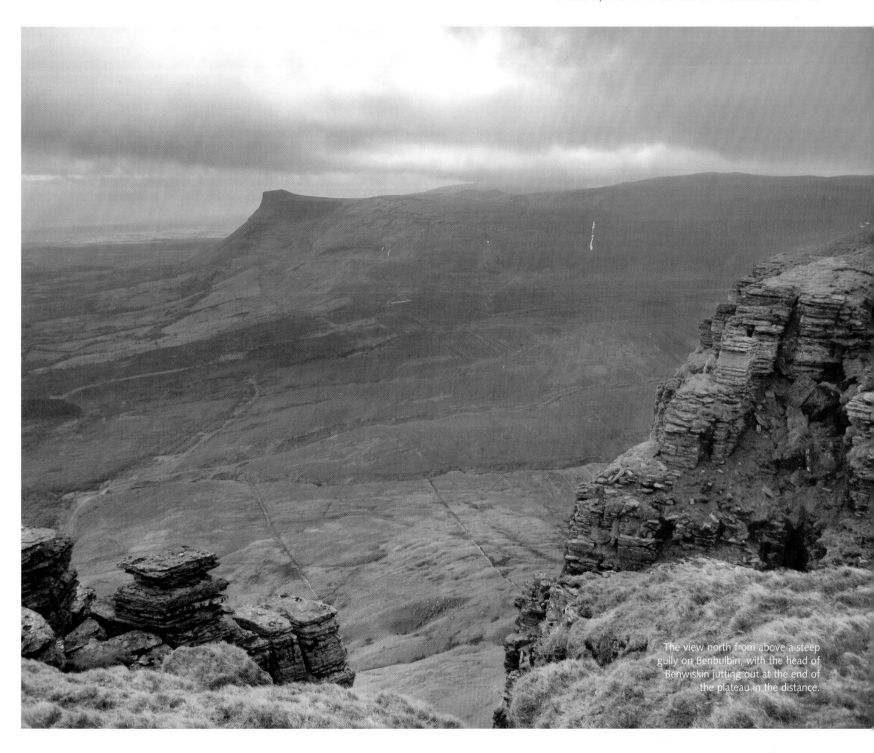

The view north from above a steep
gully on Benbulbin, with the head of
Benwiskin jutting out at the end of
the plateau in the distance.

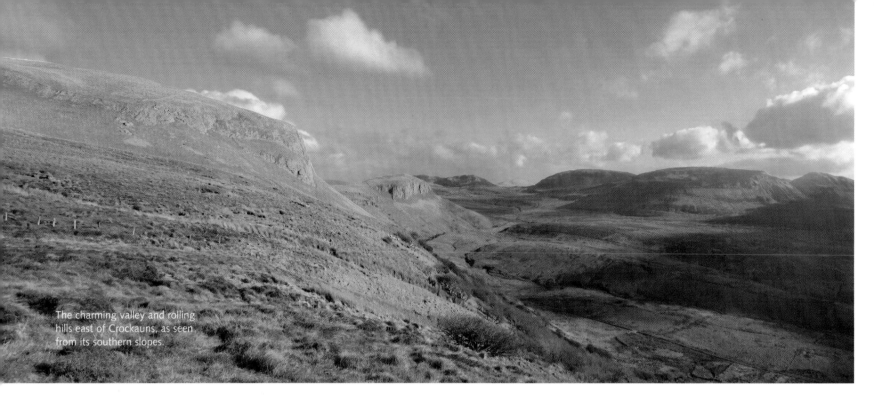

The charming valley and rolling hills east of Crockauns, as seen from its southern slopes.

Swear by those horsemen, by those women
Complexion and form prove superhuman,
That pale, long-visaged company
That air in immortality
Completeness of their passions won;
Now they ride the wintry dawn
Where Ben Bulben sets the scene.

William Butler Yeats

The western wind wisped, blowing gently against the yellow gorse. Amongst a clump of fern-green bracken and purple heather, Diarmuid lay gored in a pool of blood. The giant boar slumped beside him, a sword pierced deep into its stomach that rendered the red-eyed beast dead. There on the mountain's slopes, Diarmuid, the great Fianna warrior-hunter, was dying. The aged leader of the Fianna, Fionn mac Cumhaill, stood over Diarmuid with water cupped in the palm of his hands. Diarmuid knew if he drank the water from Fionn's magical palms he would be healed. But grey-haired Fionn was swathed in a jealous rage, and as memories of Diarmuid's elopement with Gráinne trickled through his veins, he let the water pour on the dry bracken instead. Fionn resented Diarmuid for running away with his betrothed Gráinne on the night before the royal wedding. For over a decade during the Fianna Cycle he had relentlessly pursued Diarmuid and Gráinne over the mountains, and across the glens and bogs of Ireland. For Fionn, time was not a healer of this ultimate betrayal; he had waited long for this moment. As the wind picked up, Fionn's son Oisín begged his father to heal Diarmuid. But Fionn could not, would not; and there, as the wind blew circular drifts on the foot of Benbulbin, Diarmuid breathed his last and died.

Benbulbin (526m/1,726ft) is the anglicised name from the Irish *Binn Ghulbain* or 'peak of Gulban'. A fifth-century Irish king, Conall Gulban, one of the sons of Niall Noígiallach or Niall of the Nine Hostages, derived his byname from this mountain. Viewed from the road between Drumcliff and Grange, it is an impressive limestone escarpment, shaped like a colossal upturned ship. Its western end, whose corner exhibits a likeness of the ship's prow, projects like the tip of a spear. Benbulbin's north-facing cliffs rise steeply as a series of dramatic jaw-shaped grooved buttresses. It is most dramatic when evening sunlight illuminates its walls.

One winter I climbed Benbulbin, having asked permission from the local farmer to use his track for access. The pleasant farm track meanders up lime-green grassy slopes of the mountain. Spotting a gully to my left I veered off the track, wanting to explore. There at the gully, damp in places, I felt closer than ever to the mountain's southern ramparts. I soon emerged at the top of the gully, greeted by an unceasing breeze that further chilled the crisp winter air. The silver sun struggled to penetrate the layers of drifting stratocumulus clouds during those early hours of dawn as I trudged along a broad, flat and wet moorland plateau to a trig point. I leapt across

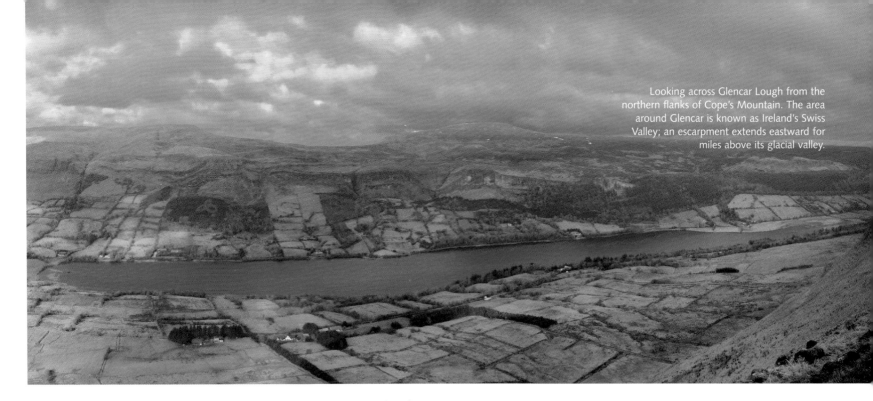

Looking across Glencar Lough from the northern flanks of Cope's Mountain. The area around Glencar is known as Ireland's Swiss Valley; an escarpment extends eastward for miles above its glacial valley.

a patch of brown bog to touch a metal plaque on the trig point. The plaque was dedicated to a Kevin Myers, aged twenty-eight, whom, as was written, 'passed on in the middle of living his dreams' in July 2002. The plateau didn't inspire me, so I wandered off north-east to its rim. Minutes later, I was staring down a gully; the ground here ruthlessly crumbled and plunged down a yawning abyss. Vestigial pillars and buttresses of eroded Dartry limestone lined the gully walls. Beyond the valley floor to the north-east, the head of Benwiskin (514m/1,686ft) jutted out conspicuously at the end of another plateau. To the north-west, Donegal Bay glimmered in the distance and a patchwork of ochre-green fields swept the wide plains of Yeats Country.

The area is known as Yeats Country as it served as an inspiration for the late Irish poet, dramatist and prose writer William Butler Yeats, who is buried at Drumcliff, 'under bare Ben Bulben's head'. The beauty of the land must have created a deep impression on Yeats, who spent much of his childhood holidays here. Glencar, Drumcliff and Knocknarea feature strongly in Yeats's poetry, such as 'The Stolen Child', 'Under Ben Bulben' and 'Red Hanrahan's Song about Ireland'. Yeats was awarded the Nobel Prize for Literature in 1923, and his works were described as, 'inspired poetry, which in a highly artistic form gives expression to the spirit of a whole nation'. In his poem, 'The Stolen Child', Yeats writes of Glencar romantically:

Where the wandering water gushes
From the hills above Glen-Car,
In pools among the rushes
That scarce could bathe a star,
We seek for slumbering trout
And whispering in their ears
Give them unquiet dreams;
Leaning softly out
From ferns that drop their tears
Over the young streams.

After climbing Benbulbin, I wanted to admire the entire length of the Glencar escarpment from a high vantage point. The escarpment stretches east-west for about 12km/7miles or so. I also wanted to seek the bliss of solitude away from the network of farmhouses that decorates the base of the main Glencar, Gleniff and Glenade valleys. Although the situation may have changed now, approaching these farmlands in the past has always filled me with a certain dread of question marks over access. Taking all into account, the area south of Glencar Lough encompassing Cope's Mountain (452m/1,483ft) and Crockauns (463m/1,519ft) seemed to fit the bill. My hopes were raised as I drove on a single-track road past Drumkilsellagh and Glackbaun, towards a cul-de-sac. The valley was isolated, quiet and full of charm, just how I like it.

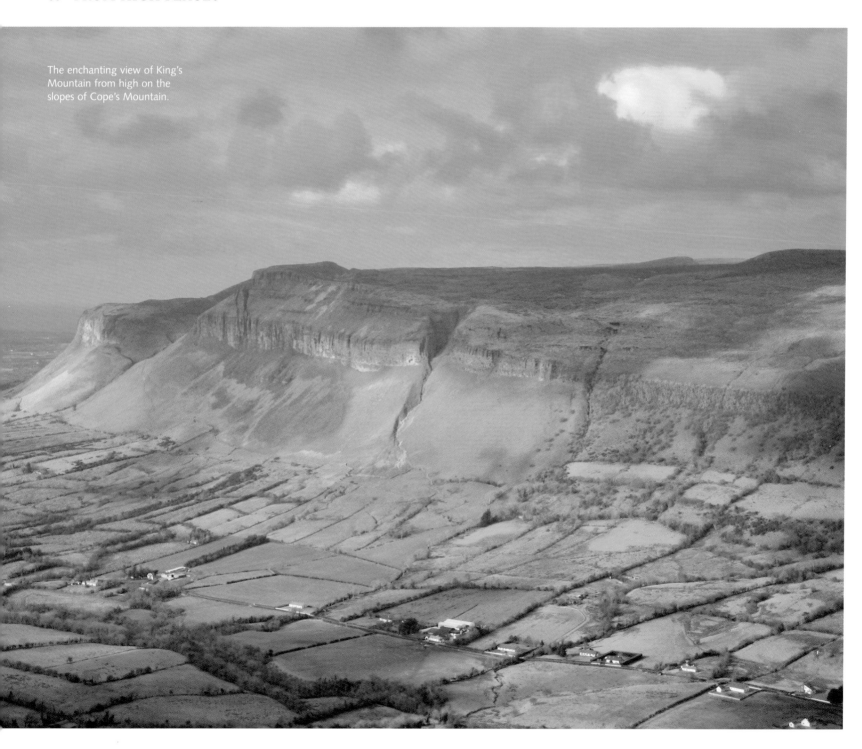

The enchanting view of King's Mountain from high on the slopes of Cope's Mountain.

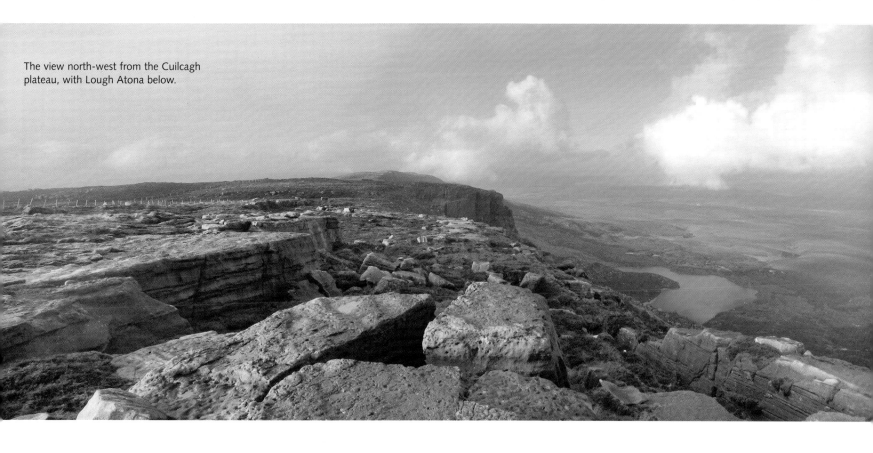

The view north-west from the Cuilcagh plateau, with Lough Atona below.

The climb up to Crockauns from the valley was moderately steep. I stepped up amongst moor-grass and skirted around a clump of trees. It was unusual for the time of year; the sun radiated gloriously on that February afternoon, tingling my cheeks with a warm sensation. In the surrounding stillness, I inhaled a lungful of fresh winter air; it felt good to be alive. I climbed higher. From the elevated slopes, a bunch of gently rolling greenish-brown hills and delightful limestone knolls embellished the land. A stream weaved its way along the olive-green valley floor until it appeared to peter out in the distance on a wide saddle between Hangman's Hill (400m/1,312ft) and Keelogyboy Mountain (438m/1,437ft). A stream of white cotton-wool clouds lined the azure blue sky; their graceful movement across the sky seemed effortless and was pleasing to the eye. I arrived at a small cairn on the summit of Crockauns and took in the surroundings. After a brief interlude I marched west across lumpy, heathery and peaty ground, bypassing several green knolls. Navigating this area would be interesting in mist, I thought. I gained another lumpy summit, and then descended to the upper flanks of a gully.

The view from the gully's upper eastern flanks was enthralling, the entire Glencar escarpment unfolded before my eyes. Rising from near the pale-blue waters of Drumcliff Bay is the bulging profile of King's Mountain (462m/1,516ft), standing like a sentry above a tapestry of green fields. Known locally as 'Fionn mac Cumhaill's table', gullies streak its limestone cliffs, culminating on the rim of the plateau. One gully in particular cuts a deep and wide fissure in the cliff face. The entire escarpment, and plateau, then stretches eastward for miles above a U-shaped glacial valley that houses a long lake. This is Glencar Lough, where a bulbous humanoid creature by the name of the Beast of Lettir Dallan was said to dwell, according to a tenth-century legend. The area around Glencar is known as Ireland's Swiss Valley. Amongst the scattering of conifers and chartreuse slopes, several waterfalls tumble down its walls into the lake, lending the area an Alpine feel. One of the streams that spill as a waterfall after a wet spell is known locally as *Sruth in Aghaidh an Aird*, or the 'stream against the height' and during strong southerly gales, water tumbling from the upper reaches of this stream is said to blast back onto the plateau.

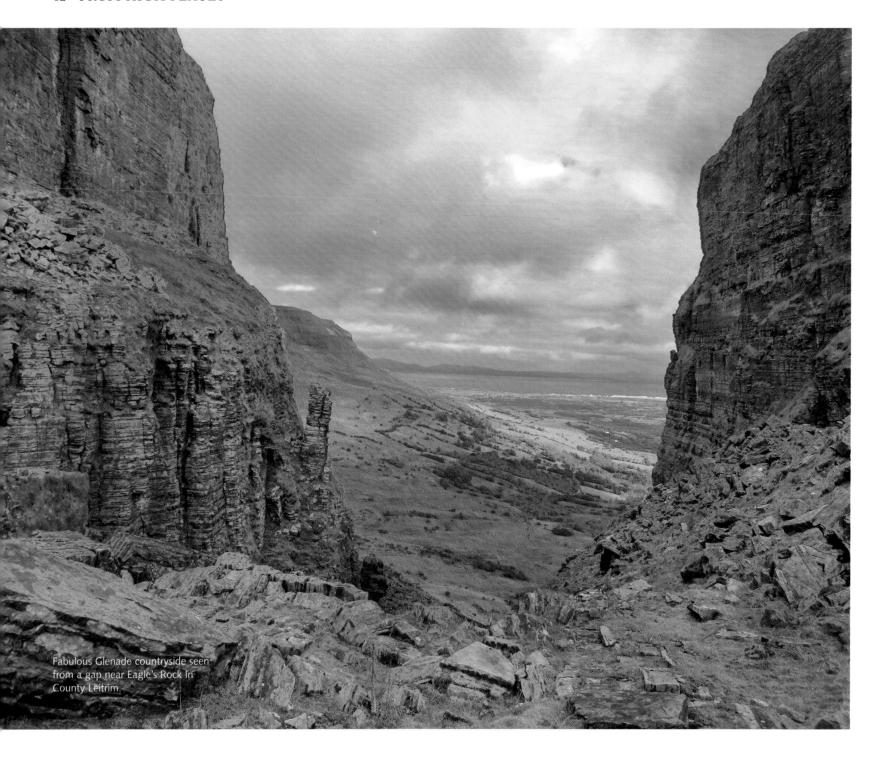

Fabulous Glenade countryside seen from a gap near Eagle's Rock in County Leitrim.

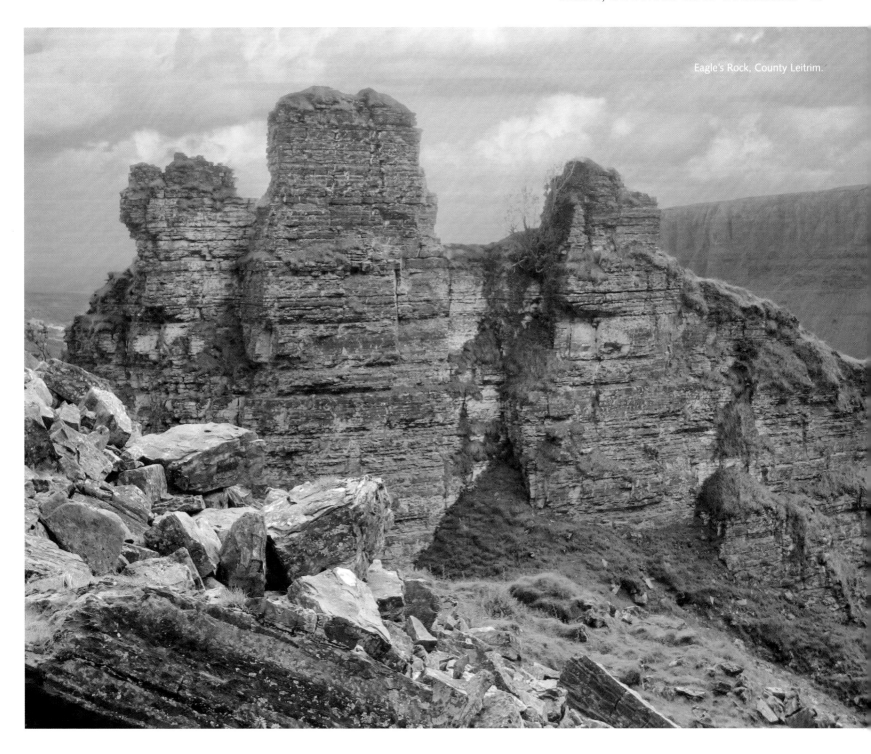

Eagle's Rock, County Leitrim.

On the opposite end of the gully from where I stood, limestone-lined green cliffs decorate the slopes and extend westward to an area called Lugnagall on the far end of the plateau near Cope's Mountain. Yeats describes the legend behind Lugnagall, or the Stranger's Leap, in his short story *The Curse of the Fires and of the Shadows*. In 1642, Sir Frederick Hamilton, a brutal seventeenth-century Leitrim overlord, and his men raided and burned Sligo Town and Abbey. According to Yeats's tale, five of Hamilton's men were ordered to pursue and kill two local rebels sent on their way to Manorhamilton to rouse an army. The five horsemen rode swiftly through woods and mountains with the intention of catching the rebels in the valley north-east of Castlegal. However, they lost their way in the dark and gloomy woods, where thick fog played out ghostly shadows. The apparition of an old grey-haired woman spooked them at a river and a corpse floated in its waters. In horror they each recognised the corpse's face as their own. Moments later, they heard music and stumbled on an old piper with a bagpipe and an old white horse and forced him to be their guide over the mountains. The piper led them up mountainous slopes miles above the woods and the red fires of Sligo Town. He cast a spell on them so that they heard the hoofs of the rebels' horses ahead. Then they realised their horses were spooked as well and galloped uncontrollably up the ever-steepening slope. Suddenly they were falling; horses and horsemen floating in thin air until they hit rock-bottom with a great thud. High on the cliff top, the piper on his white horse cracked a wry smile.

One winter, on the southern slopes of a mountain called Cuilcagh, 27km/17miles south-east of Manorhamilton, like Hamilton's men on that night in 1642, I too was caught out in thick fog. The summit of Cuilcagh, intriguingly, at 666m/2,185ft, straddles the border between Northern Ireland and the Republic. I had climbed it years before from its northern slopes via the Legnabrocky trail. However, on this occasion I approached the vast, reversed L-shaped massif from Bellavally Gap on its southern side. The air was still except for the crunching of my boots on the frosty tussocks. Some trees appeared like tall dark shadows in the haunting fog. Soon I was on the top of a spur. Only the brownish-purple moor grass and reddish-yellow sphagnum moss underfoot provided some colour to the grey world of mist that surrounded me. The wind picked up the higher I climbed, it blew from the south-east as I negotiated bog patches and peat-hags. Moments later, looming through the patch of mist was the summit's trig point, perched on a massive cairn. I rambled a short distance across the boulder-strewn plateau to its northern rim,

passing some way-marked posts. As I stared northward at the monotonous mist, the wind strengthened, and I felt the warmth of the sun on the back of my neck. Then it appeared: there on the upper surfaces of cloud layers enveloping the northern plains was my shadow, magnified tenfold, encompassed by halo-like rings of a rainbow. I swung my head around; the winter sun was bursting through odd-shaped clouds above the summit cairn. I looked back down the plains, but alas, the clouds had drifted and my Brocken Spectre was gone.

The brownish-green hummocky plains below Cuilcagh's northern rim then spread before me over a vast area, snow patches splattered around a network of fences. On the northern end of these plains, near the minor road, there are a series of sink holes and underground caves formed by rainwater flowing down grikes and clints of limestone beds, dissolving the soluble rock over time. Down cracks near Pollasumera and Pollawaddy, rivers vanish and after flowing through underground caverns, they reappear below the Marble Arch Caves, a kilometre north, as the Cladagh River.

I followed the rim of the plateau westward, toward a jumble of rocks and crumbling cliffs above Lough Atona. Lower down, amongst a chaos of boulders, I stopped for lunch. Here, inspired by the rocky scenery around me, I began to recollect a scramble up Eagles Rock in an area marked as Cloontyprughlish on the OSi map in County Leitrim a few years before. A steep ascent on its northern end leads to a distinct gap between limestone walls above. Even from the valley floor below, the conspicuous fin-like pinnacle of Eagles Rock towers majestically toward the sky. A boulder field tumbles down from the gap; the heart of the gap is impressive – precipitous rock-walls tower on either side framing the Bundoran coastline to the north. From a ridge lined with boulders beyond a sheep track, giant limestone pinnacles dominate the view. These shattered pinnacles are disjoined from the main escarpment as the result of glacial forces of the Ice Age tens of thousands of years ago when the ice retreated.

Grey clouds gathered once again up on Cuilcagh and it was time to leave. As I retraced my steps back towards Bellavally Gap, a bird of prey with brown plumage swooped down from the sky and hovered above the valley below. It was probably a kestrel, but it once again made me think of eagles. However, on this occasion, my thoughts drifted not to Eagles Rock in County Leitrim but to the Eagle's Nest in County Donegal.

six

GIANTS AT THE EDGE OF THE SEA

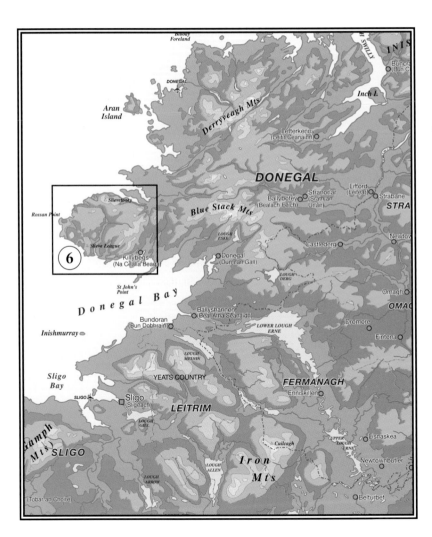

I only went out for a walk, and finally concluded
to stay out until sundown:
for going out, I found, was really going in.

John Muir

The eagle soared high in the steel-blue Donegal sky, its wings fully extended and feather-tips separated. Its golden head glimmered in the silvery sunlight as it graced the sky in sweeping circular loops. The eagle's large dark-yellow pupils honed in on its prey hundreds of feet lower on the bay below. Its talons interlocked, and like a truculent, gyrating wheel, the bird swooped down with terrifying speed toward its unsuspecting target. A shrill cry of a baby girl, only months old, pierced the wistful summer air. The mother cried out. A crowd of onlookers gasped in horror and disbelief, as the outline of both bird and baby diminished into a speck in the sky. The mother and others gave chase with their arms flailing, fingers pointing and mouths screaming. Their soles thumped clouds of dust on the dirt track as they tried to keep pace with the eagle in flight. They raced downhill. At a bend in the road some began to tire, but the mother, fuelled by adrenalin, and several able men slogged up the grassy slope toward a signal tower. One of the men saw the bird of prey swoop down the side of a cliff. Then he saw something fall, less than a hundred feet, to the cliff edge at Carrigan Head below. As the rest approached the brow of Carrigan Hill, they saw the eagle fly north-west toward Malin Beg. The mother's heart sank; she fell to her knees and broke into a raft of tears, thinking her child gone. But a shout startled her, then cries of joy, as a crowd pointed to a heathery ledge on the cliffs below. The man who saw the baby fall had descended the cliffs, and waved from the ledge that the baby was alive. The baby girl was badly scarred but miraculously survived; in fact she lived to a ripe old age. Years later, her tale of the eagle and its eyrie high above the sea cliffs is passed down the generations by her great-granddaughter Nanny O'Byrne.

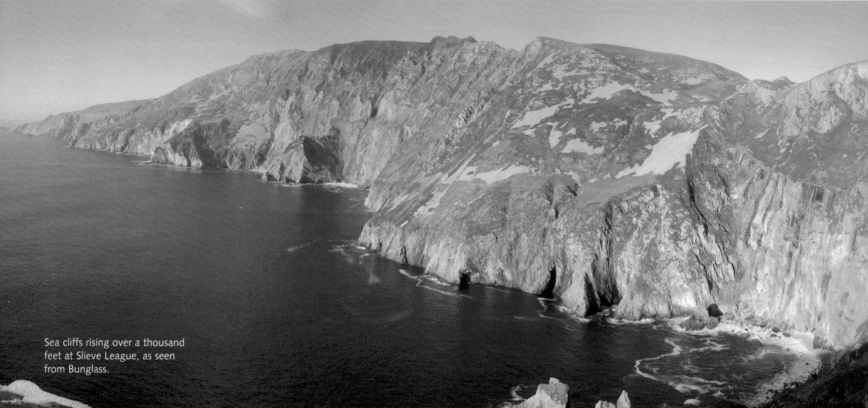

Sea cliffs rising over a thousand feet at Slieve League, as seen from Bunglass.

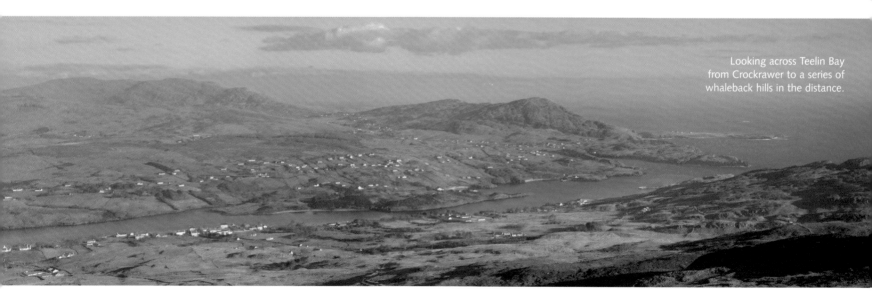

Looking across Teelin Bay from Crockrawer to a series of whaleback hills in the distance.

Some time after this incident, around the period of famine in 1817, a desperate Andrew McIntyre ventured high on the cliffs north of Carrigan Head, above an area called Bunglass, to seek out the Eagle's Nest. McIntyre eventually stumbled on the nested platform, and found the carcass of a lamb there. He seized the dead animal from the eagle chicks and brought it home as food for his family. One day, during the height of the famine, McIntyre returned to the eyrie, but to his astonishment he discovered human limbs this time. McIntyre and a group of men hunted the eagles and later set the nest on fire. The prevailing wind blew the smoke of the burning nest north-west, drifting over thousand-foot cliffs by the edge of the sea to the summit of Slieve League (595m/1,952ft).

East of Slieve League, a minor road creeps uphill from Teelin, a small coastal village with a reputation for fishing and traditional music, then winds it way in a series of switchbacks, passing under Lough Meehaviller and Lough O'Muilligan to a car park south of Bunglass. This parking area is known locally as *Amharc Mór*, which means 'great view', and I for one cannot argue with that, as no sooner does one step out of the car than one is greeted by sea cliffs over a thousand feet extending several kilometres north-west.

One fine evening in mid-February, having revelled earlier in the day with a climb up Slievetooey (511m/1,677ft), a mountain range west of Ardara, I wanted to top it by savouring a sunset from the heights of Slieve League. It was a gorgeous winter's afternoon, and under a cloudless azure-blue sky I drove south from Maghera through the villages of Meenaneary and Carrick amidst some delightful Donegal countryside to Amharc Mór. The gentle wind caressed my cheeks as I laced my boots, my spirit invigorated by the salty smell of the sea and the soothing rhythms of Atlantic waves lapping against the cliffs. Several grey-white gulls wailed in the sky, blowing intermittent squawking calls and floating freely in the air without a care in the world. Views were far-reaching; I could even make out the unique shape of Benbulbin in the distant south. I wandered alone up the flagstone path, and this seemed to fit the bill, as Slieve League in Irish, *Sliabh Liag*, means 'mountain of the flagstones'. I passed two couples descending from Scregeighter (308m/1,010ft); one of them expressed concern that it was late in the day to be going on up, but I assured them I was well prepared to usher in the darkness. Like the solemn chanting of saints, the mountain was calling me.

There is something truly special about this place. A sweet melody tugged at my heartstrings as I marvelled at the immense facade of the Bunglass sea cliffs. These concave cliffs, green at the bottom, were sculpted by the Atlantic over the millennia and drop precipitously to the foaming sea. The amalgamation of colours here is both profound and vibrant; the cliff-face bursts in different shades of green, yellow, amber, brown, silver and gold, produced by the variation of rock types, mineral ores and flora that emblazon its slopes. There are two rock stacks out in the sea, not far from the main cliffs, separated by a narrow channel. These pinnacles are large enough for a giant to sit and write on, and so are rather appropriately named by the locals as 'The Giant's Chair' and 'The Giant's Desk'.

I continued on up to Scregeighter, where the couples probably shared a romantic embrace, and then to the notorious Eagle's Nest, perched near the elbow of some cliffs. Slightly higher, on Crockrawer (435m/1,427ft), slopes of brown heather and sap-green moor grass roll down the mountainside to the sea, while farther on, the ridge appears to narrow, and crumbling cliffs of quartzite, schists and conglomerates extend finger-like into the waves below. It is likely that millions of years ago, probably during the Carboniferous period, part of the mountain had been submerged under the sea. I looked inland, and the gentlest of views captured my eye. The sheltered blue waters of Teelin Bay extend for miles to Carrick Lower Bridge, a pockmark of white dwellings line rolling green fields on either side of the bay and a series of whaleback brown hills curve in the distance.

I walked along the cliff path on the edge of the sea to *Keeringear*, the 'sharp crest'. This is a narrow quartzite rock-rib about three-quarters of a metre wide. It projects upward some 10m/33ft, with inclines on either side, but the precipitous slope of heather, grass and jutting rock is somewhat more dizzying on its seaward side. On an overcast and breezy day years ago, this section of rock eluded me, so in a sense there was some unfinished business on my return to Slieve League. Hands on rock, I stepped up, using little footholds on the initial rock-step. An easy scramble followed, to the mid-way point of the rib, and then a final rocky rise that served as a climax to this short but exhilarating section.

The ridge broadened after Keeringear, becoming increasingly stony underfoot, the rock scattered into fragments and standing as tiny cairns in places. I had a little more than half an hour of daylight left, so I moved on at a canter, trotting along the feature marked as One Man's Pass on the map. This is nowhere near as demanding or narrow as Keeringear, for One Man's Pass is wide enough for even three people to stroll on. Only moderate drops of heathery slopes littered with a splash of rocky outcrops decorate either side. Moments later, I carried out the ritual of touching the trig pillar on the summit. I didn't linger long there, but retraced my steps back along One Man's Pass. Nearly a thousand feet below on the left, the pastel-blue waters of Lough Agh added colour to the corrie floor, which transformed into darker hues of green as time ticked by. At the southern back wall of this corrie sits the ruins of a sixth-century Christian hermitage and oratory. The rugged Donegal countryside to the north was filled with a rosy haze and the skyline radiated with soft tones of purple and pink that gradually turned darker as dusk approached. Slievetooey stood proud in the distance, and as the sun started to dip in the western sea, I reflected on my day's earlier ascent.

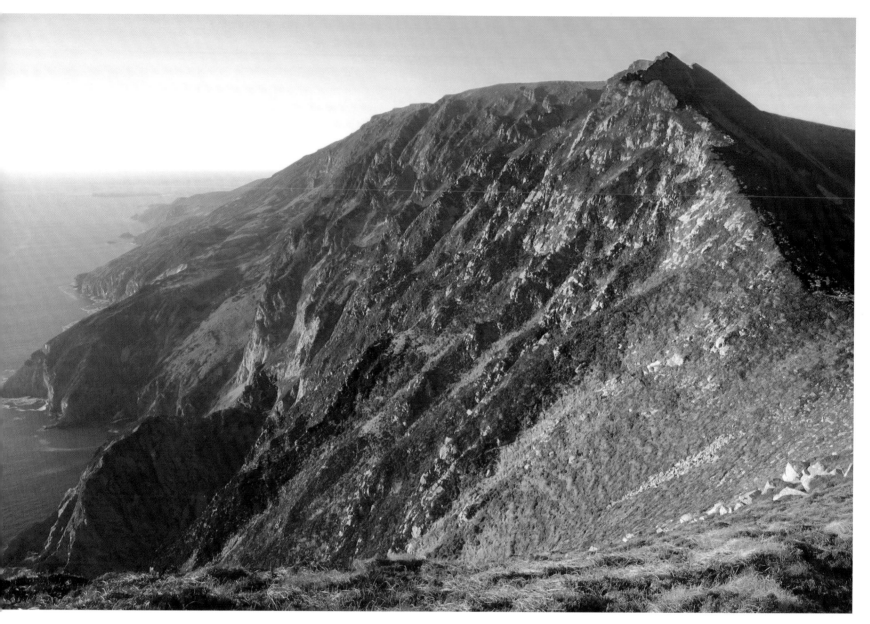

The sharp crest of Keeringear projects
on the skyline with steep cliffs
tumbling to the Atlantic on its left.

Opposite Looking down toward Bunglass
from Keeringear's narrow rock-rib.

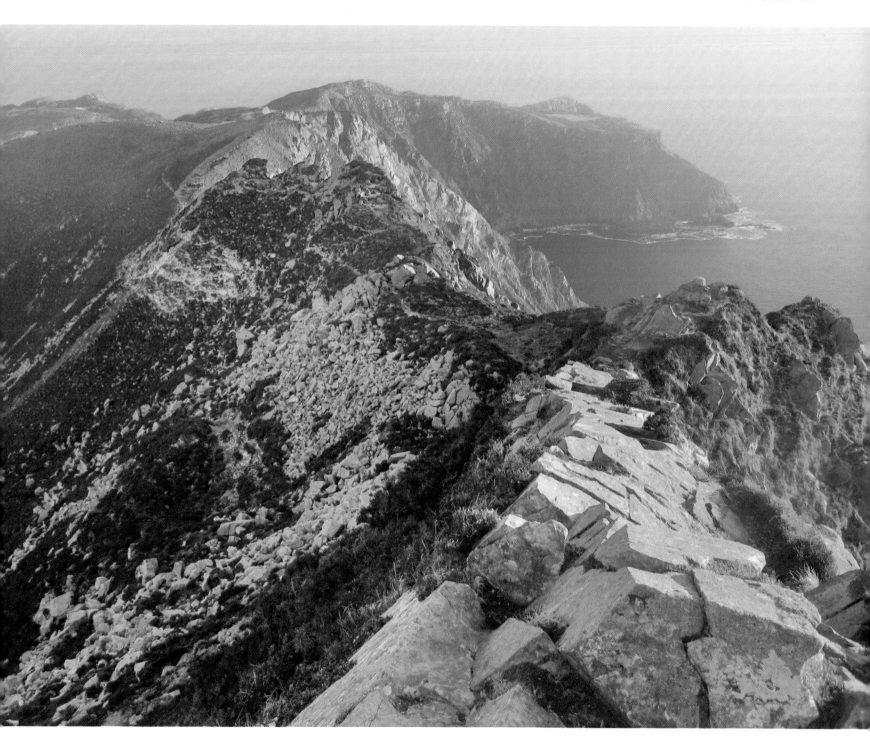

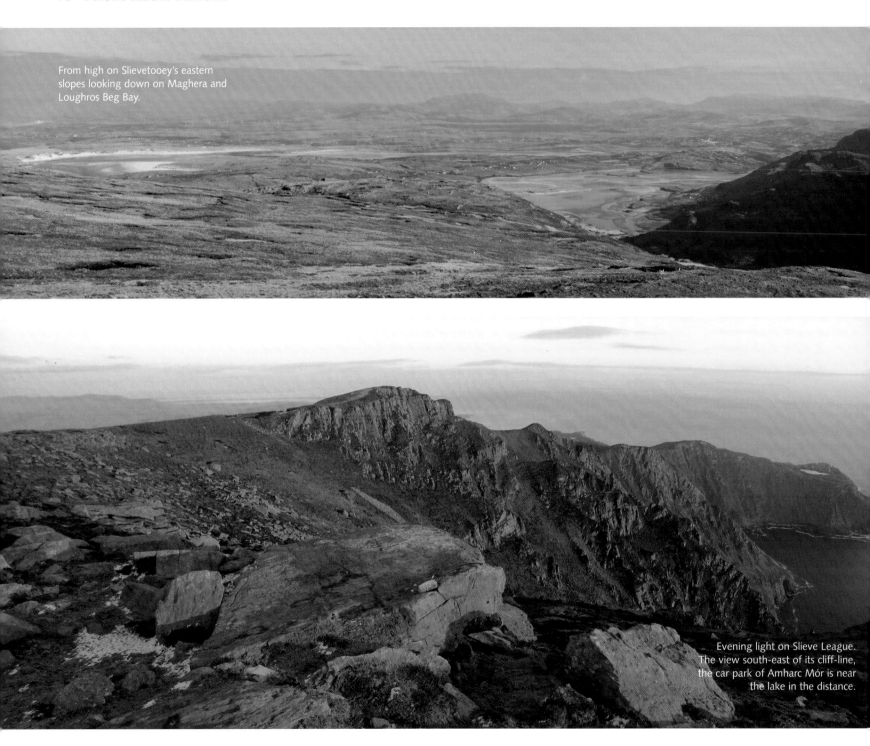

From high on Slievetooey's eastern slopes looking down on Maghera and Loughros Beg Bay.

Evening light on Slieve League. The view south-east of its cliff-line, the car park of Amharc Mór is near the lake in the distance.

Slievetooey, a quartzite mountain mass, extends from the remote enclosed basin and abandoned harbour at Port to the white sands of Maghera Strand, nearly 13km/8miles east. There, beyond the craggy hillocks, are the stone-walled ruins of a hill-fort on a promontory along the spur that rises above Maghera, the 'plain of the fort'. The spur changes direction above Lough Acruppan, and then again at the corner just above Lough Beg. The view back toward Ardara is commanding from up here – Maghera Strand, with its twisting inlet of water leading to Loughros Beg Bay, is dwarfed by the larger Loughros More Bay that sits behind the protruding green thumb of Loughros Point, and beyond that the distant blue-grey outlines of the Glendowan and Derryveagh Mountains. I reflected while edging up the spur above a larger lake, Lough Croaghballaghdown, which was lying in the shadow of the cliffs that guard its southern end. A fence leads gently up to the summit trig point, and there the entire expanse of the Slievetooey massif spreads out, with views as far as the scraggy headland of Sturrall, nearly 11km/7miles away. South of Sturrall are the black cliffs of Glen Head. Here, in 1870, a vessel named *Sydney*, travelling with a cargo of timber from Quebec to Greenock, tragically crashed. A few souls struggled up the bleak cliffs to survival but twenty-seven unfortunate crew members perished in the wild sea.

Back on Slieve League, I dropped down to a notch in the cliffs as the evening sun dipped below the horizon. As the mountain waited for the final rays of light to depart, so did I. Amidst the symphony of glowing colours reflected in the water and that of the sky, I was filled with contentment. I stood in awe, and for a brief moment my spine went both numb and cold at the same time as I observed the golden-yellow luminance of the sun dance like diamonds on the iris-blue waters of the sea. It was then that I reflected on the words of H.V. Morton, which he wrote in his classic book *In Search of Ireland*, 'And you feel that if God chose a place to reveal Himself it would be upon these western hills at sunset when the whole hushed world is tense with beauty and earth seems waiting for a revelation'.

Just standing still in the presence of beauty moved me in ways that words simply could not. The sun began to sink into the ocean; its reflection in the tranquil Atlantic waters was an intense yellow line, bursting like a tongue of fire which turned into a darker shade of amber and vermillion farther away. The skyline was divided into two beautiful sections, a gentle blue at the top and an orange band closer to the horizon. As the sun dipped even lower toward the horizon, the sea burst with lavender blue and then indigo, before its surface seemed to ripple with ruby streaks reflected from the dying embers of sunlight. The orange band above the horizon transformed into a dazzling display of crimson. As all the colours of land, sea and sky grew more intense, my heart rejoiced with the beauty of it all. For a moment, time stood still and then darkness, as body, mind and soul fused into the landscape. But I was blessed in more ways then one that night; the moon soon took charge and then there were hundreds of stars twinkling in the night sky. I walked on the cliff-top of Slieve League under the starlit sky, guided by the moon and scurrying sheep, whose eyes gleamed silvery-white in the dark.

About an hour later, I arrived back at Amharc Mór to the sounds of waves crashing against Bunglass and greeted by a pair of badgers that appeared from beneath my car. Like the couples on Scregeighter, I suppose they too were enjoying a romantic interlude. After all, it was that kind of day, when you wished a moment would last an eternity. I stuck my key-card into its slot, started the ignition and mentally counted the miles of road home to Dublin. It was late but it was worth it, so I smiled. And there, under the shadows of the Blue Stacks, I drove from Killybegs to Donegal Town, full of the joys of life.

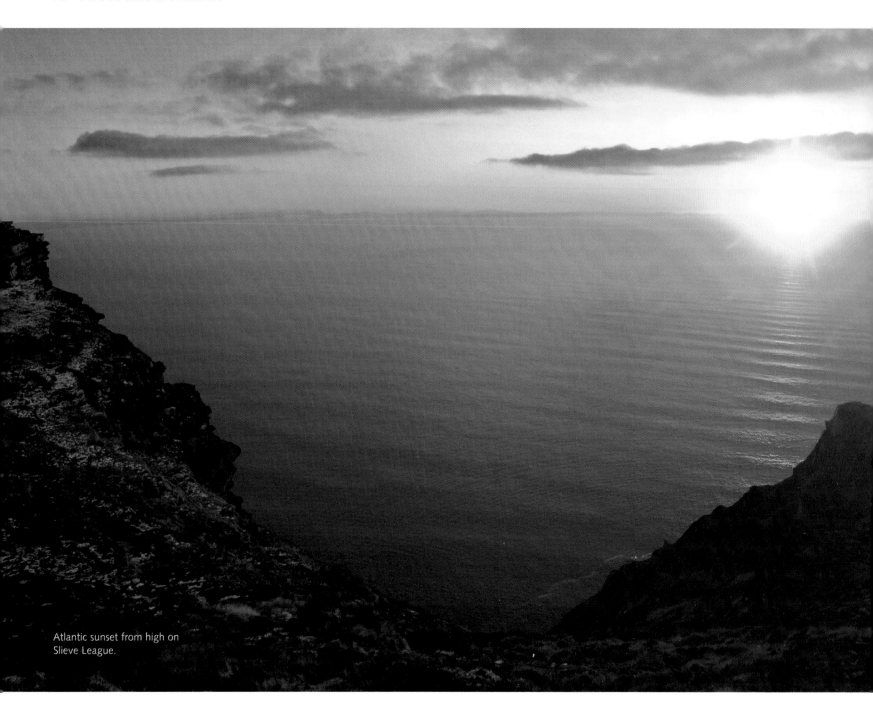

Atlantic sunset from high on
Slieve League.

seven

DEEP IN THE BLUE STACKS

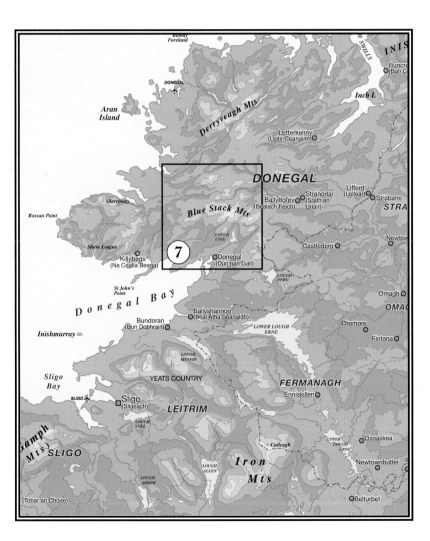

Like old ghosts in Winter,
the clouds came stealing
in off the sea
and in o'er the land
touching the top of the hills with their hand.

Eamonn Bonner

The lake was frozen to the core. I tapped at its surface, the hard ice glittering like diamonds under the force of the sun. I dug under a clump of heather and stuck my arm through a gap between the earth and the lakeside. Down below, as far as my arm would go, my fingers felt the lake's water-edge, solid as a bell and cold as a freezer. It was unreal. I imagined all living organisms – snails, insects, newts, waterweeds and plankton – in suspended motion, trapped in time until the great thaw. The summit of Aghla Mountain (593m/1,946ft) was clearly visible from this nameless lake, its trig point peeking out on top of a rocky mound amongst a jigsaw of quartzite outcrops and snow-fields that adorned its hollowed slopes.

I saw sets of footprints of different shapes and sizes in the crunchy snow, marked both by human and sheep. These prints wound up the snow-field that led to the summit area. Some sections of the snow-field were hard ice, probably due to the snow thawing in the day and refreezing overnight. Using the edge of my boot soles I sliced-stepped up the moderately angled snow-field. According to statistics, 2010 was the coldest winter in Ireland for almost fifty years, creating ethereal alpine-like conditions in the mountains, with air temperatures falling below -10°C during some periods in January. But it was not just the coldest winter on record, it was also the driest, sunniest one for years, with mean wind-speeds well below the normal average. This all meant heaven for me, for Ireland's high places were transformed into an ethereal world of their own.

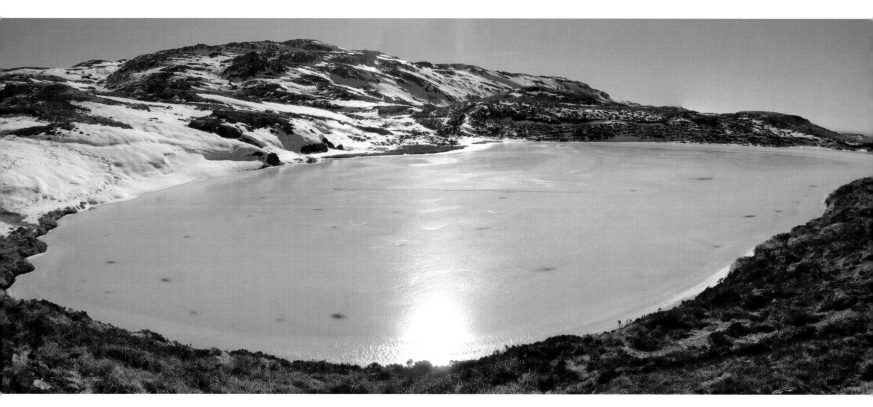

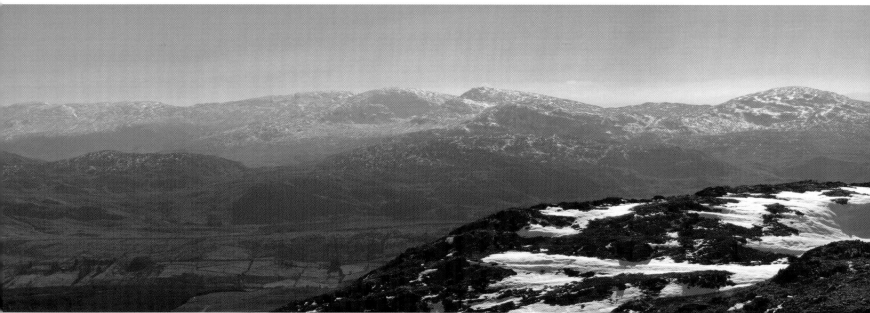

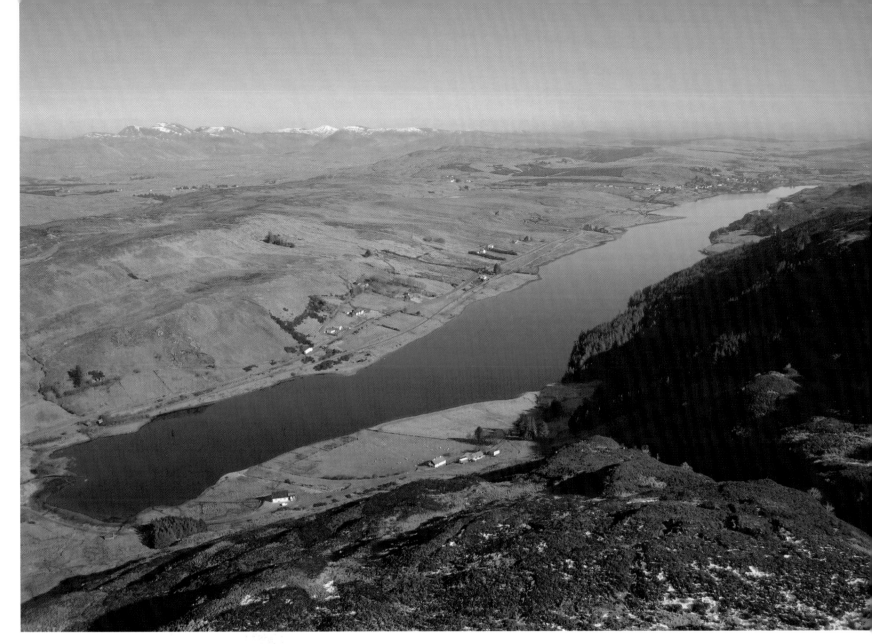

High above Lough Finn on the
slopes of Aghla Mountain, with the
Derryveagh Mountains in the distance.

Opposite from top
A frozen lake below the summit of Aghla
Mountain in the Blue Stacks.

The main Blue Stack Mountains ridge, a
formidable mass of rounded granite, as seen
from the summit of Aghla Mountain.

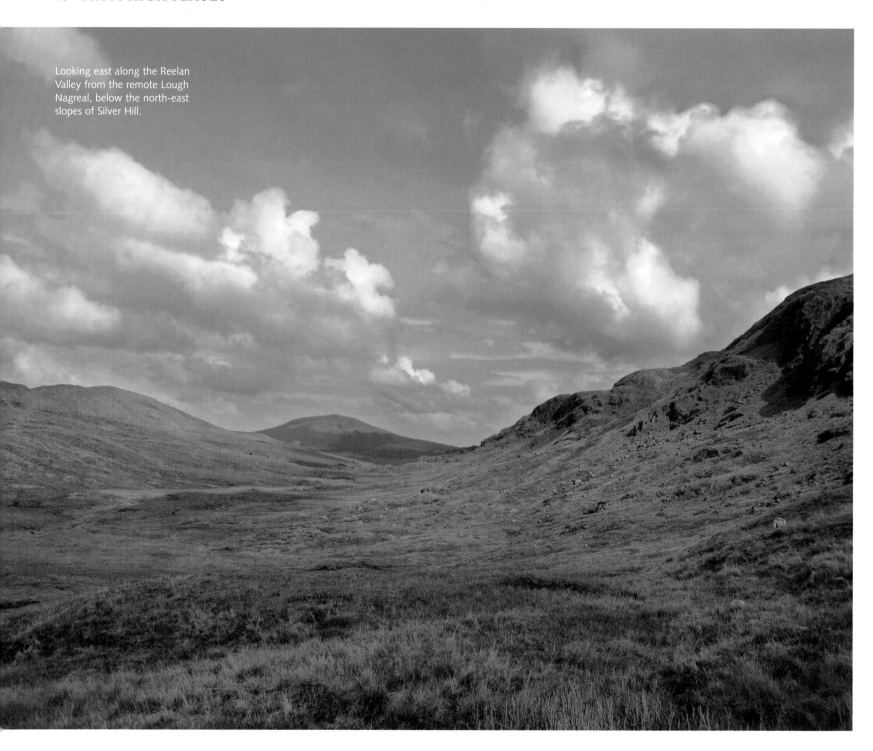

Looking east along the Reelan Valley from the remote Lough Nagreal, below the north-east slopes of Silver Hill.

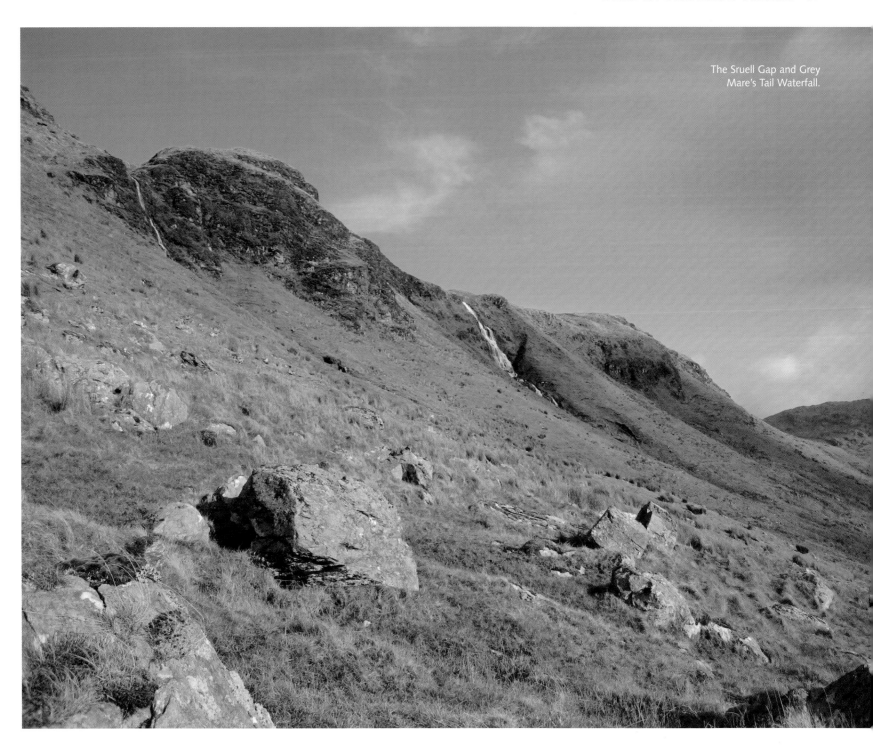

The Sruell Gap and Grey
Mare's Tail Waterfall.

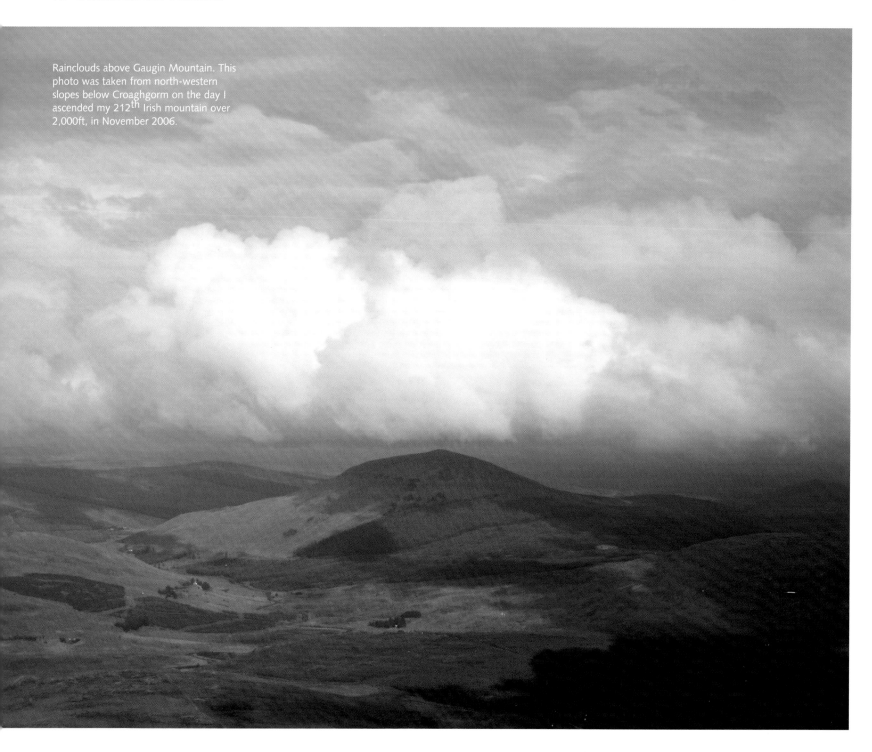

Rainclouds above Gaugin Mountain. This photo was taken from north-western slopes below Croaghgorm on the day I ascended my 212th Irish mountain over 2,000ft, in November 2006.

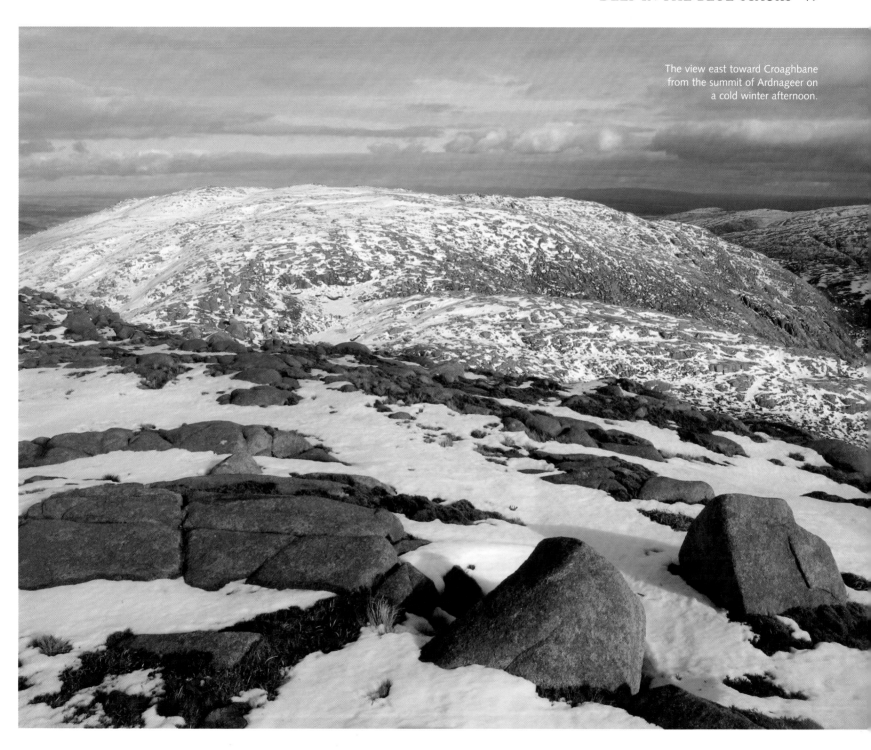

The view east toward Croaghbane from the summit of Ardnageer on a cold winter afternoon.

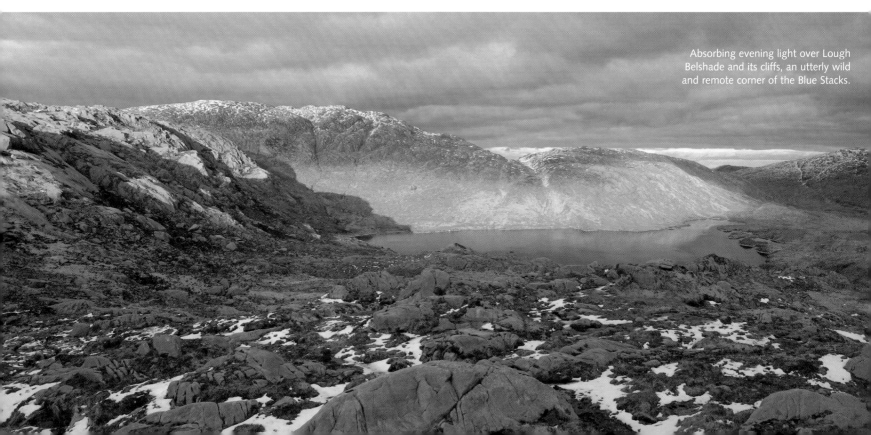

Looking west along the rugged Blue Stack ridge from Ardnageer. Croaghgorm is the broad mountain on the left, with Lavagh More to its right.

Absorbing evening light over Lough Belshade and its cliffs, an utterly wild and remote corner of the Blue Stacks.

The views from Aghla's summit were far-reaching indeed that afternoon. The Derryveagh Mountains featured like white puddings on a brown plate to the far north. I then looked south-east. A distinct set of hills graced the skyline, its summits rising proudly above the myrtle-green trees, sepia-brown plains and brown foothills that decked the valley. These summits belong to the Croaghgorm, or Blue Stack Mountains, a formidable mass of rounded granite that rises above Donegal Town. From afar on Aghla's modest heights, the Blue Stack range seemed to slither like a snake; on that day its granite surface was coated with snow, gleaming like the snake's shiny, lustrous scales.

Carnaween (521m/1,709ft), in the western Blue Stacks, is an example of a mountain littered with ancient quartzite rocks. It looms high above a graveyard at Disert, a site dating back to the sixth century and associated with St Colmcille, an Irish missionary of the time. Here at Disert, Mass was said during penal times and the graveyard was used for adult burials until the 1840s, and infant burials up to the 1930s. I approached Carnaween from Disert some years ago, walking to some wind turbines near the mountain, an alien sight sorely embedded in the landscape. Grey clouds rolled the skies as I approached the grassy summit area, peppered by rocky outcrops. A silver Celtic-like metal cross sat in the centre of a rock cairn. Not far from the summit decoration there is a tall stainless steel sculpture of Fionn mac Cumhaill looking over the mountains, sword and shield in hand.

I then recalled an amusing experience of a friend, Brendan O'Reilly, who climbed the mountain with his wife Bernie one summer's day in 2008. Brendan recalls nearly a hundred people clustered on the summit area. He heard a man playing the fiddle, and as he neared the summit he saw a sight that would amaze him forever. There, in Nashville and Rhinestone jumpsuits and white boilersuits, were several dozen Elvis impersonators, some with black wigs. It was a bizarre scene. A helicopter hovered in the sky, and then landed, a couple of hundred yards from the summit, perhaps to cartwheel the Elvis Superstars to and from the summit in celebrity style. From online research, this all seems to be part of a good cause hosted by a local community at Frosses. The extraordinary sight witnessed by Brendan is part of the Blue Stack Shoes Festival, a charity event supporting sick children for Temple Street Children's Hospital in Dublin.

East of Carnaween is the Eany Beg Water, a river whose source emanates from the slopes below Silver Hill (600m/1,969ft) and Lavagh Beg (650m/2,133ft). It is one of four main rivers that flow south down the stronghold of the Blue Stacks on its southern side, the others being the Sruell, Eglish and Corabber. These rivers cut beautiful valleys through the heart of the mountains. The Bluestack Way, a way-marked long-distance walking route, traverses all four of these valleys. The valleys tend to get increasingly remote and rugged the further east one travels from the Eany Beg. The Sruell Gap gashes through the next valley, leaving its imprint on the steep-sided glen. There are cliffs on its western corner and in the middle of this area of steep ground a 100m/328ft high cascade, the Grey Mare's Tail Waterfall, tumbles recklessly to the valley floor. The rugged valley is laced with tussocks, moor-grass, rushes and moss in different shades of green. Along its usually wet floor, the Sruell River twists and turns some 10km/6miles from the Bluestack Way in the south, to the col between Lavagh More (671m/2,201ft) and Croaghgorm (674m/2,211ft) in its northern end.

Croaghgorm, or Blue Stack, is the highest mountain in the range. It sits proudly above steep and broken ground north of the Eglish valley. Its summit will always hold a special place for me. One bitterly cold November afternoon in 2006, I ascended its north-west slopes from a wooden marker post. There was no view, as a thick mist shrouded the Blue Stacks that day, and incessant drops of water poured from the grey Donegal sky. Even so, time stood still for me as I took my final steps toward the summit. And there, out of the cloud and mist, it appeared: a cairned shelter marking the summit. It was 12.35p.m. A squall of cold wind momentarily numbed the senses. I was overcome by a flood of emotions. A tear of joy warmed my cold cheeks, followed by a grin of delight. I kissed the cold rocks that made up the summit cairn. Croaghgorm was my final, and 212th, Irish mountain over 2,000 feet in height, a humbling journey that made up four years of my life, taking me to corners of Ireland I otherwise would not even have thought of visiting.

Some, however, might remember Croaghgorm for entirely different reasons. Late in the night on 31 January 1944, a storm raged and the wind was blowing hard. A British Sunderland DW110, with twelve crew members, was directed over the Donegal Corridor, then a neutral territory, with the intention of landing at Castle Archdale in Lough Erne, Northern Ireland. The men were possibly fatigued, after thirteen hours on patrol over the coast of France and Bay of Biscay, and the savage Donegal weather didn't help. Visibility was nil, there was no modern technology to aid navigation at the time, and it depended on 'drift sight' taken by a tail gunner. The plane drifted off course, and sometime before midnight, on steep ground north-east of Croaghgorm's summit, violent explosions lit up the granite rock. One crew member, Jim Gilchrist, was thought to have been thrown out of the aircraft and some others managed to crawl out of the wreckage. Tragically, seven men did not survive the impact on that rain-lashed night. This wreckage still remains today. Sprinkled along a gully in the mountainside are sections of riveted metal and engine parts. On a rock further down the hill, there is a plaque in memory of the seven who died with the moving words, 'To the end … To the end … They Remain'.

The Corabber River lies east of the Eglish. It flows from the remote Lough Belshade in a southerly direction to Lough Eske for several kilometres. It was March,

The impressive skyline of Derryveagh peaks
stands out against a clear winter sky, as seen
from below Ardnageer's steep eastern slopes.

but the mountains were still engulfed in snow. I walked up a stony track north of Edergole that wound its way up the hillside. Scores of rhododendron bushes bedecked its flanks, along with splashes of hard fern and ling heather. Up ahead, there appeared to be a gash in the rock. I walked toward the edge of a small gorge; there at the end was an ink-black pool at the bottom, and a waterfall about 30m/98ft high cascaded down into it. Lough Eske stretched out harmlessly, like the outline of a fish, to the south. I wandered on up, following the west bank of the Corabber, and there in a valley of brown humps and dark hollows, I was propelled far from the world of men into a strangely alien setting. I walked under a knoll, ascended a grassy ramp, and onto a rugged plateau where at last the granite walls of the Blue Stacks loomed, looking menacing under the grey wintry sky. I crossed a stream, following it north-west to the edge of Lough Belshade, known in folklore as the 'lake with the jewel mouth'.

Lough Belshade, like many other lakes in Ireland, is associated with legends. In 1593, English troops seized an abbey in Donegal. Before they arrived, the monks of the abbey had taken off, carrying treasures of gold and silver with them. It is believed they hid the loot on an island on Lough Belshade. Local folklore speaks of a black cat watching over a pot of gold on an island in the middle of the lake. I looked back at the lake as I picked my way through granite slabs on its eastern side, but could see no cat, or treasure pots, nor islands on the lake.

Legend goes that the island is submerged, swallowed by the dark waters of Belshade, forever lost like the city of Atlantis. On it a castle once stood. A fair maiden called Eileen once lived there, and in that wild and romantic spot on castle grounds where sunlight is obscured by towering granite cliffs, she fell for a charming young knight. They wandered in the wilds, and sat for hours on the rocky shores of the idyllic lake. However, on the day before their wedding, she discovered the knight had magical powers, for he transformed into a great black cat. Eileen was distraught at this revelation. When she refused to marry him, the knight cast a spell over the castle. The castle, along with its gates, towers, walls, and inhabitants, with Eileen among them, sunk in the waters of Belshade, cast away forever into an enchanted sleep.

I eventually reached the summit of Croaghbane (641m/2,103ft), a white, steep-sided mountain that day. An endless carpet of snow enveloped the ridge toward Ardnageer (642m/2,106ft), and beyond only the greyish-pink tops of larger granite boulders swam over the snow-covered slopes. The snow was soft and deep, and in places my six-foot-tall figure sank waist-deep into the powdery mess. The crossing to Ardnageer was awkward; at times it felt as if I was swimming in snow, paddling through its white drifts. There were some exposed granite slabs in places, edges of boulders were buried in snow and it was hard work reaching the summit cairn of Ardnageer, the 'height of the berries'. But I got there in the end. From there, the Derryveagh Mountains stretched out along the northern horizon, the tops of those peaks also covered with a blanket of snow. Closer at hand, imposing masses of grey clouds touched the tops of Croaghgorm and Lavagh More to the west, shafts of sunlight attempting to pierce through its thick layers in sections.

The evening light was utterly absorbing as I descended back toward Lough Belshade over scores of snow-laced granite boulders and under the towering dark-grey granite buttresses of Binmore. The evening sun caught the cliffs on the back of Belshade with striking intensity, lighting up its crags in a yellow glow. The cliffs and all their dazzling colours were reflected off the wild ice-scratched basin of Belshade, which itself cast a purple-blue glint under a display of rolling clouds. The landscape looked rather strange, as if a vortex had opened up and catapulted me into a Jurassic world.

An hour later, under the diminishing evening light, I arrived back at my car feeling content. I had mobile coverage at last. I dialled a number not far away and the hostel manager answered. I advised him I'd be an hour late. The Donegal skies darkened into a pallid black as I drove through the large gap of Barnesmore. Later, the bright lights of Letterkenny lit up the night sky, if only briefly, for after Kilmacrenan I headed west along the dark, frosty road toward Dunlewy. It's a road I have driven on countless occasions. This time, under the murky shadows of night, familiar shapes sprang to life ... shapes of a flat-topped hill cast like an overturned ark and of conical peaks that seemed to touch the sky.

Derryveagh and its mountains, those timeless hills, had once again cast their spell on me.

eight

TIMELESS DERRYVEAGH

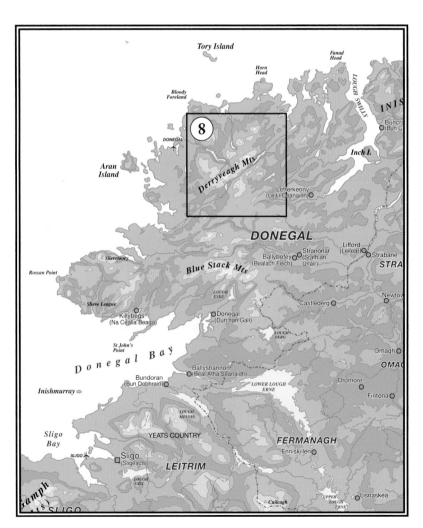

Today is a soaring; and summit and steeple
And smoke from the clearing discover the sky.
Uncover the sky for us, upward-bound skylark –
The song will remain though the singer must die!

Phoebe Hesketh

4 a.m., 8 July 2009. In pre-dawn darkness, at the derelict roofless church, Karl Harold was mentally prepared for the challenge that lay ahead. The mountain, shaped like a volcano, loomed above him casting a shadow over the mouth of the Poisoned Glen. From the ruined church in the depths of Dunlewy, Karl was to climb every single vertical metre of the mountain that day. Not once, but ten times to the summit and back, equating to a total ascent of about 6,800m/22,310ft. Over twenty hours later, at half past midnight on 9 July, Karl, full of emotion, completed his phenomenal feat for charity. But what was even more remarkable was that, only eleven months before, he underwent a surgery for bladder cancer. Some complications during the twelve-hour surgery resulted in Karl losing a muscle on his right shin. As a result, it was necessary for Karl to lift his right knee higher than normal to step up. Despite everything, Karl's desire to turn a negative into a positive by helping people less fortunate than himself persevered that day. Funds were raised to erect a school in Sierra Leone and for the international charity SERVE. But for Karl also, it was a way of moving on from cancer and to focus on the precious gift of life.

Dunlewy has been home to Karl for the last nine years. Today, he manages the newly refurbished, state-of-the-art Errigal Hostel, situated at the foot of its namesake mountain. Originally from Dublin, Karl is now very much a Dunlewy man and he sees the Derryveagh landscape, with its changing moods and unique weather patterns, as home. Over the years, Karl has made over 500 ascents to the oratorical summit of Errigal (751m/2,464ft), almost always with his dogs Bob and Gweedo. Unlike Karl, I've made only just over half a dozen ascents to its twin

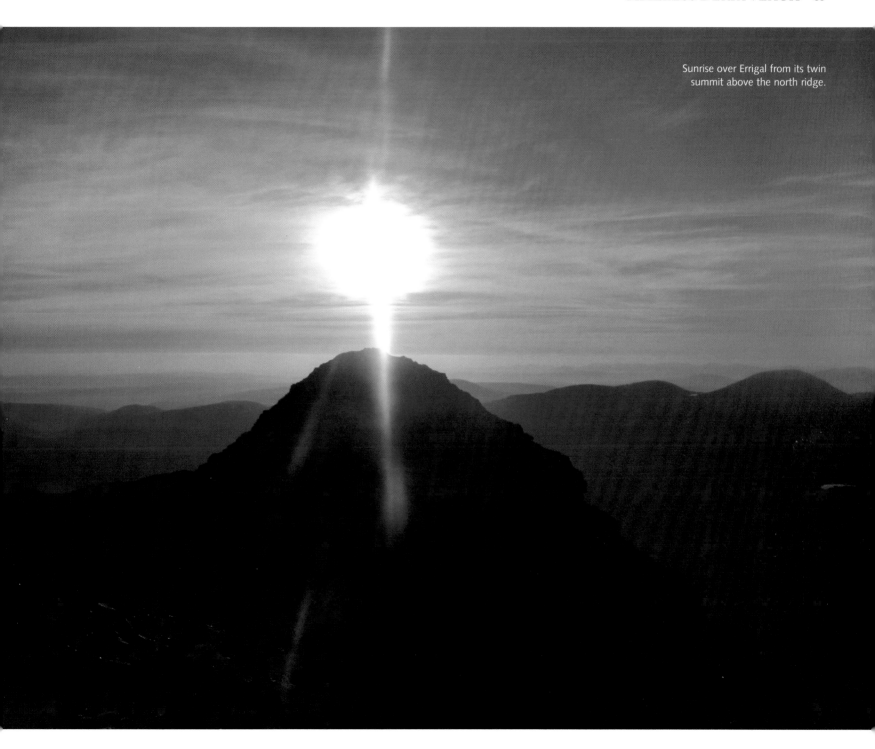

Sunrise over Errigal from its twin summit above the north ridge.

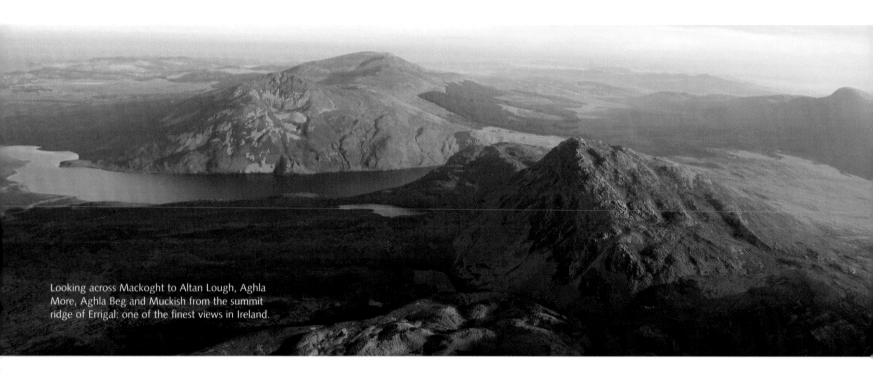

Looking across Mackoght to Altan Lough, Aghla More, Aghla Beg and Muckish from the summit ridge of Errigal: one of the finest views in Ireland.

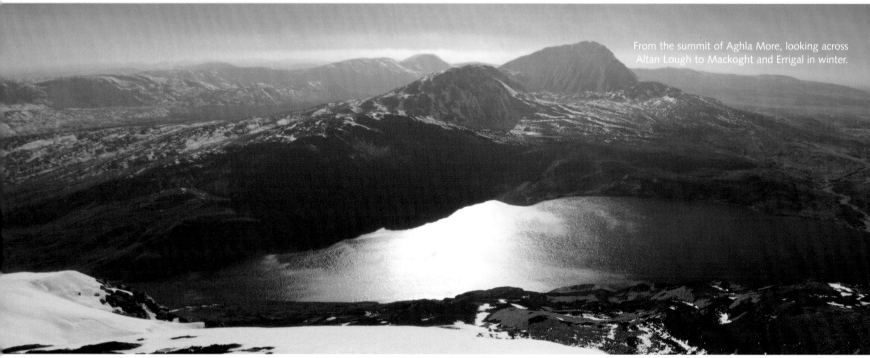

From the summit of Aghla More, looking across Altan Lough to Mackoght and Errigal in winter.

summits. However, I could climb it another hundred times and never tire of it, for there is an aura of timelessness on its summit. I've approached it several times from the south-east, back and forth the straightforward 'Tourist Route', and once from steep ground under the screes of the west ridge. I've cherished winter sunsets and sunrises from its lofty perch, marvelled at the play of light and shadows of the Poisoned Glen from its airy ridge during the joys of spring, and trampled on its quartzite rocks on windy autumn days, in the foulest of weather.

One ascent, however, stands out from the rest, and that was via the North Ridge. The early hours before sunrise were calm. There was something absorbing about the silence of the land and the colours of the sky as night transitioned into day. Errigal towered above from Drumdoo and bog soon gave way to scree. The loose rock, grey under the pre-dawn light, moved under my feet in places, otherwise it was silent for the world was still sound asleep. Higher up, I soon hit solid rock, a jumble of quartzite slabs and outcrops; the dark shades of grey had become increasingly lighter with the dawn of day. I weaved my way through the rocks, traversing slightly to the right at times, and clambered up minor gullies. Above me, on the skyline, was a circular opening in the rock, shaped like a keystone arch with its upper arm slanted at an angle. I stepped through the arch. It felt like entering a different dimension, as now, a yellow silk blanketed the sky and orange ribbons weaved along a horizon of peaks beyond as the sun awoke from its slumber. I reached the first of the twin summits of Errigal, before it dwindled to a narrow path. There I sat and waited for the sun to rise. And as it rose, its warmth caressed my soul. The sun's rays burned off wispy cirrus layers as it began its gradual ascension above the twin summit.

The world was now a sky of blue, blossoming into brightness as the minutes ticked by, revealing a splendid view. Thousands of feet below the sharp crest of the west ridge, two blue lakes, each separated by a causeway, extended across the land like the arms of a welcoming giant. The neck of the longer lake, Nacung Upper, narrowed as it meandered toward the village of Gweedore. To the far west and north, a boundless length of baroque indentations, fretted islands and blue bays weaved its way along the Atlantic coastline. I looked down the way I came; Errigal's monstrous shadow was now cast down the North Ridge, engulfing it in a dark triangular profile whose apex culminated in the yellow-brown pastures of Cloghaneely. The most striking view, however, lay to the north-east, beyond the drumlin-studded and scree-littered landscape below Errigal's sheer east face. A suite of crenated quartzite peaks danced like waves to the distant horizon – Mackoght (555m/1,821ft), Aghla More (584m/1,916ft), Aghla Beg South (603m/1,978ft) and Muckish (666m/2,185ft), punctuated only by Altan Lough, the curve of water below the screes of Aghla More. Along with Errigal and the minor hump of Crocknalaragagh (471m/1,545ft), this line forms the Glover Highlander, a classic 20km/12mile high-level route involving a cumulative ascent of 2,020m/6,627ft.

Traditionally held in September, the Glover Highlander commemorates Joey Glover, one of the founding members and the first chairman of the North West Mountaineering Club (NWMC) since its inception in 1955. Joey loved the Highlander route. In fact, he also loved the mountains in the west of Ireland, and went on to climb all peaks above 2,000ft north of the line from Dublin to Galway. For someone who started mountaineering late in life at the age of thirty-two, he had later chalked up thousands of ascents on mountains both at home and abroad. A closer look at this character reveals an eccentric man of charisma and tenacity, a man whose remarkable life story was largely unrecorded. His profuse enthusiasm and unflagging vitality for the hills inspired many who knew him. Together with Joey they participated in mountain pursuits that would be classed as borderline lunacy to some, for Joey was a man who had stirred up a group of friends to catch the sunrise over the Blue Stacks from the summit of Lavagh More one freezing 3a.m. They hauled firewood up Errigal one frosty night and ushered in the New Year at its summit. They also raced over the ten highest peaks in Donegal at midnight. Despite enjoying the camaraderie of friends, Joey also cherished time alone in the hills, communing alone with nature in unfrequented upland areas or exploring different routes to a mountain's summit.

Joey's figure, in a brick-red sweater and clashing yellow anorak, would often be seen striding at a ridiculous pace over distant Donegal summits, for he knew these mountains intimately, and even in mist Joey would soar like an eagle on the hills. The man once said, 'The secret of hill-walking is the knowledge of how to pace oneself with the maximum relation and minimum effort.' Sadly, this shining light and exemplary figure of Irish hill-walking was taken away from the people he inspired so dearly and the hills he loved in 1976, at the age of sixty-four. In a possible case of mistaken identity, Joey was brutally murdered on his doorstep by gunmen that fateful year. After his cremation, Joey's ashes were scattered high on Errigal, the mountain he had climbed over eighty times during his lifetime. Alan Tees, President of Mountaineering Ireland and a member of the NWMC wrote this poem as a tribute to Joey:

And on the heights above Dunlewy
and the cliffs around Slievetooey
Where the cold winds toss the hair
Joey's presence will be there
The mountain streams shed crystal tears
For those who kill so young in years
Maybe some day they will see
They slay the land they strive to free.

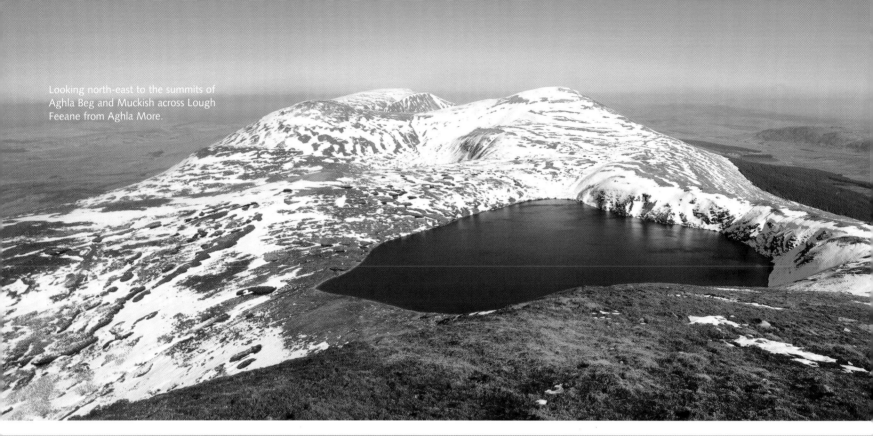

Looking north-east to the summits of Aghla Beg and Muckish across Lough Feeane from Aghla More.

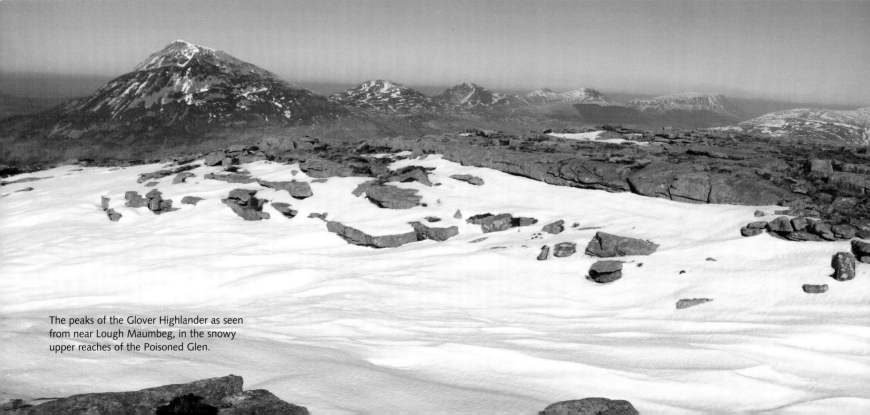

The peaks of the Glover Highlander as seen from near Lough Maumbeg, in the snowy upper reaches of the Poisoned Glen.

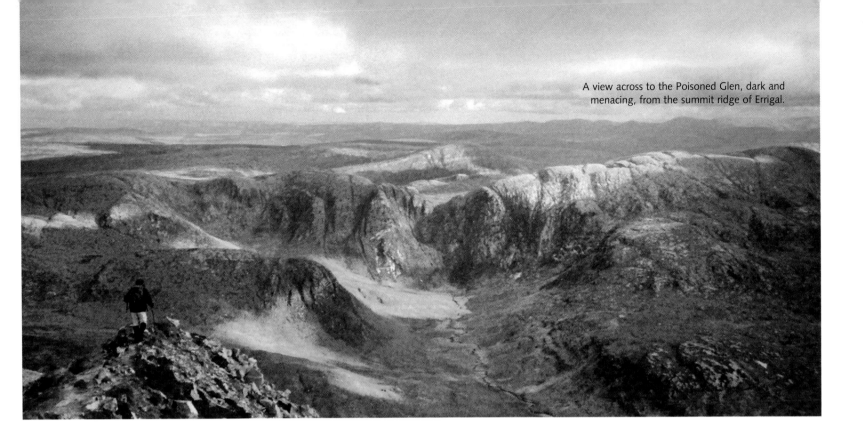

A view across to the Poisoned Glen, dark and menacing, from the summit ridge of Errigal.

Close to midwinter of 2009, under the dimming light of day, I was walking away from the clutches of the Poisoned Glen. Joey must have also walked this glen at night, I thought. My boots crunched against the soggy brown moor grass on the barren floor of the glen. The stern headwall of the glen loomed up a mile behind in dark brown, grey, pink and silver tones. Its wet granite rocks glistened like scales of a dragon under the evening light. The shadows of bare rocky buttresses threatened to consume the valley on both sides. Gullies appeared dark and menacing. The glen's amphitheatre was sombre and intense, its silence overwhelming. I rotated the bezel of my head-torch; its LED bulbs illuminated a zone of boulders littered around the glen's surface. These boulders, or 'erratics', were left on the ground as ice melted during the Ice Age thousands of years ago. Above the glen at Dunlewy, a bunch of lights started to flicker in the night sky.

Dunlewy is said to have got its name from the sun god Lú. Legend tells us of a mighty battle that ensued in the Poisoned Glen between Lú and Balor, an evil ruler of a Formorian pirate tribe. Balor had an evil eye in his forehead, a 'basilisk', and could slay his enemies with a single glance. When a prophecy warned Balor that he would be killed by his own grandson, he imprisoned his only daughter Ethniu in a crystal tower on his stronghold on Tory Island. However, MacKineely, one of Balor's enemies, infiltrated the tower and seduced Ethniu. She gave birth

to triplets, but Balor, in his wrath, drowned them in the sea, and then later slayed MacKineely. However, one of the babies fell into the harbour and escaped. He was raised by his father's tribe, the Tuatha Dé Danann, and grew up to be a warrior. Years later, Lú sought out Balor for revenge for his father's murder, and challenged him to battle. They battled for hours on end, scarring the cliff faces that line the glen. Eventually, Lú pierced the sinister eye of Balor with his magical spear, the Sword of Light. A vile fluid poured out of the eye, poisoning the glen, as Balor writhed in agony and died.

Legends aside, it is thought that the Irish spurge once thrived along the stream that drains the glen. It is a toxic plant, the stems and leaves of which contain a poisonous milky sap which makes livestock very ill. It is also plausible that English cartographers mistranslated the name centuries ago as the Irish for 'poisoned' – nimhe – sounds almost like neamhai, which means 'heavenly'. Three months after my midwinter rendezvous in the Poisoned Glen, I returned to the scene. The morning winter sun had not yet hit the glen. I maintained high ground above the Cronaniv Burn to avoid boggy patches, heading south-east at first, then later bearing left. After stepping through two deer fences, I eventually reached a boulder field at the foot of a gully on the eastern end of the glen. Scrambling cautiously, I picked a route around pockets of thick hard snow and brittle ice. The March sky

Looking toward the summit of Dooish from
the eastern slopes of Aghla More.

Opposite Lough Beagh and the
Glenveagh National Park from high on
Farscallop's northern slopes.

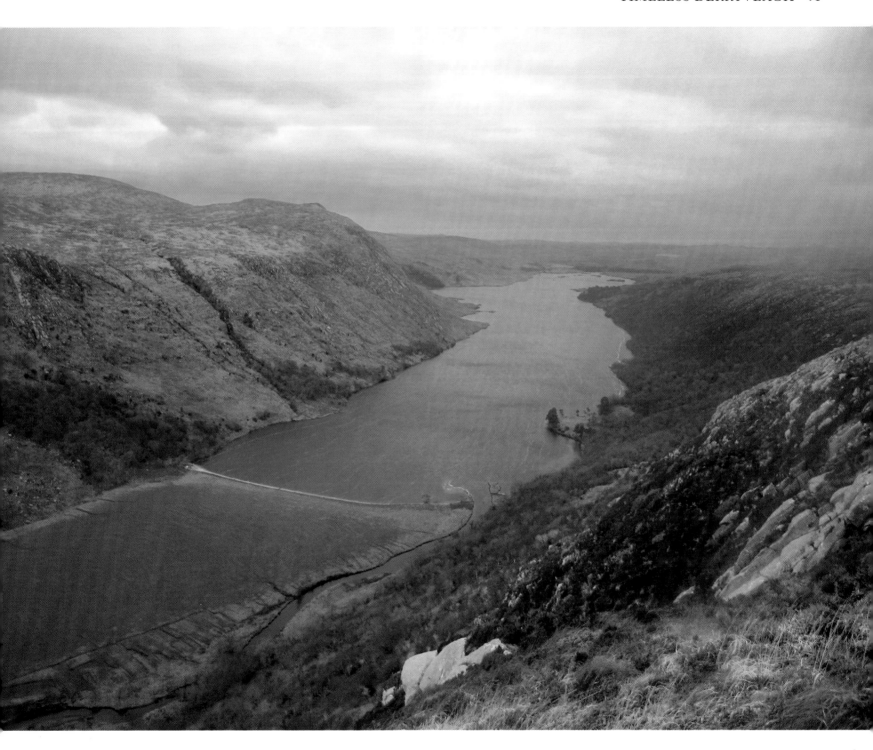

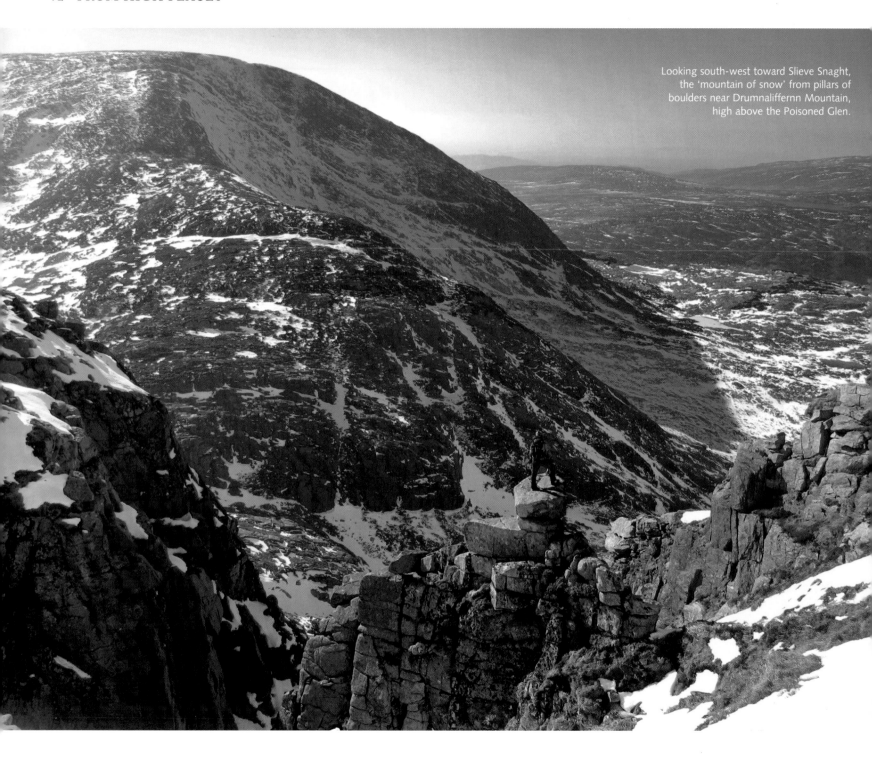

Looking south-west toward Slieve Snaght, the 'mountain of snow' from pillars of boulders near Drumnaliffernn Mountain, high above the Poisoned Glen.

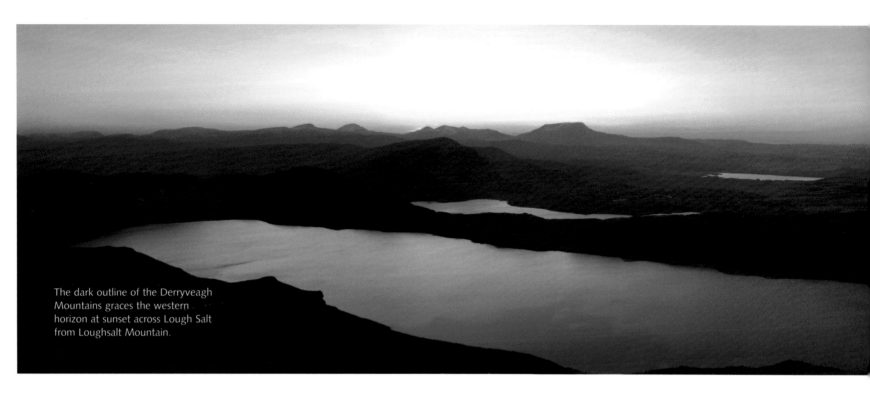

The dark outline of the Derryveagh Mountains graces the western horizon at sunset across Lough Salt from Loughsalt Mountain.

was cloudless and azure in colour. I soon emerged at the top of the ridge to a winter wonderland; I may as well have been in heaven for a sheet of white covered the land. The Glendowan Mountains and Farscallop (423m/1,388ft) were endowed with a white blanket of snow and so was Dooish (652m/2,139ft), to the north-east. The summits of the Glover Highlander lined the skyline to the north with patches of snow on its south faces.

I picked my way carefully around huge granite slabs on the rough summits that graced the eastern side of the glen. Some of the boulders and slabs were laced with verglas, making it somewhat treacherous in places. Deep snow filled gaps between rock-slabs; in other areas significant sections of snow-fields had to be negotiated. Even Lough Maumbeg, a small tarn nestled between two granite walls, was half frozen. On a rocky plateau above the tarn, in a sheltered spot, I sat and waited for two friends. They started later in the day and we had planned to meet halfway. While munching on a muesli bar, I noticed contrails shoot across the blue sky. The vapour trails made me think of shooting stars and this in turn made me reflect on where I was at sunset the day before.

About 20km/12miles north-east, stands a mountain of modest height of 469m/1,539ft, and named after the long lake that stretches beneath its western flanks. In 1821, a glowing meteor was said to have burst from the skies and struck its summit. Apparently, the heat from the meteor scorched the heathery slopes and tumbled as a rumbling inferno into the lake. The lake, Lough Salt, which now supplies water to the town of Letterkenny, is reputed to be one of the deepest in Ireland. Old guidebooks put its depth at about 65m/213ft, and some even say the bed of the lake is a crater of an extinct volcano. High above this dark-blue sheet of water, I sat on a cushion of ling heather amongst some quartzite rocks. Another lake glided behind Lough Salt, a rib of high ground separating them. Beyond, almost the whole of Donegal was bestowed on me. Was that the Blue Stacks in the distance? A stiff wind blew, but the cold was secondary as I watched the orange sun gradually sink above the dark outline of the Derryveagh Mountains, those timeless hills many miles away on the western horizon. There was no clutter in this tranquil world above Lough Salt; even death has no power over the eternal beauty it presents. But night drew closer, prompting me to leave. I took one last look around, toward the dark shapes of Errigal and Muckish, then north-eastward to Lough Swilly, and farther still to the hills of Inishowen beyond.

INISHOWEN – A PLACE APART

Slieve Snaght, the mighty monarch,
That wears the royal crown,
Is first to catch your wondering gaze;
He looks in splendour down
Upon the little zone of hills
That guard their Royal sire,
And sparkle in the setting sun,
Like glittering gems of fire.

Alexander Reid

Dark grey clouds swirled over the summit area. Murky shadows loomed above on the skyline, casting odd horizontal and vertical shapes in the drifting mountain mist. I moved up a slope of wet quartzite rock. It was silent, except for some dislodged stones rolling down behind on the rocky slope. The odd shapes turned out to be rock slabs, spread out over a vast barren area, arranged as dozens of cairns of various sizes and a collection of standing stones. The encircling mist intensified and this peculiar rockscape felt like an ethereal graveyard.

Six years on, I returned to the summit of Slieve Snaght – back to the cairns and rock slabs that graced its summit area, but this time under rolling clouds and clear February skies. At 615m/2,018ft, Slieve Snaght rises as a broad quartzite dome over miles of brown moorland. There is nowhere higher in all of Inishowen than its summit, a trig point situated inside a walled enclosure. Inishowen, or *Inis Eoghain* in Irish, means 'the island of Eoghan/Owen'. It was named after Prince Eoghan, one of the sons of Niall of the Nine Hostages, a High King of Ireland in the fourth century. At 884sq.km/341sq.miles, it is the largest peninsula in all of Ireland, projecting like a broad fist at its northernmost tip. The bedrock of this peninsula is a series of ancient Dalradian rocks, formed hundreds of millions of years ago through

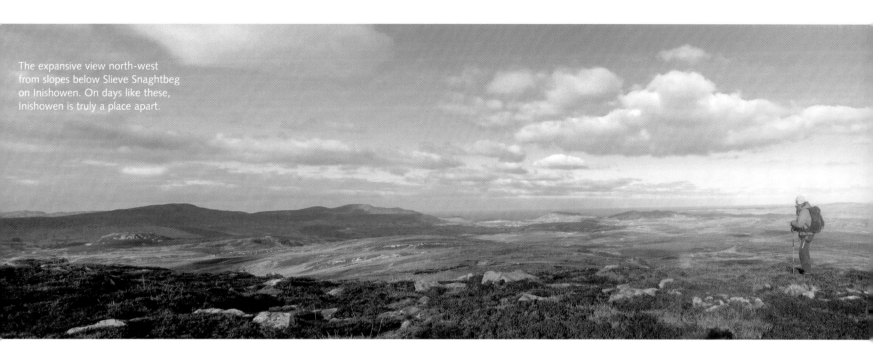

The expansive view north-west from slopes below Slieve Snaghtbeg on Inishowen. On days like these, Inishowen is truly a place apart.

prolonged action of heat and pressure, and aligned as wide bands in a north-east to south-west direction.

There was nowhere else in the world I would rather be on that cold winter day than on the snow-patched summit of Slieve Snaght. It seemed to fit the bill, as the Irish for the mountain, *Sliabh Sneachta*, translates to 'mountain of snow'. The whaleback top of Slieve Main poked out south-west of the graveyard summit area. Behind this, Lough Swilly stretched out as an endless horizontal plain with the pale-blue outline of the Derryveagh Mountains nudging out of lower brown hills farther beyond. Another extensive plate of water unfurled south-east of Slieve Snaght's summit; this was Lough Foyle, gleaming like silver under the early afternoon sun.

Lough Foyle is recognised as meaning 'borrowed lake'. Like most lakes in Ireland, it has a tale associated with it. There were once two sisters who practiced the art of sorcery. The elder sister desired a lake, as she lived in an area both barren and bleak. So she implored her younger sibling for the loan of a lake, promising to return it on Monday the following week. The younger sister willingly bundled up a lake using her powers and delivered it over the hills and glens to her sister. However, when Monday arrived, the elder sister replied, 'I am keeping the lake. It is true I had said Monday [In old form Irish, *Dia Luain*], but I actually meant Judgement Day [also *Dia Luain*].' So she kept the lake between Inishowen and County Derry.

To the north-west of Inishowen, the finger of Malin Head extends out to the Atlantic. About two kilometres to the north-east of Malin Head is the most northerly point on the map of Ireland – Banba's Crown. They say hundreds of miles beyond this, somewhere out in the sea and in the path of the setting sun is the mythical realm of *Tír na nÓg*, a land of perpetual youth and beauty where disease and death do not exist. I certainly could not make out *Tír na nÓg* from the summit of Slieve Snaght, but what I could see with astounding clarity were the outlines of some of the Inner Hebrides of Scotland, at my guess just over fifty miles away. The distinct shapes of the Paps of Jura caught my eye and also the flatter island of Islay. And could that distant lump possibly be Ben More on the Isle of Mull, I wondered.

There was another island closer at hand to the north-east of Malin Head; in fact it is approximately 10km/6miles away. This is the island of Innistrahull, and the story goes that an Innistrahull lad once visited the Herbridean island of Islay and snatched a local maiden as a bride. A group of Scottish Highlanders followed her to Innistrahull, and there on the beach a savage battle ensued. The entire group of Highlanders was slaughtered and from that time on the island was known as 'the island of the bloody strand'.

To the west of Slieve Snaght, the windmill farm at Drumlough graced the ochre landscape like white matchsticks. To the right of the windmills, the horned peak of Bulbin (494m/1,621ft) rose elegantly above a blue lake, Lough Mintiaghs, its

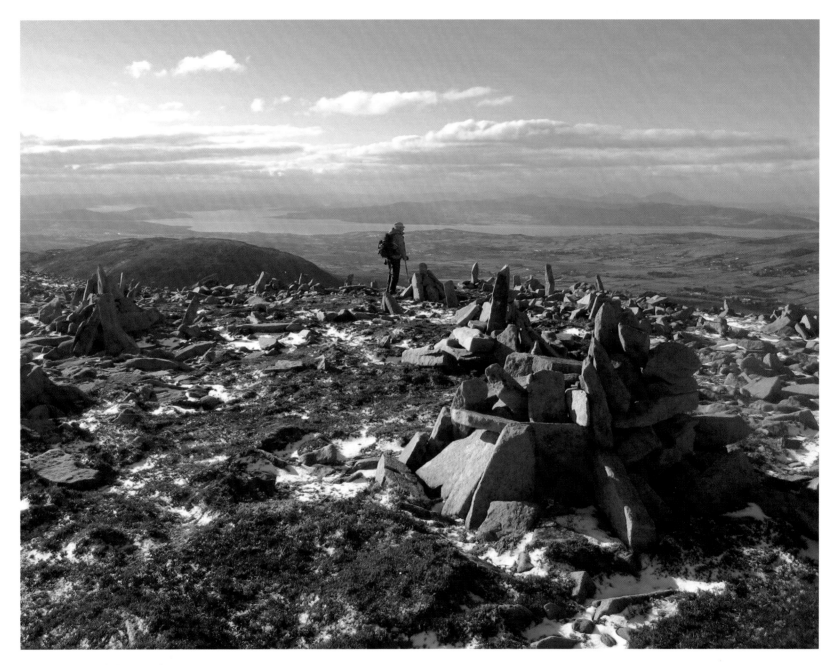

The summit area of Slieve Snaght
resembles a high-level graveyard,
especially on grey, misty days.

waters surrounded by smooth green pasturage under the mountain face. The rugged dark-brown crest of the Urris Hills (417m/1,368ft) resembled a giant worm wriggling its way behind Bulbin's ridgeline, whose monstrous head terminates as the knobbly bumps of Raghtin More (502m/1,647ft) and Ragthin Beg (416m/1,365ft).

Later that same day, I found myself on the summit of Bulbin, contouring under its steep western face. I watched the shadows of giant clouds dance like waves on the dazzling Inishowen landscape. The sky was a vivid blue that faded into a virgin whiteness closer to the horizon. White dots of dwellings punctuated the brown, yellow and green tones of the hills and pastures that surrounded Clonmany. I weaved my way under the north-east ridge, and staying close to its airier western end, trotted up it. The man-made summit decoration is an airy perch, a large concrete cross standing several metres above a stack of large concrete blocks, erected to commemorate Ireland's Eucharistic Congress in June 1932. I gazed eastward toward Slieve Snaght, where I stood earlier in the day, now sparkling under the setting sun. Lough Swilly was sparkling too, and so were the mountains behind it.

There is something truly magical about Inishowen sunsets. When the day dawns bright and clear, and the winter air is crisp and fresh, one feels almost obliged to stay out until sundown. On Inishowen, being on the northern fringe of things, this obligation is accentuated, and I felt compelled to make the most out of the limited hours of the winter light in order to admire the beauty of an almost forgotten land of Ireland.

The next day I arranged to meet a friend at a lay-by east of Dunree Hill. We planned to traverse the ridge from Raghtin More in the north to the Urris Hills farther south, with the intention of walking into the darkness. Dunree Hill overlooks Dunree Head, a promontory that protrudes out into Lough Swilly. A fort is situated by this rocky bluff, bastioned by the British in 1812 as an artillery station to counter Napoleonic attacks. This stronghold was handed by the British Royal Artillery to the Éire Coastal Defence Corps in 1938 when the Union Jack was replaced by the green, white and orange flag of Éire in a ceremony that lasted all but a matter of minutes.

We parked a second car on waste ground at Pinchers Corner, rambled up Slievekeeragh (389m/1,276ft), descended to a col, then later pulled up heathery slopes to the summit of *Raghtin More*, 'Fionn's great rath'. Legend goes that from this summit area of scattered schistose rock, the ubiquitous leader of the Fianna, Fionn mac Cumhaill, decreed his laws. If legend holds true, Fionn certainly had the knack of picking his spot, as views of idyllic blue bays and rustic greenish-brown headlands decorated the intricate Inishowen coastline to the north and west. The sea was a striking ultramarine blue, fittingly mirroring the azure sky. One of the bays, shaped like a horseshoe, caught my attention. A line of white caravans were parked on a green pasture beside its golden sands. A little yellow-brown hill of heather and scree rose on the far end of the bay, separating it from the arm of yet another bay farther to the north.

Leaving Raghtin More, we walked south-west, toward a rugged line of hills. These brown hills dip and rise like a dragon's back and extend for miles before the line appears to hurl itself down into the silver waters of Lough Swilly beyond. In fact this ridge runs some 8km/5miles from the summit of Raghtin More to a beach at Crummie's Bay. It drops to Crockmain (460m/1,509ft), only to rise again to Mamore Hill (423m/1,388ft) followed by a more significant drop to the great breach in the mountain that is the Gap of Mamore.

A final pull-up from the shaded gap saw us on the rough ridge of the promontory-shaped hills of Urris. The rocks on these hills are quartzite in essence. The final hour of winter light was soon approaching as we moved along the ridgeline high above the round lake of Crunlough and the long lake of Lough Fad. During this 'golden hour', the light is softer and warmer in hue, and shadows extend, they become longer. We sat high in the Urris Hills and waited for the sun to set, gazing at the silver arm of Lough Swilly stretching out below us to the south.

The waters of the Atlantic enter the mouth of Lough Swilly between the round promontory of Dunaff Head on its east and the tip of Fanad Head on its west. It snakes inland for some 40km/25miles. It is wider at its mouth, but narrower the deeper inland it winds. It is derived from the Irish root word *Súil*, meaning 'eye'. There is an ancient tradition that there once lived a monster called Suileach at the source of the River Swilly. Suileach had 200 beastly eyes on each side of his gargantuan head. St Colmcille was said to have pursued this creature to the ends of the river. Over a mighty battle, the sword of the saint slashed the monster in two halves. But Suileach's tail sparked to life; it wrapped itself around the saint's body and grasped him tightly. The other half of the monster, its head, edged toward St Colmcille, with its jaws wide open, its sharp teeth glowing and ready to rip into the helpless saint. However, just in the nick of time, St Colmcille freed himself from the clutches of the creature's tail and drove his sword into Suileach's head, finally killing the beast.

Back on the Urris Hills, the sun was now a fiery ball of glowing yellow above Lough Swilly. Its rays seemed to part the silver waters of the Swilly as a royal yellow carpet that rolled from the mountains of Derryveagh in the distance. The orange glints at the edge of this yellow carpet sparkled like diamonds on the Swilly. We watched the ball of fire slowly descend behind those shapely hills, gradually losing its intensity. Now the circle of yellow transformed to darker shade of orange. As it did, the winter sky turned purple and its horizon burst into a flame of orange-red. The wild hills became even wilder, and its dark shapes seem to kiss the waters of the Swilly, which was now dark purple.

On days like these, Inishowen is truly a place apart.

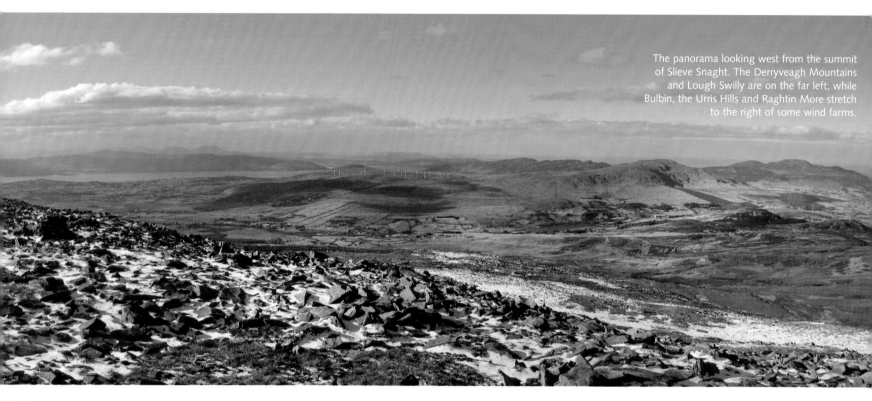

The panorama looking west from the summit of Slieve Snaght. The Derryveagh Mountains and Lough Swilly are on the far left; while Bulbin, the Urris Hills and Raghtin More stretch to the right of some wind farms.

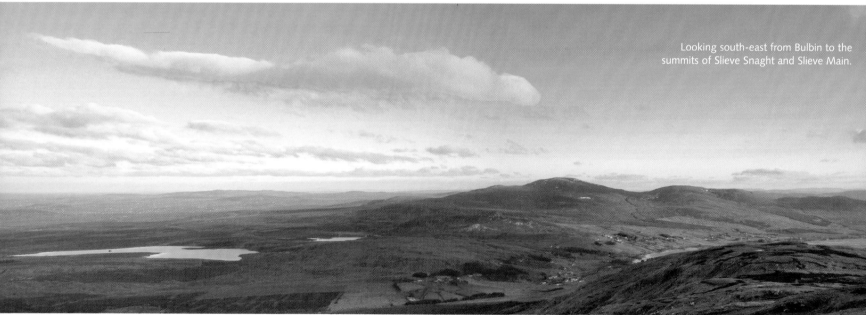

Looking south-east from Bulbin to the summits of Slieve Snaght and Slieve Main.

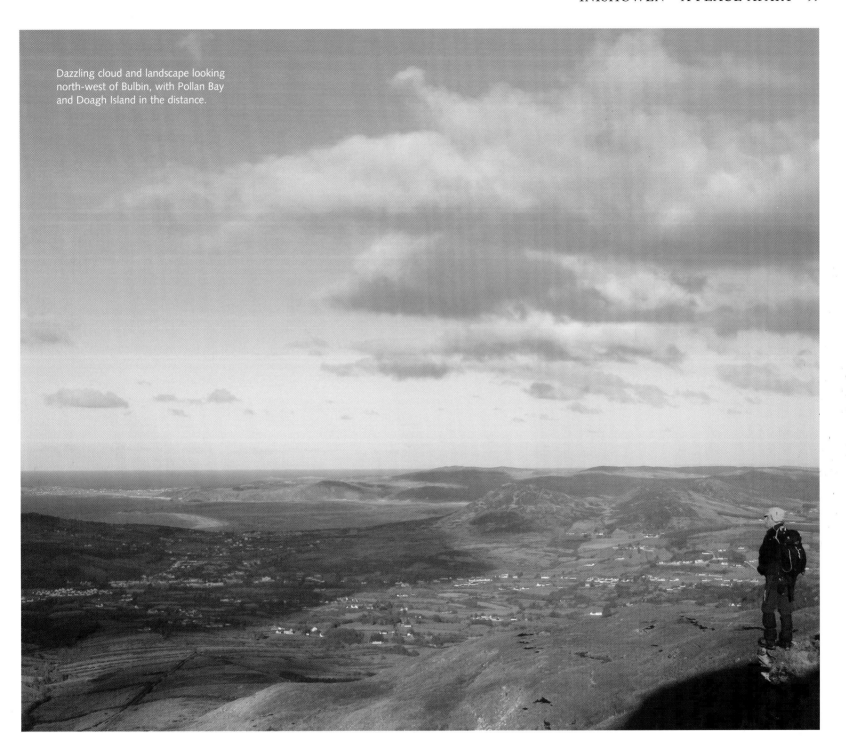

Dazzling cloud and landscape looking
north-west of Bulbin, with Pollan Bay
and Doagh Island in the distance.

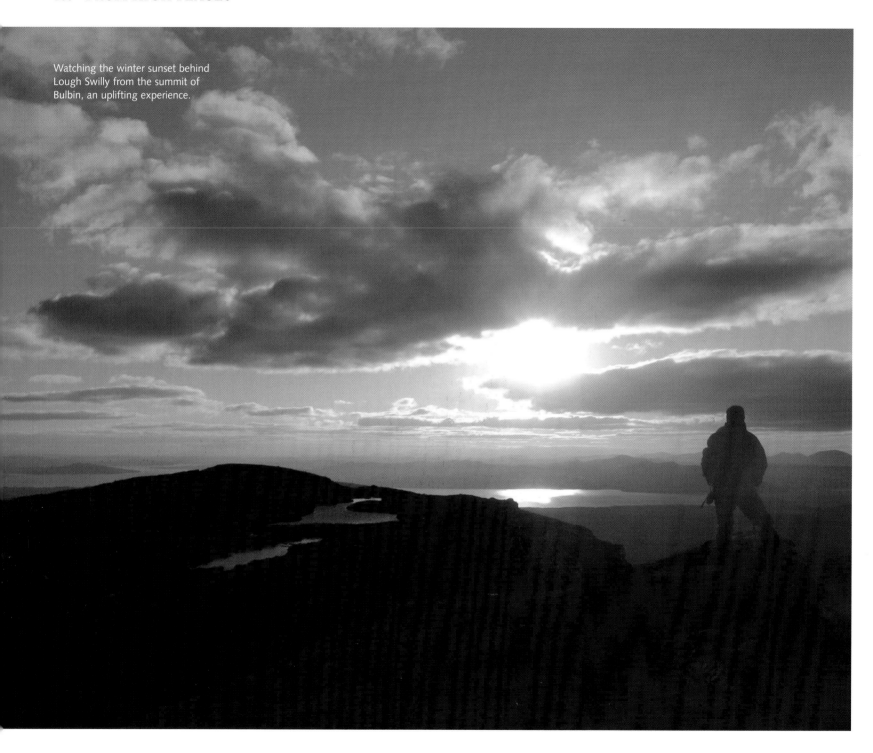

Watching the winter sunset behind
Lough Swilly from the summit of
Bulbin, an uplifting experience.

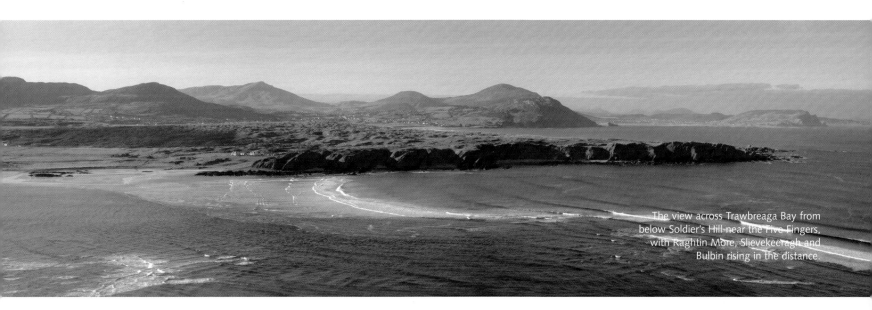

The view across Trawbreaga Bay from below Soldier's Hill near the Five Fingers, with Raghtin More, Slievekeeragh and Bulbin rising in the distance.

Lenan Head and Dunaff Head from high on the Urris Hills. The ridgeline leading north-east is visible on the right, with Raghtin More the highest hill in the distance.

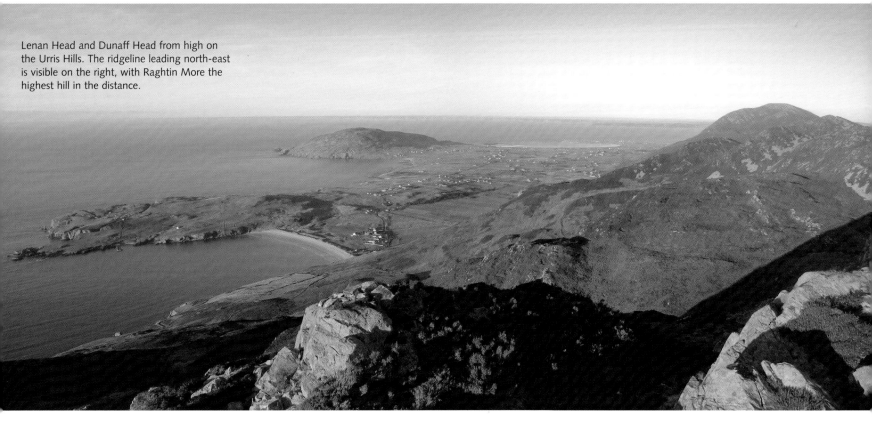

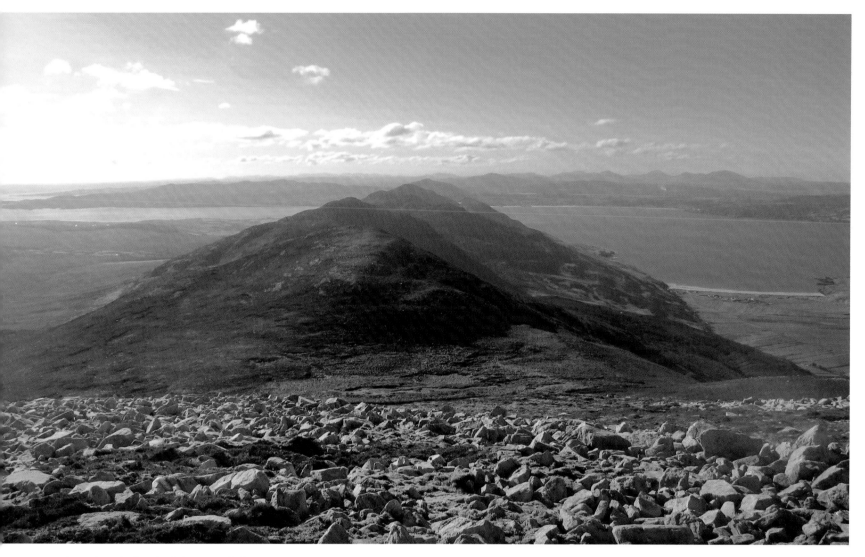

Looking along the length of the Urris Hills from
the rocky southern slopes of Raghtin More.

Opposite Urris Hills sunset behind Lough Swilly and
the Derryveagh Mountains, a magical sight to behold.

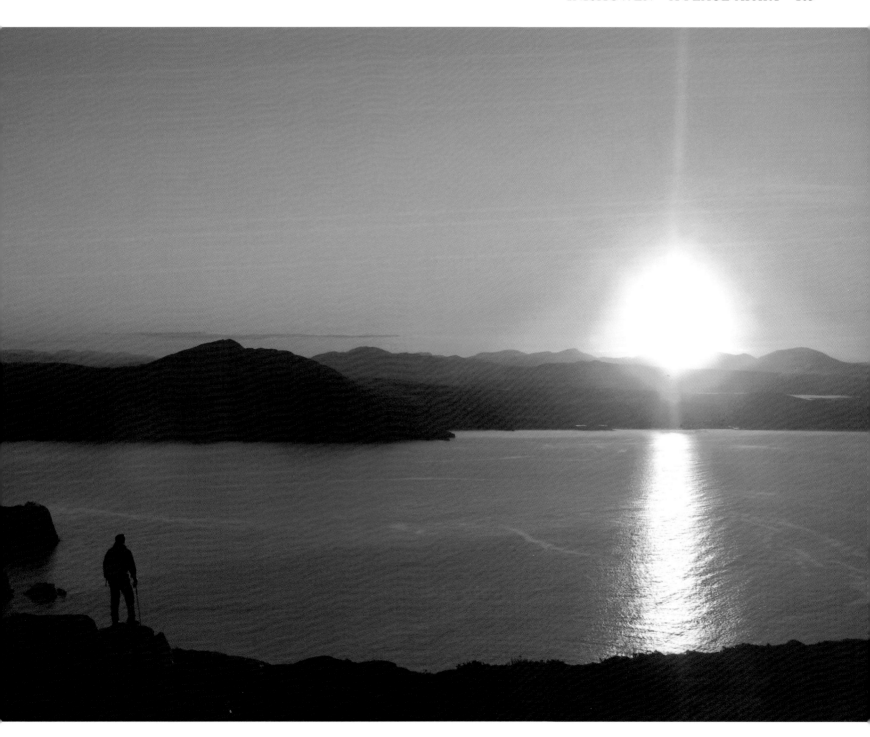

ten

SPERRIN SKYWAY AND THE NINE GLENS

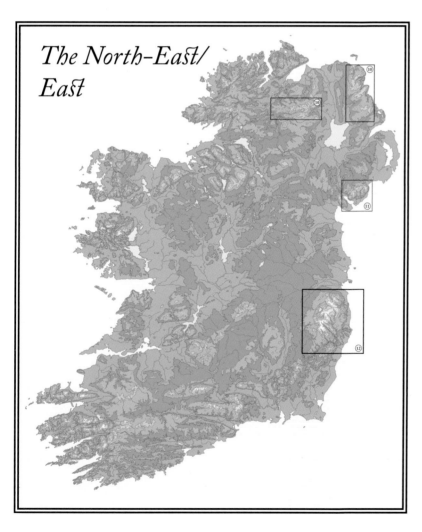

The North-East/East

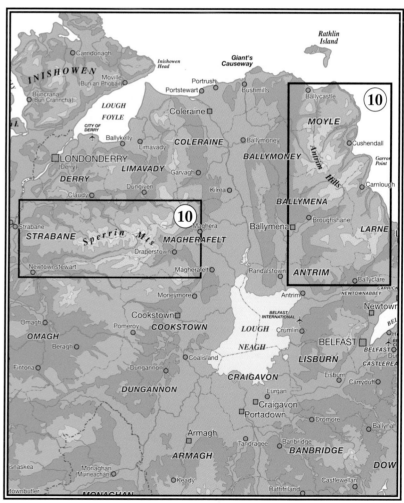

I live my best in the landscape, being at ease there;
the only trouble I find I have brought in my hand.
See, I let it fall with a rustle of stems in the nettles,
and never for a moment suppose that they understand.

John Hewitt

A mass of grey loomed above. It wasn't any different below, or around me. The lower valley, and its patchwork of green fields, was no longer visible. The only thing that made sense was the ground beneath my feet, typical brown moorland, now increasingly squelchy and boggy owing to the incessant water that poured from the sky. The north wind howled, blowing the lashing rain almost horizontally with such strength that it pelted spear-like icy drops of ferocious intensity on my face. The heavens showed no mercy, a line of fences flapped in the wind. I reached a junction of fences on a broad moorland crest, and then the cairn that marked the top they call the 'summit of stones'. There was no view, only a pallid world of blank grey-whiteness. I did not linger long on Mullaghclogha's 635m/2,083ft summit, but instead wandered back down toward Oughtdoorish.

Oughtdoorish is a townland on a long linear road that meanders eastward from Plumbridge above a lush verdant valley. A river twists and turns for miles along the narrow valley floor. An array of north and south-flowing streams, probably carrying alluvial deposits, rush into it. South of the river, a range of green hills flows gently, seamlessly blending into the rolling landscape. I often gaze down at this charming valley of Glenelly whenever I drive into the Sperrin Mountains. The contrasting shades of green, from the bright pasturelands to the darker woodlands and copses, are sprinkled with an intricate network of hedgerows and grey stone walls. There are a scattering of settlements, a cluster of shaded clachans and farmsteads. Some steep, narrow minor roads seem to lead to the lonely valley floor.

One January, I drove past the crossroads village of Plumbridge, over its bridge that spans the Glenelly River, to the hamlet of Mount Hamilton or Sperrin. The day dawned clear and the sun burned like gold in the sky. Gold, in fact, was panned for years in Sperrin streams. I spotted on one or two dwellings along the road the distinctive cross of St Brigid on top of its painted doorway, made from rushes, with its woven square in the centre and four radials tied at the ends. I turned left at the hamlet, and the road climbed uphill east of the Oughtnamwella Burn. I parked on the highest point of the road, below a conspicuous boulder that is marked as County Rock on the Ordnance Survey Northern Ireland (OSNI) map. The map reveals county boundaries between Derry to the north and Tyrone to the south to run near it. These boundaries extend westward to the summit of Sawel, at 678m/2,224ft, the highest point in the Sperrins.

I followed a line of fences under the ice-blue sky. Clouds were scarce. A white dusting of ground frost covered the green grassy slopes. The morning breeze ruffled the ends of patches of windswept brown moor-grass. Grey schistose rocks littered the area. The gentle brown arms of Meenard Mountain (620m/2,034ft) swept down the valley behind me. A cluster of round brown-blue hills poked up in the distance behind Meenard. I reached Sawel's summit trig point and cairn. Another hill, Dart Mountain, looks like a brown lump from it. I walked toward a broad peaty gap between Sawel and Dart, south-west as the crow flies, toward the lump, which grew increasingly rockier the nearer I got to its summit. There was a cairn on the highest point, with the white skull of a ram on top of its grey rocks, staring at me as I inched closer to the 619m/2,031ft top of Dart.

Dart rises proudly in the middle of the Sperrins, whose spine unfolds from the highest point in the Draperstown-Feeny Road in the east. It then weaves its way along some 25km/16miles to the head of Butterlope Glen in the west. I opened my OSNI map and counted eleven summits above 500m/1,640ft along this spine. Joey Glover named these hills the Sperrin Skyway, and under clear skies on Dart, with the morning dew still on the tough grass and white frost on grey rocks, I could see why. Fold after fold of unassuming hills stretched out before me, rolling gently like brown waves above a carpet of green. Also visible were the steel-blue outlines of shapely peaks floating royally above a white blanket of cloud, in what seemed to be a little less than 100km/62miles away. I instantly recognised them as Errigal, the Aghlas and Muckish.

The Irish for Sperrin is *Speirín*, which means 'little pinnacle'. It is hard to see these rounded hills as pinnacles, but hundreds of millions of years ago, the Sperrins were over ten times higher than they are today. Viewed from space, it sits in the middle of an ancient mountain range called the Caledonians; a range that if not for the Atlantic Ocean, runs from the Appalachian Mountains in North America, through the Sperrins and ends in Scandinavia.

Five hundred million years ago, the Ireland of today existed as two separate land masses hundreds of miles apart; the north and west belonged to one continent, while the east and south stood in another. A wide ocean, the Iapetus, separated these continents, but over a period of time, it closed up, sending the land masses hurtling toward each other. Like two giant trucks colliding head-on, these continents were thrust into the heavens, the thunderous impact folding the masses like a concertina and creating mighty mountain ranges. However, millions of years of erosion following this cataclysmic episode, now leave us with these silent rolling hills.

About 50km/31miles north-east of the Sperrins is a raised plateau in County Antrim, from which nine beautiful glens radiate out to the coastline. Each of these glens is individually named, and from the north to the south they are: *Glentaisie*, glen of the princess; *Glenshesk*, glen of sedges; *Glendun*, glen of the brown river;

Glencorp, glen of the slaughter; *Glenaan*, glen of rush lights; *Glenballyemon*, glen of Edwardstown; *Glenariff*, glen of the plough; *Glencloy*, glen of the hedges; and *Glenarm*, glen of the army. The glens cover an area from Ballycastle in the north to Glenarm village in the south, and are linked by a coast road, so near that it sometimes hugs the sea. The road winds around blue bays and wild headlands, and in some places such as Red Arch, is blasted through rocks.

Before the 1830s, there was no road. People had to take a perilous route inland, which was riddled with steep slopes and muddy ground in order to reach other parts of Antrim. Tales were heard of horsemen falling to their deaths over cliffs and fatal passages in the winter. Some would travel by curragh, a skin-covered wooden boat. Strangely, it was possibly easier for people of those days to go to Scotland than to other areas in Antrim.

I arrived in the Glens of Antrim one February to a wintry wonderland; the hills were white, the glens were white, its fields were white and peat hags stood out like white puddings. I was on my way up to Trostan (550m/1,804ft), the highest mountain in County Antrim. The ground I was to cover was normally boggy – but not today. The packed snow and hard frozen ground made it unusually delightful to walk on. The blanket of whiteness gave the Antrim landscape an immense sense of space, as fleeting mist and odd-shaped clouds streaked the grey-blue sky. Lurigethan, the fabled birthplace of Fionn mac Cumhaill, hovered

Approaching Dart Mountain with the
lump of Sawel Mountain behind.

Opposite Looking east from the summit of Sawel
Mountain toward the long arm of Meenard
Mountain and a range of Sperrin hills behind. The
view on a clear day is gently captivating.

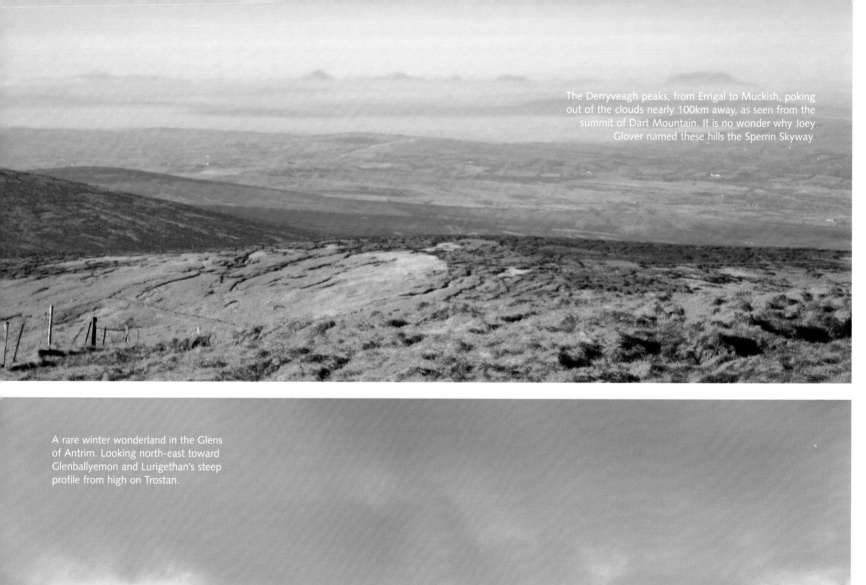

The Derryveagh peaks, from Errigal to Muckish, poking out of the clouds nearly 100km away, as seen from the summit of Dart Mountain. It is no wonder why Joey Glover named these hills the Sperrin Skyway.

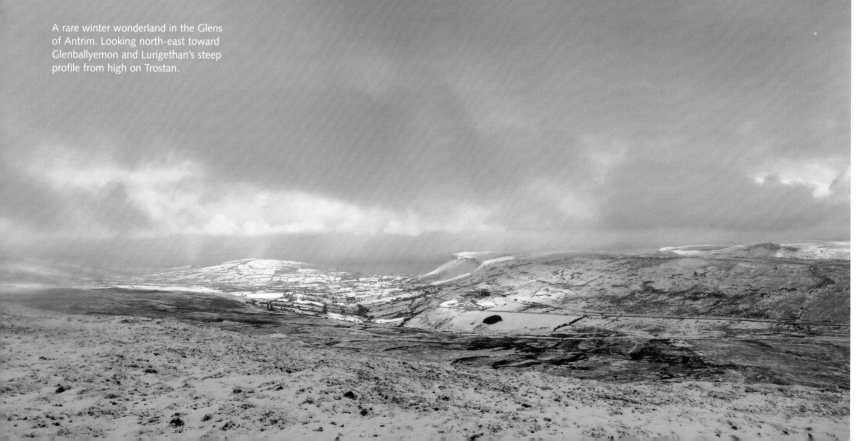

A rare winter wonderland in the Glens of Antrim. Looking north-east toward Glenballyemon and Lurigethan's steep profile from high on Trostan.

Slemish, as viewed from the south. The mountain stands out against the flat landscape, towering to the sky like a little volcano.

over Glenballyemon like a vulture's claw, before the land dips into a valley, and then rises again like a pointed axe biting skyward to the summit of Tievebulliagh (402m/1,319ft). Interestingly, a Neolithic axe quarry once stood below the eastern face of the mountain, at the foot of its rock buttress and scree. Neolithic axe heads and stone tools, fashioned from porcellanite, a hard dense rock, and durable flint, were found on Tievebulliagh's slopes, dating 2500BC.

Several kilometres north-east of Tievebulliagh, in an area called Lubitavish in Glenaan, a Neolithic burial tomb lies amongst green grass in a gently sloped field above the valley. Horns of upright stones, some as large as boulders, open out as semicircular court chambers. Legend says, and it is also marked on the OSNI map, that this is the site of Ossian's Grave. Ossian, or Oisín, was a Fianna poet warrior-hunter of the third century, and the son of Fionn mac Cumhaill. During one of his hunts, Oisín was visited by a captivating woman of blue eyes, red cheeks and golden hair, or so the tale goes. She was Niamh, queen of the mythical land of Tír na nÓg. Oisín fell for her charms, and against Fionn's wishes, left with the magical queen to northern shores and disappeared out to sea. Years later, Oisín, still a young strong man, returned to Erin's shores riding a white horse from which he was warned never to dismount. He passed some men lifting a boulder, and offered to help. But alas, his girth holding the saddle broke. The horse vanished. Oisín fell, hit the ground and immediately aged beyond his years. The feeble, blind and white-bearded Oisín implored the men to take him to his father, Fionn, but they declared that Fionn had been dead for 300 years. It is said that Oisín was taken to St Patrick, but the saint could not talk Oisín out of grieving until his death.

St Patrick has, in fact, strong associations with a mountain called Slemish (437m/1,434ft) or *Sliabh Mis*, about 22km/14miles south of Tievebulliagh. It was here that the saint arrived in captivity, at the age of sixteen, when he was still Patrick. The pirate fleet that captured Patrick sold him to a local chieftain, to whom the young Patrick spent six years as a slave, tending herds of sheep on Slemish's slopes. The mountain is an unmistakable feature in the landscape amongst the green Braid valley to the north and brown boglands to the south. It towers to the sky like a little volcano, with steep rugged slopes that look daunting to the observer from afar. Slemish is in fact the plug of an ancient volcano, whose activity is now all but extinct. However, about 60 million years ago, titanic flows of red-hot lava spilled out of cracks and fissures in the earth's crust as tectonic plates started to move apart again. County Antrim is in the middle of all this, and its plateau is the bed of cooled lava from millions of years ago, an action that forms basalt, a dark fine-grained rock, and dolerite.

Earlier in the day, before ascending Trostan, I ventured out to climb Slemish. The narrow lane that led uphill to a car park was dangerously iced up, so it was a case of parking farther down and walking up the icy tarmac. Slemish looked grim, its

snow-covered steep slopes towering like a menacing beast rising from a snowy hell. I swung the gate open, and walked up some rough stone steps, partially buried under snow. This path was rapidly becoming nondescript, the snow was extensive and too deep. A hare, with its distinctive white top, scurried in the distance, breaking the silence of the desolate-looking surroundings. I stared up a heather-filled gully; its branches stuck out like black dots from thick coats of white snow. It was then a matter of clambering and scrambling up the gully to the summit under the murky whiteness of the dawn sky. The sun appeared as a tiny yellow-white spot, glowing in the milky sky. I waited at the summit, but apart from fleeting glimpses of white fields separated by dark-brown boundaries, I saw nothing.

After Slemish and Trostan, I wanted to admire Glenariff, described by nineteenth-century English novelist Thackeray as 'Switzerland in miniature', from an elevated perch so I hiked on rough countryside north of its forest park to Altnagowna Burn. There, high above the plateau, and on its rim, the U-shaped glaciated valley stood below me, extending for miles out to the sea. The steep snow-filled side of its eastern plateau tumbled to the valley floor from over a thousand feet high. It was the last hour of day, so I soon descended, and later drove along a delightful road high above its western slopes. The cliffs on both sides of the plateau, with its many gullies and buttresses, looked even more enticing from the road. I vowed to one day return and further explore the Queen of the Glens.

Under an evening sky filled with inspiring clouds of innumerable shapes, I stood at the water's edge of the Sea of Moyle at Cushendall. A thousand ripples blew on its surface in the wind, and the smell of the sea filled the air. Farther out to sea, there was a distant patch of land, perhaps 20km/12miles away. I gathered it to be the Mull of Kintyre. A flash of light momentarily lit up the sky. It made me look south-east, upward to the thunder in its heavens. The sudden glow gave a golden tint to the mountains below, whose edges seemed to sweep down to the sea. It made me think of the mountains of Mourne.

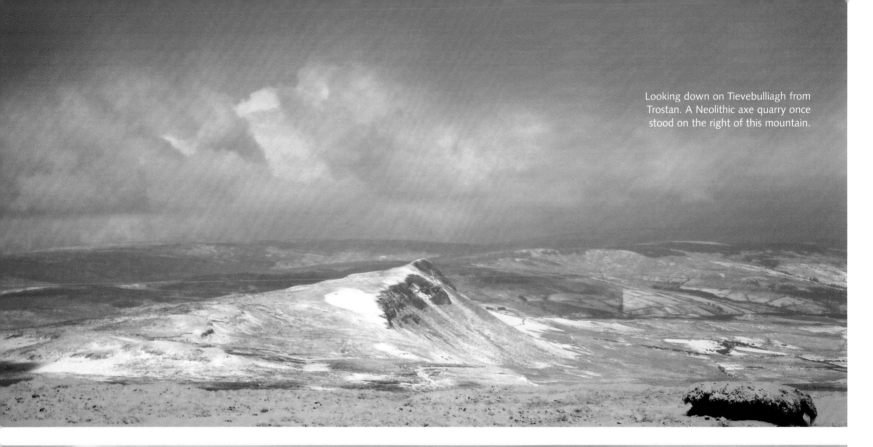

Looking down on Tievebulliagh from Trostan. A Neolithic axe quarry once stood on the right of this mountain.

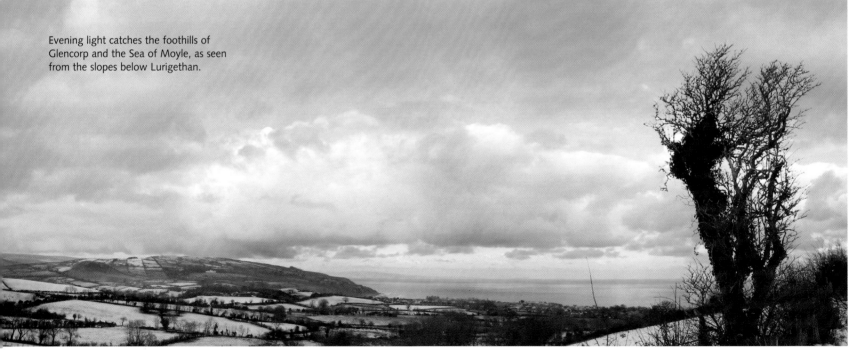

Evening light catches the foothills of Glencorp and the Sea of Moyle, as seen from the slopes below Lurigethan.

MIST AND MAGIC

Oh, Mary, this London's a wonderful sight,
With people all working by day and by night.
Sure they don't sow potatoes, nor barley, nor wheat,
But there's gangs of them digging for gold in the street.
At least when I asked them that's what I was told,
So I just took a hand at this digging for gold,
But for all that I found there I might as well be
Where the Mountains of Mourne sweep down to the sea.

William Percy French

Mahon's face turned pale, as if he'd seen a ghost. She'd been dead for nearly a decade. But it was Sheelagh's face that Mahon saw and the galloping feet of her horse he'd heard in that wild glen. He'd dismissed shepherd tales of a mysterious lady they called 'The Maid of the Mist' riding these parts as hearsay – until now. The white doe he was hunting was instantly forgotten, for now Mahon was only focussed on pursuing the ghost of his forlorn lover. Mahon's steed gave chase through the thick fog over a mountain pass and moorland to finally arrive on the shores of a lake. He recognised the lake as Lough Shannagh, for it was these enchanted waters that consumed his dearly beloved. It was in these depths that Sheelagh, the fair maiden of the O'Haidth clan, then drowned as the fox she was hunting suddenly vanished in the thick fog and her horse failed to reach the shore. A shrill cry of a woman's anguish suddenly filled the air and the waters of the lake splashed about in the mist. It stirred Mahon into action. He urged his steed into the lake. Deeper into its waters they went, until Mahon reached the spot where the cries were heard. But only the white doe was there, struggling to stay afloat. The enchanting waters rose all around Mahon and his steed, and they were never seen again.

Like Mahon in the legendary tale, I descended a broad grassy path to the shore of Lough Shannagh, the 'lake of the foxes', from a high mountain pass. Shafts of

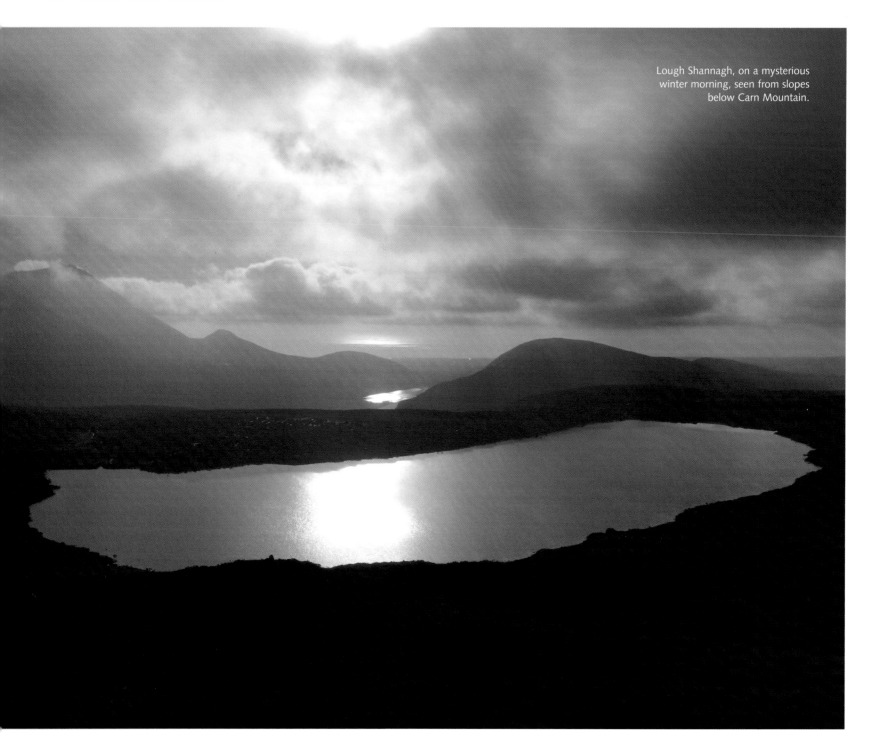

Lough Shannagh, on a mysterious winter morning, seen from slopes below Carn Mountain.

sunlight burst through thick grey clouds that hovered in the dawn sky like a swarm of large bees. Beams of sunlight, sparkling like silver, moved along the surface of the grey-blue lake, which stretched for nearly a kilometre. There was no fox, doe, maid or horse at Lough Shannagh that day, but only silence. The lake's still waters, the lull of the morning breeze and the dark outline of peaks far behind rose silently to touch the sky. And in that silence I was headed for an outcrop of rock that arched skyward from the brown heathery plain. Some short granite crags blocked the way to its rock-sculpted summit and I scrambled up to its airy perch. A larger sheet of water sprawled for miles due south, with steep-sided mountain slopes tumbling thousands of feet down into its glittering waters. The sun burned any lingering mist on the summit of Doan (593m/1,946ft) to reveal a circular cluster of brown peaks that soared like mighty giants, some summits rocky and rugged, other domes protruding in the distance like priceless pearls.

These are the jewels of Northern Ireland that 'sweep down to the sea' in a compact area of countryside termed as an Area of Outstanding Natural Beauty. These are the mountains that inspired Belfast-born novelist C.S. Lewis to create his magical land of Narnia. Less than an hour's drive from Belfast, these are the peaks of Mourne, formed in fire as batholiths of molten granite rose up through the earth's crust 60 million years ago – cooling, solidifying and later sculpted during the Ice Age.

Before they were known as the Mournes, these mountains were termed locally as Beanna Boirche, or the 'hills of Boirche'. In AD250 Boirche was a Celtic chieftain recognised as 'the cow herd to the High King of Ulster', a name bestowed onto him based on the number of cattle he owned – a measure of wealth in those days. The name Mourne, however, was derived in later years from a Gaelic clan called the Múghdorna.

The highest mountain in the Mournes, and indeed all of Northern Ireland, is Slieve Donard (850m/2,789ft). I've approached its rounded summit, whose lower slopes are steep, several times, during different seasons of the year, and each time from different directions. Approaching a mountain from a different direction always reveals a different character to it: contrasting views, new experiences, and sometimes even a varied degree of difficulty.

A popular route up Slieve Donard starts from Donard Park, climbing through lovely woodland populated with birch, holly, oak and rowan. It later follows the course of the Glen River, passing green slopes of firs, larches and pines. A domed stone structure that looks like an igloo can be seen across the river. This in fact was once a primitive freezer for residents of a lodge in the demesne of Donard in the nineteenth century. Granite is everywhere – granite rocks are strewn about the green grass, granite boulders guard the river and granite slabs lead uphill to a granite wall.

This dry-stone wall sweeps down from the heights of another summit, across a col, and then soars again upward to the summit of Slieve Donard. The stone wall, also known as the Black Ditch, is high enough to require one to stand on tiptoes to see across to its other side, and wide enough to walk on. This section of wall is in fact only a small part of a larger jigsaw, one that rolls like a roller coaster along a string of summits for a distance of about 35km/22miles. The wall defines the boundaries of 36sq.km/14sq.miles of land bought by the Belfast Water Commissioners in the late nineteenth century. Its statistics are staggering. Completed in 1922, it took 'men of rock' with herculean strength and hands like shovels eighteen years to build. Without the use of mortar, 140,000 tons of stone, prised and shaped from granite rock of the mountains, was painstakingly put in place. Interestingly, the only mortar used was on stone lookout towers on three of its many summits, that on Slieve Meelmore (704m/2,310ft), Slieve Commedagh (767m/2,516ft) and Slieve Donard.

Another route up Donard begins from Bloody Bridge, the site of a 1641 massacre, slightly more than halfway along the coast road from Annalong to the south and the busier Newcastle in the north. Centuries ago, a group of Presbyterian prisoners, led between Newcastle and Newry gaols, were ambushed and slaughtered by a band of rebels. The path here follows the course of the Bloody Bridge River upstream, passing yellow gorse bushes, pipelines, granite slabs on the river bed, quarry mounds, and the Bog of Donard, before finally reaching the Mourne Wall that soars upward to Donard's summit.

Over the years I have been seeking out new routes of ascending familiar Irish mountains; paths not to be found in guidebooks, lesser-known valley lakes and spurs, and isolated mountain areas. One glorious autumn day I followed a quiet course northward along the Glen Fofanny River, a kilometre away from Bloody Bridge, leaving a line of walkers who were on the standard path west leading to the Mourne Wall. I pulled gently up the Leganabruchan spur, tramping on brown moor-grass and purple heather. The eastern ramparts of Donard towered to the skyline on my left, in various shades of green, brown and grey. On my right, the sea was a force of blue, curving as Dundrum Bay into the distant jumble of grey concrete that is Newcastle Town.

I eventually found myself on Millstone Mountain (459m/1,506ft), and then on a spur that offered fabulous views of the sea, green flatlands and low-lying brown hills to the north. The spur ascends forever upward. To the west, Eagle Rock protruded as a precipitous scarp. The royal green sweep of Slieve Commedagh, with its grey eastern cliffs and the curved corrie known as the Pot of Pulgarve poked out in the distance. On the northern fringe of Donard, I arrived at the Lesser Cairn, an ancient burial cairn, dating back to the Bronze Age. A sea of cotton-wool clouds swept the blue sky northward, a sky that

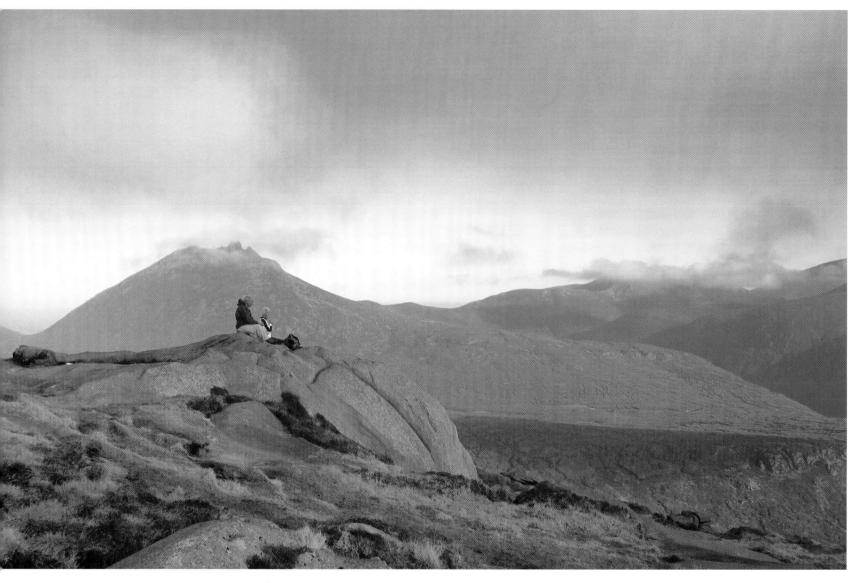

The view northward from the summit of
Doan toward the mountains of Mourne.

Opposite A section of the Mourne Wall tumbles
westward from the summit slopes of Slieve Donard
against a backdrop of compact mountains.

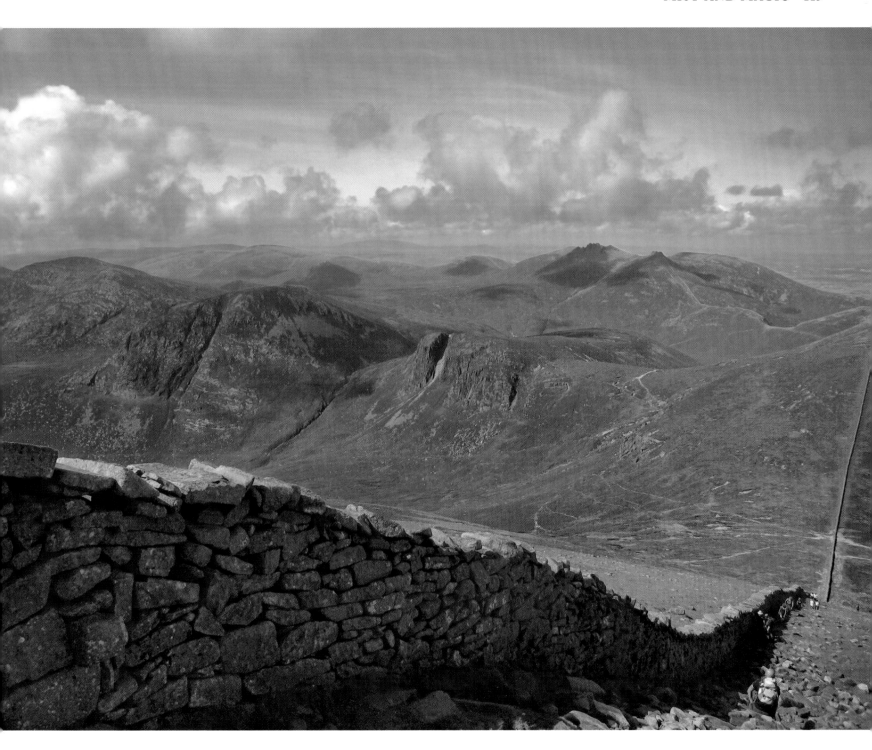

mirrored the blue sea, and then there were the brown-green plains that drew comfort from the sea.

I walked amongst granite rocks and short grass toward a stone tower in the corner of the wall with a trig point perched on top of it, toward the summit cairn of the highest point in Ulster and Northern Ireland. The summit cairn is known as the Great Cairn, or Slainges Cairn. Slainge was a Partholan prince of Grecian roots who came to these shores after the battle of Troy. According to the *Annals of the Four Masters*, his final resting place is supposed to be under the Great Cairn, and so it was that the mountain was named after him for 2,000 years, known as *Sliabh Slainge*, until the arrival of St Patrick's follower Domangard. St Domangard, or Donard, like other great Irish saints, found solace on such lofty heights, so much so that he built an oratory on the summit. They say that the stones of the Great Cairn may have once been part of the saint's oratory, altar and even his passage grave.

There is nowhere higher in the Mournes than Slieve Donard, thus making its summit a unique vantage point for admiring all the great peaks in the area. Its wall extends somewhat like the Great Wall of China over those peaks. In his book *In Search of Ireland*, H.V. Morton speaks of the mountains of Mourne being different to the hills of the West of Ireland, but that they, 'are linked to all these by that unearthly quality of the Irish landscape which I can describe only as something half of this world and half in the next'.

I experienced this 'unearthly quality' once, in the middle of a cold November, when I set out to climb Slieve Binnian (747m/2,451ft) with a friend. We parked at Carrick Little and followed a gravel track that led to an information board. A wall of brown-grey mountains surrounded the wide Annalong Valley ahead of us, with paintbrush clouds brushing its proud tops. A cuckoo called out from the depths of the dark Annalong Wood to our right. Old tradition suggests if a cuckoo calls, then it's a sign of rain. There must be an element of truth in it then, as grey clouds and mist soon encircled us the higher up along the Mourne Wall we got. Soon we were faced with a different wall, one of bare granite rock, drifting in and out of sight through the thickening mist. A steep path led to a gap in the rock, and soon we found ourselves on the Summit Tor of Slieve Binnian.

The sky was now a sheet of platinum-white, limiting our world to one of grey granite consisting of rocks, slabs and tors. A giant tor resembled a Celtic monk's beehive hut. Another outcrop of wrinkled tor, as large as a house, formed a rugged crest on the skyline, the edges of which looked like Easter Island 'Moai' statues. As we explored this granite wonderland, I noticed a glowing circle of white the size of a wheel in the pallid grey sky. This circle got larger and larger, dissolving the surrounding grey mist, as if by magic, to reveal an entirely different world: a world of wispy clouds and blue skies, of rugged peaks and crenellated summit ridges, of blue lakes and blue reservoirs.

Two large reservoirs stretch to the west and north of Slieve Binnian, both several kilometres in length and each holding millions of litres of water, serving Belfast and its surrounding areas. Astonishingly, the construction of these reservoirs was approved in 1893 by the Belfast Water Act – 215 years after the Belfast Water Commissioners identified the Mournes as the best source of water catchment. The construction of both took about half a century to complete. The one to the west of Binnian, Silent Valley Reservoir, was completed in 1933, and the one to the north, Ben Crom Reservoir, was completed in 1957. There was a proposal to dam the Annalong Valley to the east as well, but when conditions proved unsuitable, a tunnel several kilometres in length, completed in 1952, was carved through the base of Slieve Binnian to redirect water from Annalong to the Silent Valley in order to boost its supply.

We walked under the massive bare North Tor of Binnian to its eastern end. There, we admired Blue Lough, nearly 1,000 feet below, and a hulking mountain behind it, its steep slopes decorated with scree and brown heather. This mountain is Slievelamagan (704m/2,310ft), and from its summit cairn, a series of dips and rises extend north-east, over Cove Mountain and Slieve Beg, along a broad ridge. On the eastern flank of Slieve Beg, just before its summit, towering granite buttresses guard a plummet over the edge. Here, crumbling grey rocks give way to a tongue of scree, this turbulent arrangement plunges relentlessly down a gully called the Devil's Coachroad. I walked the top of these mountains years ago, eventually reaching a track called the Brandy Pad, under darkening autumn skies.

The Brandy Pad was deserted that evening. But it probably would not have been the case in the eighteenth or early nineteenth centuries. Then, the thud of smugglers' boots and ponies' hooves would grace the pad under pale moonlight. The ponies would be strapped with illicit stock of wine, spirits, tobacco, silk and spices. These goods were transported from the coast in the east, along the Bloody Bridge River to the Bog of Donard, then along the Brandy Pad, to Hare's Gap, the Trassey Track and finally to Hilltown, a further 10km/6miles west.

I walked east along the Brandy Pad for a few hundred metres until I stood under the Castles of Commedagh. A block of dark grey buttresses loomed above me, pinnacles of irregular shapes and sizes arranged like a battlement of turrets, its granite rock shaped like gloomy wrinkled faces in the fading light. Purple-grey clouds brushed the mountaintops as I descended a heathery slope strewn with boulders into the Annalong Valley. I walked alone, deep in the heart of the Mournes. A mystical air filled the valley as the mist descended, swallowing up towers of dark granite above, and then dispersing again to reveal a shadowy cleft in the cliffs above. Only briefly though, as another coat of mist soon gobbled the cleft up.

The magic of the mountain mists indeed.

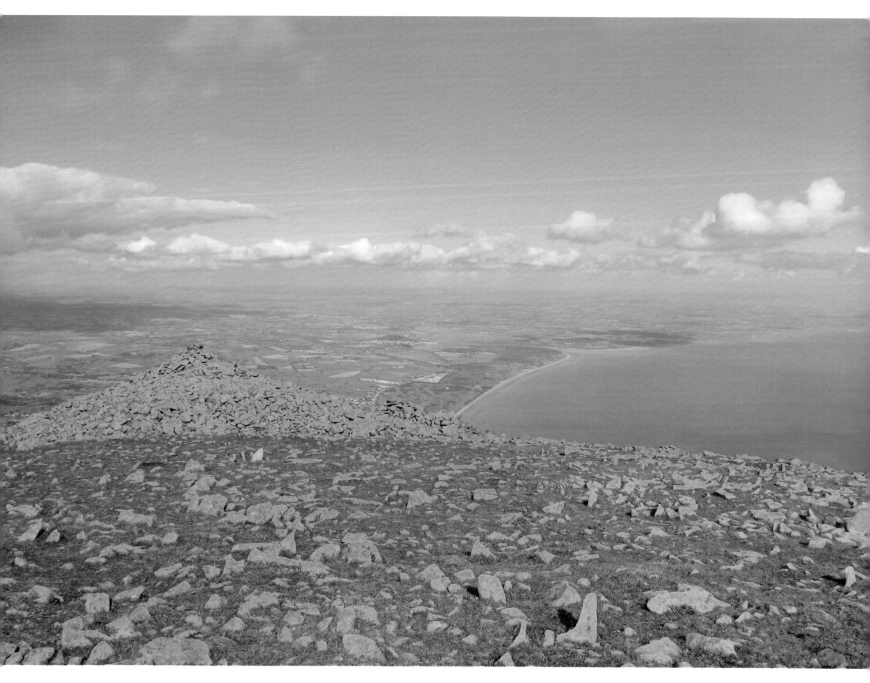

Looking north across the Lesser Cairn toward
Newcastle Town and Dundrum Bay below, from
near the summit of Slieve Donard.

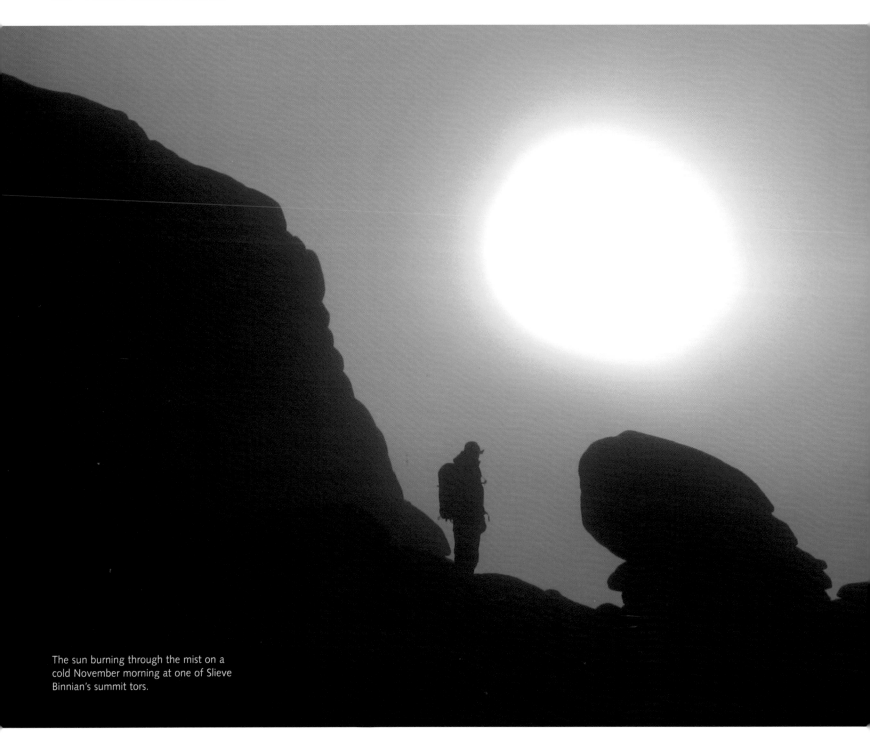

The sun burning through the mist on a
cold November morning at one of Slieve
Binnian's summit tors.

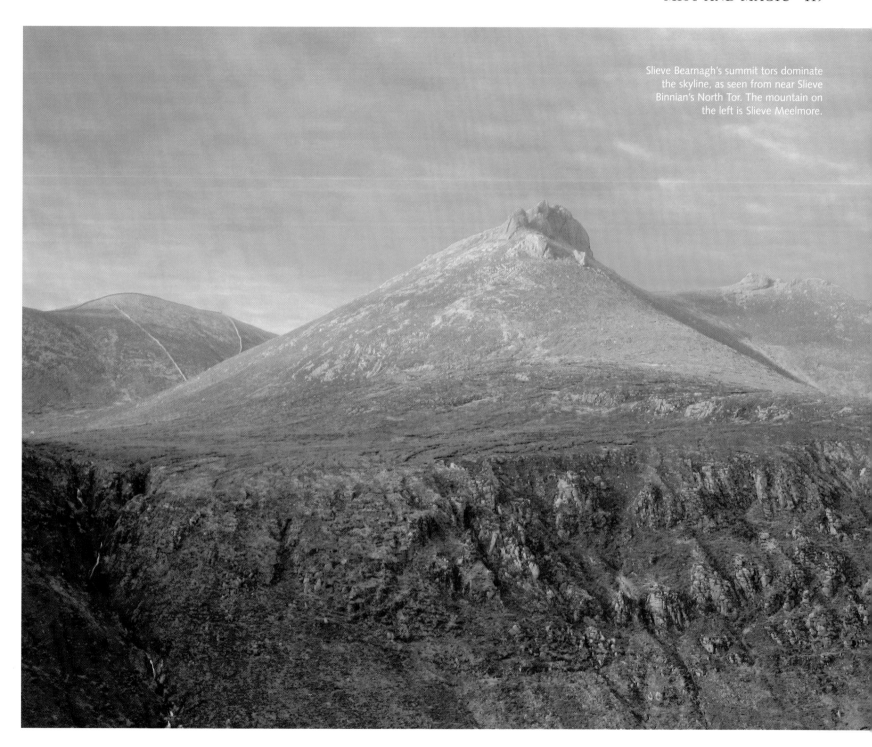

Slieve Bearnagh's summit tors dominate the skyline, as seen from near Slieve Binnian's North Tor. The mountain on the left is Slieve Meelmore.

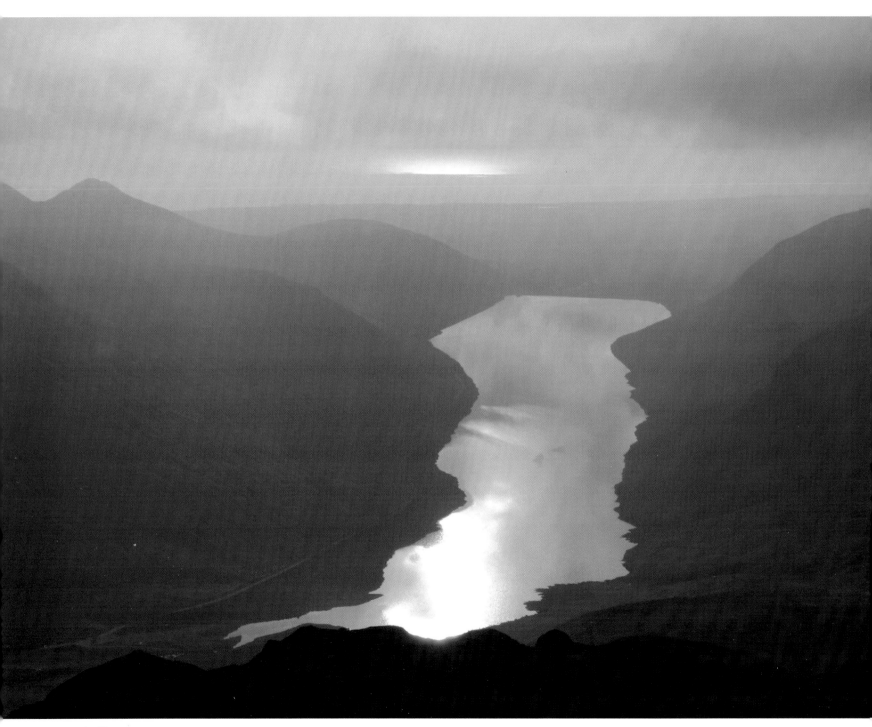

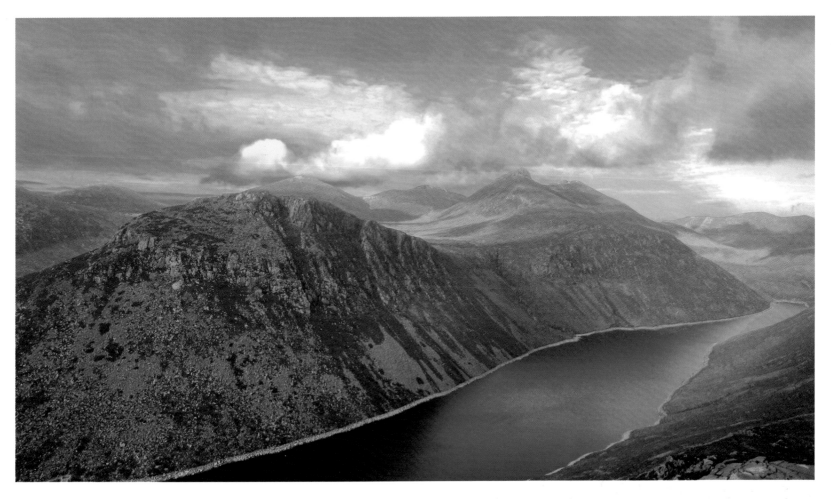

Looking across Ben Crom Reservoir from Slieve Binnian's North Tor summit slopes to a panorama of peaks. Ben Crom rises above the reservoir. The line of summits in the background, from left to right, is Slieve Loughshannagh, Slieve Meelbeg, Slieve Meelmore and Slieve Bearnagh.

Opposite The Silent Valley Reservoir from the summit of Doan.

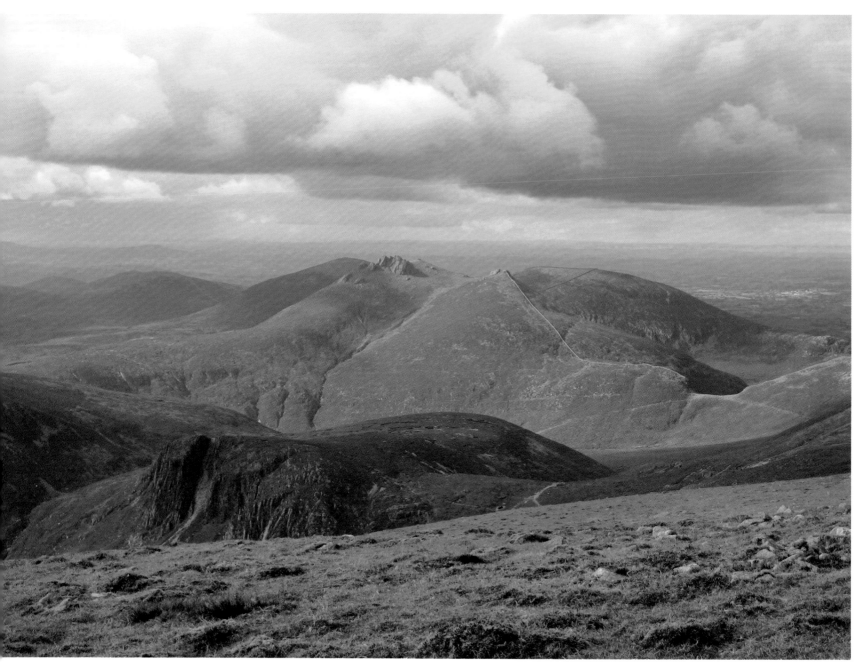

Looking across Slieve Beg from Slieve Donard's western slopes toward the rocky summit of Slieve Bearnagh rising up from Hare's Gap. The narrow cleft running up Slieve Beg is the Devil's Coachroad gully.

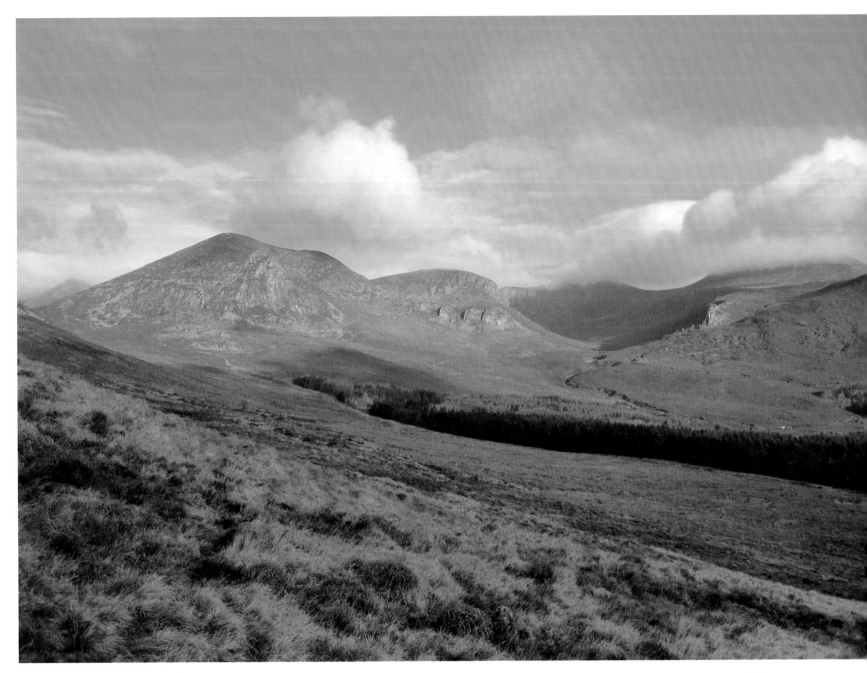

The view along the Annalong Valley from the eastern slopes of Slieve Binnian.
Slievelamagan and Cove Mountain can be seen on the left, while the tops of
Slieve Commedagh and Slieve Donard are enveloped in cloud.

WILD WICKLOW

Still south I went and west and south again,
Through Wicklow from the morning till the night,
And far from cities, and the sights of men,
Lived with the sunshine, and the moon's delight.

John Millington Synge

About 150km/93miles south of the Mournes is yet another sprawling mountain range whose bedrock is essentially granite. The map that represents these mountains, OSi Sheet 56, covers an overall area of 40km/25miles by 30km/19miles. A glance instantly reveals that most of its squares are coloured in different shades of brown. These shades typically denote upland regions, and the sea of continuous brown on the map suggests a large mountainous area. These are the Wicklow Mountains, and in fact they form the largest continuous upland region in all of Ireland.

It is a busy mountain range, being relatively close to Dublin, and especially in the height of summer, when throngs of locals and tourists flock over hotspots such as Blessington Lake, Enniskerry village, Powerscourt Waterfall and especially the Glendalough valley. It is easy to see why people are drawn to Glendalough. The Irish for it is *Gleann Dá Loch*, or 'valley of the two lakes'. Millennia ago, when glaciers that filled the valley floor melted after the Ice Age, there used to be only a single long lake. But scores of gravel, mud and sand were deposited by an onrushing river from the south, creating a natural barricade, dividing the lake into two. The smaller Lower Lake is now tucked away in the eastern corner, near the remains of a Christian monastic settlement founded by St Kevin in the sixth century. The ruins of a medieval gateway, formed by two large granite arches, guard the entrance to this Monastic City which includes a 30m/98ft high round tower, a Romanesque-style Priest's House, ancient churches and a 2.5m/8ft high granite cross.

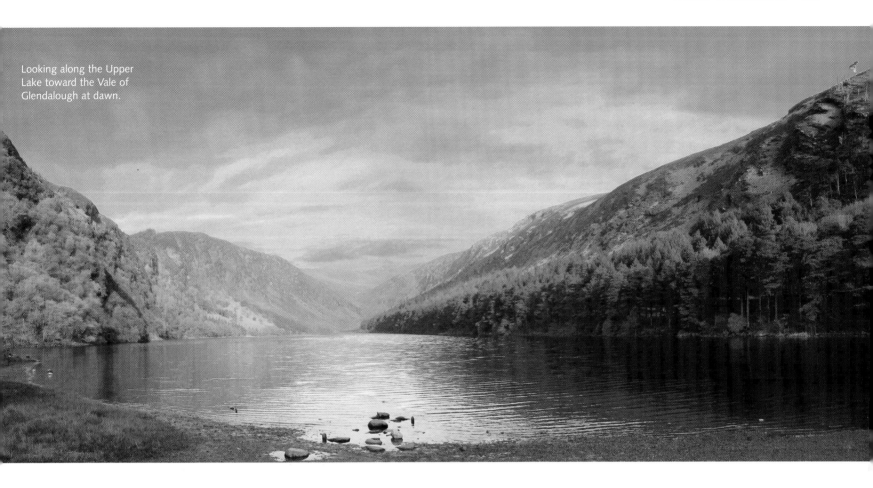

Looking along the Upper Lake toward the Vale of Glendalough at dawn.

The larger of the two lakes is the Upper Lake, situated in the western end of the valley, and it is over a kilometre long. The lake is a tranquil setting at dawn when no crowds are gathered, and when early at springtime a chorus of birdsong bursts into a melodic rapture around its shores. From its eastern shore, one can gaze deep into the valley flanked by yellow-brown hills. The rising sun gradually floods the valley with silver light, brushing dew droplets off heathery mountaintops and lighting up the lake in a blue glow. The sun also enlightens a band of Scots pine that line the northern shore, giving colour to its blue-green leaves and orange-red bark. A path runs along these shores, leading westward, away from the civilised world. Through gaps in the trees, one can stare across the lake to its opposite end and strain the eye to pick out a cave, no more than a metre high and just over a metre wide, cut into the rock face above a grassed shelf. It is said that on this small bed of rock, St Kevin retreated to meditate in isolation.

The path continues westward and soon trees give way to boulders, and scores of them decorate the slopes. Beyond these boulders, grey granite cliffs with dark crack lines project skyward. These cliffs, with buttresses both large and small, are today a Mecca for rock-climbers. However, in the nineteenth century, it wasn't rock-climbers that graced the area but a flock of miners that came in thousands. A vein of metal ore, the Luganure, was formed through the mountain that separated Glendalough and the valley to the north, along the geological divide between the granite core and surrounding schist, yielding deposits rich in lead, silver and zinc. Only ruins of this industrial past exist today: crumbled dwellings, slag heaps and rusted machinery.

The path zigzags up to the higher Glenealo Valley along a lovely river, its waters breaking into cascades and rock-pools amongst boulders and slabs as it pours from the heights. There is a bridge across the river at the top of the valley, followed by

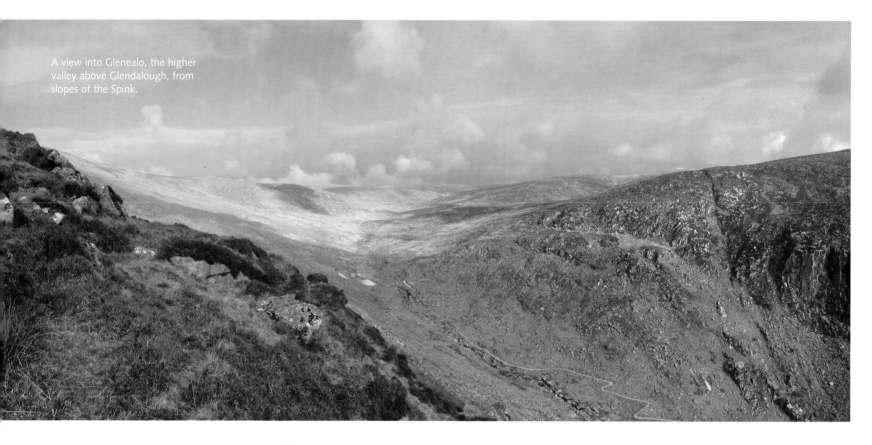

A view into Glenealo, the higher valley above Glendalough, from slopes of the Spink.

a boardwalk angling up a pointed hill. Some follow the way-marked trail, but my favourite area in this neck of the woods lies beyond the security of paths: ever westward into a world of mountain wilderness, deep in the brown moors where deer roam. I camped here once, in the depths of winter, below the southern slopes of Camaderry (698m/2,290ft), waking to a morning of pure snowflakes tumbling white from the sky. There was not a soul in sight except for a herd of feral goats in the furthest reaches of the valley.

The valley is flanked by higher ground, Camaderry to the north and the broad Lugduff ridge to the south, both peaty hills embossed with a carpet of heather. These hills are part of the larger Wicklow Mountains National Park, which encompasses a total area of 205sq.km/79sq.miles. An interesting projection can be seen rising to the west from Camaderry in the shape of a green flying saucer with a brown chimney-like structure sprouting out from its centre. This is in fact a reservoir known as Turlough Hill; water from a lake in a corrie below is pumped up to it, and during peak electricity demand, water from the upper reservoir is released, flowing through turbines linked to generators. The corrie lake is Lough Nahanagan, or *Loch na hOnchon*, roughly meaning 'lake of the savage beast', and there are tales of old that a serpent-like creature once inhabited its waters.

I love secluded spots in the mountains. From Camaderry, hikers normally drift west from its col toward the southern rim of Turlough Hill. However, I traditionally wander north from the broad peaty gap to the edge of some rugged ground overlooking Lough Nahanagan. It is a wild spot with the lake below and with vehicles trailing along the Wicklow Gap, while the whaleback hump of Tonelagee (817m/2,680ft) along with endless brown hills roll in the background. I have a great deal of affection for Tonelagee, as it happens to be the first mountain in Ireland that I climbed, back in 1999.

A stretch of rough ground connects Turlough Hill to a bump south-west of it, Conawalla (734m/2,408ft). Its upper reaches are boggy, peaty and heathery, like everything else in the area, with only the tiny Lough Firrib to settle navigational

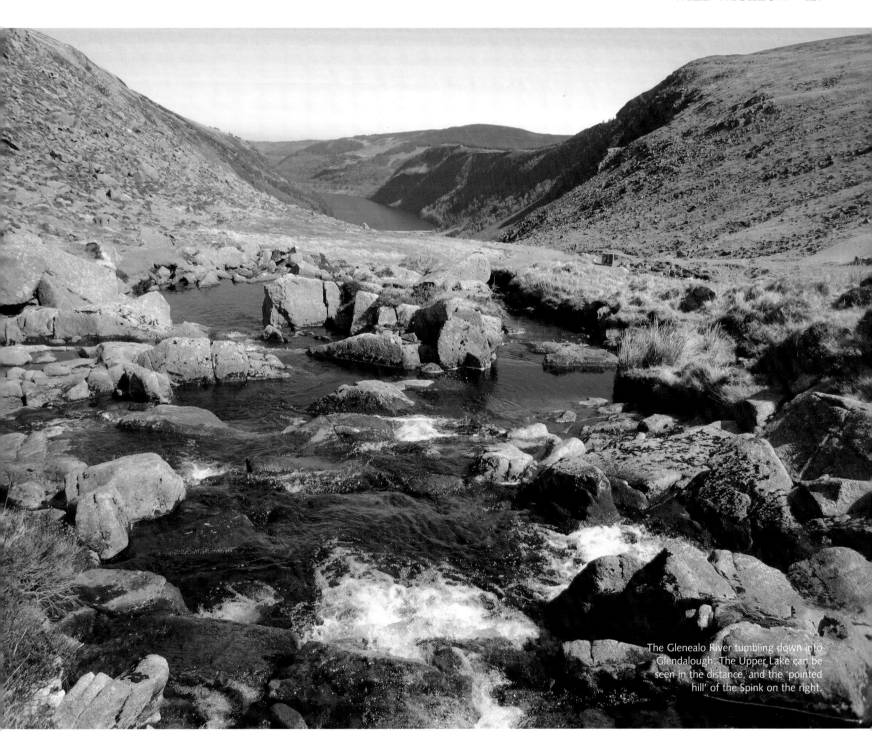

The Glenealo River tumbling down into Glendalough. The Upper Lake can be seen in the distance, and the 'pointed hill' of the Spink on the right.

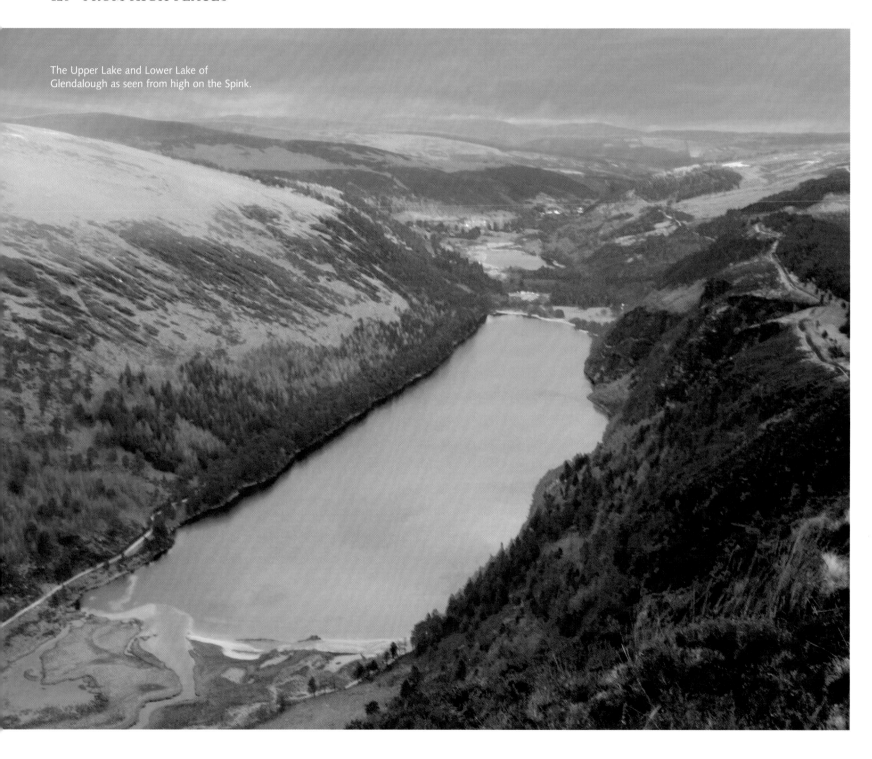

The Upper Lake and Lower Lake of
Glendalough as seen from high on the Spink.

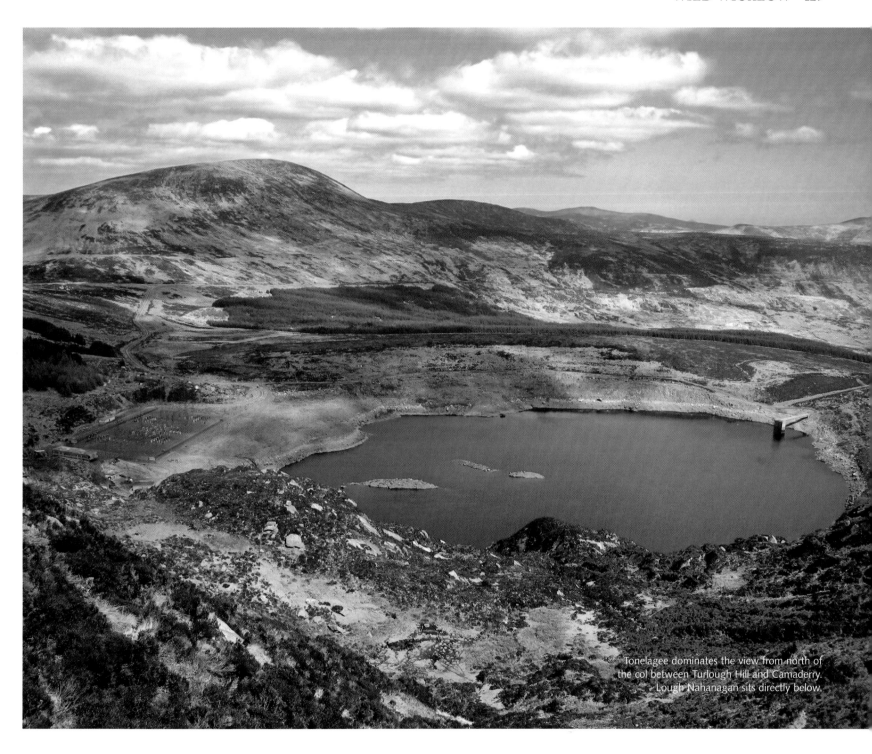

Tonelagee dominates the view from north of
the col between Turlough Hill and Camaderry.
Lough Nahanagan sits directly below.

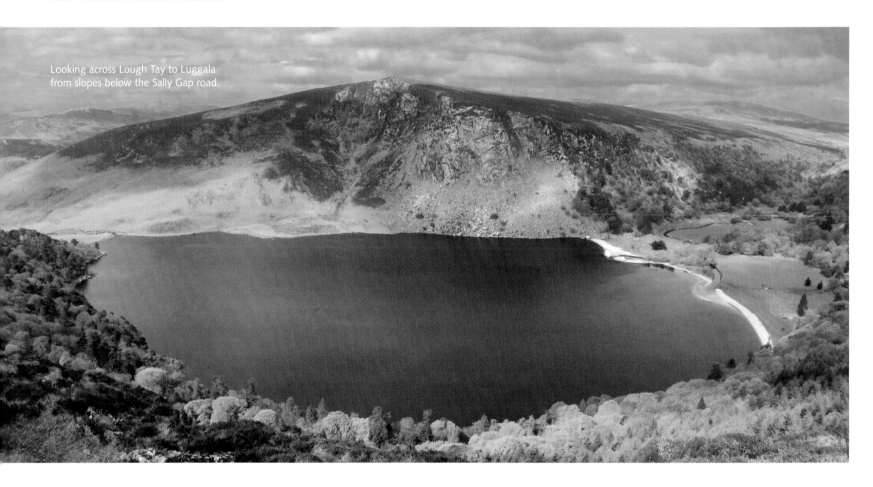

Looking across Lough Tay to Luggala from slopes below the Sally Gap road.

disputes. I was here some years ago in fading light on a navigation exercise. It was a chilly winter's evening. I had heard about it and read about it in books, and wanted to see the site for myself. And so, I followed a bearing north-west from the tiny lake, to the edge of a plateau overlooking Glenreemore Brook.

Thick fog descended, but I kept at my bearing, following it religiously. Soon, among swirls of grey mist, there it was, a wooden cross standing in an area of desolate moorland. I touched its cold timber frame attributed to a man called Art, and then set myself the challenge of finding his memorial plaque. I followed a stream tumbling away from the plateau to the bottom of a cascade, and there amongst heather and rushes, a little cross sat on a boulder. I edged down to the foot of the grooved boulder, bringing a plaque positioned in the recess of the rock into view. Words in Irish suggest it was placed there in 1992, 400 years after the death of Art O'Neill, the son of a clan's chief in Ulster.

I looked around; if this indeed is the spot where Art died, he couldn't have picked a wilder place, but what choice did he have? It was a savage winter's night in January 1592, one of lashing rain, stinging sleet and bitingly cold winds. Darkness descended rapidly as Art and Red Hugh O'Donnell, wearing only thin garments and flimsy shoes, scampered over these hostile mountains. Red Hugh himself was a prince, that of *Tír Chonaill*, more or less County Donegal today. At only fifteen years of age, he was kidnapped in a scheme masterminded by Sir John Perrot in a ploy to hinder an alliance between the O'Donnell and O'Neill clans, and imprisoned at Dublin Castle. Together with Art and Henry O'Neill, he broke out from captivity that night, somehow knocking off iron fetters, roping down a privy shaft, wading through a moat sewer, nervously traversing busy streets and finally fleeing through open city gates.

They were headed for the safe haven of Fiach MacHugh O'Byrne, a guerrilla chieftain in Ballinacor, in what is the locality of Greenan today, south-east of

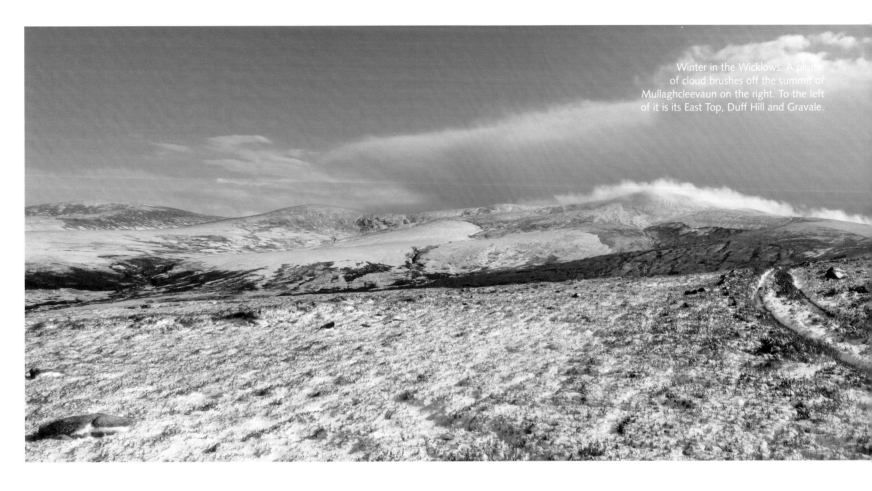

Winter in the Wicklows. A plume of cloud brushes off the summit of Mullaghcleevaun on the right. To the left of it is its East Top, Duff Hill and Gravale.

Glenmalure. One of O'Byrne's men guided their southward epic through an endless stretch of rough country. They soon lost Henry, who was nowhere to be seen. The steel-iron cold and unforgiving terrain soon took its toll on Art, who collapsed into the snow-clad heather. Red Hugh and the guide seemingly dragged Art to a shelter under a small cliff. Art was too weak to continue, so the guide hurried to Ballinacor for assistance, and Red Hugh remained behind. By the time help arrived, possibly during the next day, Art was dead. They buried Art nearby. Red Hugh was severely frostbitten and had to be carried to safety, with some toes later amputated.

The Wicklow Mountains have endured harsh winter conditions, especially over the last few years, conditions that would turn a routine hillwalk into a serious mountaineering expedition. Some climbers had not even set foot on the hill when they experienced such conditions. In the winter of 2009, in one of the busiest periods for the local Mountain Rescue, several vehicles were stuck at Sally Gap, at around 497m/1,631ft, the highest point on a regional road running north-west to south-east for miles through the Wicklow Mountains. It is a popular road of sorts, meandering along the River Liffey, barren moorland and above deep corrie lakes; even its surrounding area have been used as film locations for major releases such as *Braveheart*, *Dancing at Lughnasa*, *Excalibur* and *Reign of Fire*. But the road was a different beast that night, for high winds and violent snowstorms buried it under several feet of snow. Mountain Rescue personnel, acting voluntarily, braved the conditions by skiing up to the Sally Gap, locating the stranded people and treating them appropriately. It was a harrowing night, waiting for visibility to improve. Fortunately, with a break of the weather at dawn, it was finally possible for a Coastguard helicopter to fly in, land and pick them up. In less menacing winter conditions, the mountains are blessed with an almost Alpine feel. Over the years, I've had some immensely fulfilling forays in virgin snow in these parts, including

Relaxing above the Fraughan Rock
Glen in Glenmalure, a nice way to
spend a summer afternoon.

Opposite Looking north-east from the summit
plateau of Lugnaquillia toward Turlough Hill
Reservoir and Tonelagee, whose whaleback
summit is capped in snow.

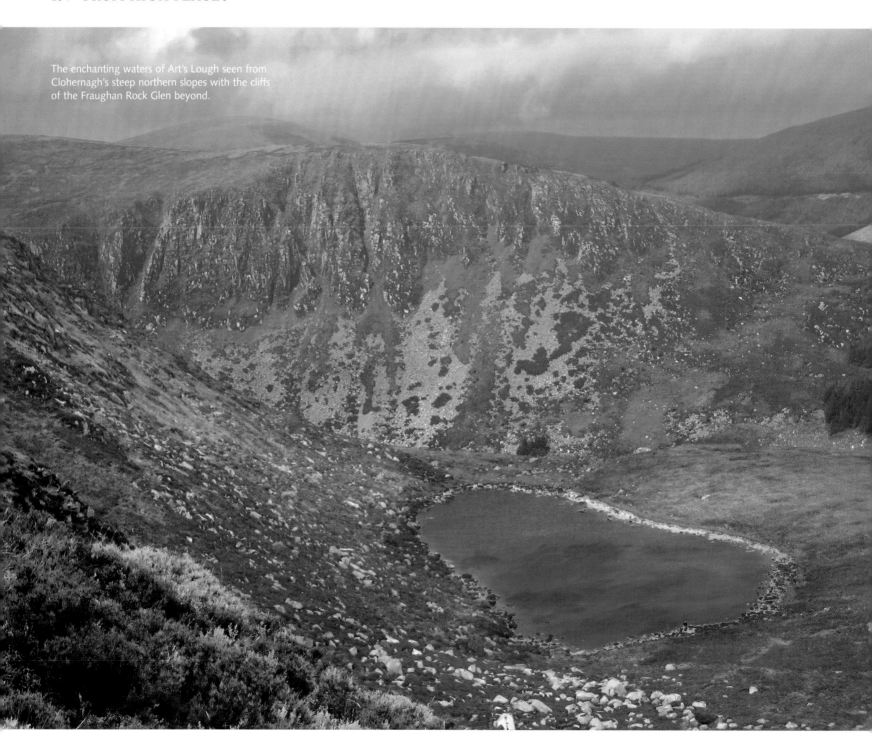

The enchanting waters of Art's Lough seen from Clohernagh's steep northern slopes with the cliffs of the Fraughan Rock Glen beyond.

once when walking over some northern Wicklow hills like Mullaghcleevaun (849m/2,785ft), Duff Hill (720m/2,362ft) and Gravale (718m/2,356ft), when packed snow transformed normally boggy ground to one that was really pleasant to walk on.

The bumps of Duff Hill and Gravale rise over a winding road that runs north-south across the spine of hills. This is the Military Road, built over a period from 1800 to 1809, in an effort to open up these mountains to English military forces and therefore assisting them in tracking down rebels who were hiding there following the 1798 Rebellion. Some 20km/12miles away from Gravale, and just south of Laragh, the Military Road leaves the R755 and climbs above delightful countryside to a high pass at the Shay Elliot Monument. Here the road dips again into a charming valley, whose sides are flanked by a flood of yellow gorse and banks of dark spruce. A stream flows near the road, under the cover of more trees: birch, holly, larch, oak and rowan. It flows to meet the Avonbeg River at Drumgoff crossroads; here a lonely road leads north-west to a cul-de-sac and into the remote valley of Glenmalure.

It's hard to beat the solitude of Glenmalure. For one, it doesn't get the Glendalough crowds. I love this glacial valley; it is a place where time ticks slowly, and its hushed hills provide respite from an increasingly weary city lifestyle. On the western end of Glenmalure, a set of zigzags lead up to an upper valley that undulates westward, tracing the down-flow of Carrawaystick Brook. At the back of this valley, several kilometres away from the zigzags, a brownish-green headwall stands guard. A large corrie lake, Kelly's Lough, is tucked away in the corner, its waters always strangely still. Two summits rise to either side of the lake – Corrigasleggaun (794m/2,605ft) in one corner and Clohernagh (800m/2,625ft) on another. Clohernagh is one of those deceptive Irish summits; its plateau is broad and stony, but away from its rugged heathery slopes in a general northward direction are some steep, fractured cliffs. Another plate of water, Art's Lough, sits at the base of these menacing cliffs. Its setting is evocatively haunting: a spray of grey rocks tumble down its slopes, dark-blue ripples float on the lake, purple heather blazes like wildfire on its slopes. Beyond its shoulder, another rugged green valley separates Art's Lough from a band of dramatic grey cliffs. These cliffs have green veins that run vertically down its crack lines and a band of scree that decorates its lower slopes. These are the cliffs of the Fraughan Rock Glen, a valley that rises as a set of three, one higher than the other, following some delightful cascades that tumble down from the eastern slopes of Lugnaquillia (925m/3,035ft).

The summit of Lugnaquillia, or Lug as it is commonly known, boasts all sorts of statistical accolades: it is the highest point in Leinster, and interestingly the only mountain above 900m or 3,000ft outside of County Kerry and other than Galtymore. Its summit plateau is broad and a trig point sits on top of a huge stony platform. I've climbed Lug more than thirty times from various directions over the last ten years. It's a mountain I know well, but I must confess it is not the summit itself that excites me but rather views from the rim of its broad plateau and the diversity of ways of approaching its towering massif over different seasons. Viewed from afar, Lug is a hulking mass; from Camarahill (480m/1,575ft) in the west it projects as a massive rounded dome with cliffs of the North Prison poking cheekily in the shadows, from the Ow valley in the south it stands sentinel-like guarded by mighty cliffs of the South Prison, and from Carriglineen (455m/1,493ft) in the east it is shaped like a giant brown pudding.

Below the northern slopes of Carriglineen, a track crosses a stream that flows out of the quiet Ballybraid valley. It wanders along forested slopes, and just before a clear-fell area it branches off left under a cover of Sitka spruce. It passes what looks like a ruined house to finally reach a cordoned area a few hundred metres beyond. A friend brought me here a few years ago on a gloomy morning, and I vividly recall a cold chill passing through me, a chill that made the hairs on the back of my neck stand up. I recently returned to this area on a sunny spring afternoon; there are now twelve new teak crosses spaced about two metres apart each, on top of lumps of earth covered with green grass, yellow moss and wood sorrel. The lumps also amount to twelve in total, slumped down the slope of the hill, shaped like bodies resting on the hillside, buried underneath the brown earth.

Local tradition speaks of a dark chapter in its history. In the 1650s, hundreds of Oliver Cromwell's troops raided these mountains to weed out rebel guerrilla bands. A group of soldiers descended into Glenmalure from a high pass on which today the Shay Elliot Monument stands. These soldiers stumbled on some locals worshipping at a Mass Rock on the lower slopes of the hill and attacked. None of the locals were spared.

I stood at the lonely spot in this corner of Wicklow where the slain twelve are reputed to be buried side by side. Shafts of sunlight suddenly burst through the dark green trees. A flurry of birdsong filled the air, Great Tits going 'seek-er, seek-er'. I touched the wood of a cross, and in silent respect left that wild place alone in peace.

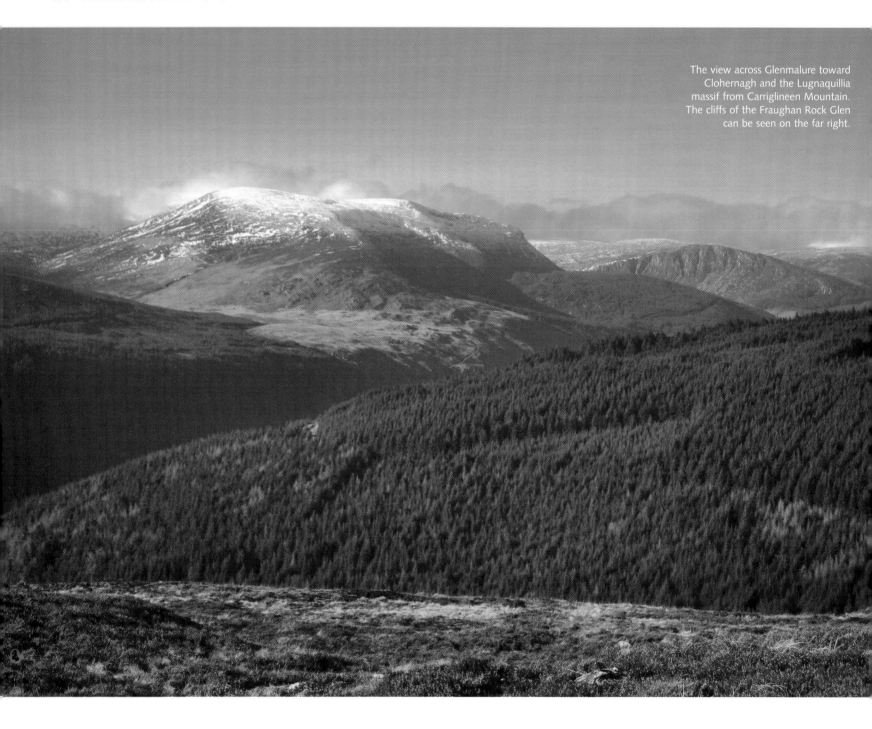

The view across Glenmalure toward Clohernagh and the Lugnaquillia massif from Carriglineen Mountain. The cliffs of the Fraughan Rock Glen can be seen on the far right.

thirteen

SOLITARY DELIGHTS

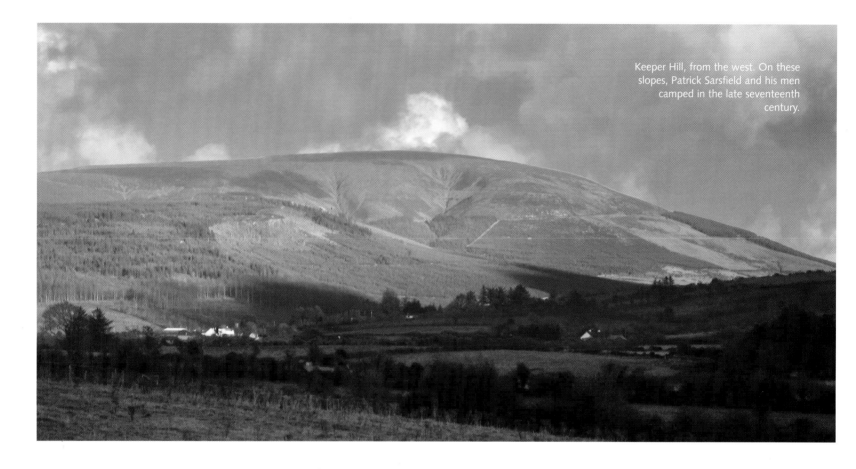

Keeper Hill, from the west. On these slopes, Patrick Sarsfield and his men camped in the late seventeenth century.

The mountain sat upon the plain
In his eternal chair,
His observation omnifold,
His inquest everywhere.

Emily Dickinson

There is a mountain, tall and proud that dominates the skyline on the road south. On a clear day, its television mast can be seen poking out of distant slopes from the Limerick road, near Nenagh. Its lower slopes are forested, with patches of dark green, while higher up, its rounded slopes are covered in heather, sphagnum moss and moor-grass. The mountain, whose underlying bedrock is essentially sandstone from the Silurian period, stands as a solitary mass between the Silvermine Mountains to its north and Slieve Felim range to the south. It stands alone from the rest and is climbed for its own sake.

The mountain in question is Keeper Hill (694m/2,277ft), or *Sliabh Coimeálta* in Irish, which means 'mountain of fosterage'. Old journals speak of a woman called Sadhbh, daughter of a king of Connacht in the third century, who married a Munster king, Oilioll Ólum. It was a marriage based on strategic alliances of the provinces. She bore two children, who were later spurned by their father, and so Sadhbh ended up fostering them on the slopes of Keeper Hill, lending the mountain its name.

I climbed Keeper Hill once from its west side, the same slopes in which Patrick Sarsfield and his cavalry of men camped in the late seventeenth century before intercepting and destroying a Williamite siege train along with its guns and ammunition at Ballyneety during the Jacobite War. Forestry tracks led east, higher up the mountain's ramparts. A green gully, decorated by a flow of several cascades, heather and scrub species lines its steep slopes. This short section of steepness amongst hawthorn, hazel and rowan proved immensely satisfying,

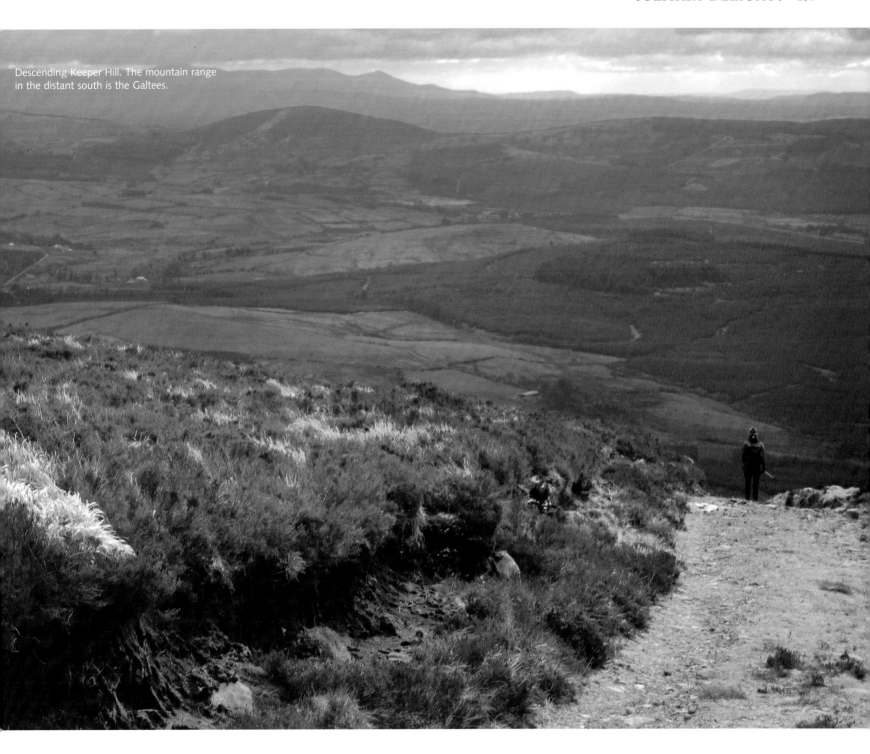

Descending Keeper Hill. The mountain range
in the distant south is the Galtees.

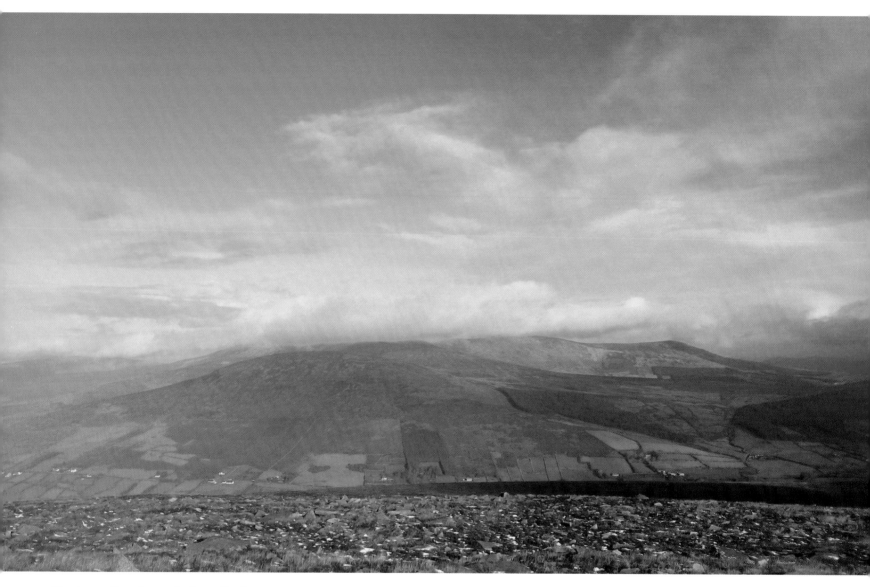

The view northward across Scullogue Gap from
Blackstairs Mountain to Knockroe and Mount Leinster,
whose uppermost heights are covered in cloud.

snaking continuously upward until reaching a comfortable track that led to its large summit cairn, trig point and TV mast. The summit felt strangely isolated from other distant mountain ranges, and lower green-brown hills encircled the landscape in all directions. The Silvermine Mountains dominated views to the north, where lead, zinc and silver were mined in the fourteenth century.

Scores of miles east of Keeper Hill, beyond the busy townlands of Thurles and Kilkenny, is a range marked as the Blackstairs Mountains on the map. Like Keeper Hill, two solitary mountains rise within this range, separated only by the narrow slit of Scullogue Gap. The more northerly of the two is Mount Leinster (795m/2,608ft), or *Stua Laighean*, the highest point in County Carlow and County Wexford. Its summit is the meeting point of four distinct spurs: from the south-west it rises amongst an array of boulders from Crannagh; from the south it sweeps upward from the red hill of Knockroe; from the east it passes a ruined stone cottage *en route* to the summit; from the north it is a trek on tarmac from the Nine Stones. The significance of these small aligned standing stones is somewhat vague. Some say it is a religious number symbolising the trinity of trinities, other traditions suggest it to be the resting place of nine slaughtered rebels, nine chieftains or nine shepherds lost on the mountain in a distant snowstorm.

Before 2010, snowstorms were a rare occurrence on this mild-mannered summit. However, the winter of 2010 was a different story altogether. The minor road leading to Ballycrystal under the mountain's eastern slopes became a deadly ice rink. The mountain itself was coated in a sea of snow; its fields and hillside resembled a true winter wonderland more akin to the Alps. The snow was soft and deep, just above my knees. A plume of cloud swirled over Mount Leinster's summit, teasingly bringing its iced-up TV mast into view and then swallowing it up again. Its summit has additional decorations of transmission buildings to accompany its hundred metre high TV mast, and like Keeper Hill, this isn't exactly the prettiest of sights. However, cast an eye away from metal and concrete, and the eye will see as far as Lugnaquillia in the Wicklow Mountains on a clear day. Closer at hand, Knockroe and the ridge of the Blackstairs ripple southwards. Interestingly, the summit cairn on Mount Leinster is an ancient burial site, dating back to the second century, when tradition decreed that kings who expired in battle were to be buried at the highest landmass in the area. And so it came to pass that Mount Leinster became known as 'the seat of the men of Leinster'.

I once brought a group up Blackstairs Mountain (735m/2,411ft), the granite mass rising south of Mount Leinster, on St Stephen's Day. The plan was for a short stroll tailored for a short winter's day, a there-and-back outing designed to burn off any leftover Christmas turkey and pudding. About half a kilometre south-west of Coonogue Crossroads, a signpost conveniently pointed the way up a stonewalled lane, almost a tunnel of sorts that led to open mountain. A paintbrush sky graced the view to the north, along with a patchwork of dark woodlands, bright fields and scattered white dwellings that adorned a wide valley below the ochre and russet slopes of Knockroe. The terrain became increasingly rocky as we ascended higher, granite boulders scattered around the slopes and patches of white snow splashed around the heather. The winter sun gleamed like a silver ball of fire from behind the summit of Blackstairs above, its dazzling rays beckoning us on like a portal to heaven. Or perhaps it was a sign to quicken the pace, as thick clouds soon gathered around its summit, eventually wrapping it in a grey pall. Mist descended when we reached the small summit cairn on an area of peat hags, and a stiff wind blew incessantly. There were some walkers on the summit; they had ascended from the southern side, passing Caher Roe's Den, an assemblage of granite tors that project like horses' teeth along its rocky spur.

The Den was an eighteenth-century refuge for a man from the O'Dempsey clan in County Laois who went by the alias of *Cathaoir na gCapall*. After his lands were confiscated by the Crown, he led a band of horse thieves who sold the haul at distant country fairs. Unfortunately for him, he was eventually caught and hanged in 1735.

Next, our journey of solitary summits sees us travelling inland, passing the busy towns of Carrick-on-Suir and Clonmel by the River Suir. A triangle, whose two base corners connect these towns, would have its apex fall roughly on the summit of a broad solitary dome called Slievenamon (721m/2,365ft). When viewed at eventide from the distant plains in the east, its dark outline looks strangely like a reclining pregnant woman against the setting sun. Perhaps that is why the mountain has strong associations with the female gender, for its Irish equivalent *Sliabh na mBan*, means 'mountain of the women', and its western plains stretching between Cashel and Clonmel are termed *Magh Femhen* meaning 'plains of fertility' or 'feminine plains'. Tales from the mythical Fianna cycle speak of a great race up its green slopes, a race where hundreds of female feet would gallop up to the summit. This was all done for Fionn MacCumhaill's benefit of course, who had countless lady admirers. Whoever reached the summit first would have Fionn as her prize. But Fionn only had eyes for one – the High King's fair daughter Gráinne. So Fionn showed Gráinne a deviously cunning way up the mountain and she won. Sadly, Gráinne later eloped with a younger hunter, Diarmuid whose brutal demise on Benbulbin is depicted in the chapter *Yeats Country and Cuilcagh*.

I recently climbed Slievenamon in midwinter. A broad track runs up the mountain from a signpost just north of Kilcash. It's a popular route during warmer conditions, so in terms of solitude, a dawn start in midwinter fitted the bill for me. A lane led up to a gate, then a stone wall by some trees, behind which stood a wooden cross commemorating a pilgrimage up the mountain's slopes in 2000. A stone armchair labelled as 'The Memory Seat' sat in front of the wall, and understandably so, as the

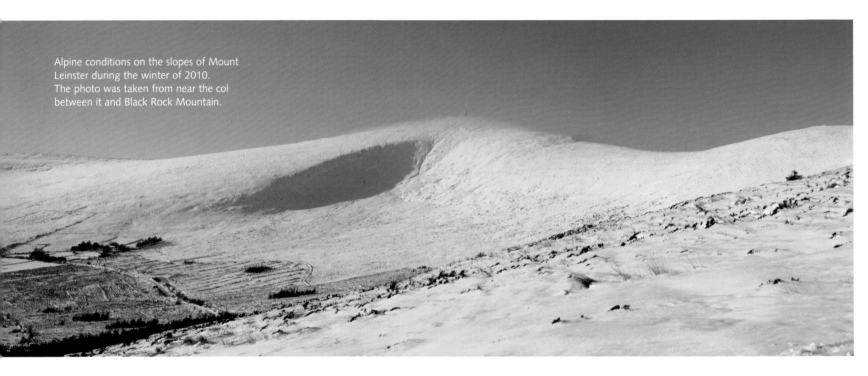

Alpine conditions on the slopes of Mount Leinster during the winter of 2010. The photo was taken from near the col between it and Black Rock Mountain.

view of mountains and plains of the Suir valley to the south is sweetly expansive. These views get better and better higher up the wide stony track which climbs at a rather gentle angle, and never drifting far from a nearby forest. Slievenamon's slopes were once richly endowed with a dense green forest, but these trees are long since gone. The new forest now ends halfway up the mountain's slope, and the terrain becomes increasingly heathery and stony the rest of the way to the summit. However, on that day, walking around the summit area was like stepping into another world altogether: the heather was frozen with brittle ice, pockets of snow splashed everywhere, and the rocks were laced with verglas.

Legend has it that the highest cairn on Slievenamon is a gateway to a *Sídh*, a mysterious Celtic underworld and a collection of stories ranging from fairy lords, fairy musicians to sightings of fairy-troops have been handed down the generations. The 'fairy factor' was to meet a harrowing climax in 1895, when a woman by the name of Bridget Cleary, who lived in Slievenamon's foothills, was torched to death by her husband when he believed she was possessed by a fairy. Her charred body was later found in a shallow grave. The Royal Irish Constabulary arrested a group of men, including her husband, Michael. He was found guilty of manslaughter and imprisoned. Michael Cleary fled to Canada after his release in 1910, but the legend survives in a Tipperary children's rhyme:

Are you a witch or are you a fairy,
Or are you the wife of Michael Cleary?

So was it a fairy scare or a bitter marital conflict, who am I to judge? There were no fairies or mystical vortexes that day but my senses were caught by surprise as a glider suddenly hovered over the crest of the summit. Three walkers took turns to wander up the icy rock pile that marked its summit cairn. The horizon behind it was an icy blue and a pale orange. I walked toward a standing stone, and gazed at the weak winter sun, its cream rays illuminating the upper recesses of an otherwise pale-violet sky. A wave of clouds veiled the mountaintops beyond in a shroud: these are mountains of Old Red Sandstone strata that projected upwards millions of years ago to form the ridges of the south-east.

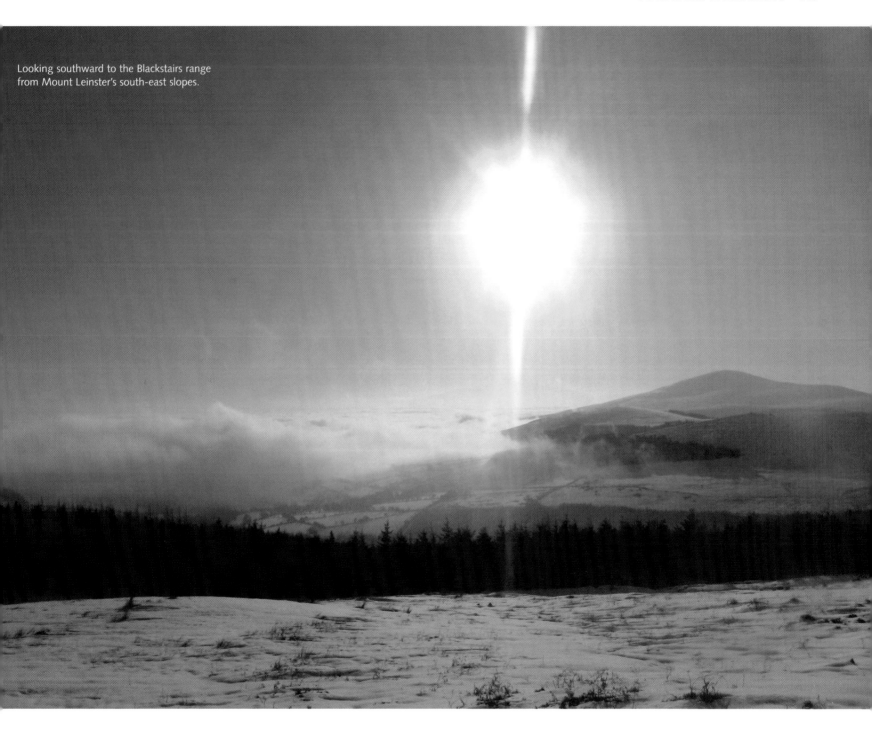

Looking southward to the Blackstairs range from Mount Leinster's south-east slopes.

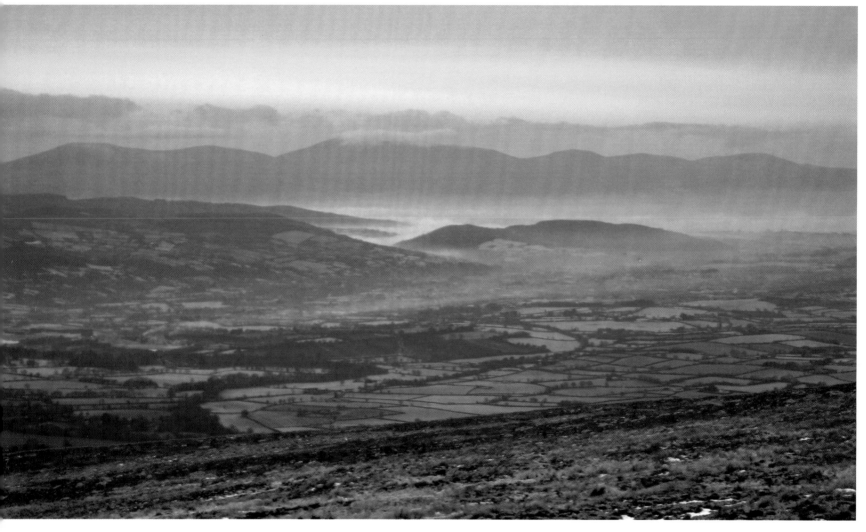

Looking across the Suir Valley to the
Knockmealdown Mountains from the
summit slopes of Slievenamon.

Opposite A magical winter morning Slievenamon's
summit plateau. The view southwards from a
standing stone with the Comeragh Mountains
shrouded in cloud in the distance.

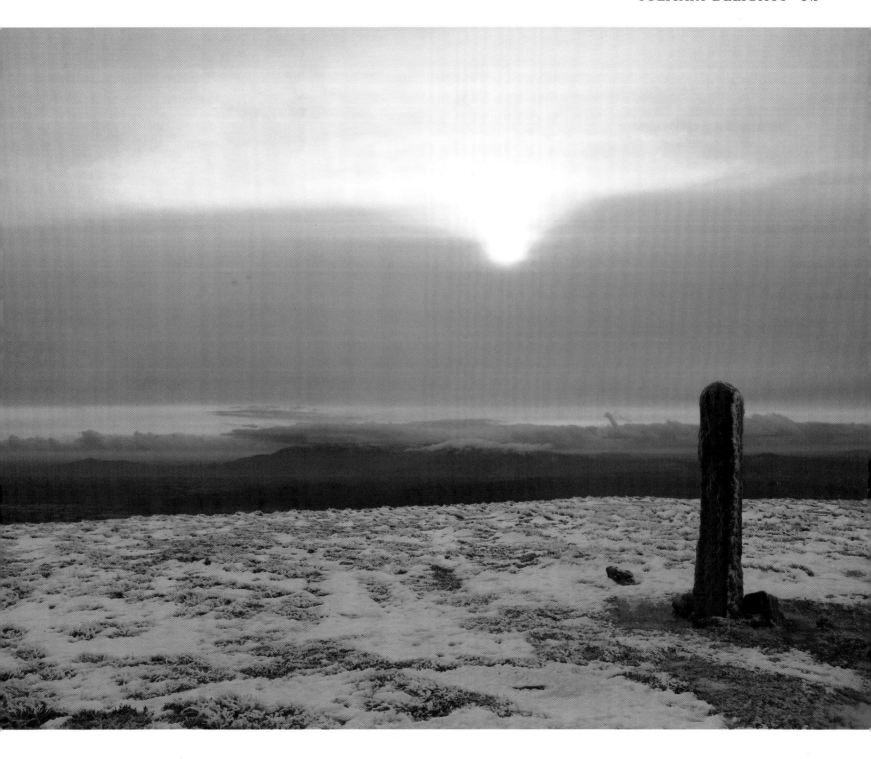

RIDGES OF THE SOUTH-EAST

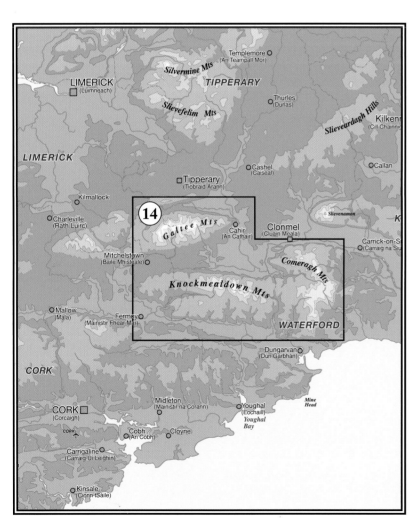

There is much comfort in high hills,
and a great easing of the heart.
We look upon them, and our nature fills
with loftier images from their life apart.
They set our feet on curves of freedom, bent
to snap the circles of our discontent.

Geoffrey Winthrop Young

A beehive monument stands on a green patch below the northern slopes of Sugarloaf Hill in County Tipperary. A man called Samuel Grubb is buried here. In the autumn of 1921, a coffin with his remains was carted to the foot of the mountain from his nearby residence at Castlegrace and then carried on the shoulders of men to the mountainside. If Grubb could see beyond the grave he would be in view of paradise, for a fertile green vale of pasture and forest, as wide as a thousand plains, spreads out before him. A line of commanding mountains soar beyond the valley, brown on most days of the year, but white as pearls in the depths of winter. A series of road-bends wind up the valley, above conifers and mature beech trees, and it is a common sight to see vehicles stopped and people alighting to admire the view, for it is a panorama both distinctively charming and moving at the same time.

This road, known as the Vee Road, was built as part of the poor law relief scheme after the Great Famine of 1847, and the carboniferous limestone valley it overlooks is also known as the Vee. An arm of mountains, thrust up into empty space millions of years ago during the Armorican Uplift, surrounds this valley in a wide semicircular arc. These mountain ranges are known as the Galtees, Comeraghs and Knockmealdowns. They form ridges, both wide and narrow, of old red sandstone and conglomerates, and are pillars of pride in the south-east.

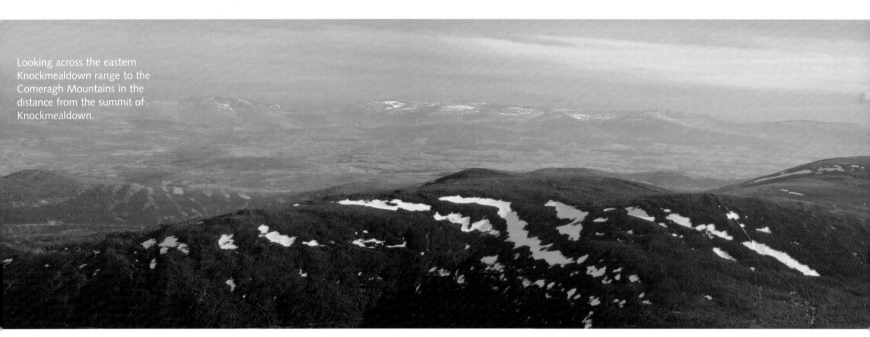

Looking across the eastern Knockmealdown range to the Comeragh Mountains in the distance from the summit of Knockmealdown.

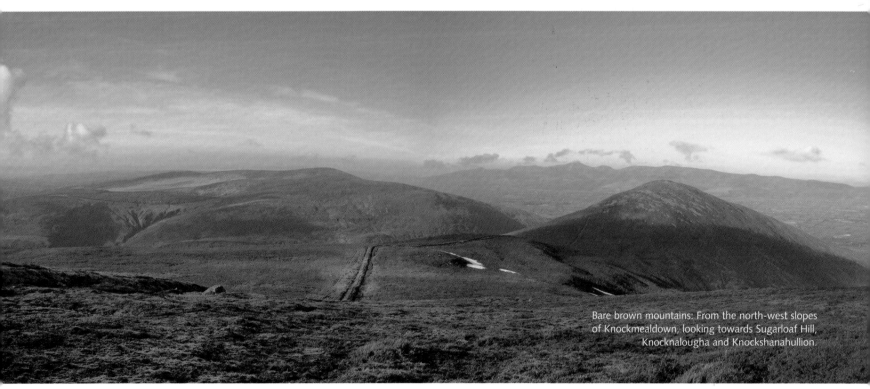

Bare brown mountains: From the north-west slopes of Knockmealdown, looking towards Sugarloaf Hill, Knocknalougha and Knockshanahullion.

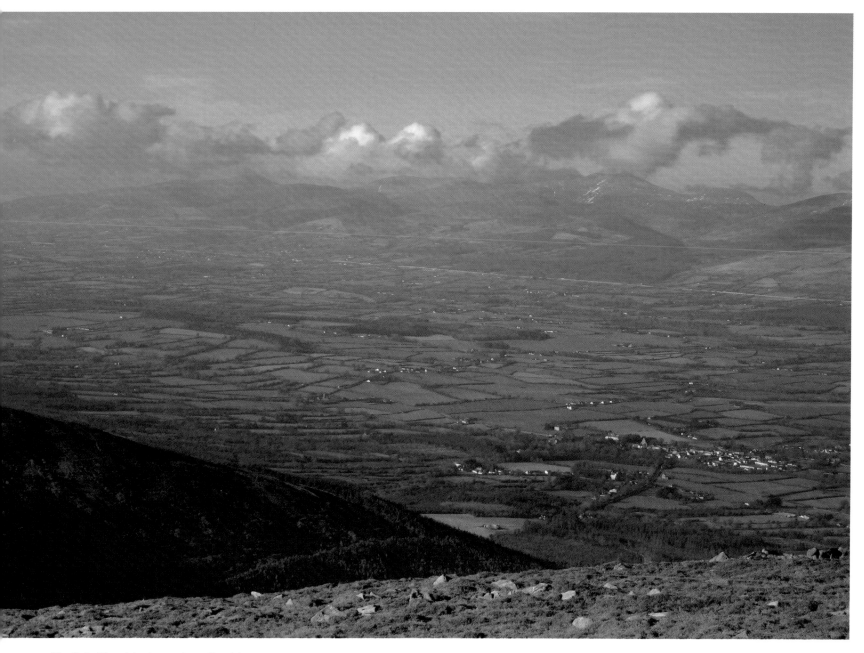

The Galty Mountains tower above the plains in the distance, as viewed from the summit slopes of Sugarloaf Hill.

Opposite The royal view of Galtybeg (left) and Galtymore (right) from the summit of Knockastakeen.

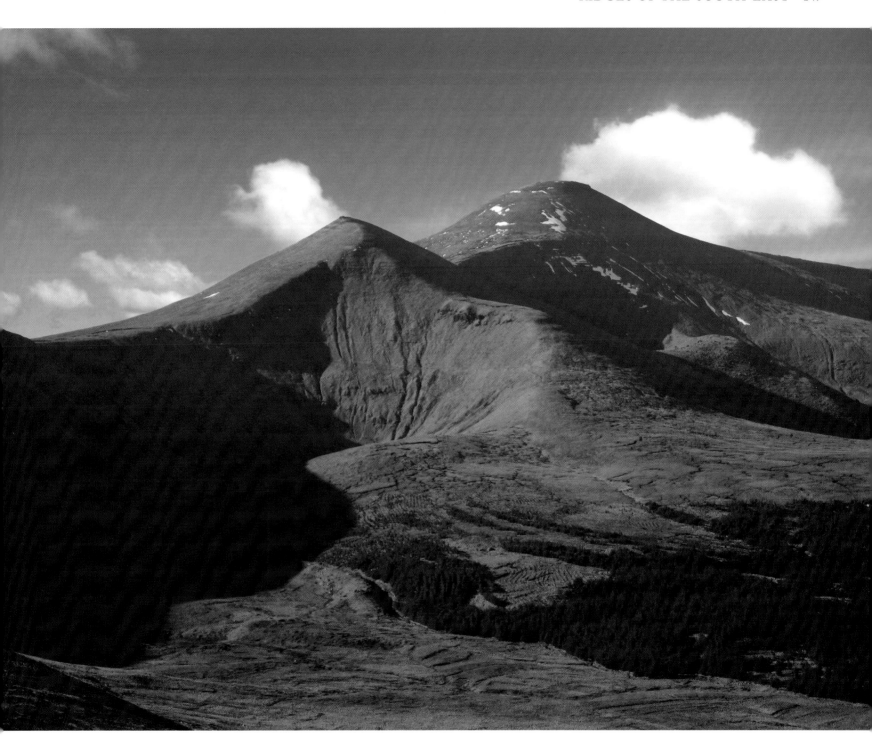

I've driven up the Vee Road several times, always to access the east-west aligned mountain range that flows above it from a place called The Gap. Once in January, the skies were blue and the air was as fresh as that of the Swiss Alps. It was a day made for mountains. I left my car in the safe hands of the Lady of the Grotto which overlooked the place and walked past Bianconi's stone hut. In a time before railways, Carlo 'Charles' Bianconi, an Italian emigrant, amassed a fortune in horse-drawn carriage services on countrywide routes for nearly forty years after 1815. This hut was one of the stage-posts for his horses. A tale of sadness is also connected to this area; a single-engine four-seater plane flying from Cork to Dublin crashed near here in the summer of 1987, on the slopes of Knockacomortish, killing the pilot, his fiancée, her father and her brother, all Dutch tourists, when the plane took a wrong turn in mist and thick fog. A lonely memorial stands by the road today as a stark reminder.

At Glentanagree Bridge, beyond a splash of rhododendrons, the open mountain welcomed me. I wandered up mossy slopes of short bracken and ling heather, beaten back by the winter, leaving only the rich flora of lichens, tiny red devil's matchsticks, to grace the floor. The New Year snows have come and gone; now all but some white crusty patches remain on the bare brown mountain. I stood at the conglomerated trig point on Knockmealdown (794m/2,605ft), the hill of Mhaoldomhnaigh, the highest point in County Waterford. The summit is in the centre of things, for a ridge extends west and east from its heights, dipping and rising like gentle overtures. A pair of ravens soared in the sky, looping around each other in a joyous cavort. If I too had wings I would soar from Knockmealdown toward the distant Comeragh Mountains, Slievenamon, then the Galty Mountains, and come back full circle. But today I had to be content with tracing these distant peaks with my eye, for the clarity of day knew no boundaries.

The only boundary that marked the day was a dry-stone embankment wall dividing the counties of Waterford and Tipperary. Echoes of the past reverberate in my mind as I walk along this wall toward the twin summit cairns of Sugarloaf Hill (663m/2,175ft). East of this conical hill, across several valleys, under the northern slopes of Crohan West (521m/1,709ft) stands an 18m/60ft round tower topped by a cross. It is a monument dedicated to a General who in April 1923 was shot by his former comrades where this tower today stands. His last words were, 'I'm Liam Lynch, get me a priest and a doctor, I'm dying.' Liam Lynch was a man with a fierce passion for Irish history. The events he witnessed one fateful morning in May 1916 at Fermoy Bridge, when armed police arrested and shot members of a local family, was to change his life forever. Twelve years after his death, as many as 15,000 people gathered, as his memorial was unveiled, to honour the man who once fought bravely in the Irish War of Independence.

Echoes of history resonate strongly in these parts. North of the Knockmealdowns is the town of Cahir. Just beyond it, I take a left turn onto a lonely road at Glebe,

westward bound, heading deeper into a secluded valley. It is early morning and the countryside is still asleep. As I drive through the quiet valley, known as the Glen of Aherlow, I am drawn toward its colourful past and reminded of an era of historians, poets, outlaws, rebels and saints. Names like Geoffrey Keating, historian, poet and clergyman, famous for his book *Foras Feasa ar Eirinn*, a historical account of Ireland; Patrick Weston Joyce, a historian noted for his passion for Irish place names; Eamonn a'Chnoic, a seventeenth-century Robin Hood type figure; Galloping Hogan, a brigand who fought in the Jacobite War; St Berrihert and St Pecaun, eighth-century monks who founded hermitages and lived in isolation all spring to mind. The River Aherlow twists and turns to the north, just like the ridge of mountains that extends for some 25km/15miles on its southern fringe. These are the Galty Mountains, whose peaks rise and fall like notes of an arpeggio, and were known at one time as *Sliabh Crotta Cliach* or the 'mountains of the harps of Cliach', for tales of old speak of a legendary harpist by the name of Cliach who serenaded alone with two harps in these mountains to win the hand of a *Sídh* lord's daughter that lived on Slievenamon. Interestingly, long before the story of the harpist, there existed the *Eóganacht Airthir Cliach*, a branch of the ruling fifth-century dynasty of Munster, who took their name from *Cliú*, which was a territory in parts of Tipperary. And *Crotta*, or *Cruit*, can also mean 'hump of a hill', which implies then that *Crotta Cliach* means 'Cliach, place of humped hills'.

The small village of Rossadrehid, in the heart of the Glen of Aherlow, marks the midway point to my destination, a quiet parking space south of Clydagh Bridge. From here, the Galty Mountains look elegant, projecting steeply skyward. One mountain towers higher than any of the other summits in the area. Her name is Galtymore, the queen of the Galtees that bears the accolade of being Ireland's highest inland peak, rising above the plains to 919m/3,015ft. Seen from the south, its gentle slopes create little impression. However, when viewed from any other direction it stirs the imagination. From the distant green hill of Farbreaga (724m/2,375ft) in the east, it protrudes behind its smaller neighbour, Galtybeg (799m/2,621ft) like a nunatak, especially during winter snows. From a clump of conglomerate boulders on the little stack of Knockastakeen (583m/1,913ft) to the north, the twin peaks of Galtymore and Galtybeg is a noble sight, with streams tumbling down the northern slopes in the shape of harp strings. Closer still from the west, from the edge of the plateau near Slievecushnabinnia (766m/2,513ft), Galtymore stands regal like an overturned ark above the blue waters of Lough Curra, with lines of scree plunging down its steep green slopes.

I stood at this point once in winter, when the upper half of the ark was suffused with a radiant glow of white snow while its lower half appeared mysterious and menacing, as if it hid a dark secret in the sheltered north face of the mountain. It was then that the Galtees looked like a scene from the Ice Age; its top packed

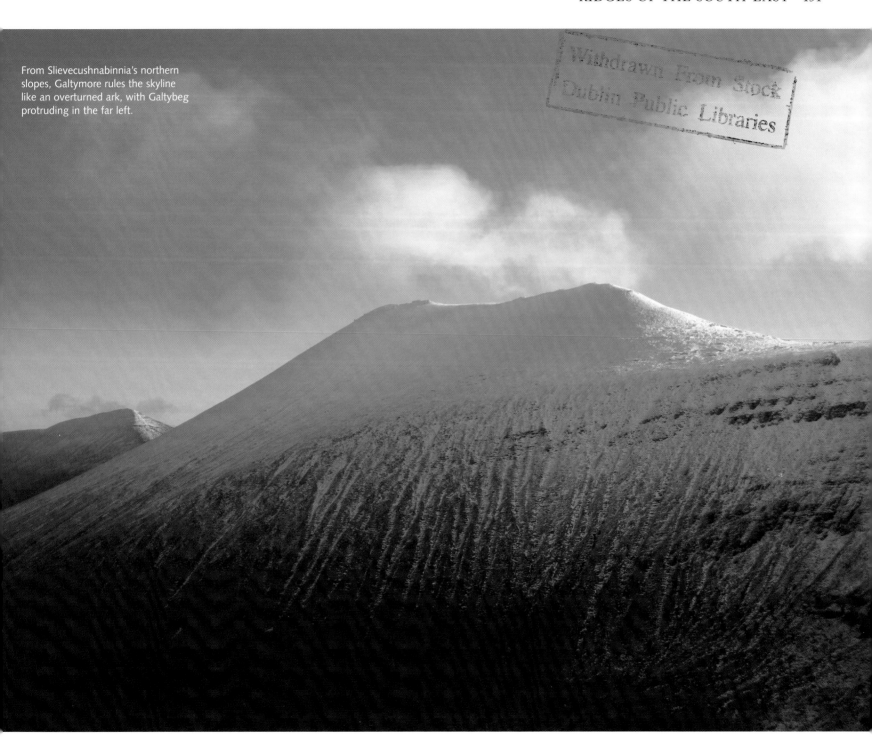

From Slievecushnabinnia's northern slopes, Galtymore rules the skyline like an overturned ark, with Galtybeg protruding in the far left.

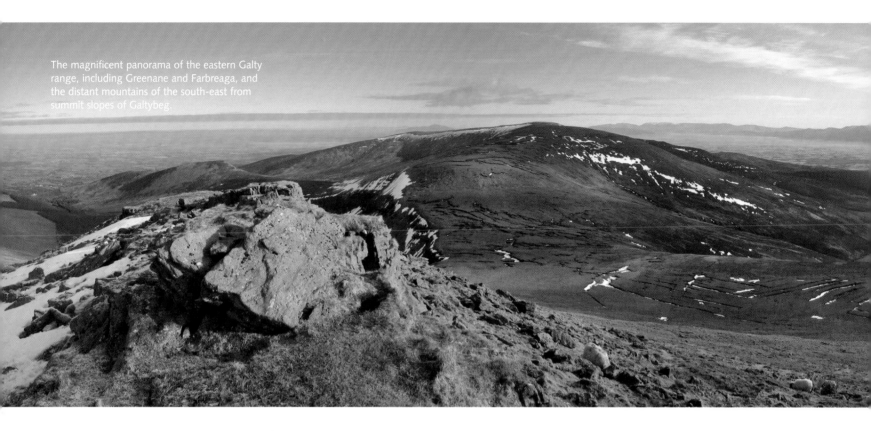

The magnificent panorama of the eastern Galty range, including Greenane and Farbreaga, and the distant mountains of the south-east from summit slopes of Galtybeg.

with knee-deep snow, the stone wall that runs along it laced with ice, and needle-shaped icicles hanging down the edges of dark peat hags. But today the snows have melted, and only patches remain. A symphony of meltwater rumbles down the Clydagh River, and the skies are filled with a harmony of birdsong. I meander uphill along a stony track accompanied by rows of conifers and gorse bushes. Some stones over a fence leads to mountain slopes decorated with compact rush and yellow-green moss. Lovely cascades tumble down a stream, enriching the crisp mountain air with its soothing melody. The morning sun hits the flanks of Cush (639m/2,096ft) and lights it up in a flurry of lime and saffron. The northern slopes leading up to Galtybeg are steep, but at least it catches the sun, unlike the cold shadowed corrie below it. I ascend into a paintbrush sky; blue, cyan and streaks of white and grey. Galtybeg and Galtymore are reminiscent of a camel's hump from high on the ridge, its steeper northern side streaked with snow like zebra's stripes, whereas its gentler southern slopes are virtually void of any.

As I near the summit of Galtymore, a certain smell of dampness fills the air, the wind picks up and grey clouds swarm like bees in the sky. A squat pile of rough conglomerate boulders rest on the summit ridge, arranged at every conceivable angle. The white steel cross on the summit comes into view, sitting on an outcrop of rock and guarding the plains of Tipperary. There was once a time when no cross existed on the summit, but only two small stone cairns. Then, over a period between 1933 and 1962, as many as three separate crosses were placed on the summit area, made out of iron, timber and limestone respectively. The limestone cross of 1962 weighed about three quarters of a ton, and was transported up in an armoured tracked vehicle called 'The Katie Daley' to about 20m/66ft below the summit, then carried the rest of way by five Samsonian men. Over a thousand graced the summit for the unveiling ceremony. One newspaper even reported then that, 'the mountain was black with people' ranging from local communities, mountaineering clubs and as far abroad as America, including authors and historians of the time.

All three crosses eventually fell, damaged beyond repair during violent winter storms. Today's cross on the summit, erected in 1975, is Celtic in design, over 2m/7ft in height and built by a local man, Ted Kavanagh, who climbed Galtymore

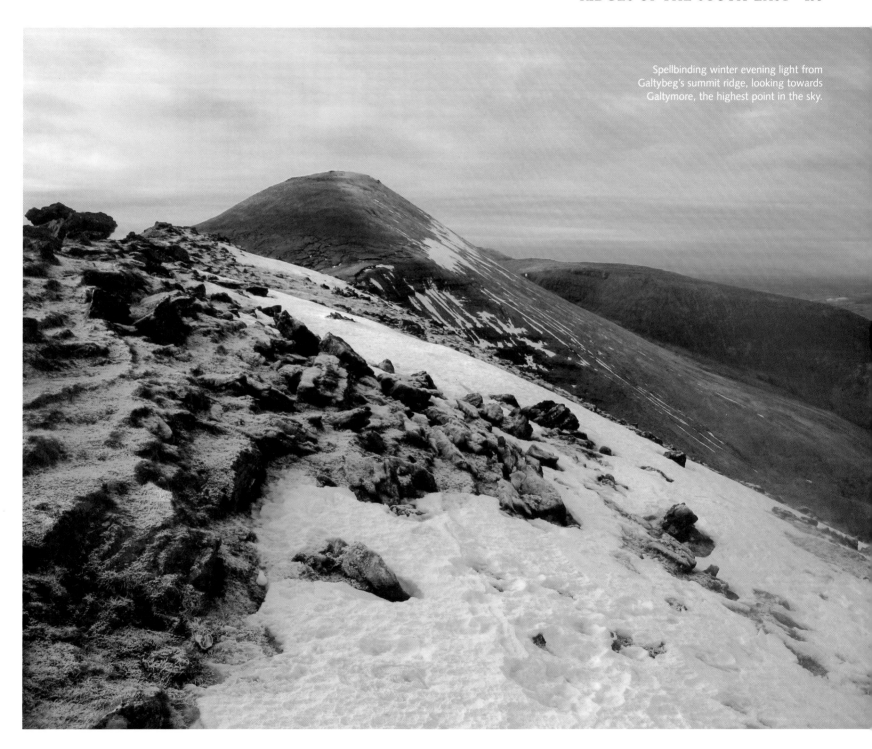

Spellbinding winter evening light from Galtybeg's summit ridge, looking towards Galtymore, the highest point in the sky.

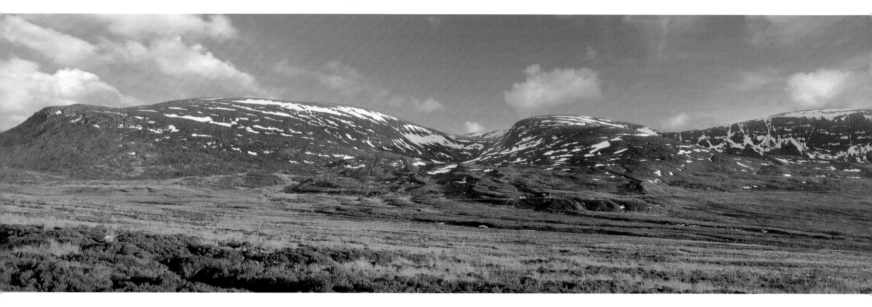

The southern end of the Comeragh
Mountains bathed in late winter sunshine, as
seen from near the Gap.

Looking across the Nire and Suir valley to a
beautiful sunset over the Galty Mountains
from near the Gap in the Comeraghs.

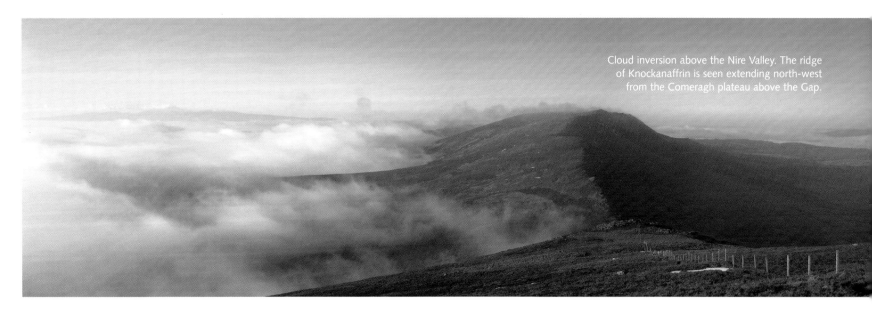

Cloud inversion above the Nire Valley. The ridge of Knockanaffrin is seen extending north-west from the Comeragh plateau above the Gap.

annually with his wife Joan to paint it until Ted's death in 1998. Since then, Jimmy Barry, a senior member of the South Eastern Mountain Rescue Association (SEMRA), has continued in that tradition, in respectful memory of Ted and Joan, who herself passed away ten years after her husband. Joan Kavanagh was an inspiration to Jimmy and many other local folk who lived at the base of the mountain. Described by Jimmy as, 'a kind lady with a warm welcome for everyone', Joan was loved by all. Small in stature, soft-spoken and unassuming, she was always in her element when talking about the Galtees. Her passion for these mountains was passed on in some shape or form to everyone who knew her. She didn't hold or break records in mountaineering terms, but as a person who loved these mountains, Joan was extremely giving; she was even in the search party that found a single-engine plane that crashed in these parts in 1976. So for Jimmy in particular, who knew her well, the steel structure is not just a cross on a mountain anymore – to him it is memories of laughter, sorrow, cups of tea and friendship. Today, Joan's spirit forever remains on Galtymore, for underneath a modest pile of stones near the summit area, she painted her own tiny cross.

The conglomerate boulders on Galtymore remind me of the rough grey outcrops of the same rock type on Knockanaffrin (755m/2,477ft), a serrated crest deep in the Comeragh Mountains, a sprawling range that rises due east of the Galtees and high above the honey meadow of Clonmel. The ridge falls steeply from Knockanaffrin's summit, forever south-east, over rock and heather, to a high pass known as the Gap. A track runs over the pass; from the green Nire Valley it rises eastward, following painted white posts and a blaze of pink heather to eventually meet the Gap. One winter in January, I wandered alone along this track, my mind set on higher places, distracted only by peculiar blasts of miniature dust devils whipping around me. I thought of those locals from days past, who carted their dead along here from the valley below, over the Gap, then east to be buried at Rathgormuck village.

At the Gap, I left the track of *Bóthar na Socraidhe*, the 'road of funeral processions' to ascend a steep slope. It was cold. Meltwater tumbled down and a pair of ravens croaked above. I spotted a clump of St Patrick's Cabbage, its coarse-toothed, spoon-shaped leaves sprouting like an explosion of small stars from dark rock crevices. Higher still, on a broad stony plateau, the warmth of the winter sun was welcoming. A sea of cotton cloud enveloped the valley and towns below. But I was above the clouds, staring down at this heavenly inversion. A line of grey-blue peaks punched through the blanket of cloud in the distance. I continued to walk south-east, leaving one ethereal world only to enter another. On the edge of the Comeragh plateau, I reached the well at world's end, for a deep wide hollow stopped me in my tracks. Through drifting clouds, I cast my eye on moonscape lakes below and craggy cliff walls above, the darkness punctuated only by Icelandic patterns of snow. I stared down at the alluring coum.

fifteen

CHARMED BY COUMS

My own lake of lakes,
My lone lake of lakes,
When the young blushing day
Beside you awakes,
The cold hoary mist
To gold glory kissed
Lifts laughing away
O'er your cool amethyst.

Alfred Perceval Graves

I sat at the edge of the Comeragh plateau as a gentle breeze blew against the purple moor-grass, my eyes fixed not on the hill of Slievenamon that protruded from a white blanket of clouds in the distant north, nor on that of shapely brownish-blue projections of Knockanaffrin to the far left, or of the rolling green pasturelands that swept the plains in between. Instead, I stared down at a deep hollow, whose steep sides rise like mighty skyscrapers, curving once in a wide semicircular arc, and then again. Patches of snow covered its precipitous dark slopes. Stygian shadows haunt the hollow's rugged bottom, where three lakes lie trapped in a cold cradle. These are the lonely lakes of Coum Iarthar, devoid of winter sunlight in the northern face of the Comeragh Mountains, and in this *coum*, echoes can sometimes be heard.

The word Comeragh comes from the Irish *Cumarach*, which means 'full of hollows', referring not to the desolate moorland plateau of its broad central table, but rather to the rim of this plateau, whose edges are adorned with a series of charming coums. When viewed from above, these bottomless hollows, many of which nestle lakes, are captivating to look at, or from the point of view of William Crotty, an ideal place to hide out. About a kilometre east of Coum Iarthar is an outcrop of conglomerate boulders that sits on an expansive perch where all the

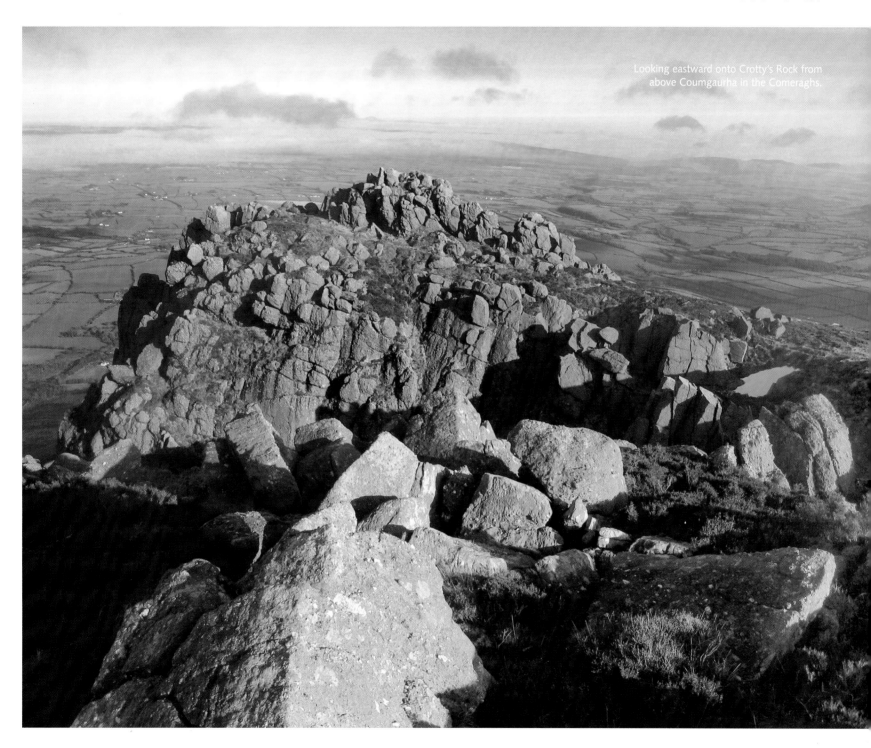

Looking eastward onto Crotty's Rock from above Coumgaurha in the Comeraghs.

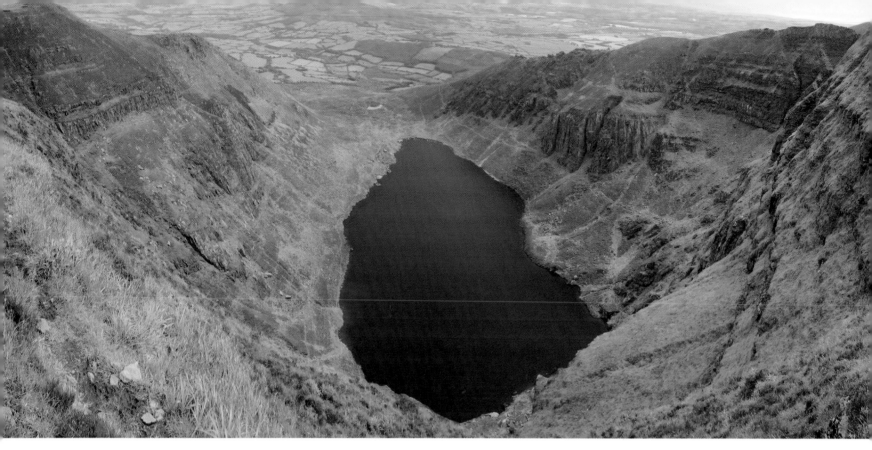

Looking down on Coumshingaun from the top
of the Comeragh plateau. It is a grand view;
there is nothing in Ireland quite like it.

Opposite from top
The lovely amphitheatre of Coummahon
from the south-east. The Mahon Falls can
be seen plunging in the distance.

The lakes of Coumalocha from Coumfea's
southern slopes, with Knockanaffrin rising
in the distance.

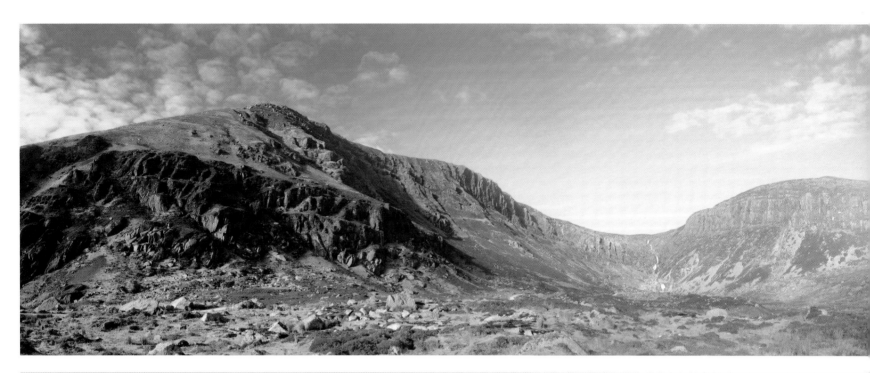

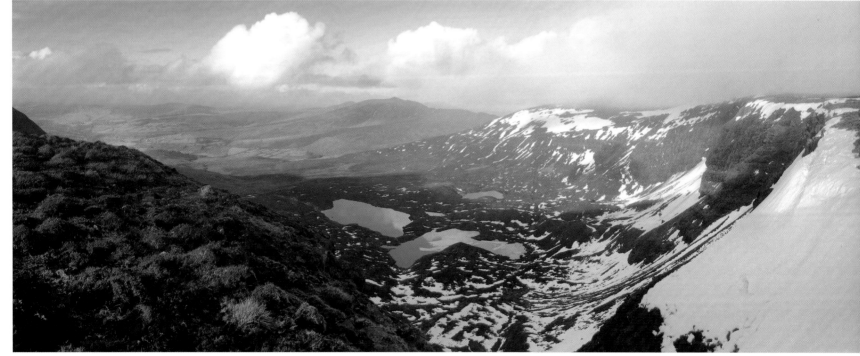

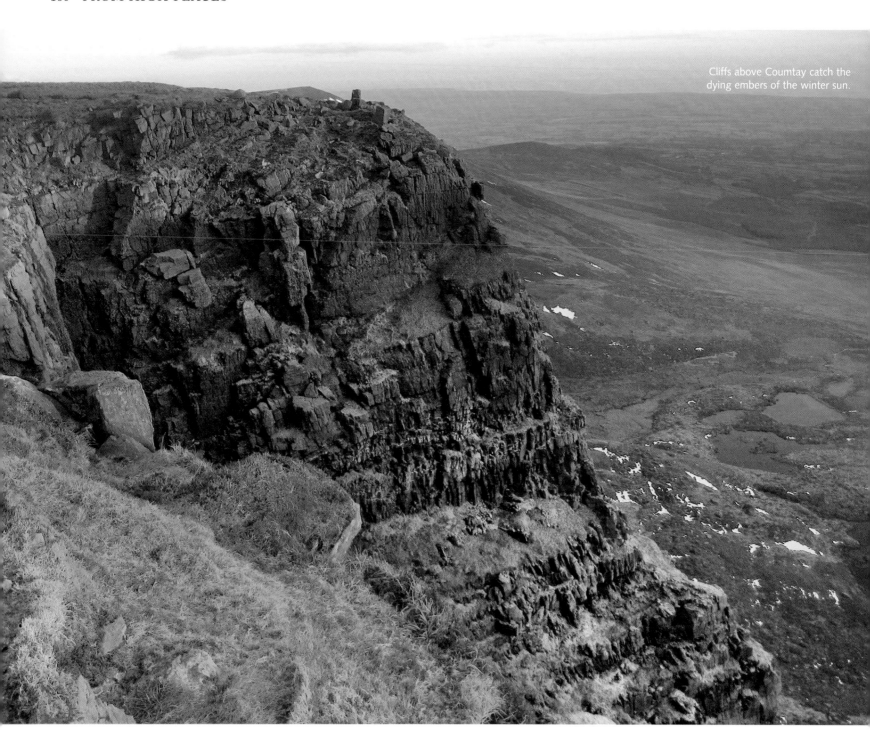

Cliffs above Coumtay catch the dying embers of the winter sun.

green plains of County Waterford can be seen. This was Crotty's lookout post in the eighteenth century; then it overlooked thickly wooded valleys. A cave above a remote lake at the bottom of a long vertiginous line of rocky crag below, accessible only by a rope, was his safe haven. The ancient name for the lake was Lough Coumgaurha, but today both lake and rock are better known after the legendary man himself. William Crotty was a wanted man, a leader of a gang of outlaws, a Robin Hood type figure of the Comeraghs who stole from the rich and gave to the poor. He eluded capture for years but was betrayed by one of his trusted companions, a man by the name of David Norris, and was arrested in 1742. Crotty met his fate at the end of a hangman's noose, was decapitated and his head displayed on a spike over the gates of a Waterford Gaol for all to see. A bounty was also issued against the outlaw's wife, who was intensely pursued, until a fateful hunt one day when she fled to the pinnacle of Crotty's Rock and tragically jumped off the cliff's edge.

The wife of William Crotty wrote a song to mourn her husband's death. One of the verses of the lament, passed down the generations, crudely translates to:

O'er Coumshingaun the dark clouds gather,
You'll sleep no more among the heather.
Through the Comeraghs hills the night winds are sighing,
Where oft you sent the Redcoats flying
Ochone, ochone, ochone, oh.

Local tales also speak of another cave called Crotty's Stable, south of Crotty's Rock, and somewhere under the cliffs of Coumshingaun. This cave was used to hide horses and cattle which his men captured during raids until they could be sold at a worthwhile fee. Coumshingaun is surrounded by sheer cliffs on three sides. The smaller, sunnier, south-facing cliffs appear less intimidating than its larger and steeper north-facing neighbour. But it is the cliffs that form the back headwall, sheer rock rising approximately 300m/984ft to the top of the Comeragh plateau, which impresses most. These cliffs are a climbing paradise to rock jocks, and there are at least sixty rock-climbing routes of various grades in the area. The first recorded rock-climb was back in 1952, when Frank Winder and Sean Rothery cracked a 130m/427ft line called the 'Ariel Route' high on the south-facing cliffs. Today, vertical routes like 'Emperor's Nose', 'Atom Ant Wall', 'Perpetual Motion', 'Sleep of Reason' and 'Talking God' would instantly appeal to any ambitious rock-climber visiting the area.

For the non rock-climber, an interesting proposition would be a horseshoe circuit, taking in its northern and southern ridges at the top of Coumshingaun's cliffs. Late one August, I approached the southern ridge from the dark-green conifers of Kilclooney Woods. It felt warm in the sweltering afternoon sunshine. A solitary blue tent was pitched by a watershed amongst grey boulders on the green valley floor. The ridge rose skyward, and narrowed with distance. A band of outcrops bristled like shark's fins across a section of the ridge, and I gladly scrambled over the rough grey rock, above a purple blaze of heather. Just beyond a grassy patch, I stood on the edge of a devilish gully, and peered down into its yawning abyss. A mild scramble up to the plateau followed, after which I stood above a colossal glaciated wonder.

From this vantage point, Coumshingaun leaves a deep impression. From these heights it deserves its name, 'the hollow of the ants'. It is a humbling sight, a Coliseum of the mountains and a grand arena that leaves one staring in reverent silence, for there is nothing in Ireland quite like it. A monstrous pear-shaped lake graces the bottom of the coum, its sheet of water stretching for almost a kilometre in length. I always struggle to leave this uplifting place. That day, as I walked toward the sparkling Iske Sullas stream, the 'water of light', to descend by the less demanding northern ridge, I once again took only memories away with me, but these memories last a lifetime.

Not all coums in the Comeragh Mountains house lakes. There is a broad glaciated valley south-west of Coumshingaun that is bordered by a band of rugged cliffs. A river, whose source tumbles down a series of rocky chutes on its north-west end, cuts through undulating terrain of bracken, heather, rushes and moss for over a kilometre until it meets a single tarmac road that runs high on the mountains slopes.

I arrived at the top of this road one bright and crisp January morning. Wispy cirrus clouds streaked the sky and Coummahon's cliffs unfolded like a stretched accordion into a wide amphitheatre, its main falls plunging as a milky ribbon to the back of it. I walked to the bottom of a cascade due east of the falls. A continuous white spray tumbled down a series of rock slabs from the plateau's heights. Keeping close to the spray, a delightful scramble over rough outcrops that poked out of sienna-brown heather clumps followed, until I arrived at the top of a plateau where a stunning panorama of the coum spread out before me. A higher valley, squelchy underfoot, undulates along a river. Stringy tea-green staghorn lichen scuppered the domination of moor-grass and ling heather in that lonely upper valley. I crossed some snow patches to a cliff edge above Sgilloge Loughs and looked down at broken sheets of grey ice that floated on the inky surface of two lakes that sat in its depths.

Massive snow-fields enveloped the plateau between Sgilloge and Coumalocha, the next coum to its south. Small white cornices formed on the plateau's edge, toward the leeward side of the mountain. I trudged carefully across the snow-fields as ravens soared over Coumalocha and its lakes, trapped below on the hummocky moraine. Moth-like patterns of encrusted snow layered the abyss below, whose

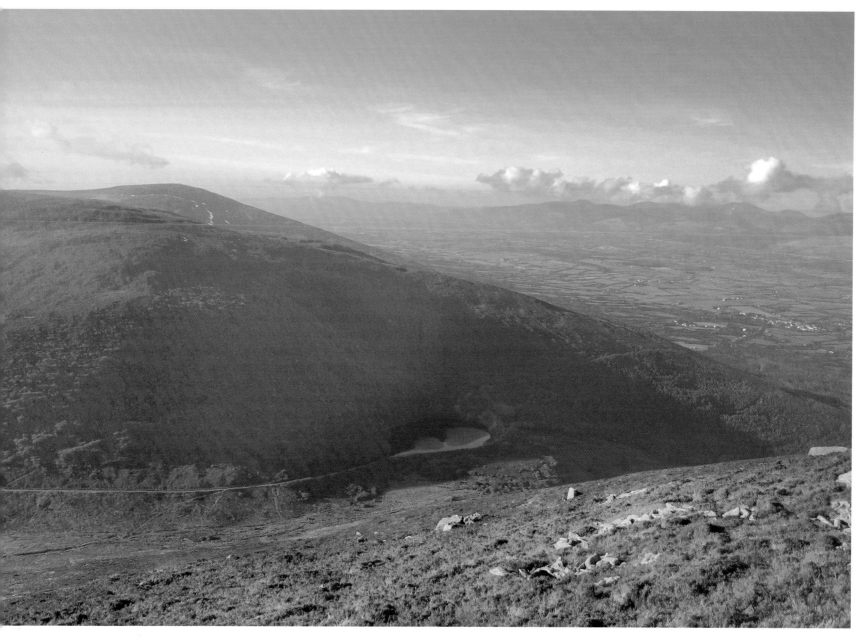

Bay Lough in the shadows of Knocknalougha's
north-east slopes, as seen from Sugarloaf Hill in
the Knockmealdowns.

Opposite Lough Curra, an impressive
corrie lake, seen below the green hill of
Slievecushnabinnia in the Galtees.

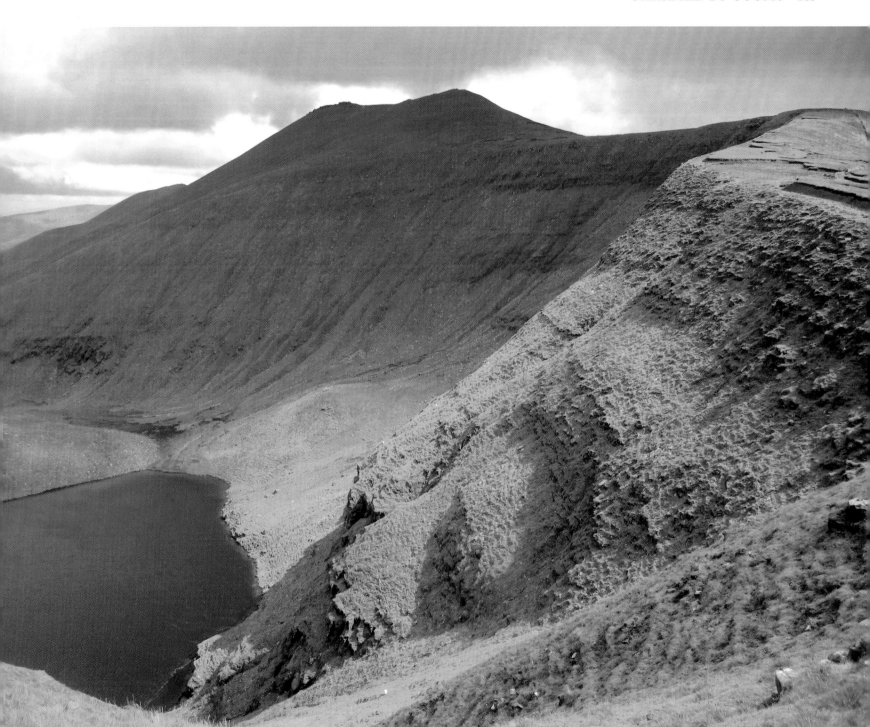

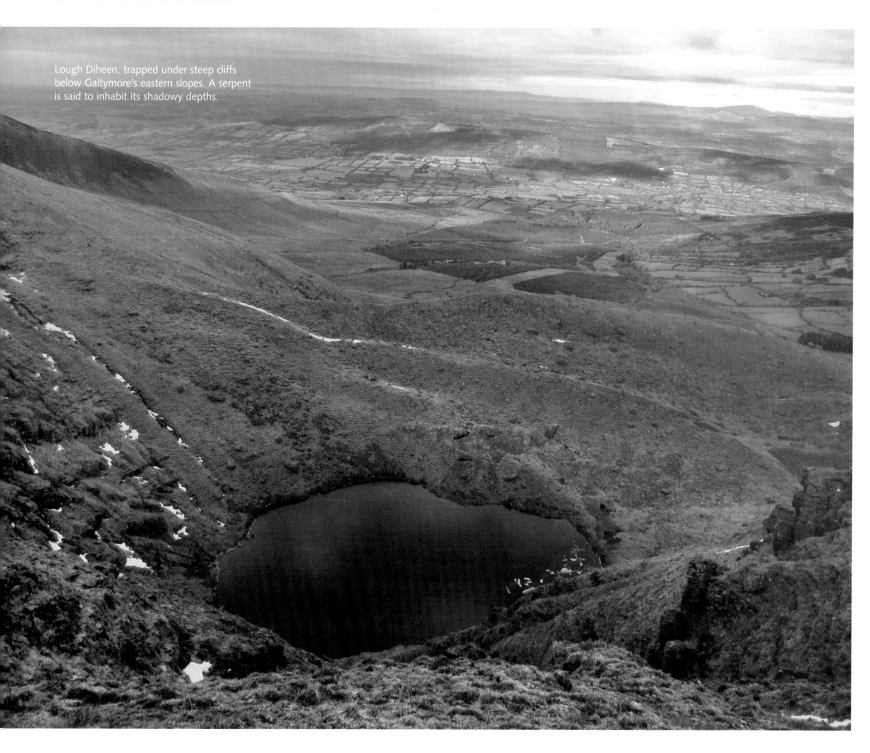

Lough Diheen, trapped under steep cliffs
below Galtymore's eastern slopes. A serpent
is said to inhabit its shadowy depths.

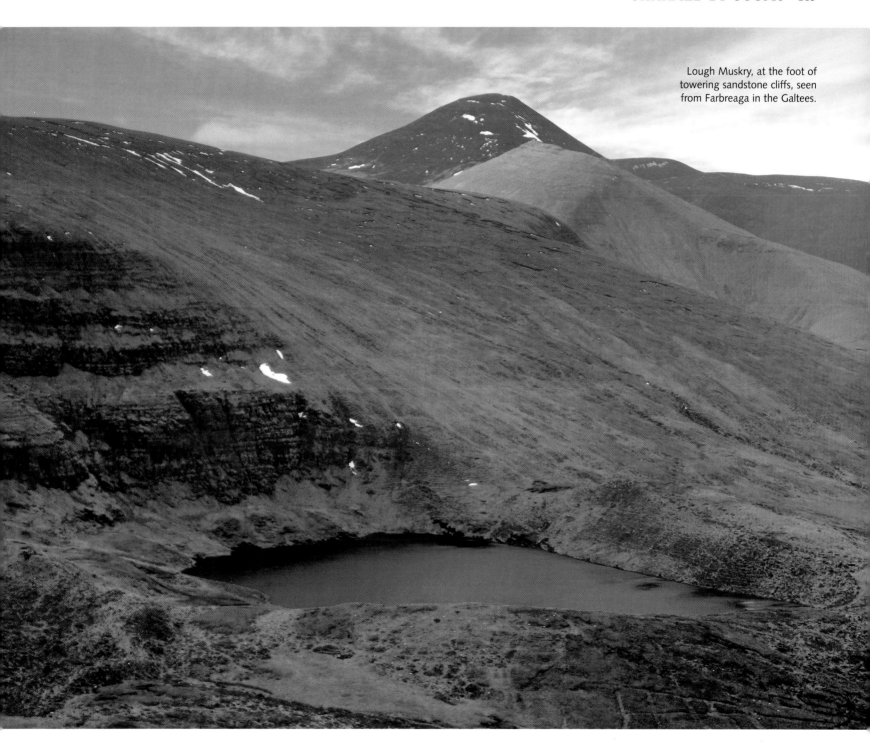

Lough Muskry, at the foot of towering sandstone cliffs, seen from Farbreaga in the Galtees.

sides were guarded by steep cliffs. I followed a wide curve on the edge of the plateau and over even more snow-fields to the top of Coumfea.

Here, legend speaks of a white mare that surfaced from the waters of the lake below. She was cared for by a local farmer who treated her like a queen, and in return she produced a fine foal for him annually. Late one evening, the tired farmer was returning home from afar with his beloved horse. Anxiety got the better of him as darkness fell, and he unknowingly lashed out at the animal. The mare whined, stomped one hoof into the ground and broke free from its harness. In the dimming light, the mare then summoned her foals and together they leapt off the top of the coum, never to be seen again.

As I wandered from Coumfea to Coumtay in the direction of a spur that pointed downhill toward my car, I reflected on coums in other mountain ranges of the south-east and how almost every one of them had a lake with a tale attached to it. These deep hollows must have captured the minds of past storytellers for them to fabricate such amusing tales around their charming depths.

In the Knockmealdowns, above the Vee, a seemingly bottomless lake of volcanic origin lies in the shadows of a splurge of wild rhododendrons. Bay Lough seldom catches sunlight in winter, and its cold recesses are said to be spooked by the ghost of a local woman called Mary Hannigan, who went by the name of Petticoat Loose, after her skirt buttons latched onto a nail during an evening of drink and merry dance, bursting the buttons open and resulting in her skirt dropping to the ground. She was a shady character; she was alleged to have bewitched another man to kill her husband. One night, after consuming half a gallon of beer for a bet, she mysteriously slumped dead. Her wraith was said to have haunted the dark country lanes and hillsides for years, until her evil spirit was exorcised by a priest who condemned Petticoat Loose to the harrowing depths of Bay Lough.

Such tales of banishment are also associated with lake-filled coums in the Galtee Mountains. Lough Curra, an impressive corrie lake below the green hill of Slievecushnabinnia, is said to be inhabited by a monster that was cast to its depths by St Berrihert in the nearby Glen of Aherlow. Farther east, trapped under steep cliffs below Galtymore's eastern slopes is the tub of Lough Diheen, an oval-shaped lake said to be terrorised by a serpent banished there by St Patrick, who put a *daibhcín* or pot over its head for eternity.

Farther eastward, still on the Galtee ridge is Lough Muskry, the largest of the Galtee lakes, an inky-blue glint splashed at the foot of towering vertical columns of sandstone cliffs. These cliffs grace the landscape like frowning faces and are separated by horizontal bands of steep green ledges. There was a time when Lough Muskry was known as *Lough Bel Sead* or the 'lake with the jewel mouth', and according to legend, an assemblage of 150 female birds, bound as pairs in silver chains, once adorned the lakeshore. One bird, Coerabar Boeth, stood out from the others, and she wore a golden-red necklace of 150 chains with a golden jewel dangled at the end of each chain. Legend suggests that these birds were actually beautiful young women who were transformed into their winged form every second year at the lake.

During one of my visits to these mountains, I walked across the mountain-tops above some of these lake-filled Galtee coums. It was then, while descending the slopes north of Slievecushnabinnia, below Knocknanuss, that I bumped into John and Una Hayes, experienced hill-walkers who have been hiking in the area for the last twenty-five years. We exchanged pleasantries and started chatting like most strangers do on Irish mountains. John is a towering figure, over six feet in height, in comparison to Una. During our conversation, I learnt that they, along with a party of four, all from the Galtee Walking Club, achieved the remarkable feat of walking along all five Galtee lakes, starting from the smaller lake behind Lough Muskry, then Lough Muskry itself, followed by teardrop-shaped Borheen Lough, the cold Lough Diheen and finally Lough Curra. But they did not just walk, they swam across each lake as they went. This is a serious undertaking but their adventure was planned, paying a great deal of attention to their safety, as they are all strong swimmers and John is a swimming coach. Impressed by this feat, I was curious to know what inspired them to plunge into those cold waters not once, but five times, so I asked John. 'The feeling of exhilaration was second to none', he replied, 'We were charmed by its setting.'

sixteen

UNDISCOVERED BEARA

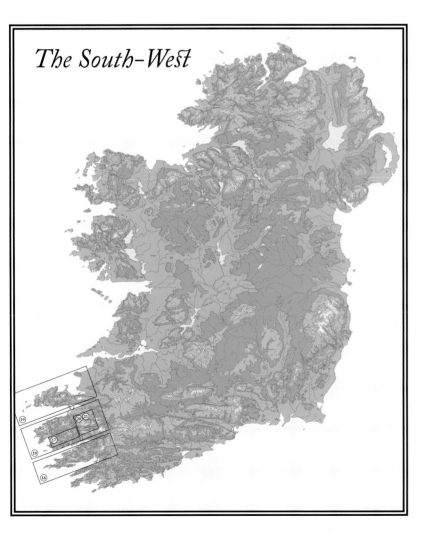

The South-West

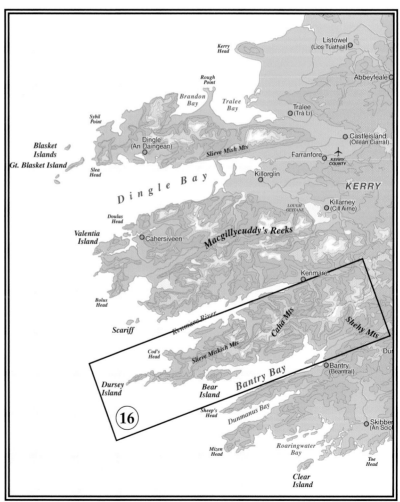

I stood on the edge of a large rock rib and looked across a remote lake at the 'angry' east face of Hungry Hill (685m/2,247ft) with a mind full of ancestral wonder. The face is a balking mass of leviathan proportions, rising as bare bands of sheer rock slabs rippling across its surface like the skin of a dinosaur, separated only by frighteningly steep ledges. It is like a scene from *The Lost World*, carved out millions of years ago, back when the old red sandstone bedrock was thrown up in tangled folds by tectonic forces, later sculpted by the masterly hand of glaciated ice. A dark, menacing gully rises for nearly a thousand feet from the western edge of Coomadayallig Lake, splitting the rock face into two brooding sections. On that clear day there was nothing between me and the blue sky above as the heat of the sun fused this vision of beauty into the frame of my bones. I stood in utter silence, feeling strangely envious of the mountain, struggling to find any words to express the indefinable quality of Hungry Hill's lonely spot.

They say these mountains, tucked along the quiet Beara Peninsula in the far south-west corner of Ireland, have been named after the seven deadly sins, which probably justified my tinge of envy on Hungry Hill. The pointed peninsula, narrower at its end and wider inland, is wedged between the Kenmare River, which is actually more like a bay, to the north and Bantry Bay to its south. Three rings of ribbon-like road weave along quiet villages and follow an intricately indented coastline, linking these corners by cutting its way through undisturbed valleys and mountain passes. A broad spine of sandstone mountains, gripping even from the road, adds to the complexity of the landscape. The mountain range extends its wings everywhere along the peninsula except for its fringes, rising as the Slieve Miskish from the abandoned copper mines and cliff fields of Allihies at its western tip to the trackless wilderness of the Caha Mountains farther inland. The eastern end of this peninsula is linked by a windy road connecting the little nest of Kenmare and the rough glen of Glengarriff via a series of tunnels. From here, the high ground extends farther eastward, away from the peninsula, to the brown moorlands of the Shehy Mountains.

A dense oak forest once covered the wooded slopes of Derrynafulla at Coomerkane, west of Glengarriff. It was here in the winter of 1602, where a battle of wits ensued between the ruling O'Sullivan Beare clan and an army of Elizabeth I, led by Sir Charles Wilmot. But at the end of the battle, having lost their herd of thousands of cattle and sheep, and their horses stolen and crops set ablaze, chieftain Donal O'Sullivan had no option but to flee the land he ruled for five centuries. On a bitterly cold midwinter, O'Sullivan, or *Donal Cam* as he used to be called, set off on a journey of epic proportions from Derrynafulla woods with a crowd of over a thousand men, women, children, along with servants, porters and 400 soldiers. It proved to be a tragic journey, one tormented by enemy attacks, terrain harshness and weather trappings; as fifteen days later only as few as thirty-four weary men and one woman arrived at Leitrim Castle, hundreds of kilometres away, to safety.

During the years before the attacks of the forces of Elizabeth I, Donal Cam resided at his fortress at Dunboy Castle, almost 36km/22miles west of Glengarriff. An old mountain track existed from Dunboy to Glengarriff in the sixteenth century, and Donal Cam and his men would have used this route to move cattle to Coomerkane at that time. Today, this route is part of the Beara Way, a long-distance way-marked trail around the peninsula. Along the length from Glengarriff toward Dunboy, the Beara Way passes south of the summits of Maulin (621m/2,037ft) and Knocknagree (586m/1,923ft) along an isolated valley, near a place marked on the map as Ballard Commons. Here, a signpost on a lonely mountain track points the way to a Princess Beara's grave, but who exactly was she?

Legendary tales point to a second-century King of Munster by the name of Eoghan Mór, who sailed to the coast of Spain from Greenane on Bere Island after he lost a brutal war against Con of the Hundred Battles, a Connacht High King. There he reputedly met and married the daughter of a Castille king by the name of Beara. After years in exile, Eoghan awoke from his slothfulness to return to the peninsula with a great army of men to repossess his rightful land. Upon landing at Greenane, he was said to have taken Princess Beara to the highest hill on the island and there, gazing out across the harbour, he attributed the entire peninsula in honour of his wife.

Today, Eoghan's legacy lives on around Castletownbere in nearby place names like Rossmackowen and Kilmackowen. Further east, high above the spaghetti-like Healy Pass road, is a hill named after Eoghan and whose summit is marked by a cairn that rests on a narrow rock rib. The summit of Knockowen (658m/2,159ft), being central to the formidable range of Caha peaks, is a fine place to sit and take in the surroundings – from the range of rugged green hills westward, including Hungry Hill, to the stark landscape of grey rocky outcrops, glimmering pools and unforgiving bog to the north-east. Even on a cloudless day, King Eoghan would have experienced a forbidding sense of isolation had he been on Knockowen's summit all those centuries ago, tamed only by the princely panorama of distant Iveragh peaks across the Kenmare River that would have filled him with envious pride.

A lonely col sits north-west of Knockowen, a short distance below the summit. A grassy ledge and rock slabs mark the boundary between *terra firma* and air.

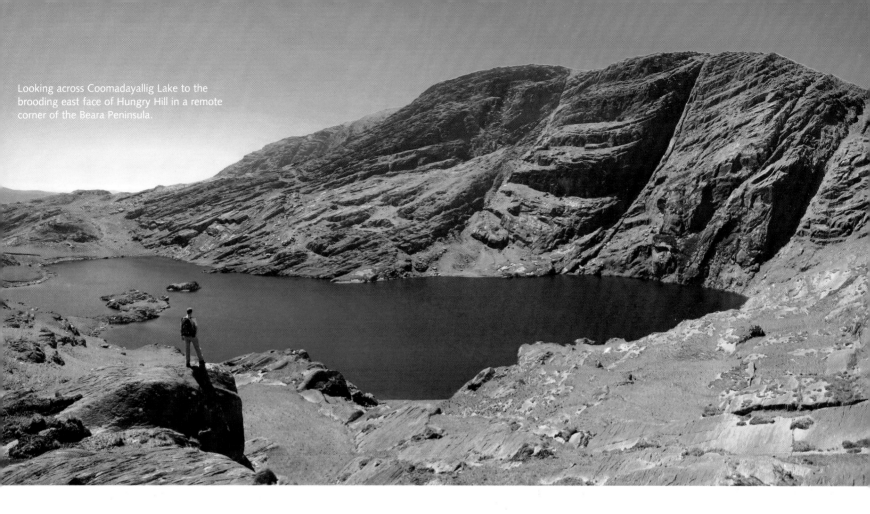

Looking across Coomadayallig Lake to the brooding east face of Hungry Hill in a remote corner of the Beara Peninsula.

A river twists like an artery along the valley floor, its tributaries spread like the tentacles of an octopus up brooding slopes. From up here, the distinctive quality of the Glanrastel Valley fuels the mystery of wild places; sparkling silver and yellow-green in the sunshine, grim grey and brown in the mist.

The beauty of these parts strikes deep chords within me, and on bright sunny days the high places of Beara pulse with a harmony that is incomparable with other parts of Ireland. Far below Knockowen's western slopes, on a rocky knoll marking the summit of Stookeennalaokareha (412m/1,352ft), the view down Glanmore Lake plays like a symphony of nature's song: a sonata of greenery hugs its crystal waters, an elongated valley waltzes deep into the arms of a cirque of summits and a staccato of peaks unfold behind a lake.

These saw-shaped peaks encircle the Cummeengeera glen to the west, a corner known locally as the Rabach's Glen. A stream flows down a V-shaped notch between sharp sandstone slabs into the Drimminboy River from the upper reaches of the glen. There are ruined dwellings here, where a man by the name of Cornelius

'Rabach' O'Sullivan once lived. On a miserable rain-soaked night, a sailor turned up at Rabach's abode looking for shelter. Fuelled by greed, Rabach murdered the sailor, thinking he had money on him. Unbeknownst to Rabach, a neighbour witnessed this savage act through her tiny stone window. This was later to come back and haunt him, for during a heated argument, the same woman threatened to go public with the information she knew. On hearing this, Rabach cornered her one day, grabbing her by the neck and drowned her in a stream. Sixteen years later, in 1830, a dying man, fatally injured in the local mines, confessed to the authorities that he had been on the hill when Rabach committed his gruesome second murder. Rabach was pursued, but evaded capture each time in the recesses of the glen. A year later, the dead woman's son tipped off the police that Rabach would be home for the birth of a child. An ambush was set up and Rabach was finally captured and hanged in Tralee Gaol.

One fine spring day, I had returned to these parts to settle an old score. Under a blue sky, it looked like I had finally beaten the Atlantic weather demons. A year

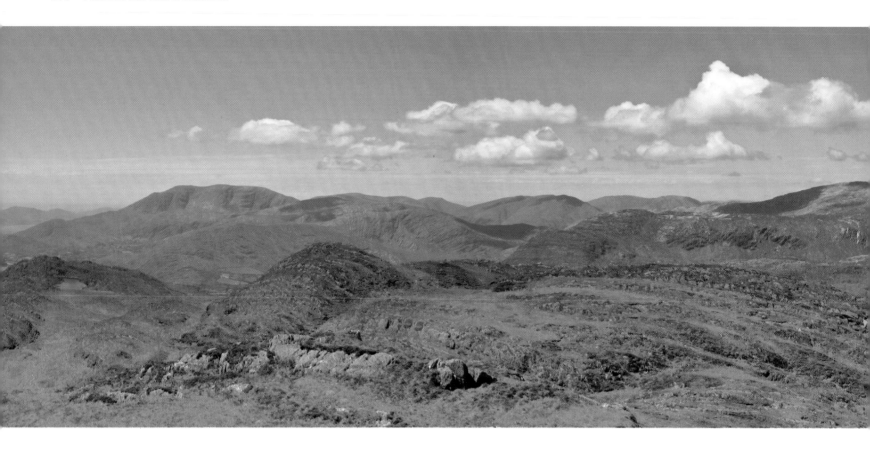

ago in winter, Beara was at its worst: thick fog, howling winds, cold sleet, freezing temperatures, zero visibility. Under such conditions, the Caha Mountains can be the most inhospitable place on Earth. I was navigating from the summit of Lackabane (602m/1,975ft) to the northern corner of Glenbeg Lough, just over 5km/3miles away. Deceptive shadows toyed with my mind as I descended broken ground on the Tooreennamna spur in driving rain. Perhaps I was haunted by the dark presence of the Hag of Beara, an ancient witch-goddess of the sea and of death who roams these crannies, according to folklore. Tooreen or *tuairín* is a 'green place used for drying' but there was no way Tooreennamna was anything like that on that occasion.

The Hag was probably asleep under the cliffs of Eskatarriff (600m/1,969ft) on that sunny spring afternoon a year later. Its northern ramparts are known as the 'steep path of the bull', and the original name of the Hag was *Boí* or *Buí*, which comes from the old word for 'cow'. I climbed up a slope of fresh green bracken and grey rock from the sheep pasture of Cummeengeera, keeping left of a tempting stream. Scores of violet butterwort were flowering. Across the glen, a gluttonous line of hills formed by angled sandstone slabs glowed like grey teeth that cut along its slopes. Tooth Mountain (590m/1,936ft) is the highest in this chain, followed by Knocknaveaceal or 'teeth hill' (513m/1,683ft) farther north, and Keecragh Mountain (363m/1,190ft) lower down. Keecragh, or *Ciócrach* in Irish means 'greedy', another one of those seven deadly sins.

The OSi maps of Beara are pockmarked with red dots that mark an ancient time of boulder burials, megalithic tombs, standing stones and stone circles, some of which can be found in the Cummeengeera glen. A closer inspection of the map in this area also reveals an interesting word, *Fulachtaí Fia*, by one of these red dots. These are Bronze Age pits for heating water using fire stones. These had a myriad of uses: washing, tanning, cooking to name but a few. Some archaeologists have also suggested that they may have been used as ancient breweries. A Bronze Age stone circle also sits in the green yard of the final house in the valley, eight stones are upright, one has fallen and some are missing.

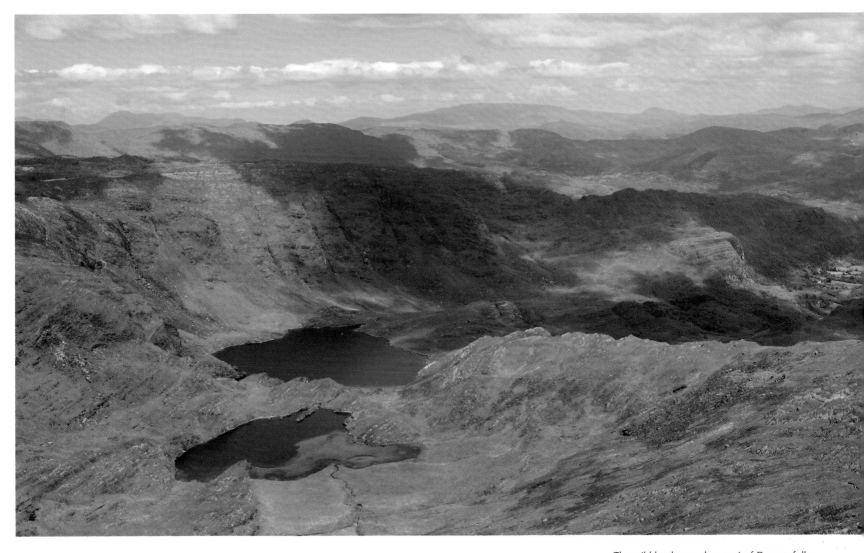

The wild landscape due west of Derrynafulla, at Coomerkane. The anglicised names of the two lakes in this glacial valley are as complex as the landscape itself; the nearer one, Lough Eekenohoolikeaghaun, and the larger lake farther away, Lough Derreenadarodia.

Opposite The Caha Mountains, a rugged mountain range in the Beara Peninsula, as seen from a summit above Toberavanaha Lough, west of Sugarloaf Mountain near Glengarriff.

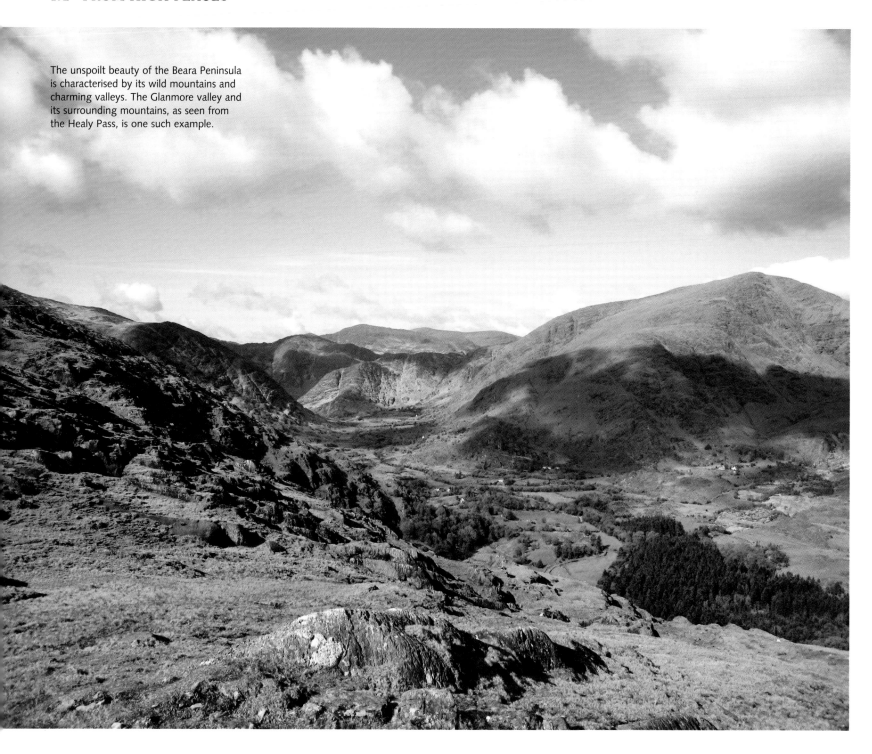

The unspoilt beauty of the Beara Peninsula is characterised by its wild mountains and charming valleys. The Glanmore valley and its surrounding mountains, as seen from the Healy Pass, is one such example.

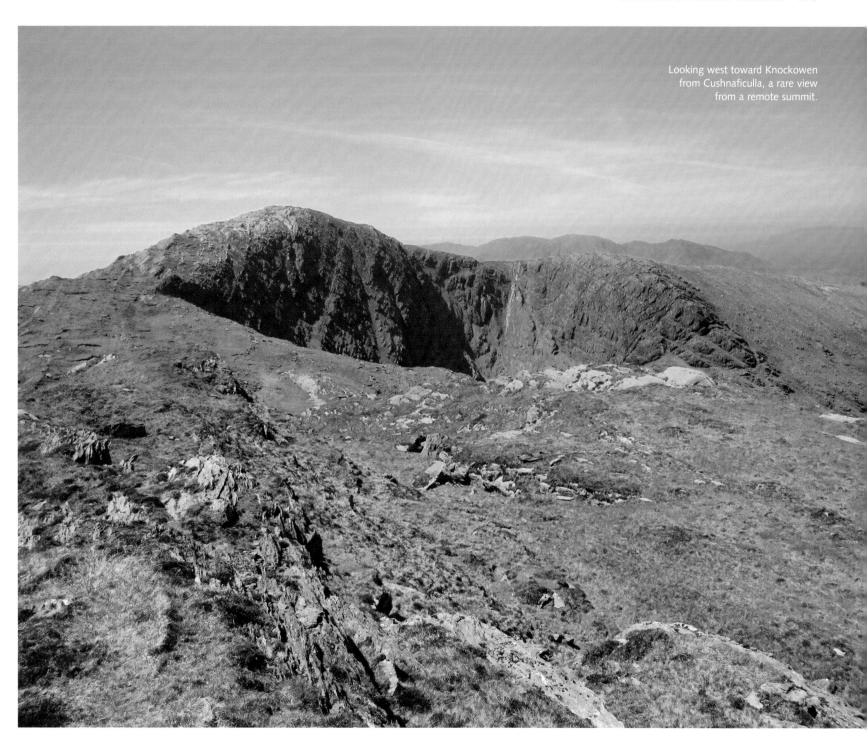

Looking west toward Knockowen from Cushnaficulla, a rare view from a remote summit.

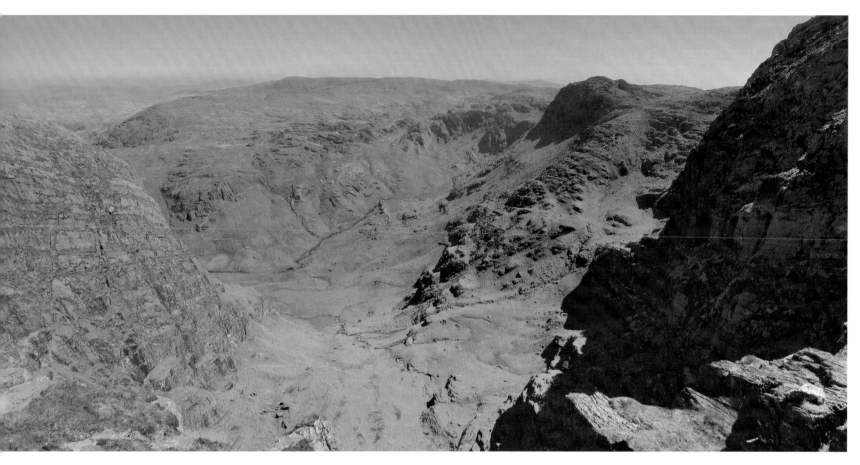

The Glanrastel valley, as seen from a lonely col
north-west of Knockowen. To look down at it
leaves one with a forbidding sense of isolation.

Opposite from top
A stunning panorama of Glanmore Lake and the Caha
Mountains from the summit of Stookeennalaokareha.
Lackabane is the peak that rises behind the lake.

Looking down along the spur leading north-east from
Lackabane to a lovely corner of Beara.

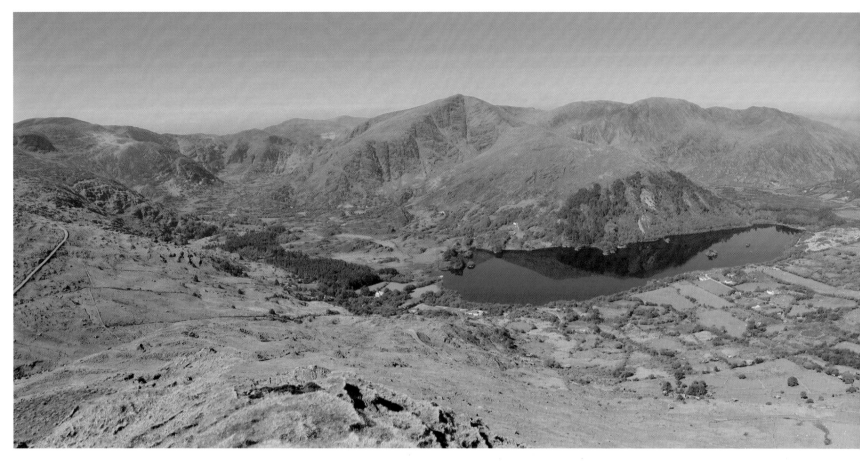

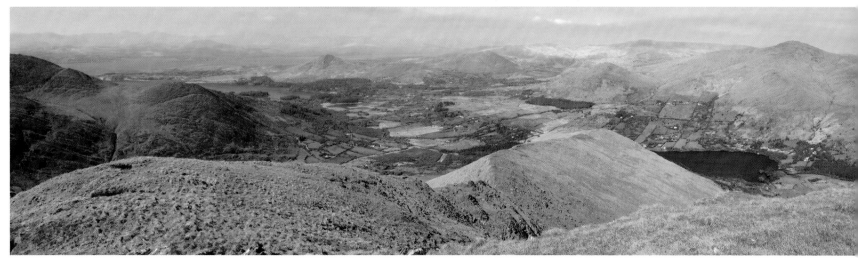

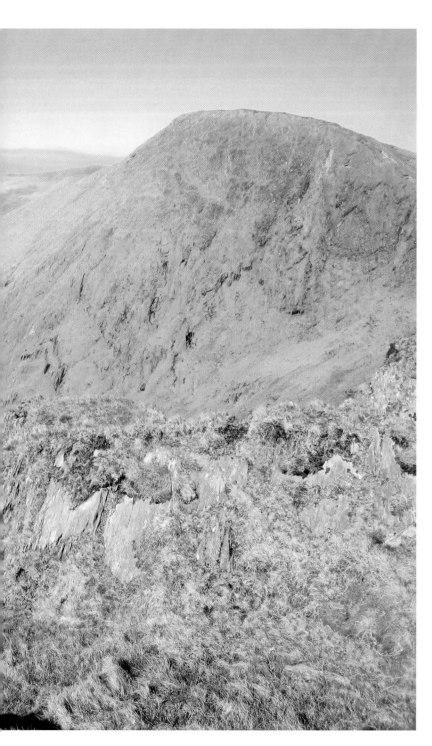

Stone circles and boulder burials are also to be found farther north-east, on a lonely tarmac road whose sides are adorned with compact rushes, near Lough Inchiquin. An old yarn suggests that this enchanting lake, nearly a kilometre and a half long, was formed following a broken promise. There was once only a hollow, where a castle stood far below with a network of caves beneath. In one of these caves, the castle's ruler lustfully observed three beautiful women who came to bathe in a gurgling well. One day he snatched the prettiest, and persuaded her to wed him. The woman reluctantly consented on condition that the ruler kept their home secret. He agreed, but alas, during a drunken spree at the races, he brought some friends back to the castle. On seeing this, his wife fled to the well and plunged into its waters which gushed out in torrents, filling the hollow and forming a lake.

Late one evening I wandered above Lough Inchiquin, on a day when the contrast of light and shadow accentuated the beauty of cloud, sky, rock, bog and lake along the intricate Beara landscape. I stood above Cummeenadillure, looking down at turbulent sandstone slabs and ridges that rampage like rocky waves, only to ebb again into a yellow-green sea of bog. I imagined wild eagles soaring on the moody skies above the coum, like they once did before they were hunted to extinction in the nineteenth century. The waterfall at the back of the glen looked tame after a dry spell. Some distance higher, I stared down a deep hollow of a hole under Coumnadiha (644m/2,113ft), yet another hidden Beara valley spilling from its heights. And then I looked up at the scratched, striated, contorted sandstone slabs on Coumnadiha's slopes. It reminded me of a hidden heart of Kerry that I cherished.

The remote Cummeengeera Glen from the mid-point of its horseshoe, near Eskatarriff. Tooth Mountain rises on the left, while Lackabane is the pointed peak on the right.

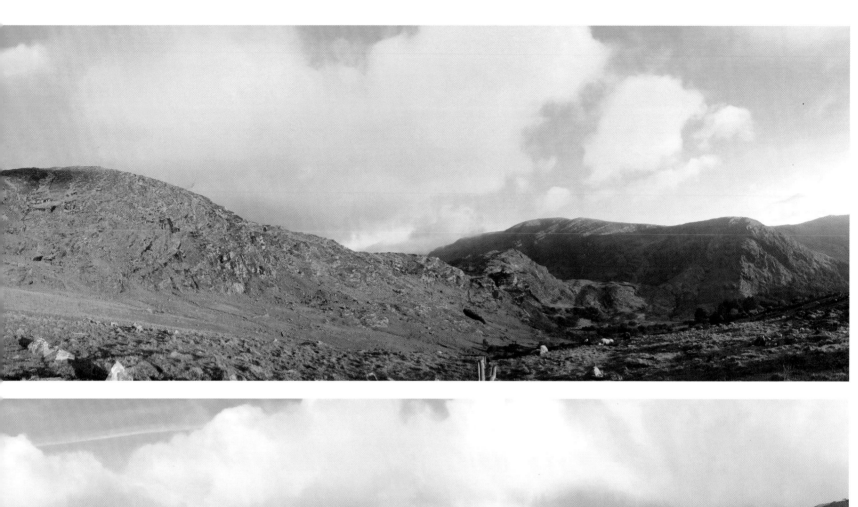

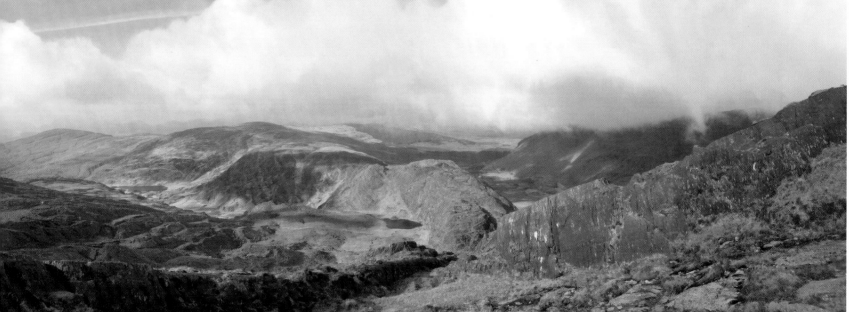

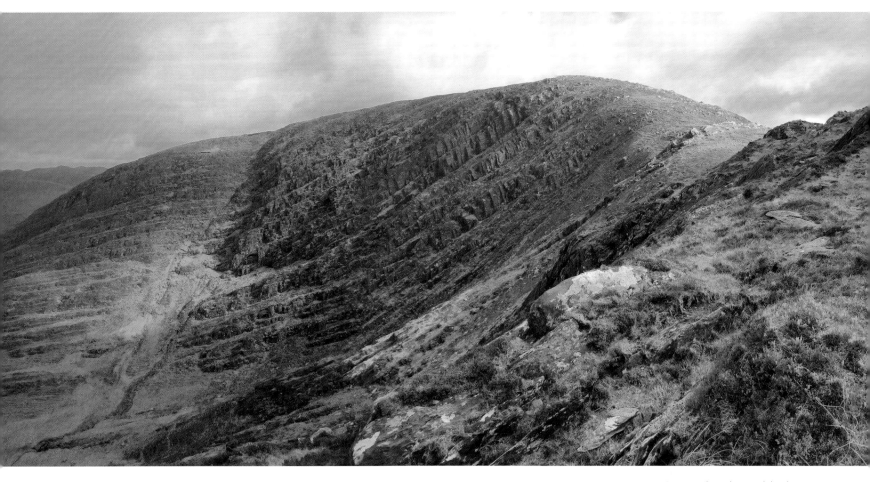

Contorted sandstone slabs decorate
Coumnadiha's north-east slopes, its surface
scratched as if by witches' claws.

Opposite from top
Glaninchiquin, as seen from a quiet valley north of
Knocknagorraveela, late on a spring evening.

The rugged ridge east of Coumnadiha, where sandstone slabs
rampage like rocky waves, only to ebb again into a sea of bog.

THE HIDDEN HEART OF KERRY

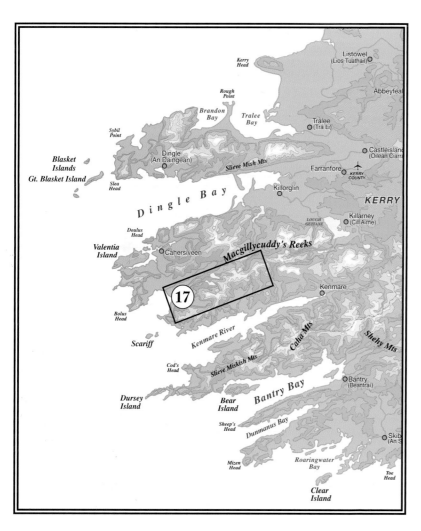

A feel of warmth in this place.
In winter air, a scent of harvest.
No form of prayer is needed,
When by sudden grace attended.
Naturally, we fall from grace.
Mere humans, we forget what light
Led us, lonely, to this place.

John Montague

There is a powerful scene at the end of the Peter Jackson's movie *The Lord of the Rings: The Fellowship of the Ring* when Sam and Frodo walk to the top of a rocky slab and stare out at a stark landscape across rock fangs to the dark mountains of Mordor, before descending into its unknown depths.

A remote corner of the Iveragh Peninsula, in the heart of its mountains, echoes that scene. Precipitous rock walls guard a group of monstrous sandstone fangs that encircle a lake, its cinereous rocks scratched as if by beastly claws. Another smaller lake is nestled below one of the fangs, its inky waters floating above a vertiginous cliff that falls as steeply as it rises for nearly a thousand feet to a lonely valley below. The ground descending into this primeval stronghold is a rocky maze, crookedly twisted in a series of shiny slabs that seem to stretch on endlessly. Where there are no slabs, the untrodden ground is covered by a complex carpet of burgundy moor-grass and russet heather.

I spent a night camped in its depths with a friend. It was early spring and we were pitched on a turf of wet moor-grass not far from a gurgling stream, in a sheltered area surrounded by rock slabs as high as houses. As light departed, we pitched our tents with ruthless efficiency. Just as well, as banshee winds soon tore at the flysheets causing the tent-poles to quiver like a shivering cat. Spear-like rain pelted the top of our tents; its pulse filled the air like hundreds of ticking metronomes.

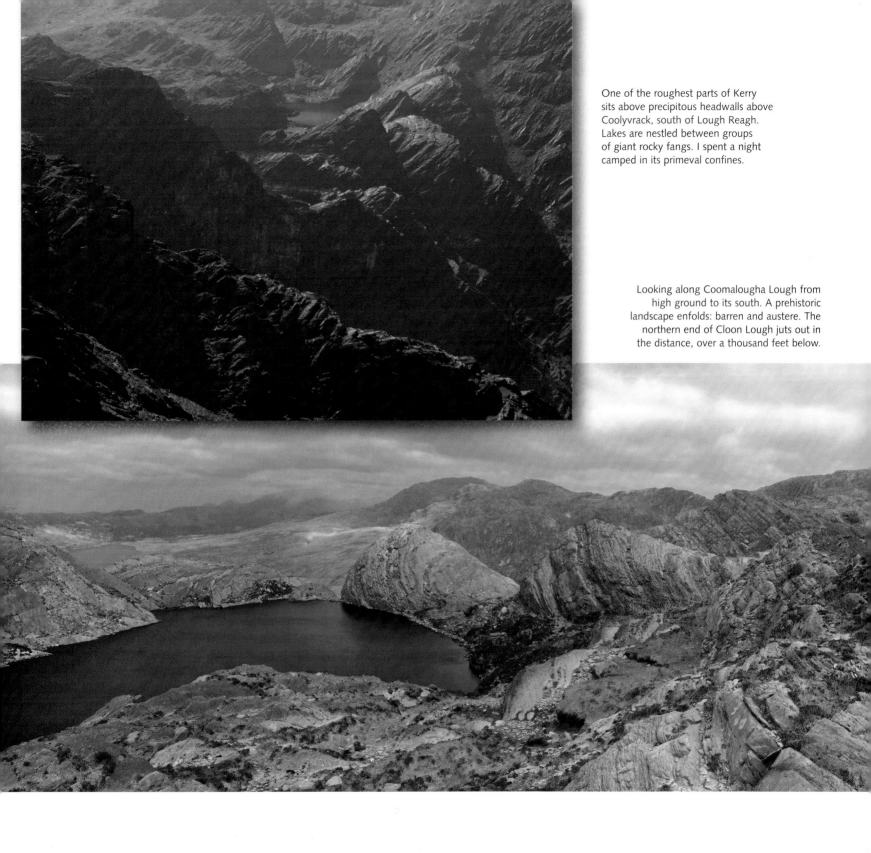

One of the roughest parts of Kerry sits above precipitous headwalls above Coolyvrack, south of Lough Reagh. Lakes are nestled between groups of giant rocky fangs. I spent a night camped in its primeval confines.

Looking along Coomalougha Lough from high ground to its south. A prehistoric landscape enfolds: barren and austere. The northern end of Cloon Lough juts out in the distance, over a thousand feet below.

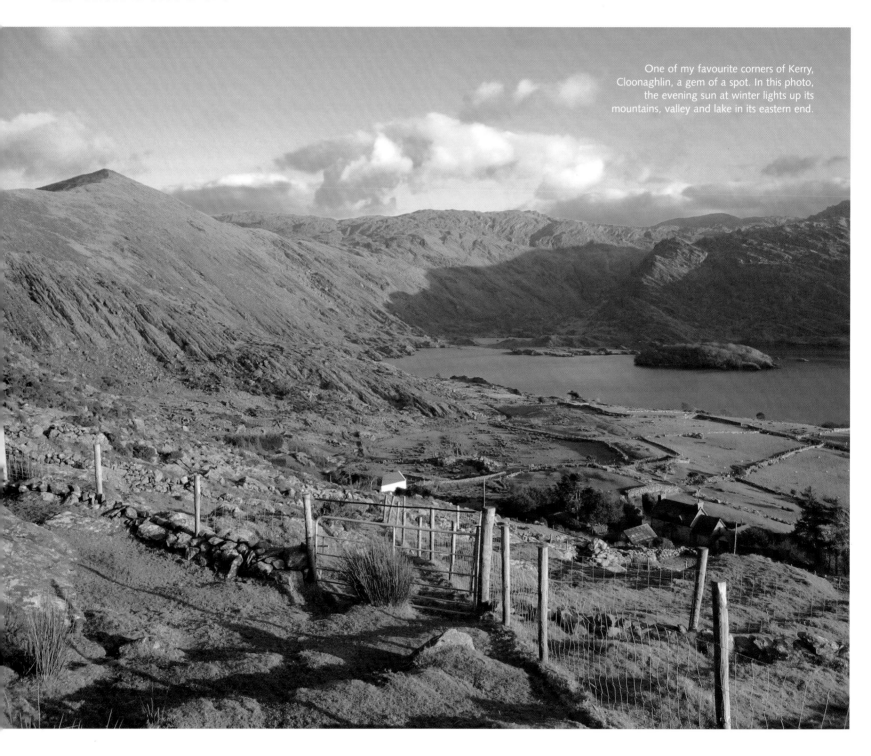

One of my favourite corners of Kerry, Cloonaghlin, a gem of a spot. In this photo, the evening sun at winter lights up its mountains, valley and lake in its eastern end.

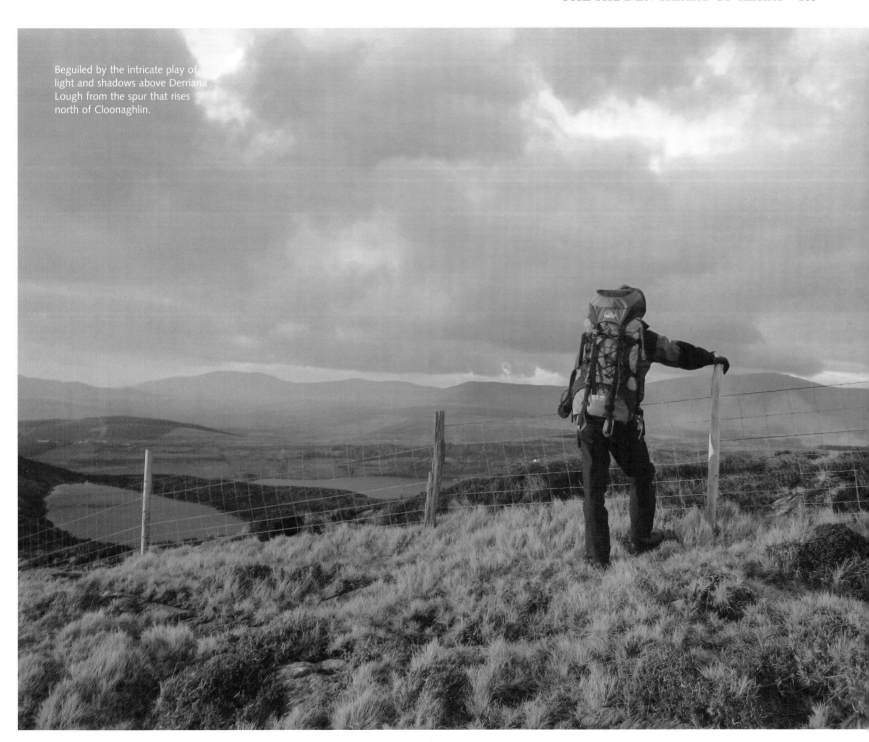

Beguiled by the intricate play of
light and shadows above Derriana
Lough from the spur that rises
north of Cloonaghlin.

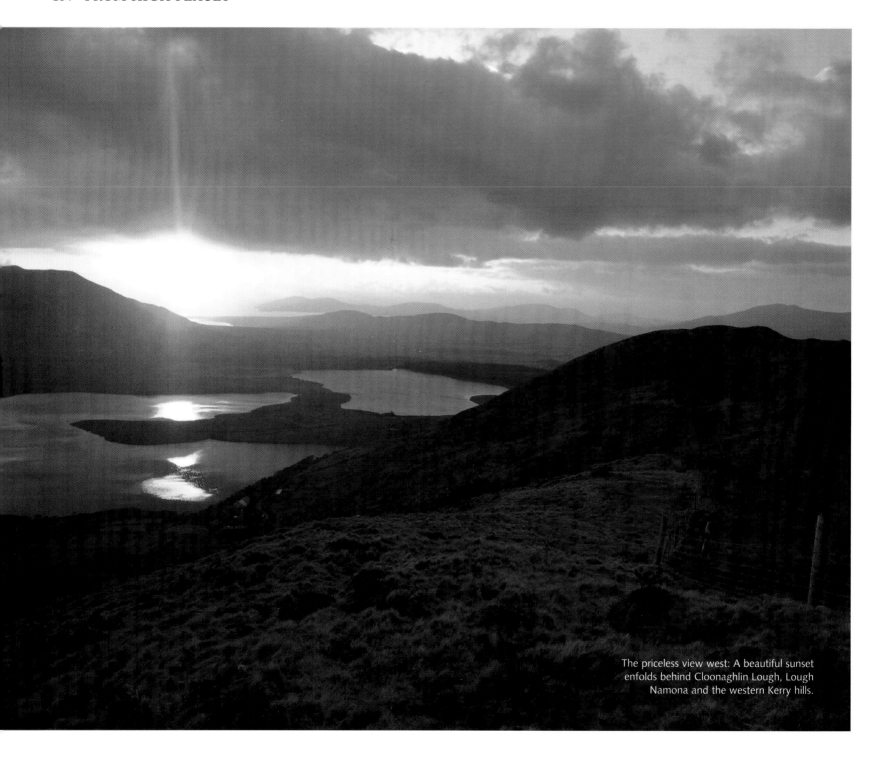

The priceless view west: A beautiful sunset enfolds behind Cloonaghlin Lough, Lough Namona and the western Kerry hills.

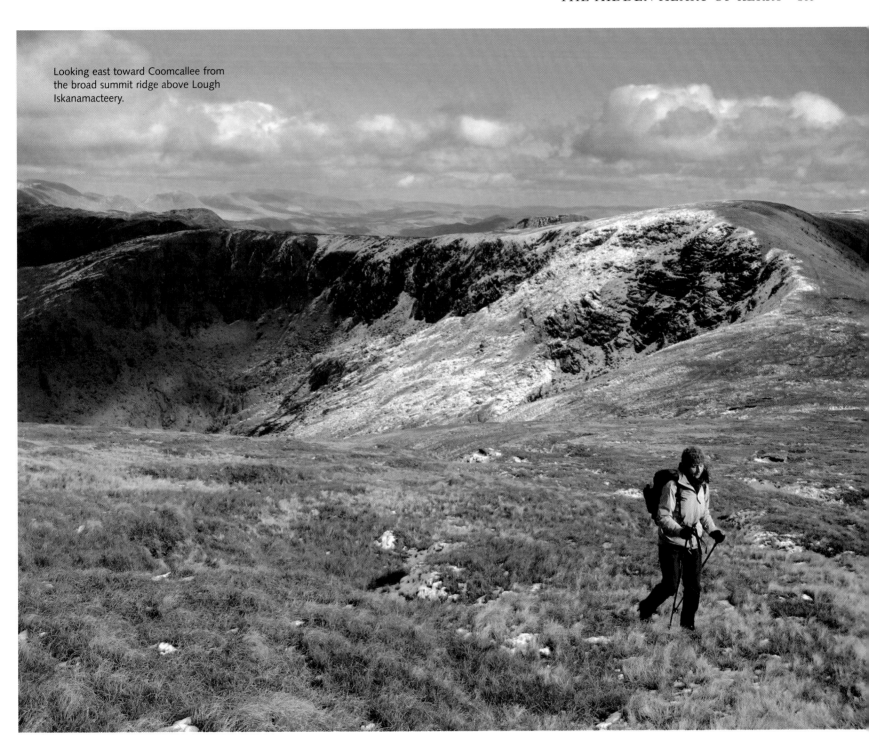

Looking east toward Coomcallee from the broad summit ridge above Lough Iskanamacteery.

We lit our miniature stoves for a brew; our bodies craved to be heated as the temperature viciously plunged below zero. The thin nylon of our tents was the only safety net that separated us from the harsh elements of nature on that wild night.

Close to midnight the rain subsided and the wind died down. We booted up and sniffed the cold air of the night sky outside our tents. The icy atmosphere was now strangely still, interrupted only by the roar of mountain streams. We crossed a stream, our boots squelching along the wet moorland, lit up by the beam of our head-torches. The rough ground crept up to a lake whose rippling waters greeted us like an oasis emerging from the shadows. Dark cliffs surrounded the lake; the night made them feel close, as if its large jaws would consume us without heed or warning.

We followed a stream that flowed north along a narrow passage between clutches of high ground. Further on, another lake stopped us in our tracks, confirming our location. Religiously following a bearing, we plodded on to a broad rock slab that stood higher above the rest. We switched off our head-torches. Our senses were heightened as night vision filtered into our retinas. A great door opened under the starlit sky and previously invisible features became easier to discern by distinct outlines of grey and black shades. Somewhere far below us beyond Coolyvrack, under cliffs to the north-east, the smaller Lough Reagh sang a subdued tune compared to the choppy waves of the larger Cloon Lough farther to its north.

A yellow light flickered in the distant dark hills to the north, moving oddly and swiftly along its slopes, leaving us intrigued. We powered on our head-torches. The distant lights ceased; perhaps they too could see us now? As we navigated back to our tents, I pondered what it was that led us here. The answers didn't come that night, but whatever it was led me back a year later to that same rocky perch. This time, in the clear light of day, I gained a full appreciation of the rocky cauldron that surrounded me. I could have been in Middle-earth; giant rocky spikes shaped like a Stegosaurus's back loomed over trapped lakes and a grotesque stratum of slanted sandstone rock grinned austerely behind the massive Coomalougha Lough. Perhaps the ethereal beauty of this barren landscape had cast a spell, even at night?

South-west of Coomalougha, just over two kilometres away as the crow flies, is a grassy hill called Knocknagantee (676m/2,218ft), where conversation usually ceases, due to some very rough ground, should the ambitious explorer choose to continue from there toward the peak of Coomcallee (650m/2,133ft). I have a special affinity for this area, tucked away in this hidden corner of Kerry. A string of tarns of various sizes decorate its rugged ridge, whose western hollows are blessed with a string of enchanting lakes, some enormous in size. I recall once in the depths of winter when I spent two nights camped on steep ground above Lough Coomeathcun with a friend. We'd barely crawled out of Dublin due to an icy motorway, but as fate had it, found ourselves on the slopes high above Cloonaghlin Lough later that freezing evening in February.

There is something beguiling about the hour before sunset, when the colours of the evening sky blossom into hues of pink, crimson and orange. On Ireland's western fringe, the sun strangely seems to take an eternity to dip below the horizon. Thick cumulus clouds, an explosion of dark-blue and purple, veiled the sky above Derriana Lough and Cloonaghlin that evening. In those precious hours of sunset's afterglow, we observed delicate shadows rolling softly over the weary breast of the Kerry hillside. Dark shadows started to fall over Coomcallee's sweeping ridge as the western hemisphere moved towards its cycle of rest. By the time we found suitable ground to pitch our tents, snow was falling and the stars above froze in their spheres. Behind us, Coomcallee plunged into a hollowed spell of the hags, billowing into darkness.

In days of old, a fisherman was said to live in a tame valley south of Coomcallee, obtaining his daily catch in Isknagahiny Lough. One sunny day, he looked up at Coomcallee's inviting slopes and decided to carry his skin-covered boat up to its saddle, then down the valley on the other side. He did exactly that, and down in the next valley, at lakes surrounded by savage slopes, he threw his line into Lough Iskanamacteery before moving on to Lough Nambrackdarrig, where it was believed he caught an endless score of red trout. The fisherman then carried both boat and catch up Coomcallee's slopes once again, on to its spur, and back down into Isknagahiny. The brindled peak of Eagles Hill (549m/1,801ft), tawny with streaks of a darker colour, sits south of the lake at Isknagahiny, continuously staring at the fisherman, wondering about his actions in curious silence. The hill's grassy, heathery and peaty crest extends south-west, toward the sea, dropping down as brown slopes to Farraniaragh Mountain (468m/1,535ft), the first notable hill of the 'backbone of the Ring'.

Opposite from top
A view up the spur that rises eastward between Derriana Lough and Cloonaghlin Lough. This photo was taken after I had spent two nights camped in its upper regions in the dead of winter.

A panoramic view down the same spur between Cloonaghlin (left) and Derriana (right) lakes: An untrodden land of virgin beauty.

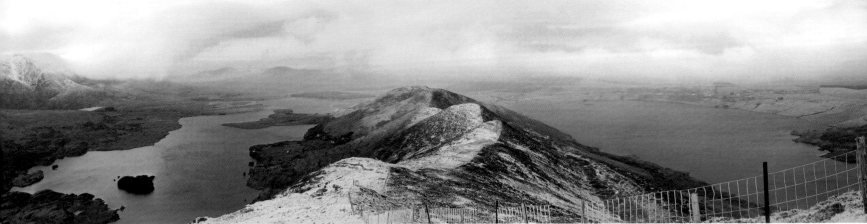

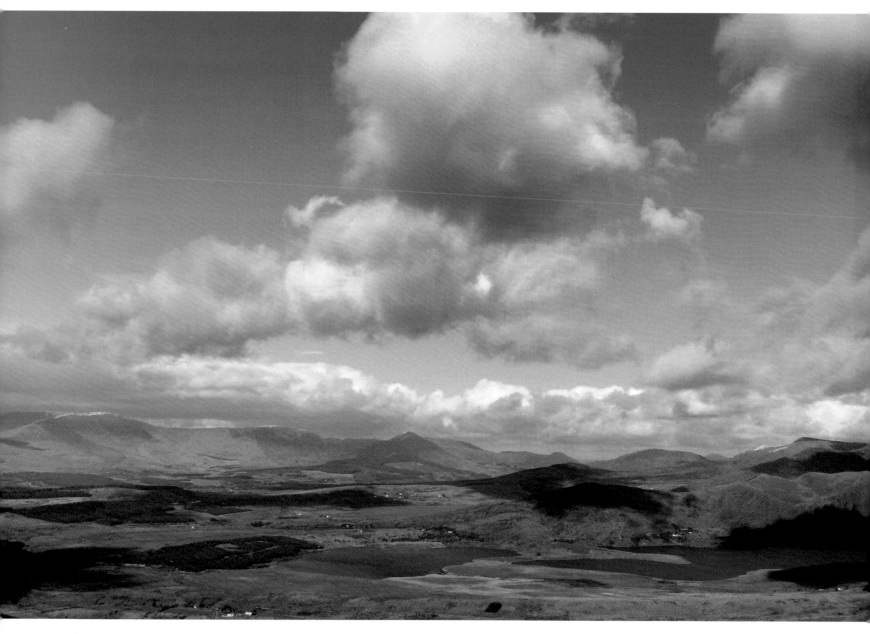

Lough Namona, Cloonaghlin Lough
and Derriana Lough from the ridge
west of Coomcallee.

Opposite Lough Iskanamacteery flanked by
steep, imposing slopes on its southern end as
seen from the spur above Maghygreenane.

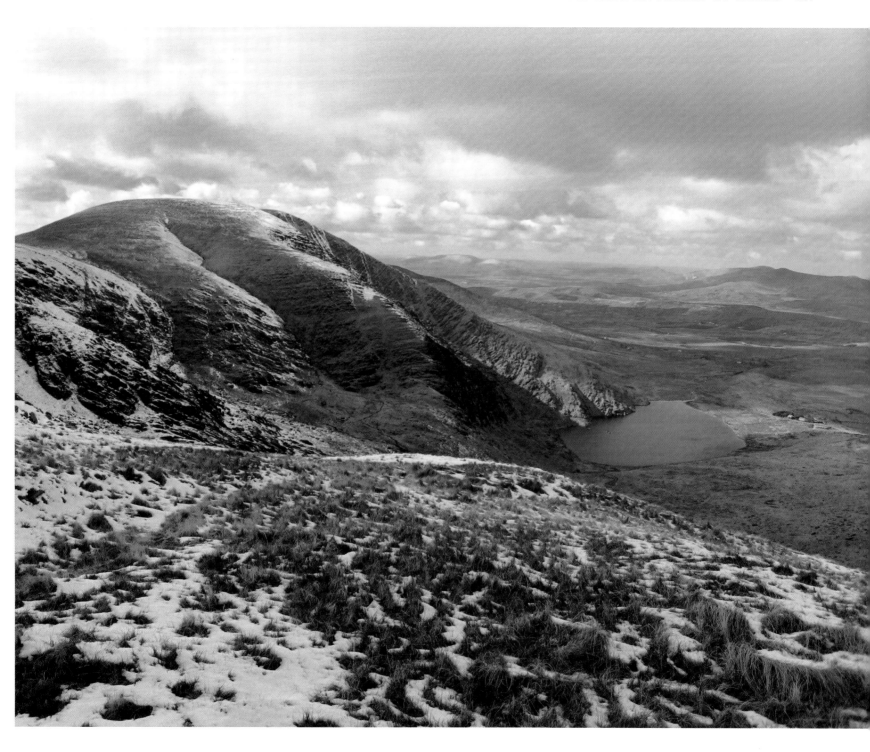

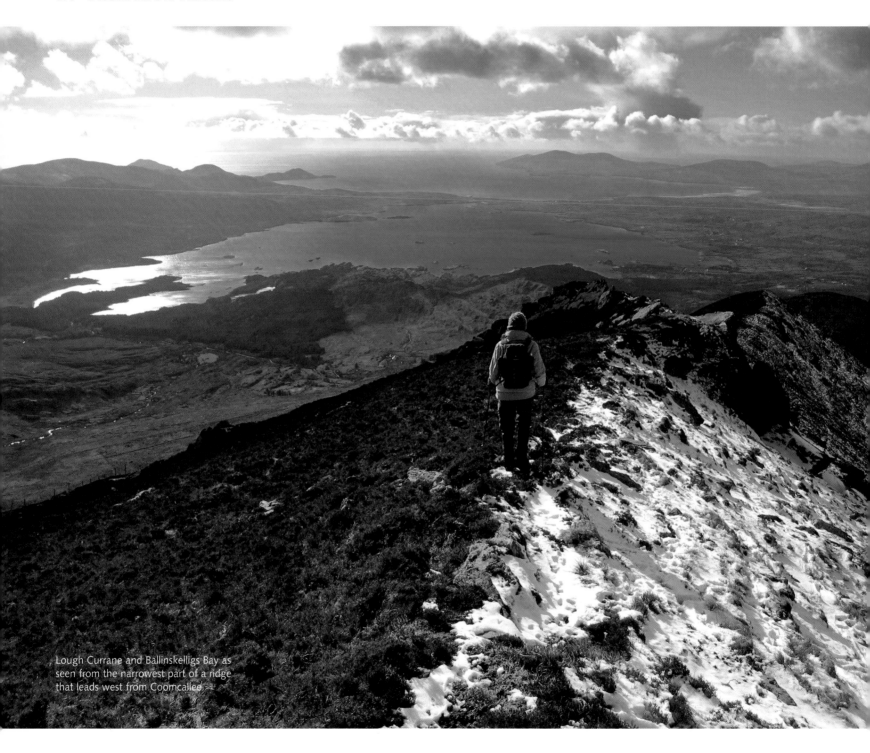

Lough Currane and Ballinskelligs Bay as seen from the narrowest part of a ridge that leads west from Coomcallee.

BACKBONE OF THE RING

Climb the mountains and get their good tidings.
Nature's peace will flow into you as sunshine flows into trees.
The winds will blow their freshness into you,
and the storms their energy,
while cares will drop off like falling leaves.

John Muir

Aspine of mountains punches the Kerry skyline, dominating the view inland from a coastal ring road that weaves its way like an endless grey thread along the fringes of the Iveragh Peninsula. It is much larger than its two neighbouring peninsulas, Dingle and Beara, which encapsulates it to the north and south respectively. The treasure chest of mountains run riot along the length of Iveragh, covering almost every nook and cranny of its peninsula and forming a backbone of approximately 55km/34miles from its western tip at Farraniaragh Mountain, to a range of hills further inland around the Mangerton massif.

The peaty moorland, bog road and rounded tops between Farraniaragh Mountain and Eagles Hill deceive the uninitiated into a false sense of security. Venture several kilometres north-east, beyond Coomcallee, and the mountains reveal the true Iveragh character: sandstone rock rippling along the skin of bog, rocky terrain full of complex indentations and small tarns. This baptism of fire extends to Knocknagantee, from there it relents, but only slightly. The mountain's arm then circumnavigates above two south-facing coums before rising along a broad crest to the summit of Finnararagh (667m/2,188ft).

A mighty band of sandstone slabs guard Finnararagh's grey slopes that crumbles down to a ridge of windswept moor-grass and tame rock. The ridge sweeps north-east, dipping and rising for several kilometres over Kerry's great heights. It is an exhilarating section: brown-green vales sweep across the plains on one side and lakes sparkle like crystals on the other. Mountains rear up

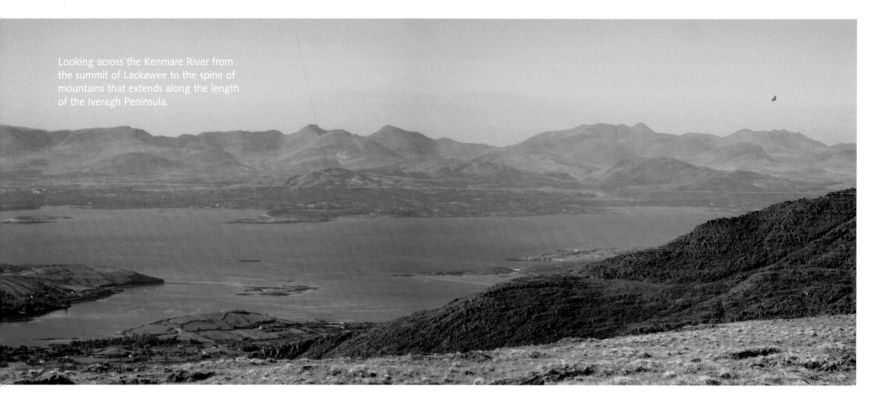

Looking across the Kenmare River from the summit of Lackawee to the spine of mountains that extends along the length of the Iveragh Peninsula.

everywhere, both near and distant, with views that stretch out as far as the Beara Peninsula.

One mountain in particular catches the eye and its presence looms ever larger on approach from above a gap on the slopes of its neighbouring peak, Beann North-east Top (692m/2,270ft), near a lonely memorial plaque. It displays a colossal triangular form, the apex of which seems to touch the clouds. I once ascended its northern spur from Eskabehy Lough on a blustery spring evening. Wild clouds swooped over the mountains as I clambered up its steep slope. There was a sting in its tail before I finally emerged at the lofty perch of its summit, Mullaghanattin (773m/2,536ft). Freezing blasts of wind tore at the exposed summit, hammering clasps of air against its trig point. It wasn't a place to linger long so I descended north-east, the ferocity of the wind abating as I continued to lose height down to Ballaghbeama Gap.

A narrow, winding road cuts through the notch of Ballaghbeama Gap and in places immense crags almost swallow it up. From Ballaghbeama, the flood of mountains pours eastward, rising as giant stumps over the Caragh, Gearhameen and Owenreagh rivers. One of these stumps, Stumpa Duloigh (784m/2,572ft), towers over Lough Duff, the 'black lake'. Not far from its summit, a plaque rests on a slab of rock overlooking a steep edge. I always approach this memorial in silent respect for the people who lost their lives here in the winter of 2002, and perhaps reflecting also on my own mortality. Members of the Kerry Mountain Rescue Team (KMRT) were dealing with a minor climbing incident when it received news of a serious situation at a steep gully high above Lough Duff; three hill-walkers had fallen down crags.

KMRT members were immediately airlifted to the location, and swiftly began a search of the area around the gully. In the approaching darkness, a man was found alive near the bottom of its narrow recesses but with serious head and back injuries. A meticulous evacuation by helicopter ensued. He lived – but what of the other two? In bitterly cold and treacherous conditions, selfless KMRT members spent the night searching the dark gully for the other two who had fallen. Unfortunately, they were found dead. At first light, when conditions improved, KMRT personnel were once again airlifted to the scene to lower the bodies to the level of Lough Duff, and then transported across the lake by inflatable canoe to an appropriate winching point, from where they were removed by helicopter to the Black Valley.

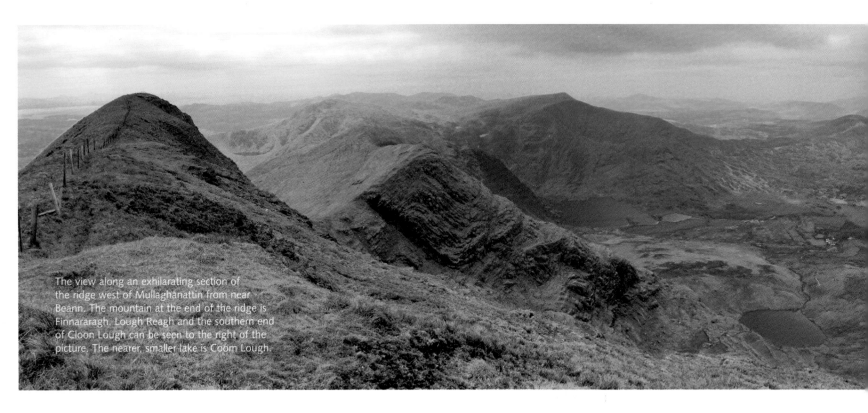

The view along an exhilarating section of the ridge west of Mullaghanattin from near Beann. The mountain at the end of the ridge is Finnararagh. Lough Reagh and the southern end of Cloon Lough can be seen to the right of the picture. The nearer, smaller lake is Coóm Lough.

The Black Valley is as remote as it gets, approached only by long, narrow and winding roads from the north or south. The Irish word *duff* or *dubh*, for 'black', is associated with the river, lakes, glens and mountains in the area. A circle of mountains surround the valley; long shadows glide across its floor when the sun is at its lowest. Some say it is a forgotten valley; electricity only arrived here in 1977, justifying its name somewhat, and the first telephones in 1990. It is a modest place, graced only by a hostel, a church and some houses, and the residents are simple folk who have endured harsh winters in recent years, none more so than the prolonged winter of 2010 when the Cummeenduff Glen and its three lakes looked more like a 'white valley' with snow-capped mountains.

A quiet bridge spans the Cummeenduff River near the end of the glen, under the forbidding eastern face of Broaghnabinnia (745m/2,444ft). My boots crunched the nearby track one fresh spring morning, as I walked under holly trees into a delightful valley. Lough Reagh, along with a white swan that swam in its serene waters, added a romantic element to the valley floor. My eyes were drawn above toward a hypnotising waterfall that plunged down crags, its setting cast amongst an outcrop of boulders strewn across the olive-green floor. Black goats ruffled through a green thicket of bracken, scurrying along the edge of a stream adorned with rock-pools. I stepped on a grassy ledge close to the waterfall, feeling energised by its spray. The ledge, strewn with lichen-covered rock, was a haven of mountain flora: St Patrick's Cabbage, star-shaped butterwort, pale primroses, purple-blue dog violets, pink bog pimpernels and yellow lesser celandines all splashed around close to the fall. I looked back down at Cummeenduff Glen, which was now dominated by Brassel Mountain (575m/1,886ft) rising above Lough Reagh, with the Black Valley tucked under a swirl of clouds beyond.

A narrow road twists north of the Black Valley, cutting its way through an equally narrow cleft that splits sharp cliffs into two contorted halves. The road, a haunt for jaunting cars in the height of summer, runs along this gap for about 8km/5miles to Kate Kearney's Cottage, passing five lakes of various sizes, all drained by the River Loe. The Gap of Dunloe gets its name from this river, which is fed by mountain streams tumbling recklessly from the imposing heights of Tomies Mountain (735m/2,411ft) and Purple Mountain (832m/2,730ft). It's almost like flying on eagle's wings from these heights; the massive outline of Lough Leane dominates the flat Killarney plains to the east, the Gap of Dunloe exhibits a primeval landscape

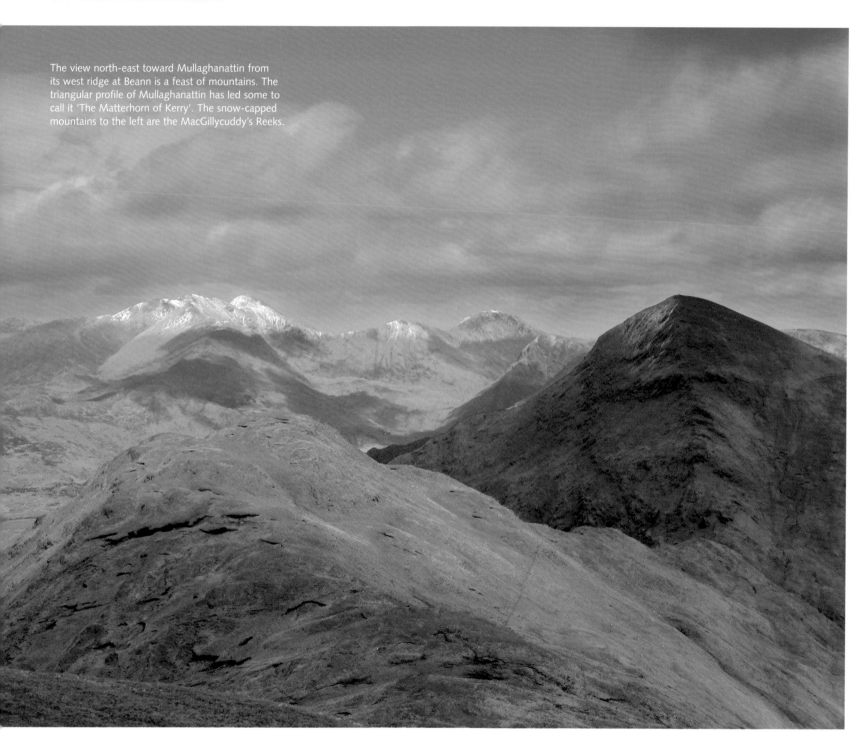

The view north-east toward Mullaghanattin from its west ridge at Beann is a feast of mountains. The triangular profile of Mullaghanattin has led some to call it 'The Matterhorn of Kerry'. The snow-capped mountains to the left are the MacGillycuddy's Reeks.

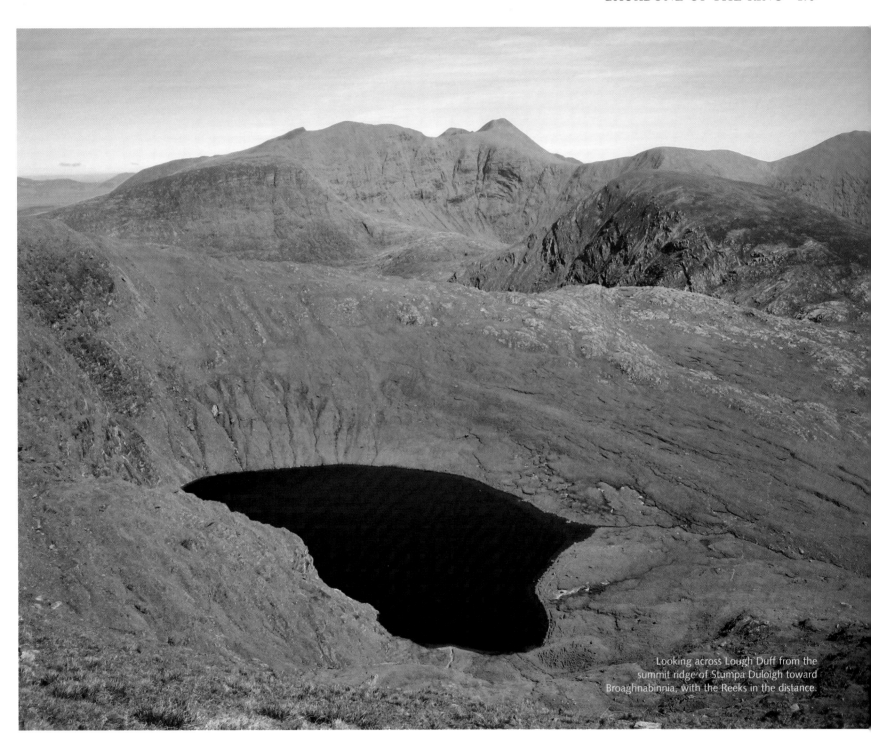

Looking across Lough Duff from the
summit ridge of Stumpa Duloigh toward
Broaghnabinnia, with the Reeks in the distance.

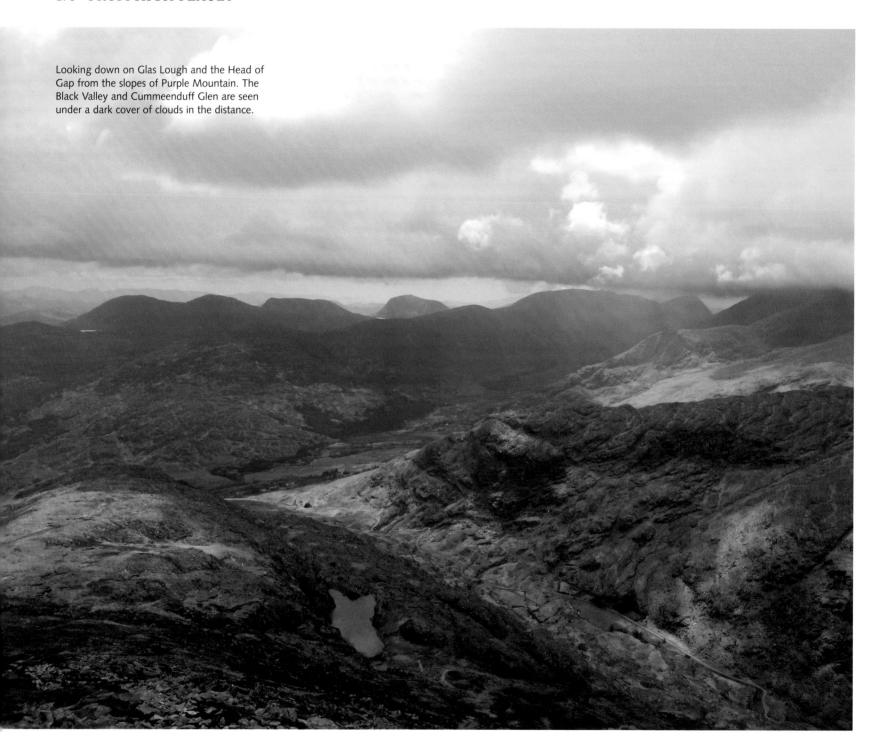

Looking down on Glas Lough and the Head of Gap from the slopes of Purple Mountain. The Black Valley and Cummeenduff Glen are seen under a dark cover of clouds in the distance.

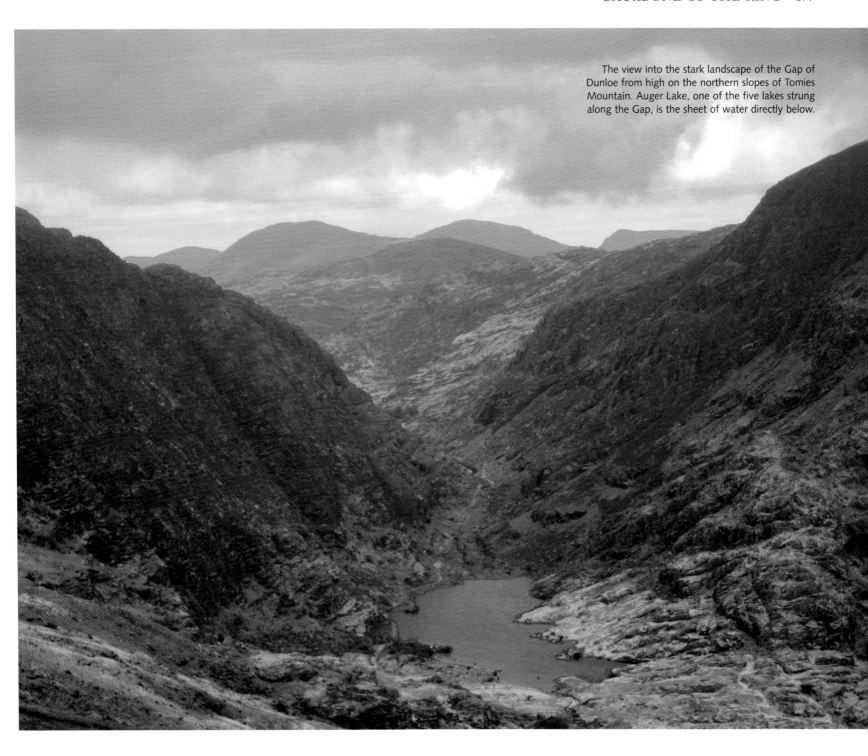

The view into the stark landscape of the Gap of Dunloe from high on the northern slopes of Tomies Mountain. Auger Lake, one of the five lakes strung along the Gap, is the sheet of water directly below.

to the west, with the end of the MacGillycuddy's Reeks towering behind, and all the bulky humps of Kerry further south.

I once stood at the edge of a spur just below the summit of Purple Mountain, admiring shafts of sunlight bursting through the clouds, floating across distant dark peaks, and illuminating Glas Lough in the process, giving it a silver glint. Near the lake, a rough path marked by rusted metal posts and sounds of a musical stream led me to the Head of Gap. As I rounded some bends decorated by rhododendrons, I was probably walking in the footsteps of poets, historians, novelists and explorers like Tennyson, Macaulay, Thackeray, Scott, who walked there in the nineteenth century. A ruined house sits under a dark-green clump of conifers. I walked beyond it to where V-shaped cliffs on both sides of the gap almost touch, before the road bends again, crossing an arched stone bridge. A heron stood unmoved in the waters of Black Lough with its long neck craned back and its pumpkin-orange beak and feet adding colour to its grey-white plumage. I weaved along some large boulders, erratics moved by glacial action, and rejoined the road.

A while later, having hitched a ride, I arrived at Kate Kearney's Cottage, now a bar and restaurant. But before the Great Famine of 1845, it was at this very cottage that Kate, an Irish lass, home-brewed her lethal *poitín*, a colourless alcoholic drink distilled from potatoes, in pots under moonlight. Kate Kearney's Mountain Dew, it was called, and many a thirsty traveller had been welcomed into the cottage to consume a portion of the dry, sweet and grainy-flavoured liquid, which required about seven times its own qunatity of water to chasten it. None of this was legal of course, but this did not put the brakes on Kate from doing her business.

Nor did it do it for Moll Kissane, who ran a small pub at Moll's Gap, a rocky breach south of the Gap of Dunloe, when the Killarney–Kenmare road was built in the 1820s. Like Kate, Moll also sold the illicit *poitín*. North-east of Moll's Gap, sitting over part of the Killarney National Park, is the Mangerton massif, a raised plateau whose highest point is 843m /2,766ft above sea level. It was somewhere on these heights where a Bronze Age gold 'lunula' – a crescent-shaped metal ornament – was found. The light enveloping the mountain was golden also as I topped out a gully from the depths of the Horses Glen late one evening. On the rim of the Mangerton plateau above Lough Erhough, I watched darkness descend on the deep hollow of the glen and shadows float above the waters of the Devil's Punchbowl. I stopped to listen to the growl of the monster that is said to be trapped in its watery prison for eternity, or lament of the slaughtered armies of the McCarthys and Normans of 1262, but heard nothing, for there was only silence: a silence that only the freedom of the mountains bring, one that inspires and uplifts. I stood above the coum and watched the Kerry sky go yellow, orange, crimson and purple as the sun descended behind the highest mountains of the Iveragh Peninsula.

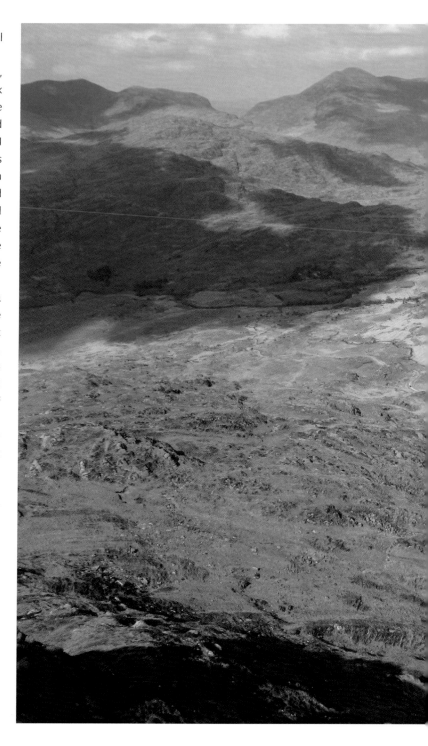

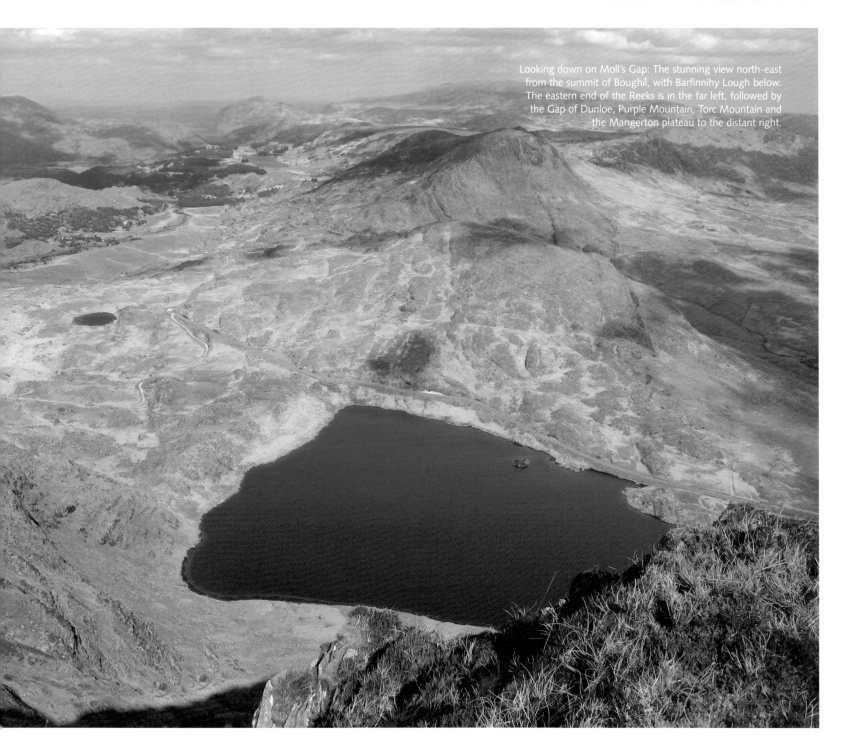

Looking down on Moll's Gap: The stunning view north-east from the summit of Boughil, with Barfinnihy Lough below. The eastern end of the Reeks is in the far left, followed by the Gap of Dunloe, Purple Mountain, Torc Mountain and the Mangerton plateau to the distant right.

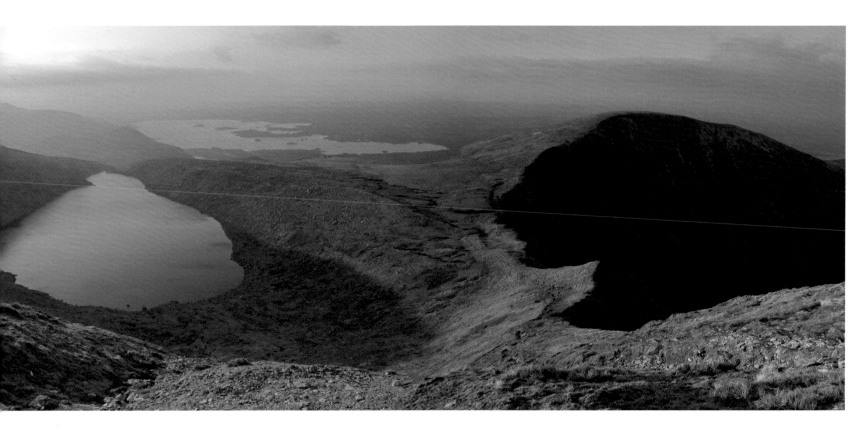

There is another area in the Iveragh Peninsula full of coums, all north-facing, and whose high ground forms a semicircle of mountains just south-west of Glenbeigh, near Killorglin. Its summits mostly rest on a gentle plateau away from menacing cliffs that bedeck its shadowy, northern flanks. On its eastern end is a grassy top, Meenteog (715m/2,346ft), which sits above a lake. The all-encompassing view of distant mountains on the peninsula more than compensates for the relative flatness of its summit area. During one of my many visits here, I wandered off its ochre moorland slopes, stopping above a devilish gully overlooking Coomacullen Lake, with another yet larger lake poking around the corner beyond. The sky was a paintbrush blue and like a visitor to an art gallery, I lingered for some time, observing its depths, before continuing toward the summits of Coomacarrea (772m/2,533ft) and Teermoyle Mountain (760m/2,493ft).

A sharp ridge falls off Teermoyle Mountain with large lakes on either side – Coomaglaslaw Lake on one and Coomasaharn Lake on the other. I stood on one of its pointy edges and looked down at the end of Coomasaharn. A local tradition speaks of travelling Mayo hunters killing the last wolf in Ireland for a meagre £5 bounty in its rocky corner. There are many such claims in other areas, but there is one thing no one could dispute and that is the priceless view north, one of mountains and sea that stretched across the horizon.

Dingle was calling.

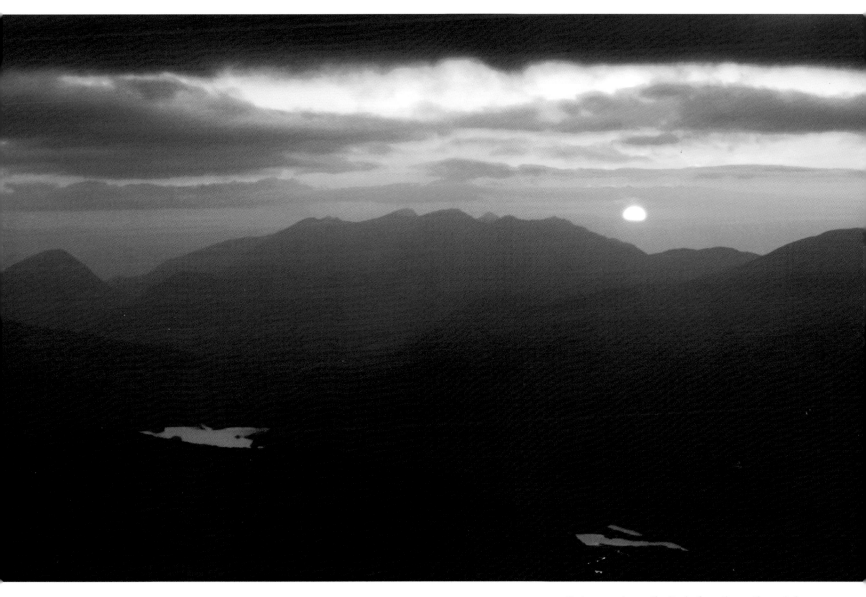

Spring sunset over the Reeks from the north-west slopes
of Mangerton: An inspiring spectacle in the stillness of
the hills. Broaghnabinnia is the pointed peak on the left.

Opposite The Devil's Punchbowl and the ridge above
the Horses Glen, catching the last rays of the sun, as
seen from the northern rim of the Mangerton plateau.
Lough Leane is the patch of water in the distance.

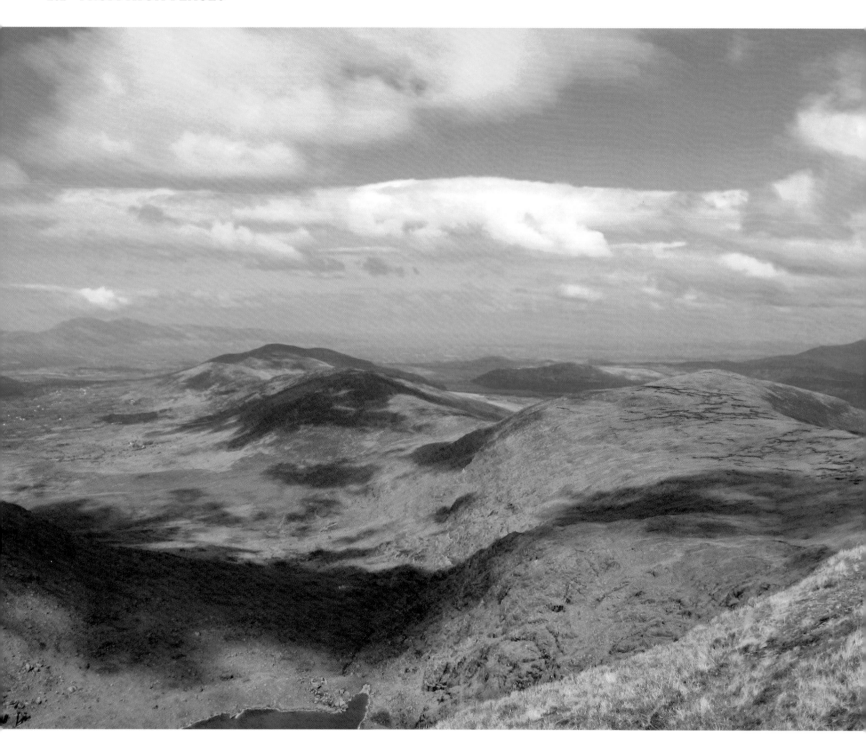

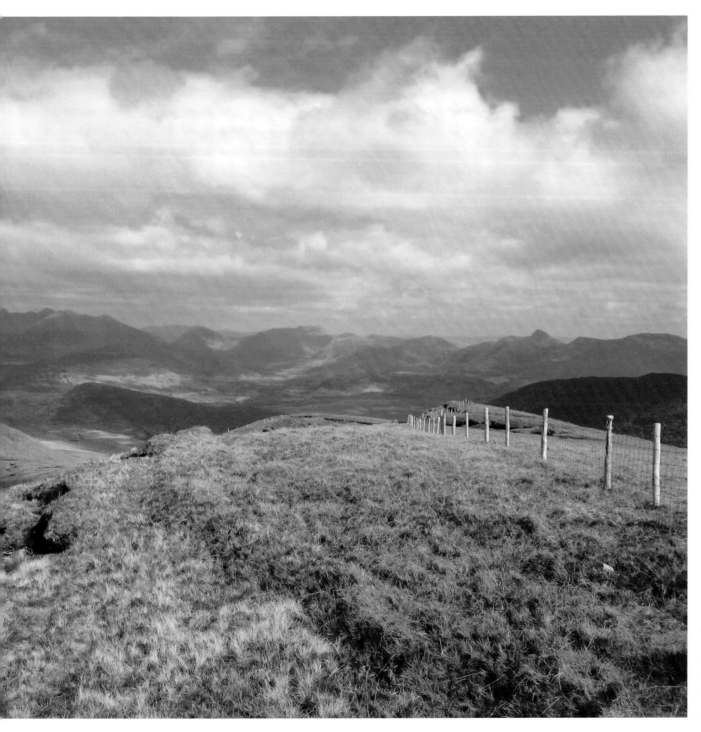

The dazzling Iveragh panorama looking eastward from the summit of Meenteog, a broad grassy mountain that sits above the hollow of Coomasaharn.

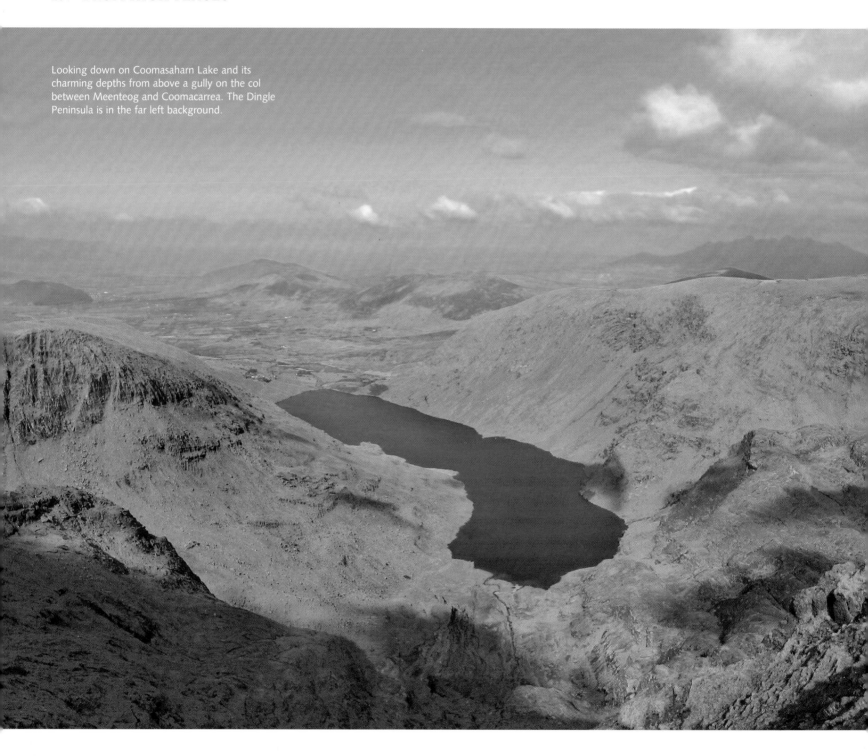

Looking down on Coomasaharn Lake and its charming depths from above a gully on the col between Meenteog and Coomacarrea. The Dingle Peninsula is in the far left background.

DINGLE: MOUNTAINS AND THE SEA

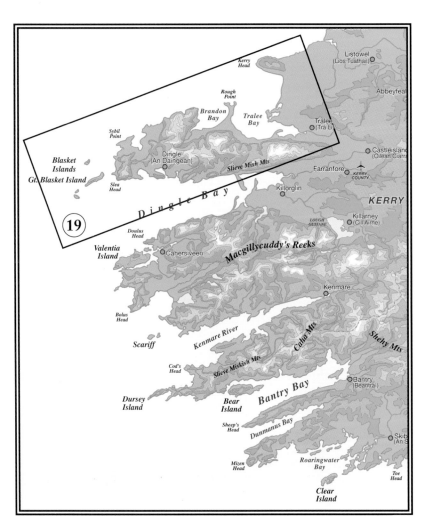

On the brow of Brandon is mist, and rest
from the racing sky:
the rollers break upon Brandon,
Brandon the blessed,
and the seagulls cry.

Geoffrey Winthrop Young

The wind tore incessantly at the flysheet, buffeting the tent and causing its poles to shudder like a ship caught out in stormy waters. The rumble of thunder in the night sky reminded me of planes that crashed in this area in the 1940s. We were camped for the night amidst rocky outcrops above Lough Nalacken, on a patch of level ground near a stream. The stream was a timid affair only hours ago, but now it roared like the Niagara Falls, its might rivalled only by the lashing rain beating on the roof of our tent, which was getting ever closer to our faces as we lay flat on its floor. My tent companion started to worry about the sound of rushing water close to its sides. I stuck my head out to look, and under the beam of light from my head-torch, saw countless cascades tearing down the dark eastern walls of Brandon Mountain like a swarm of bees. But we were safe; the cascades were flowing away from our tent.

In the early hours of dawn, the tempest subsided, and the wind continued to howl but only like a tired animal. Our tent stood the test of storms. There was no sunrise that morning, only a shroud of grey. The fleeting mist created a powerful atmosphere over the Paternoster Lakes, which stretched like a beaded chain over a series of rocky valleys perched one over the other. The valleys rose to an amphitheatre of sorts, an arena of rock whose heights are the towering flanks of the ridges that loomed above – Faha on one, Brandon on the other. The summit of Brandon Mountain (952m/3,123ft) along with its trig point, cairn, cross, stone oratory and holy well, as many locals will say 'was wearing its cap that day'.

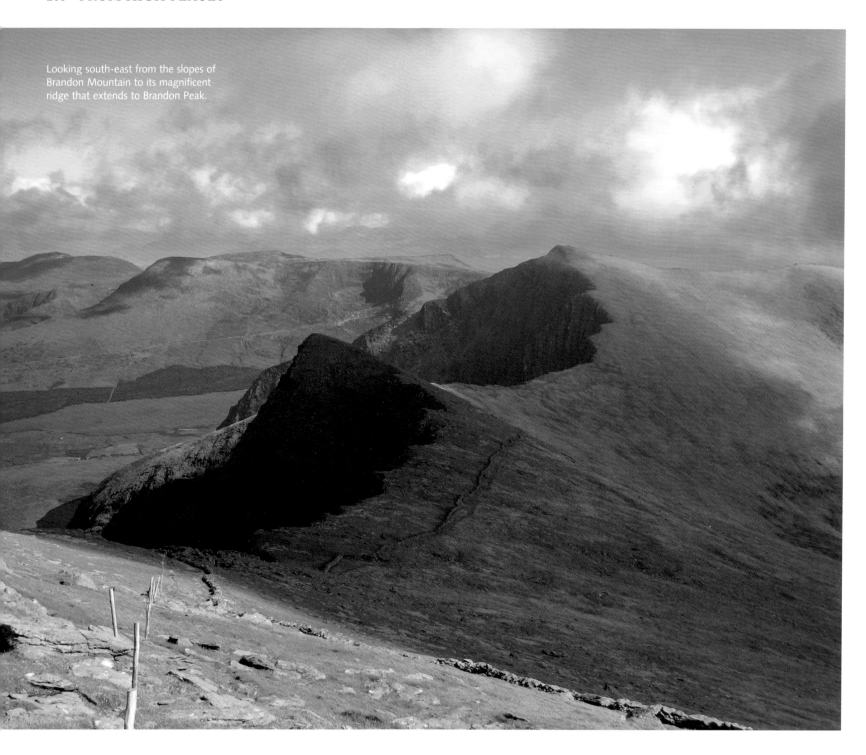

Looking south-east from the slopes of
Brandon Mountain to its magnificent
ridge that extends to Brandon Peak.

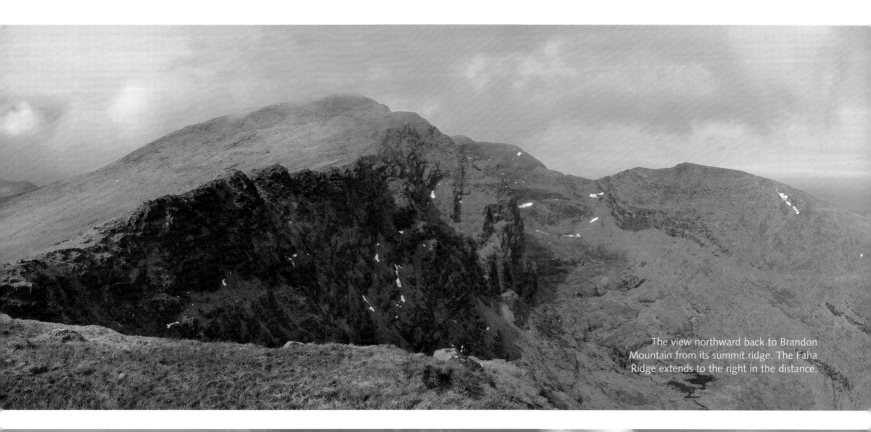

The view northward back to Brandon Mountain from its summit ridge. The Faha Ridge extends to the right in the distance.

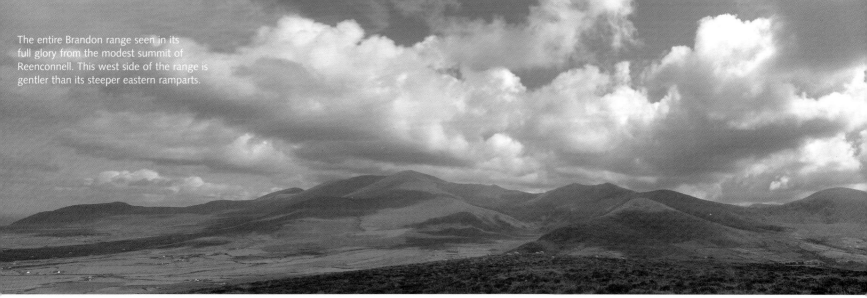

The entire Brandon range seen in its full glory from the modest summit of Reenconnell. This west side of the range is gentler than its steeper eastern ramparts.

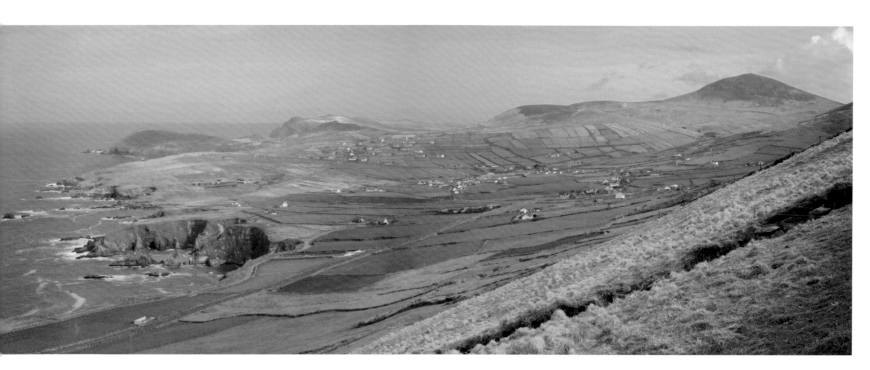

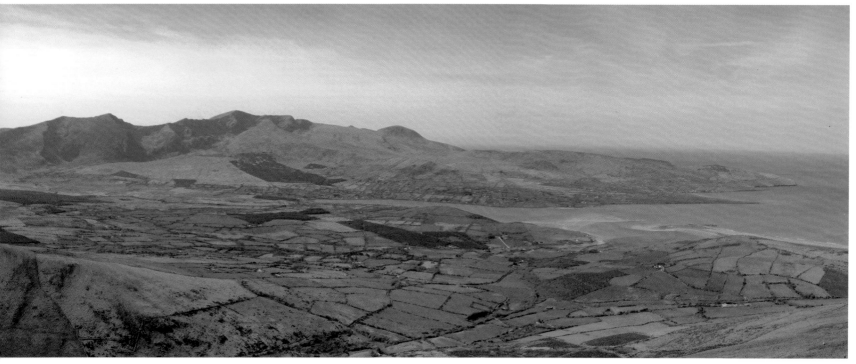

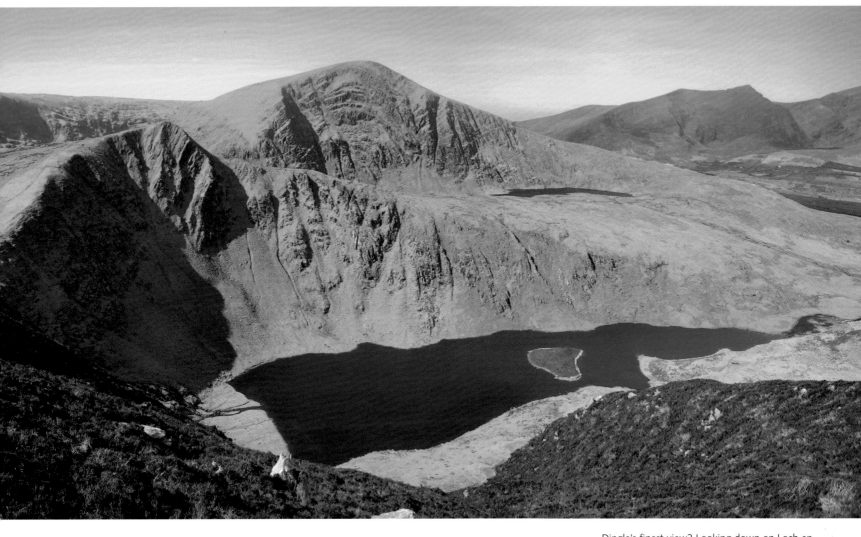

Dingle's finest view? Looking down on Loch an Duin from the summit of Slievenagower. The sharp peaks of Slievenalecka and Slievanea North-east Top rear up behind the lake, while part of the Brandon ridge sweeps the skyline to the far right.

Opposite from top
The west Dingle coastline as seen from western slopes of Mount Eagle. The mountain on the right is Cruach Mhárthain, on whose slopes the village of Kirarry in the film *Ryan's Daughter* was built.

Looking toward the craggy east face of the Brandon range from the summit of Binn an Tuair, a fabulous vantage point above the Glennahoo River and Maghanaboe Valley.

I consider myself lucky, as it 'wore its cap' on just three out of my seven ascents over the years, although I did once climb it twice the same day to be rewarded with a clear view from its summit, which is an irresistible cocktail of mountains and the sea. Brandon Bay curves into a cluster of hills in the distance, its stature beaten only by the razor-sharp tail-end of the Faha Ridge that soars up to Brandon's elevated heights. Only the peaks of the MacGillycuddy's Reeks are higher than Brandon Mountain, whose ridge extends northward over Piaras Mór (748m/2,454ft) and Masatiompan (763m/2,503ft) to fall into the Atlantic in a sweep of sea cliffs that are fractured by lonely coves at Brandon Head.

An old pilgrims' road rises along a stony path marked by a series of white poles from Brandon's western slopes. It bears the name *Cosán na Naomh*, or 'the path of the saints'. Many follow this route today to arrive at the summit of Brandon to be greeted by a powerful vision of the sea. The blue Atlantic is a striking feature, a medium for contemplation and a symbol of curiosity as the mind wonders, 'what of the land on the other side?' And perhaps, so did St Brendan, when he stumbled on the summit in the sixth century. Maybe the same wonder filled him with a desire so overpowering he was convinced to set sail in a tiny leather curragh from Brandon Creek, with a band of pilgrims, to seek out this Promised Land.

And so it came to pass that the mountain was named after St Brendan, for *Cnoc Bréanainn* or Brandon Mountain, is recorded as an entry for AD1063 in the *Annals of the Four Masters*. However, the *Book of Lismore*, a fifteenth-century Irish vellum manuscript, mentions it as *Sliabh n-Daidche*, in its section *Betha Brenainn meic Fhinnlogha* (The Life of St Brendan). Dr Alan Mac an Bhaird, formerly a place names officer with *An Brainse Logainmneacha* (The Placenames Branch) in Dublin, has ingeniously identified *Sliabh n-Daidche* with Brandon. This idea has been developed by Paul Tempan, a researcher of Irish mountain names at Queen's University Belfast, who argues that this makes it possible to relate the mountain to the Latinised form *Mons Aitche*, and from here to *Faithche*, or Faha, the name of a townland on the mountain's eastern slopes and that fearsome ridge on the same side.

From the top of Faha, the ridge rises to Brandon Mountain, and from there it slithers south-east like a prehistoric sea reptile that boasts sharp, angular fins. The contrast between the wild and the tame on the ridge is profound, especially close to the edge, beyond the safety net of its wall and fence. A yawning chasm gapes to one side, ending in the deep-blue beads of the Paternoster far below, reminding me of the words of Friedrich Nietzsche, '…when you gaze long into an abyss, the abyss gazes also into you'. A green nirvana of gentle slopes, wide valleys and glistening streams breaks this spell. This exhilarating section reaches a crescendo on the steep, rocky ascent to the summit cairn of Brandon Peak (840m/2,756ft), where all the mountains on Dingle seem to come together. The ridge now meanders southwards, over a narrow grassy ridge at first, then broadening to rise at Ballysitteragh

(623m/2,044ft) before finally dropping eastward to the top of the Conor Pass, nearly 10km/6miles away from Faha.

A narrow road winds along the Conor Pass by the steep mountainside, linking the peninsula's northern and southern ends. Workers involved in the construction of this road, built as part of famine relief efforts, were fed only soup as rations. The watery liquid had fewer calories than they burned, so ironically they perished sooner than they would have without working for those rations. There are probably many hidden secrets buried under the peat bog along the Conor Pass. Around 1950, the body of a child was found near here, preserved in the peat. She was believed to be from the seventh or eighth century, had red hair, wore a dress and held a purse in her hand. The top of the pass reveals a peninsula of stunning contrasts: blue lakes, brown mountains, green valleys, russet heathery slopes, blanket bog, ancient field-systems, scattered villages and a blue bay.

From the air, the Dingle Peninsula points to the sea like an outstretched finger, extending from Tralee to Dunquin at its western end for about 65km/40miles. Thirteenth-century records show the names of Dingle and *Daingean Uí Chúis* used in tandem. There are two interpretations of the meaning of its Irish equivalent. The *Annals of the Four Masters* refer to a chieftain named O'Cuis who governed the area before the 1169 Norman invasion. However, it can be also taken to mean 'fortress of the Husseys', named after the arrival of a ruling Flemish family shortly after the invasion.

There is yet another name. It is found as a series of slashes carved across the edges of standing stones found scattered around the peninsula. This alphabet system is primitive, dating back to the fourth century, and is named after Ogma, the Celtic god of eloquence. The name *Duibhne*, one of the Celtic goddesses associated with fertility and protection is inscribed on several of these ogham stones. Such names are traditionally used as markers defining land boundaries, so the peninsula then was known as *Corca Dhuibhne*, or 'Duibhne's tribe'.

An ogham stone stands by a large stone cross and ancient sundial in a graveyard at Kilmalkedar. There is a church here of Irish Romanesque architecture, sitting on a site that dates back to the seventh century. A bank of fuchsias, red-violet flowers hanging down on stalks, follows the *Cosán na Naomh* pathway by a stone wall and a flame of yellow gorse. The gently sloped path creeps up the hillside to a flat expanse of windswept grass and wild heather. Its highest point, at 274m/899ft, is modest, but the summit of Reenconnell makes an excellent vantage point to appreciate the entire sweep of the Brandon range with a minimum amount of effort. The low-lying range of hills at the western end of the peninsula, rising beyond the extended arm of Smerwick Harbour can also be seen: Mount Eagle (516m/1,693ft) is to the far left and Cruach Mhárthain (403m/1,322ft), on whose slopes the Kirarry village of *Ryan's Daughter* was built, rises like a brown pap.

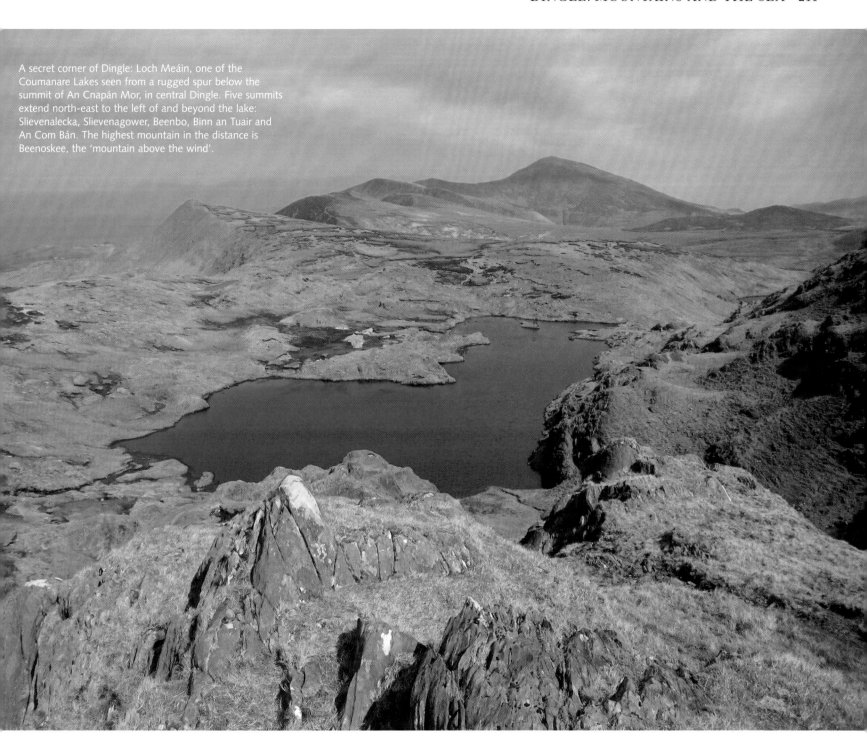

A secret corner of Dingle: Loch Meáin, one of the Coumanare Lakes seen from a rugged spur below the summit of An Cnapán Mor, in central Dingle. Five summits extend north-east to the left of and beyond the lake: Slievenalecka, Slievenagower, Beenbo, Binn an Tuair and An Com Bán. The highest mountain in the distance is Beenoskee, the 'mountain above the wind'.

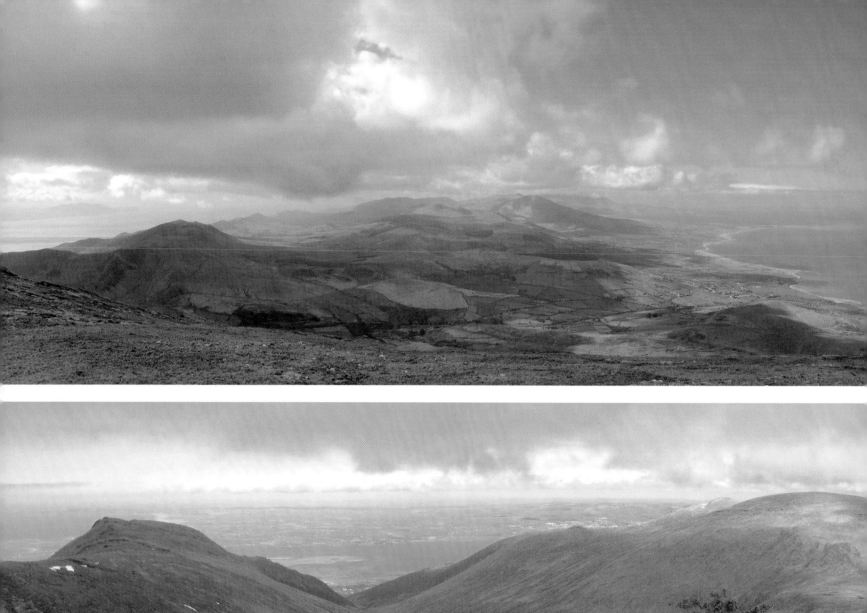
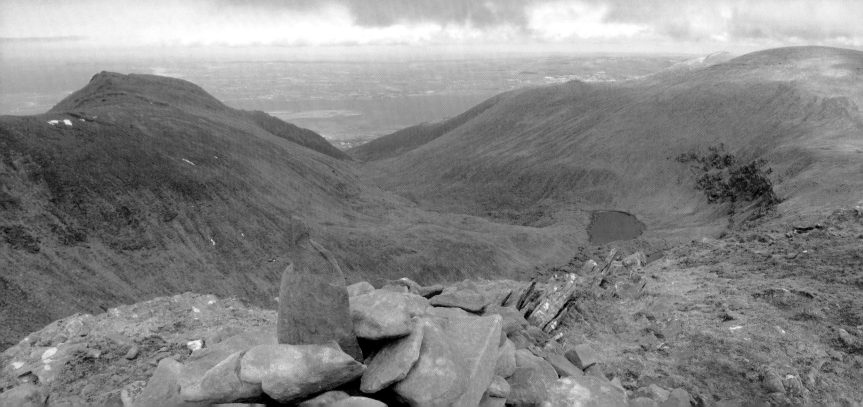

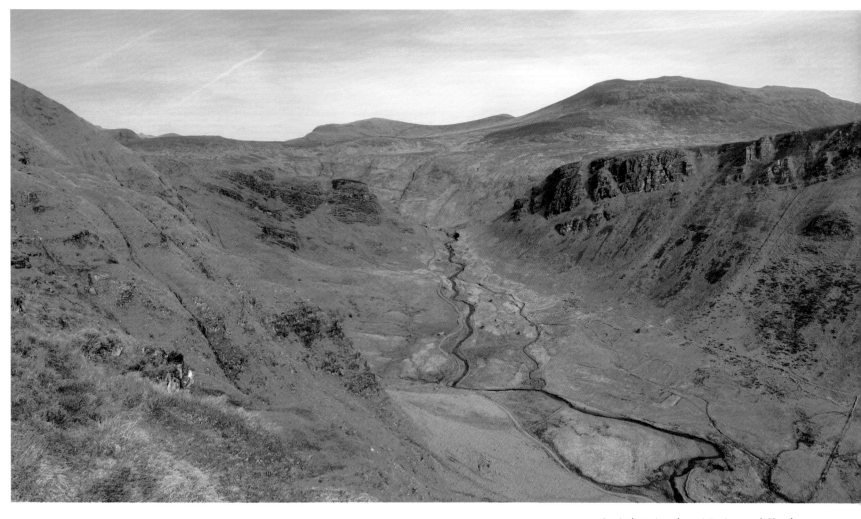

A priceless view down into Anascaul Glen from above the Carrigblagher Cliffs. The summits of Beenoskee and Stradbally Mountain loom above the Reamore cliffs to the right.

Opposite from top
A absorbing view of mountains and the sea: Looking west toward the Dingle Peninsula from the north ridge of Caherconree in the Slieve Mish Mountains.

Looking down into Derrymore Glen, flanked by the tops of Gearhane (left) and Baurtregaum (right), from the summit of Caherconree.

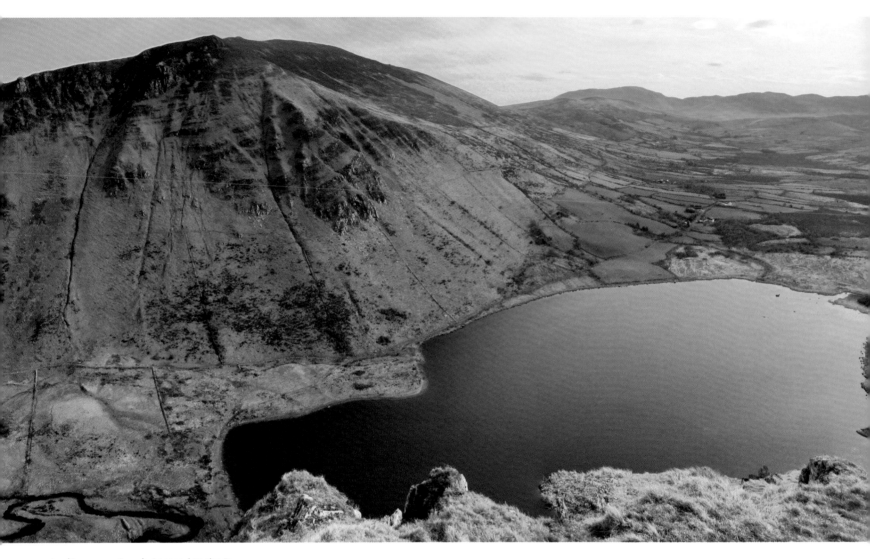

Looking across Lough Anascaul to the Reamore cliffs and Dromavally from high on the eastern spur of Cnoc Mhaoilionáin.

DINGLE: MOUNTAINS AND THE SEA 215

There was a time during the Iron Age when ancient settlers celebrated the Celtic harvest on Brandon; a ritual known as *Domhnach Crom Dubh*, in honour of the Celtic god Crom Dubh. A graveyard lies south of Brandon Bay, in the townland of *An Bhaile Dubh*, whose name relates to this same god. A narrow valley runs south-east from here, boasting an air of sanctity to match the gods. The Glennahoo River twists and turns along its floor in the shadow of slopes on both sides. The valley is the Maghanaboe, where cattle once grazed and families eked out a living by the ruined stone buildings at its very back in the nineteenth century. From here, the stream ascends into the throne of the gods, cutting its way sharply up a gully in the pear-yellow hillside. A cascade tumbles down a secluded corner of the hill, clear waters galloping over wet sandstone rock-shelves, missing only the scrubby holly trees and fraughan clumps that are strung along its sides.

A green road leads up to a higher plateau and then westward over trackless ground that is driest across its northern fringes. The ground crests the heathery hills of Beenbo (474m/1,555ft), shaped like an eagle's beak and Slievenagower (484m/1,588ft). The view from the summit of Slievenagower must be regarded as one of the finest on Dingle. The Brandon ridge sweeps the skyline to the far right and fang-like peaks rear up in front. A deep-blue lake stretches out for about a kilometre beneath. A small island, a crannog perhaps, sits on a patch of green except for a thin strip of sandy shore circling its perimeter. It sits on the lake as a silent fortress, forever isolated from dry land.

The crannog reminds me of the stone fort of *Cú Roí mac Daire*, the mythical figure of the Ulster Cycle of Irish Mythology, on the south-western slopes of Caherconree. Cú Roí kept a mistress called Bláthnaid there, a woman he snatched from faraway lands, and using magical powers he could command its fortress walls to spin, keeping intruders out. But one day Bláthnaid deceived him, and signalled to her beloved, Cú Chulainn, that the fort's defences were down by pouring milk that speckled the Finglas River white. Cú Chulainn burst into the fortress in the clouds with his men and slaughtered Cú Roí.

The summit of Caherconree (835m/2,739ft) sits in the Slieve Mish Mountains on the eastern end of the Dingle Peninsula. It is a mountain range named after Mis, a Milesian princess who was driven to madness after her father perished during a battle. I've walked the secluded Derrymore Glen that leads to its upper reaches following a gorge several times. Its southernmost depths are a stunning amphitheatre – hidden valleys that rise and rise again, each time revealing a lake, and sometimes sandstone boulders the size of houses. It is a world apart from Tralee, and to explore it is like entering a different dimension. From the back of this valley, I once ascended a grassy slope to arrive at the top of a spur just north of Caherconree's summit. I was blessed with a view that was all-consuming: an intricate web of light and shadow, of cloud and sky, and of land and sea. A string of mountains stretched toward the Atlantic – the Brandon range in the distance and the hills around Anascaul closer at hand.

A quiet road at Anascaul village crosses a stone bridge near the Tom Crean South Pole Inn and meanders northward to a lake flanked by sheer cliffs. It's a remote location, and one that the polar explorer himself probably did not visit prior to his enlistment with the Royal Navy just before the age of sixteen. The village and the lake are named after Scál Ní Mhurnáin, another one of Cú Chulainn's many women. Scál was taken captive by a goliath and held at the remote lake of Anascaul. Cú Chulainn rampaged toward the high ground above Dromavally and hurled fiery boulders at the goliath, who stood on the opposite side on Cnoc Mhaoilionáin. The tirade of boulders went on until Cú Chulainn suddenly gave a loud groan. Scál presumed her lover was struck, and in grief she drowned herself in the lake.

A path winds its way between these fractured cliffs, twisting beside a fountain of cascades to a higher valley. During one visit, however, I took a different course, ascending rock-strewn slopes and scrambling up a gully near the Carrigblagher cliffs. It led me to the top of a spur high above Lough Anascaul, giving a bird's-eye view of the wide valley to the north. It was windy by the lakeshore, but the air remained oddly still up higher. That may seem strange, but perhaps the cliffs of Reamore and the summit of Beenoskee (826m/2,710ft) were also 'above the wind' on the opposite side. I wandered on up to the twin cairns of Cnoc Mhaoilionáin (593m/1,946ft). The Dingle Peninsula was an oasis of calm that morning, and its mountains filled my scope of vision to the west, north and east, leaving me entranced. Dingle Bay also held me in its spell; I looked south-east across its blue waters and wondered if it was windier on the peaks of the MacGillycuddy's Reeks.

PEAKS OF THE REEKS

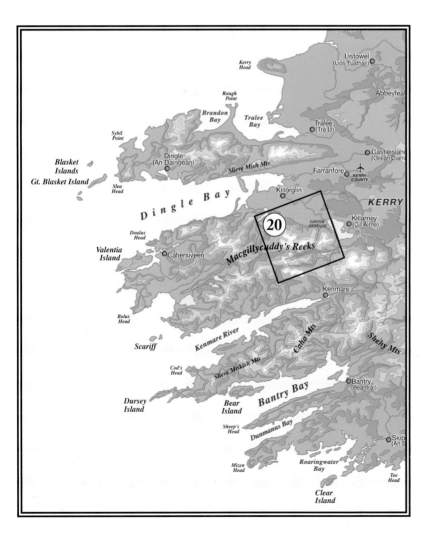

I saw the summer sun go down behind the sea,
And o'er the pale moon grow a golden light,
From lonely Caran-tual's topmost height
Towering aloft in cloudless majesty;
The serried hills beneath seem in the night
Like billowy ocean, heaving in its might
And turned to stone; while far as eye can see
The lengthening shadows o'er the surface flee.

Thomas Gallwey

I thought of the man from Ballyledder who toiled for years, it was said, to bring cement, gravel and water to these heights in the 1970s. A friend and I were scrambling up a boulder field in a mountain recess called Cummeenapeasta. It is likely that the man might also have ascended these punishing slopes, hauling plastic bags filled with water from the lake in its hollow. The locals attributed the area to serpents, but the only demon of the day was of the sky. Thick grey mist swirled over the eastern end of the MacGillycuddy's Reeks, lending it a sombre tone, broken only by bright-red flurries of tiny apothecial rings of devils matchsticks growing in rocky corners. The mountains here are rather special, not just in shape and form, but also in height, for they are home to Ireland's highest peaks.

The mountain range of the Reeks stretches for about 15km/9miles from Kate Kearney's Cottage at the Gap of Dunloe to the blue recesses of Lough Acoose further west. The range is named after the servant-son of Cuddy, a former local landlord in the area, but in Irish it is known as *Na Cruacha Dubha*, or 'the black stacks'. Nine of the ten highest mountains in Ireland sit in this range, with only Brandon Mountain in Dingle breaking its stronghold. These nine peaks boast of Munro standards, those exclusive summits over 3,000ft in Scotland named after Sir Hugh Munro.

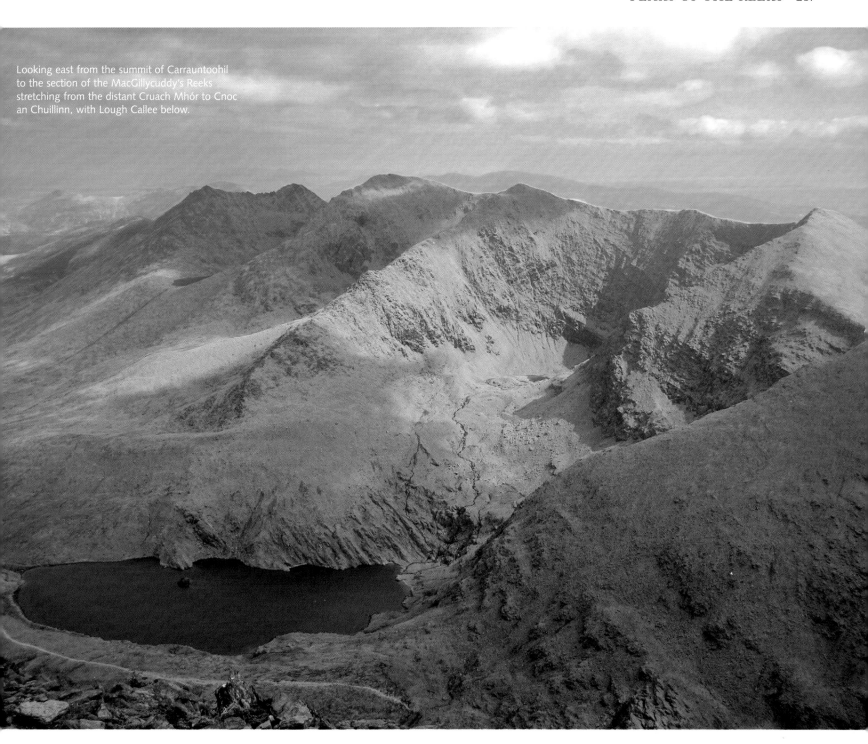

Looking east from the summit of Carrauntoohil to the section of the MacGillycuddy's Reeks stretching from the distant Cruach Mhór to Cnoc an Chuillinn, with Lough Callee below.

We edged up the boulder field and soon arrived at the stone grotto, the handiwork of the Ballyledder builder, marking the summit of the big stack of Cruach Mhór (932m/3,058ft). The lake below drifted in and out of view as we waited around in the hope of some clearance from the skies. I once read somewhere that a plane's wing can sometimes be seen gleaming under its watery depths. On a tempestuous night during the war in December 1943, an American C47 transport plane flew off course, mistaking the south-west of Ireland for that of England. A violent explosion erupted on the unforgiving cliffs above the lake in the ensuing snowstorm that ravaged the bitterly cold dawn. None of the five-man crew survived.

The waiting was in vain. Just as we thought it would clear, grey clouds swallowed the mountain up again. It was time to press on along the ridge's rocky crest, a stretch adorned with sharp pinnacles, or *gendarmes*, to the summit of the Big Gun (939m/3,081ft), and then along a knife-edge *arête* to a higher summit, Cnoc na Péiste (988m/3,241ft). A man called Isaac Weld was led by local guides to these lofty heights and writes of a dozen eagles hovering by in a gunshot in his book *Illustrations of the Scenery of Killarney and the Surrounding Country* published in 1812. Weld, a topographical writer, explorer and artist born in Dublin, was to be involved in a chain of events that must surely go down as one of the classics in the annals of early Irish mountaineering.

Before the nineteenth century, the MacGillycuddy's Reeks was virgin territory; nearly no one scaled its peaks, nor were there conclusive barometrical measurements to ascertain its heights. Before Weld's time, Dr Charles Smith, a pioneer in Irish topography, wrote in his 1756 book *The Antient and Present State of the County of Kerry* that the Reeks seemed to be higher than Mangerton, the mountain south of Lough Leane, near Killarney. But then he discredits it, suggesting that conical hills 'appear' higher farther away than broad mountains like Mangerton. We all now know, of course, that Mangerton is nearly 200m/656ft lower than the highest mountain in the Reeks.

Weld, in the company of guides, crossed Lough Leane to Benson's Point, and then clambered up rocky slopes, hanging on to oak saplings, to reach a broad meadow where hundreds of cattle grazed. After hours of toil, they finally reached what Weld thought was the summit of *Gheraun-tuel*, the highest mountain in these parts, and in fact, all of Ireland. Weld speaks of the mountain's shape being wedge-like, and the ridge leading to its summit being so narrow that they could drop stones into its terrifying depths from each hand simultaneously. Stones rolled

On one of the pinnacles near the summit of the Big Gun looking along the section of ridge toward Cruach Mhór.

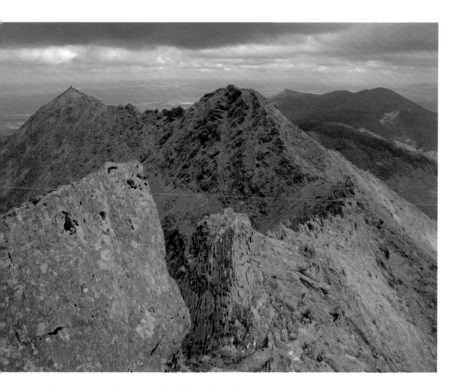

The narrow *arête* connecting the peaks of
Cruach Mhór, the Big Gun and Cnoc na
Péiste, as seen from below its summit.

down the crest, catapulting rocks, its gravitational fall giving a thunderous roar that echoed from one peak to the next, then dissipated, but only to explode again from the abyss below. Aware of the vast precipice on both sides, the men cautiously scrambled to the small summit of *Gheraun-tuel*.

Back to the present: by the time my friend and I reached the summit of the Big Gun, we had walked in the footsteps of Weld and his guides. But what Weld thought was *Gheraun-tuel* was in fact the Big Gun, and the edge of its precipice was the closest I got to flying. The clouds and mist that enveloped the morning had dispersed, now clear skies rewarded us with a sublime view of the Reeks. It was at this point that Weld noticed a higher peak ahead, but his guides suggested it was an optical illusion. At any rate, it was out of reach for the men of the time, as Weld writes that the 'intervening precipices were impassable'. The ridge from the Big Gun to Cnoc na Péiste is sharp like the edge of a knife and to faithfully crest it is a breathtaking experience, made even harder under snow and ice conditions.

We left the Big Gun with our senses engaged, scrambling down on to the airy ridge. At a midway point, I convinced my friend to crest the *arête*, and so we did; our feet and hands on grey sandstone rock as sharp as the teeth of a saw. A final sting in the tail led up to a rock-pile on the grassy summit of Cnoc na Péiste, the 'serpent's hill'. We ambled along the grassy ridge to the yellow flat-top of Maolán Buí (973m/3,192ft), descended a spur known as the Bone before stopping in the shelter of a rocky niche. The view westward was engaging: the moth-like shapes of Lough Callee and Lough Gouragh sitting in the Hag's Glen, below two of the highest mountains in Ireland.

From here Carrauntoohil looks like a pointed fang, which compliments Weld's use of *Gheraun-tuel*, from the Irish form *Géarán Tuathail*, meaning 'Tuathal's tooth or fang'. Astonishingly, no trace of this name remains, for the mountain is now known in Irish as *Corrán Tuathail*, widely publicised in meaning 'inverted sickle'. Tuathal was also one of the most popular names in medieval Ireland; it occurs in town-names like *Lios Tuathail* (Listowel) in County Kerry, for example.

Weld's feelings of jubilation about climbing *Gheraun-tuel* were dashed as soon as he descended from the Reek's great heights. An old grey-haired man challenged Weld by saying that if it had indeed been *Gheraun-tuel*, they would not have returned before dark. They stood outside a cottage near the Upper Lake, and Weld retraced their route with the Reeks in view. The old man then surprised Weld by saying that *Gheraun-tuel* stood above those peaks, and was invisible from where they stood. Weld's guides argued, of course, but the explorer's senses prevailed – he had to try again.

At daybreak the next day, Weld left with another guide, trudging along a lake-filled valley due west of the Upper Lake. They then ventured into another remote valley on the right and ascended a steep slope of firm grass to a broad summit; and from there Weld saw, for the first time, the conical head of *Gheraun-tuel*. They then walked for miles along the ridge until reaching the edge of a bottomless abyss. Here, Weld noted that *Gheraun-tuel* was connected to another mountain that resembled a stone fort by a narrow ridge. Weld stepped up the final slopes to gain the summit of his dreams, and from there he looked down on all of the Reeks, and appreciated the mountains he had previously climbed to indeed be lower.

Weld's ascent of Carrauntoohil took him seventeen hours, an admirable accomplishment at the time. Today, there are several routes to scale this mountain without resorting to rock-climbing, my two favourites being the Coomloughra Horseshoe from the west, and via a remote rocky valley leading to the base of O'Shea's Gully from the north. The Coomloughra route forms a circuit around its hourglass shaped lake, and is one of Ireland's classic routes taking in three of its highest peaks: Carrauntoohil (1,039m/3,409ft), Beenkeragh (1,010m/3,314ft) and Caher (1,001m/3,284ft). I once arrived at the summit of Beenkeragh one sunny

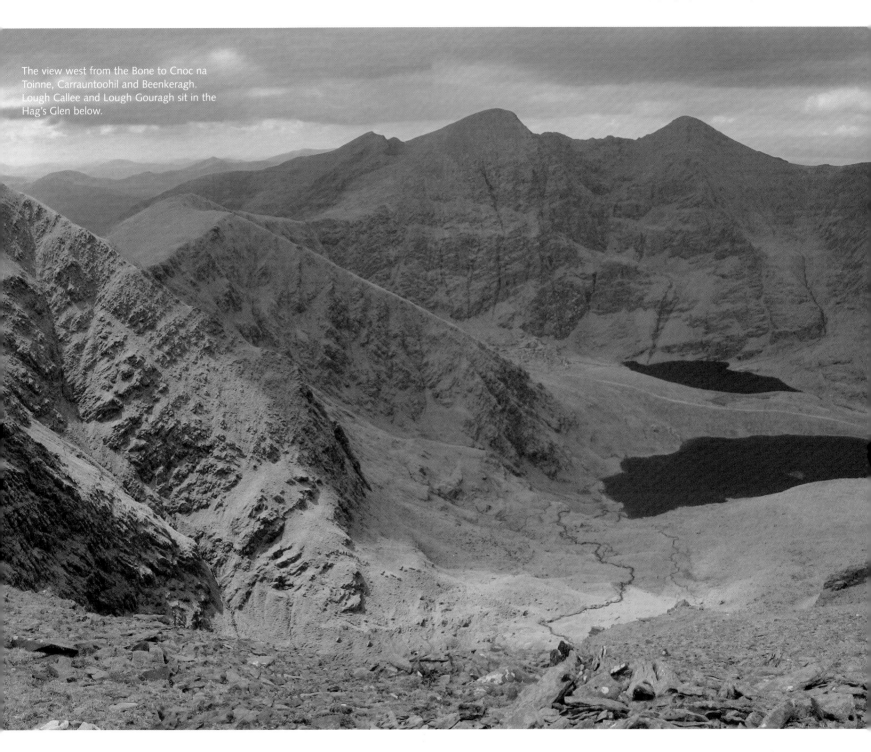

The view west from the Bone to Cnoc na Toinne, Carrauntoohil and Beenkeragh. Lough Callee and Lough Gouragh sit in the Hag's Glen below.

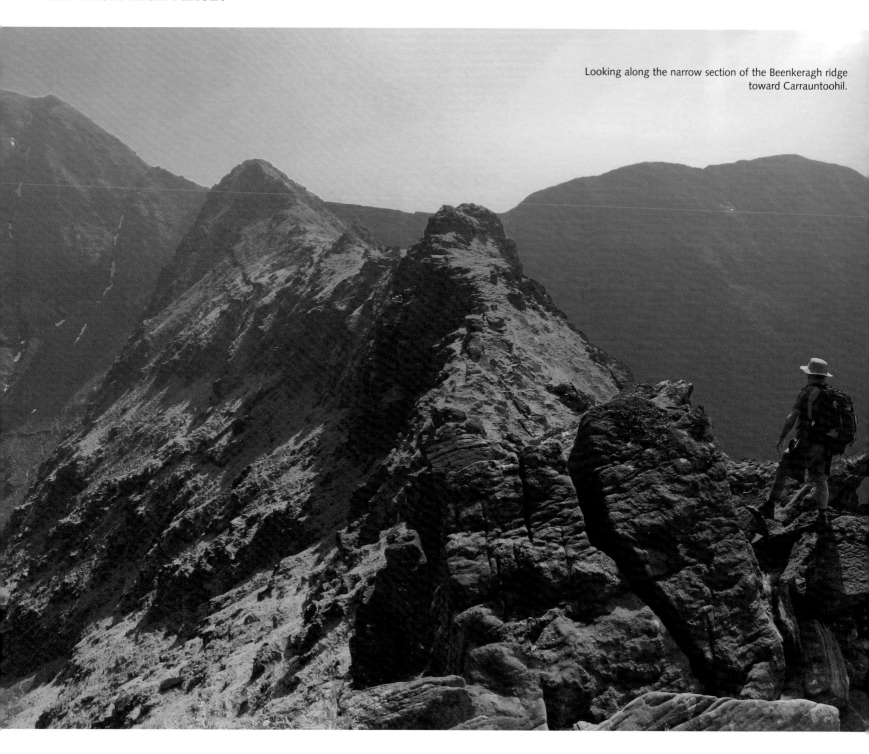

Looking along the narrow section of the Beenkeragh ridge toward Carrauntoohil.

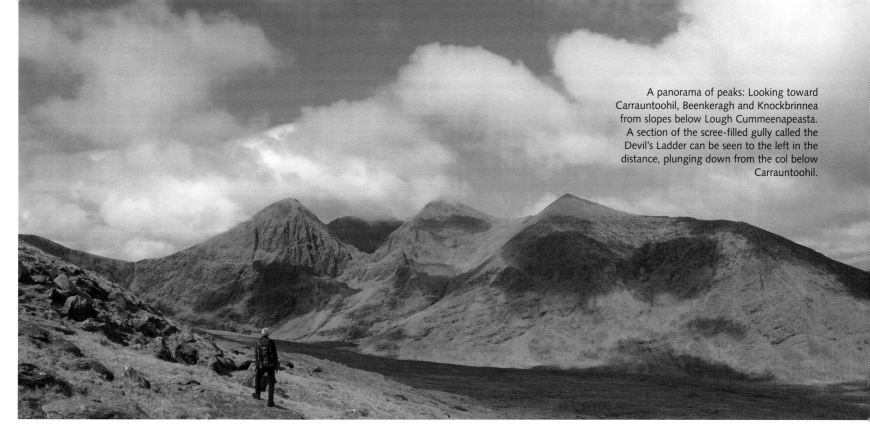

A panorama of peaks: Looking toward Carrauntoohil, Beenkeragh and Knockbrinnea from slopes below Lough Cummeenapeasta. A section of the scree-filled gully called the Devil's Ladder can be seen to the left in the distance, plunging down from the col below Carrauntoohil.

spring morning to find two men sitting on its rocky perch. They were elated to have got this far, but weren't too keen about the narrow ridge ahead. I persuaded them to follow me, citing that it would be worth the effort. They did.

Minutes later we were traversing along Beenkeragh's teeth-like crest, at times getting our hands warmed by the rough sandstone rock, wary of the precipices on either side. Eighteenth-century annals suggest goatherds once grazed its slopes, only to be replaced by sheep after the famine, and thus giving the mountain its name, 'peak of the sheep'. Halfway along, after a downward scramble on rock, we arrived on a saddle that marked the top of O'Shea's Gully. We didn't descend, but continued south-east, over rocky ground to finally emerge on the summit of Carrauntoohil. Unlike Weld's time, a metal cross, erected in 1976, now stands at the summit. Its surface is charred black, due to lightning strikes, but it has stood the test of time unlike the timber cross before it.

As we sat in a stone shelter near the summit, one of the men remarked how peaceful and quiet it was compared to other peaks, like Snowdon in Wales for instance. The sound of traffic was non-existent, no voices but ours filled the air and a peculiar kind of stillness matched the view around us. It is times like these that make Carrauntoohil a cut above the rest, and I for one savour such precious moments in her bosom.

Late another evening, I set off with the intention to spend a night in the Reeks, and to summit Carrauntoohil before dawn. I followed the track that led south-west from Cronin's Yard, crossing the new bridges that spanned the Gaddagh River and one of its tributaries. I was headed for the Hag's Glen, the abode of *An Cailleach*, a powerful Celtic goddess of creation and destruction, and a protector of the wild. I thought of the poor souls who lived in this remote glen during the Famine as I ascended the steep ground above Lough Gouragh. Familiar sights greeted me in the evening light: the tooth-like feature of *Stumpa an tSaimh*, the terrifying Howling Ridge and the scree-filled gully of the Devil's Ladder.

I scrambled up a series of rock steps to Cummeeneighter, a flat green arena surrounded by towering grey cliffs. A jagged ridge ran like a dragon's back above to my right and a giant cascade rocketed down sandstone slabs from a higher valley above. There, crags towered above a scree-worn path that led to Cummeenlour, the middle coum. I pushed on higher into the jaws of the mountain, ascending to a third valley that sheltered a sapphire-blue lake.

There, at Cummeenoughter, under the shadow of Carrauntoohil, and with O'Shea's Gully rising ahead, I pitched my tent.

It was home for the night, and I was glad to be back.

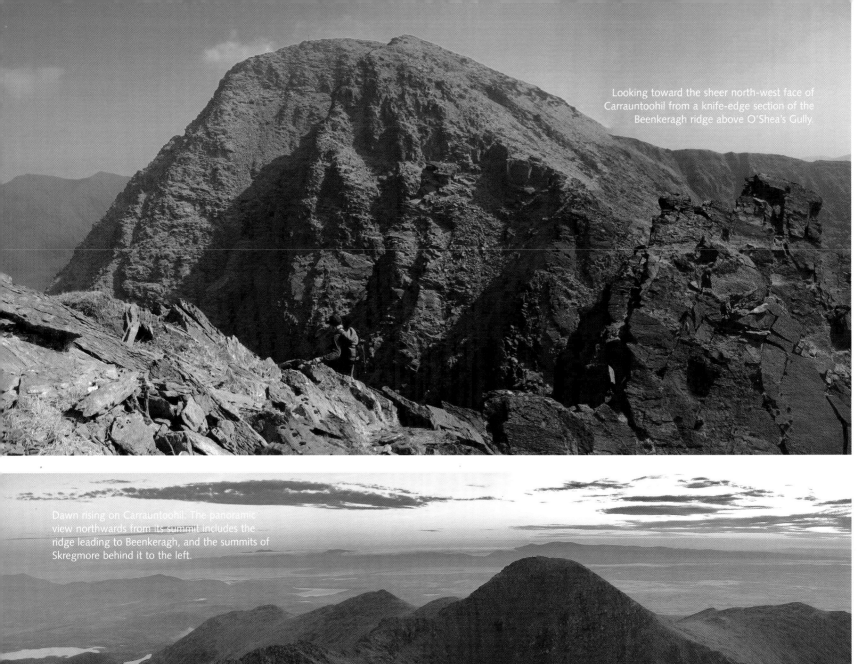

Looking toward the sheer north-west face of Carrauntoohil from a knife-edge section of the Beenkeragh ridge above O'Shea's Gully.

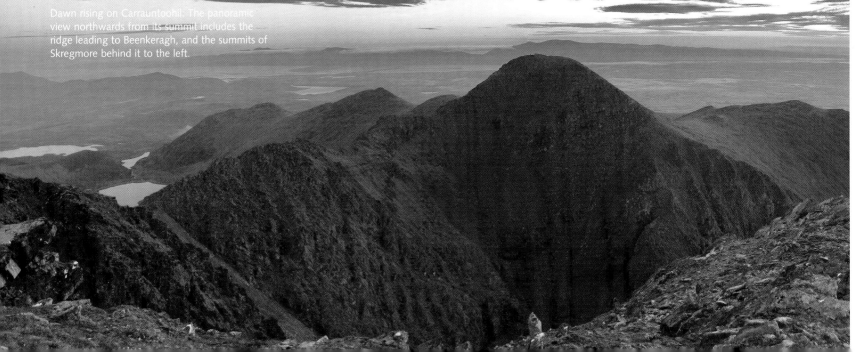

Dawn rising on Carrauntoohil. The panoramic view northwards from its summit includes the ridge leading to Beenkeragh, and the summits of Skregmore behind it to the left.

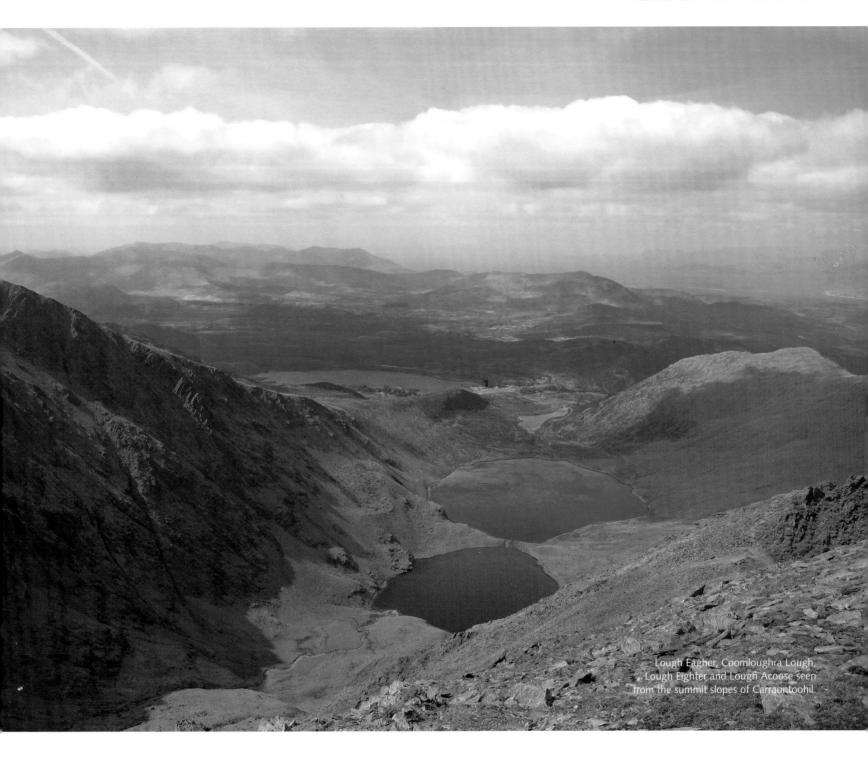

Lough Eagher, Coomloughra Lough, Lough Eighter and Lough Acoose seen from the summit slopes of Carrauntoohil.

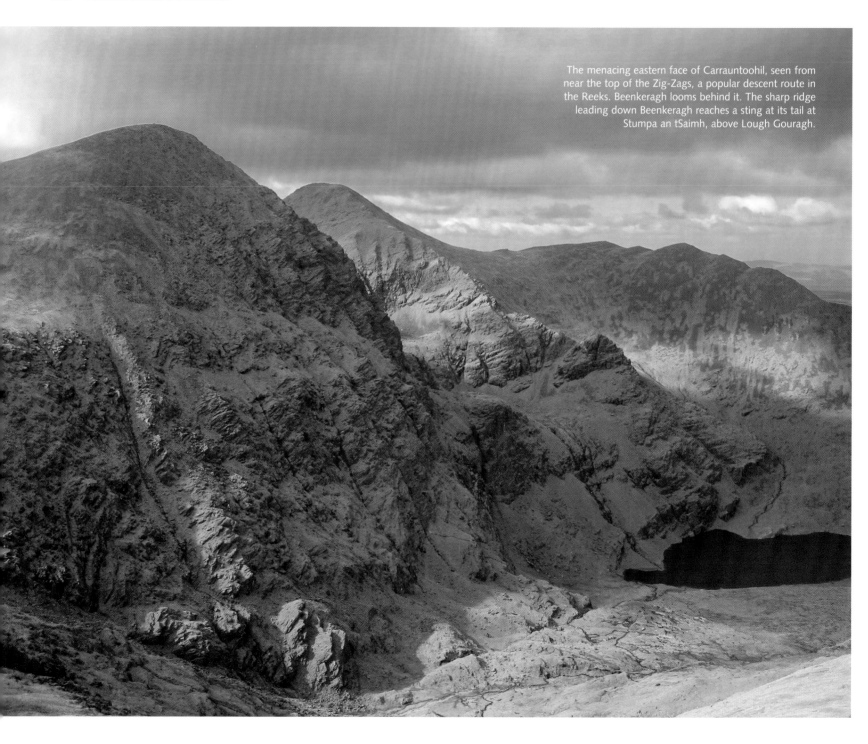

The menacing eastern face of Carrauntoohil, seen from near the top of the Zig-Zags, a popular descent route in the Reeks. Beenkeragh looms behind it. The sharp ridge leading down Beenkeragh reaches a sting at its tail at Stumpa an tSaimh, above Lough Gouragh.

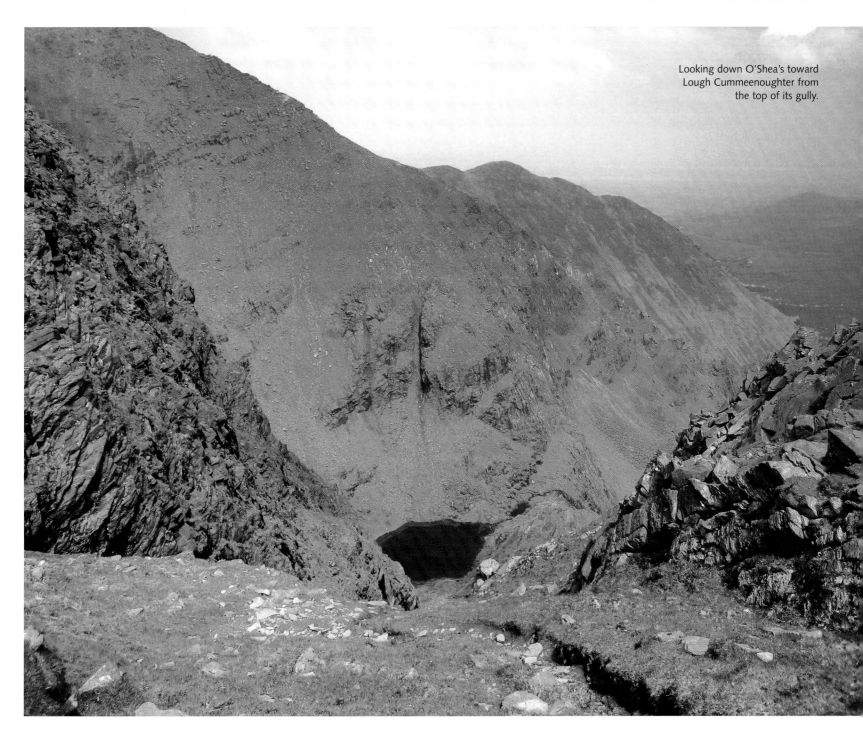

Looking down O'Shea's toward
Lough Cummeenoughter from
the top of its gully.

twenty-one

EPILOGUE

These are my riches, these and the bright remembering
Of ridge and buttress and sky-shouldering spire;
These I shall count, when I am old, of an evening,
Sitting by the fire.

Showell Styles

15 June 2010, 3.15a.m., Lough Cummeenoughter.

My watch alarm beeped, but I was awake long before. A plane hovered above, and then it was silent, except for the gentle caress of the stream. A delicate wind flapped at the tent's flysheet. I unzipped its door. The bright neon lights of civilisation far below lit up the dawn sky, causing it to glow a reddish-orange. The sky above was a pale shade of grey, like lightly coloured slates. I chewed on a muesli bar and drank some juice. Growing in anticipation, I swiftly rolled up my Therm-a-Rest, and stuffed my sleeping bag in the sack, along with all my other bits and pieces. As I stepped out of the tent to lace my boots, a surreal presence of the surrounding mountains hit me. It was an incredible sight to behold, these sheer sandstone walls, half in darkness and half sparkling grey. The smell of rock was potent, and I felt I was almost part of it, as if I was touching every single part of the mountain's rocky arm that embraced me in a wide semicircle. I dropped a tent peg on an outcrop of rock, and to my surprise, its ping echoed all around the mountain. I yelled out loud, 'Mo-orning!' and the mountain roared back at me.

With my tent finally packed up, I was ready to go. There was no need for a head-torch; O'Shea's Gully was already illuminating tints of silver-grey. I started up its treadmill of loose rock and thought of Brother O'Shea who died falling in this gully decades ago. Part of the sky near the horizon flushed an intense pink and vibrant orange and by the time I got to the top of the gully; the rest of it sparked

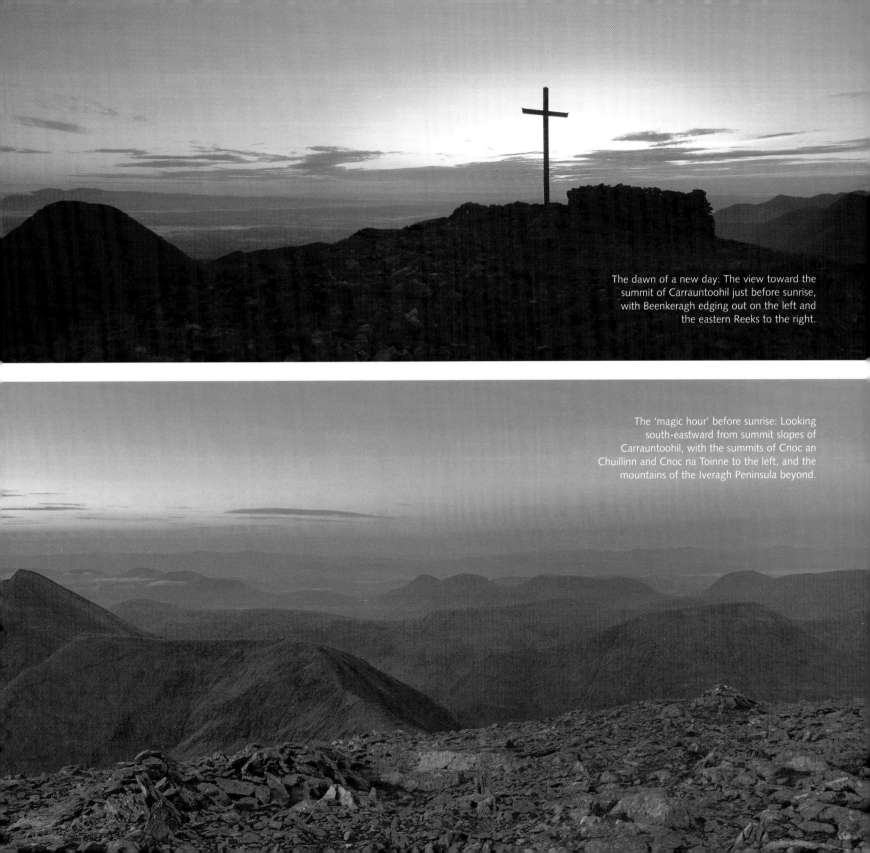

The dawn of a new day: The view toward the summit of Carrauntoohil just before sunrise, with Beenkeragh edging out on the left and the eastern Reeks to the right.

The 'magic hour' before sunrise: Looking south-eastward from summit slopes of Carrauntoohil, with the summits of Cnoc an Chuillinn and Cnoc na Toinne to the left, and the mountains of the Iveragh Peninsula beyond.

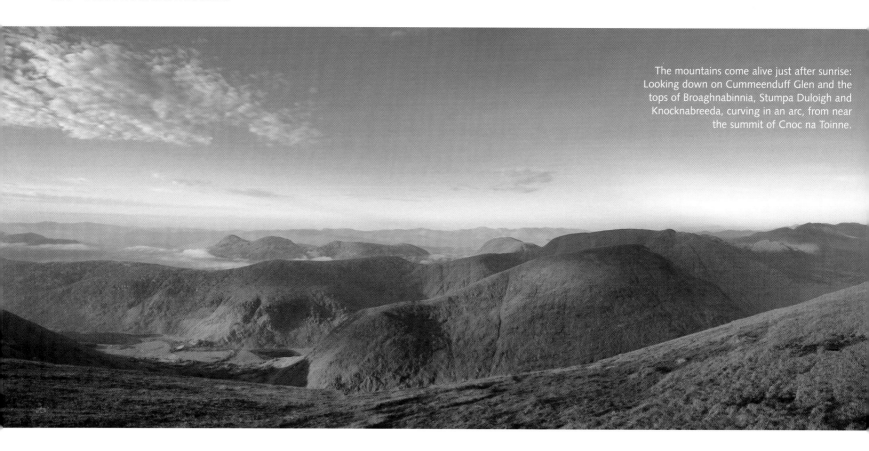

The mountains come alive just after sunrise: Looking down on Cummeenduff Glen and the tops of Broaghnabinnia, Stumpa Duloigh and Knocknabreeda, curving in an arc, from near the summit of Cnoc na Toinne.

a whitish shade of purple. The sky uplifted my spirits and I felt my cheeks glow. It was just before 5a.m. when I arrived on Carrauntoohil's summit, with its cross and stone shelter silhouetted against the dawn sky.

The world was hushed below me. I tried to remember the number of times that I had stood on the highest point of Ireland, but I lost count. This dawn was special, and I would rather be nowhere else in the world. This was how Isaac Weld must have felt during his seventeen-hour epic, I thought. I noticed a plaque in memory of Ger McDonnell, who was the first Irishman to summit K2, but was killed on descent, having helped injured climbers. Men have measured themselves against mountains for centuries; there must be a profound attraction in the earthly domain of such high places.

I stood on Carrauntoohil's summit and watched the sky light up. I watched the clouds wrap around the valleys below like a baby-blue carpet of cotton wool. I watched the eastern face of Beenkeragh etched in delicate detail with the onset

of light. I watched the sun edge higher up the sky over the Reeks. I watched all the mountains of Kerry to the south light up with a delicate dawn quality.

A dense clump of sea-thrift decorated the summit slopes, its pinkish-white flowers glowing like pearls in the morning dew. It seemed fitting for the time of year, as pearls are indeed the traditional birthstone for the month of June. The ancient Greeks think of pearls as hardened tears of joy from their goddess of love as she was born out of the sea. The mountains of Ireland were once of the sea and now most are near the sea. And like the humble origins of pearls, these mountains too are humble, and are precious gems of unsurpassed beauty.

As I descended Carrauntoohil, the sun rose over Ireland, turning her valleys green, her lakes blue and warming the rock and heather that lined her mountainside. Her mountains came alive in the growing fullness of light, and they smiled at me, in the peculiar way only these mountains can.

I smiled back at them, knowing I would soon return again.

ACKNOWLEDGMENTS

There are a number of people I would like to thank, for without their support, encouragement and contribution, this book would not have been possible. For those not mentioned, please accept my apology in advance, as this is simply an oversight.

First and foremost, I would like to thank my wife, Una, for her love, patience, encouragement and for reading the text in its draft stages. There are also various people that I must also thank for reading the draft text and offering invaluable comments, namely Tanya Oliver, Joss Lynam and Kay Oliver.

Joss Lynam deserves special thanks for agreeing to do the foreword, for his advice and for generously offering his time to pore over countless images, many of which have been selected for this book. Joss is a doyen and legend in Irish mountaineering; his books have always been an inspiration to me.

I would also like to thank Ronan Colgan and everyone at The History Press for their belief in the project and support during the making of the book. A special mention goes out to my editor, Stephanie Boner, for her expertise, perspicuity and patience.

My grandfather, John Hendroff, deserves a special mention for his love and support, and for allowing me to seek my own path in life; and to the late Agnes Oliver, who has been a shining example to me ever since we met. This book is also dedicated to my Godson, Aaron Oliver, and his brother James, who both have already ascended a mountain with me; may this book provide the inspiration to seek out your own fulfilling journeys in the future.

This book would not have been possible without the promptings of Steve Brown, who encouraged me to climb all the Irish 2,000ft mountains during one fateful day in the Mournes – this book is also dedicated to him.

A special thanks also to Patrick O'Sullivan, who edited my first ever printed article in the *Irish Mountain Log* that set me off on a writer's streak, and for support in my articles ever since.

For your generous hospitality during my stay during the making of the book, I would like to thank: Alan and Margaret Tees, Brendan and Geraldine Ceallaigh, Brendan and Joy Whelan, Brian and Maura McCaughey, Charles O'Byrne and Pauline Emerson, Dave and Maria Williams, Denise Kane, Gráinne and Eddie Ryan, Kay Oliver, Iain Miller, Maureen and John Fleming, and all the staff of Errigal Youth Hostel. Maureen, thanks as always for your gorgeous home-baked cakes to keep me going in the mountains!

Several people have helped me make sense of my limited knowledge of the Irish language, in addition to the stacks of books that I used for reference: Aonghus Ó hAlmhain and Gráinne Ryan – thanks for the enormous help and for your patience during the odd hours of enquiry; and also to Aisling Kelly.

On the subject of translations and place names, I'd like to acknowledge Paul Tempan and Dr Alan Mac an Bhaird for reference material and insight into *Sliabh n-Daidche* used in 'Dingle: Mountains and the Sea'; and Paul Tempan again for reference material on the Carrauntoohil place name used in 'Peaks of the Reeks' and invaluable help on other mountain place names in general.

Thanks also to these people for a variety of reasons: Alan Tees, Anja Bu, Barry Kehoe, Barry Speight, Blathnaid Wiseman, Brendan Whelan, Brigitte Murphy, Caoimhe Nic Allabroin, Caoimhe Gleeson, Cóilín MacLochlainn, Declan Mahon, Dingle Peninsula Tourism, Donal Cronin, Eithne Rosenstock, Finbarr Mullin, Florian Schöne, Gary Mallon, Gerry Dwyer, staff of Glenmalure Lodge, Iain Miller, Jim Holmes, Jim O'Sullivan and staff at Beara Tourism, John Fitzgerald, John Noble, John Oliver, John Quinn, John Rooney, Josephine Madden, Kathleen Cronin, Mark Brennan, Mark O'Sullivan, Miah O'Sullivan, Micheal O'Connell, Mossie O'Donoghue, Nicoletta Sandona, Olivia Geraghty, Paddy Lynch, Padraig Oliver, Patrick Ambrose, Patrick Brown, Pat Madigan, Paul Duffy, Peter Corless, Piotr Warno, Richie Casey, Ronan O'Brien, Sean Kehoe, Sean O'Byrne, Sean O'Donoghue, Simon Stewart, Sinead Oliver, Susan Breen, Tom McHugh and Tomas Turley.

Special gratitude is given to Kay Mullen, Eamonn Bonner and Alan Tees, and for the kind use of your poems in this book which appear in 'Space, Summits, Stillness', 'Deep in the Blue Stacks' and 'Timeless Derryveagh' respectively.

I gratefully acknowledge Theresa McDonald, the Achill Archaeological Field School and *The Mayo News* for permission to use quotations that appear at the end of 'Next Stop, America'; Brendan O'Reilly, Bernie O'Reilly and KN Network Services (and their fundraising for Temple Street Children's Hospital) for material about Elvis on Carnaween used in 'Deep in the Blue Stacks', and in the same chapter to the website http://www.freewebs.com/dw110/ for material on the Croaghgorm plane crash; Karl Harold for kind permission to use personal material in 'Timeless Derryveagh', and in the same chapter to Alan Tees, North West Mountaineering Club and Simon Stewart (material first published in 1997 on www.simonstewart.ie) for material on the life of Joey Glover; Ronan Lenihan for material on mountain rescue and Carmel O'Toole for information on the Twelve Graves used in 'Wild Wicklow'; Jimmy Barry for material on the Galtymore cross and on the life of Joan Kavanagh used in 'Ridges of the South-east'; John and Una Hayes for material on swimming in Galty lakes used in 'Charmed by Coums'; Kevin Tarrant of Kerry Gems for material on the Conor Pass used in 'Dingle: Mountains and the Sea'; and Gerry Christie and the Kerry Mountain Rescue Team for material on mountain rescue used in 'Backbone of the Ring'.

The following acknowledgements apply to the following copyright holders:

Quotation from *The Way That I Went* by Robert Lloyd Praeger used in 'Space, Summits, Stillness' and 'Next Stop, America' by kind permission of The Collins Press.

Quotation from *The Wild Places* by Robert MacFarlane used in 'Jewels of Connemara' by kind permission of Granta Books and Robert MacFarlane.

Quotation from *In Search of Ireland* by H.V. Morton, © Marion Wasdell and Brian de Villiers, used in 'Giants at the Edge of the Sea' and 'Mist and Magic' by kind permission of Methuen & Co.

Extract from 'Achill' by Derek Mahon, by kind permission of the author and The Gallery Press, Loughcrew, Oldcastle, County Meath, Ireland from *Collected Poems* (1999).

Extract from poem 'Nothing Grows Old', © Phoebe Hesketh, 1952, from her collection *No Time For Cowards*, reproduced by permission of Enitharmon Press, London.

Extract from 'The Ram's Horn' by John Hewitt, taken from *The Selected Poems of John Hewitt*, ed. Michael Longley & Frank Ormsby (Blackstaff Press, 2007) and reproduced by permission of Blackstaff Press on behalf of the Estate of John Hewitt.

'Blessing' by John Montague, by kind permission of the author and The Gallery Press, Loughcrew, Oldcastle, County Meath, Ireland from *Collected Poems* (1995).

Extract from poem 'Epilogue', © Showell Styles, 1976, reproduced by permission of Curtis Brown Ltd, London.

Every effort has been made to trace other copyright holders, but whereby impossible and a work has been included in the book, I trust that its use will be approved. Any oversights will be dealt with at the first opportunity.

BIBLIOGRAPHY

Barry, Jimmy, 'The Crosses of Galtymore', *Irish Mountain Log*, No.89 (Spring 2009).

Berry, James, Horgan, Gertrude M., *Tales of the West of Ireland* (Colin Smythe Limited, 1988).

Bourke, Angela, The *Burning of Bridget Cleary: A True Story* (Pimlico, 1999).

Brown, Hamish, Berry, Martyn, *Speak to the Hills: an Anthology of Twentieth Century British and Irish Mountain Poetry* (Aberdeen University Press, 1985).

Byrne, Francis John, *Irish Kings and High-Kings* (Four Courts Press, 2001).

Craik, Dinah Maria Mulock, *Is It True? Tales Curious & Wonderful* (Biblio Bazaar, LLC, 2009).

Crawford, Michael George, *Legendary Stories of the Carlingford Lough District* (Frontier Sentinel Printers and Publishers, 1926).

Dunne, John, *Irish Lake Marvels: Mysteries, Legends and Lore* (Liberties Press, 2009).

Flanagan, Deirdre, Flanagan, Laurence, *Irish Place Names* (Gill & Macmillan, 1994).

Gallahue, John, *The Galtees Anthology* (J. Gallahue, 2002).

Gill, Denis, *The Legend of the Twelve Graves* (Walking World Ireland, No.89).

Gray, Peter, *The Irish Famine* (H.N. Abrams, 1995).

Holland, Charles H., Sanders, Ian S., *The Geology of Ireland* (Dunedin Academic Press; 2nd revised edition, 2009).

Joyce, P.W., *A concise history of Ireland: from the earliest times to 1908* (The Educational Co., 1924).

Joyce, P.W., *Irish Local Names Explained* (BiblioBazaar, LLC, 2009).

Kennedy, Patrick, *Legendary fictions of the Irish Celts* (Macmillan & Co., 1866).

Kirk, David, *The Mountains of Mourne: A Celebration of a Place Apart* (Appletree Press Ltd, 2002).

MacDermot, Brian, Hennessy, William Maunsell, *The Annals of Loch Cé: A Chronicle of Irish Affairs from A.D. 1014 to A.D. 1590* (Kraus Reprint, 1965).

MacFarlane, Robert, *The Wild Places* (Granta Books, 2007).

Massey, Eithne, *Legendary Ireland: Myths and Legends of Ireland* (O'Brien Press, 2005).

McAnally, D.R., Heaton H.R., *Irish Wonders* (Gramercy Books, 1997).

McKay, Patrick, *A Dictionary of Ulster Place names* (The Institute of Irish Studies, Queen's University of Belfast, 1999).

McKeever, Ian. *Give Me Shelter* (Blackwater Press, 2007).

Morton, H.V., *In Search of Ireland* (Methuen, 1930).

O'Curry, Eugene, *Lectures on the Manuscript Materials of Ancient Irish History* (J. Duffy, 1861).

O'Donovan, John (ed. and transl.), *The Annals of the Kingdom of Ireland, by the Four Masters, from the Earliest Period to the Year 1616: Vol 1-7* (Edmund Burke Publisher; Facsimile Edition, 1990).

Praeger, Robert Lloyd, *The Way That I Went* (The Collins Press, 1998 reprint).

Raymo, Chet, *Climbing Brandon: Science and Faith on Ireland's Holy Mountain* (Walker & Co., 2004).

Robinson, Tim, *Connemara: Listening to the Wind* (Penguin Ireland, 2006).

Severin, Tim, *The Brendan Voyage* (Abacus, 1996).

Sheane, Michael, *The Glens of Antrim: Their Folklore and History* (Arthur H. Stockwell Ltd, 2010).

Smith, Charles, *The Antient and Present State of the County of Kerry* (1756).

Smith, Michael, *An Unsung Hero: Tom Crean – Antarctic Survivor* (The Collins Press, 2000).

Somers, Dermot, *Endurance: Heroic Journeys in Ireland* (O'Brien Press, 2005).

Swan, Harry Percival, *Romantic Inishowen: Ireland's Wonderful Peninsula*

(Hodges Figgis & Co., 1947).

Swan, Harry Percival, *Romantic Stories and Legends of Donegal* (Carter Publications Ltd, 1965).

Swan, Harry Percival, *Twixt Foyle and Swilly: Panorama of Ireland's Wonderful Peninsula* (Hodges Figgis & Co., 1949).

Tempan, Paul, 'Some Notes on the Names of Six Kerry Mountains', *Journal of the Kerry Archaeological and Historical Society*, Series 2, Vol. 5 (2005), pp5-19.

Waldron, Jarlath, *Maamtrasna: The Murders and the Mystery* (Edmund Burke Publisher, 1992).

Walsh, Mick, 'Climbing at Coumshingaun', *Irish Mountain Log*, No.90 (Summer 2009).

Weld, Isaac, *Illustrations of the Scenery of Killarney and the Surrounding Country* (Longman Hurst, Etc.,1812).

Wilde, Lady, *Ancient legends, mystic charms & superstitions of Ireland: with sketches of the Irish past* (Ward & Downey, 1888).

Williams, R.A., *The Berehaven Copper Mines: Allihies, Co. Cork, S.W. Ireland* (Northern Mine Research Society, 1991).

Young, G.W., *Freedom: Poems* (BiblioBazaar, LLC, 2009).

SELECTED GUIDEBOOKS

The following guidebooks have been used by the author during his explorations and ascents of the Irish mountains, and also as general sources of information for *From High Places*. They are a worthwhile addition to any hill-walker's library.

Bardwell, Sandra; Fairbairn, Helen; McCormack, Gareth; *Walking in Ireland* (Lonely Planet Publications, 2003).

Dillon, Paddy, *Connemara: Rambler's Guide* (Collins, 2001).

Dillon, Paddy, *The Mountains of Ireland* (Cicerone Press, 1993).

Dillon, Paddy, *The Mournes Walks* (O'Brien Press, 2004).

Lynam, Joss, *Best Irish Walks* (Gill & Macmillan, 2001).

Lynam, Joss, *Irish Peaks* (Constable, 1982).

Marshall, David, *Best Walks in Ireland* (Frances Lincoln, 2006).

Ryan, Jim, *Carrauntoohil & MacGillycuddy's Reeks: A Walking Guide to Ireland's Highest Mountains* (The Collins Press, 2006).

REFERENCE MAPS

The following maps have been used as references in *From High Places*. These are detailed maps recommended for walking in the mountains of Ireland. All maps, listed in the order of chapters in *From High Places*, are Ordnance Survey Ireland (OSi) Discovery Series 1:50,000 or Ordnance Survey Northern Ireland (OSNI) Discoverer Series 1:50,000, unless otherwise stated.

'Jewels of Connemara': OSi Sheet 37, 44 and 45; Harvey Superwalker Connemara.

'Destination Leenaun': OSi Sheet 37 and 38.

'Space, Summits, Stillness': OSi Sheet 23, 30, 31 and 37.

'Next Stop, America': OSi Sheet 30.

'Yeats Country and Cuilcagh': OSi Sheet 16 and 26.

'Giants at the Edge of the Sea': OSi Sheet 10.

'Deep in the Blue Stacks': OSi Sheet 11.

'Timeless Derryveagh': OSi Sheet 1, 2 and 6.

'Inishowen – A Place Apart': OSi Sheet 3 and 7.

'Sperrin Skyway and the Nine Glens': OSNI Sheet 5, 9 and 13.

'Mist and Magic': OSNI Sheet 29.

'Wild Wicklow': OSi Sheet 56 and 62; Harvey Superwalker Wicklow Mountains.

'Solitary Delights': OSi Sheet 59, 68 and 75.

'Ridges of the South-east': OSi Sheet 74 and 75.

'Charmed by Coums': OSi Sheet 74 and 75.

'Undiscovered Beara': OSi Sheet 84 and 85.

'The Hidden Heart of Kerry': OSi Sheet 78 and 83.

'Backbone of the Ring': OSi Sheet 78 and 83.

'Dingle: Mountains and the Sea': OSi Sheet 70 and 71.

'Peaks of the Reeks': OSi Sheet 78; OSi MacGillycuddy's Reeks 1:25,000; Harvey Superwalker MacGillycuddy's Reeks.

GLOSSARY

Arete – a sharp, narrow ridge found on rugged mountains.

Belay – a safety technique in which a stationary climber provides protection, by means of ropes, anchors and braking devices, to a climbing partner.

Bohereen – narrow (unsurfaced) road or an old country lane.

Bothy – a mountain shelter or small cottage.

Buttress – a broad protruding rocky bulge on a mountain.

Cairn – pile of stones, normally marking the summit of a mountain.

Clachan – a small village, hamlet.

Col, saddle – lowest point or a pass between two mountain summits.

Coum, corrie – a round hollow in the mountainside, a cirque, often of glacial origin.

Crannog – an ancient dwelling on a natural or artificial island in a lake.

Cul-de-sac – a dead-end road or lane.

Dog-leg – a length of route, usually on a ridge, that contains bends in the shape of a dog's leg.

Drumlin – a rounded hill formed from a moraine.

Frostbite – destruction of tissue (usually fingers or toes) resulting from prolonged exposure to freezing temperatures and characterised by tingling, blistering and gangrene.

Glen – a valley.

Gully – a deep, wide fissure between two buttresses on a steep mountain, usually containing a stream or scree.

Hand-rail – A navigation technique to take advantage of a feature (e.g. a line of trees, a wall, a ridge, the rim of a plateau) that heads in the intended direction and then to follow it.

Horseshoe – a mountain route or circuit that reflects the 'U-shape' of a horseshoe.

Massif – a large mountain mass or compact group of connected mountains forming an independent part of a range.

Moraine – an accumulation or mound of boulders, stones or other debris carried and deposited by a retreating glacier.

Nunatak – an isolated mountain summit that projected above the surface of surrounding glaical ice and escaped the scouring action of glaciers when the ice receded.

Pitch – a section of rock between two belay points, no more than the length of one climbing rope.

Plateau – an elevated, level expanse of land.

Ridge – a long, narrow raised land formation with (steep) sloping sides on a mountain, normally connecting two summits.

Scree – a mountain slope, usually steep, of loose rock debris.

Spur – a (broad) ridge projecting laterally from a mountain peak or subsidiary summit, normally leading down to lower ground.

Tarn – a small mountain lake.

Therm-a-Rest – a light-weight, compact self-inflating mattress, handy for use during wild camping on the mountains, for example.

Traverse – to negotiate or scale a mountain or a mountain range by ascending one side and descending its opposite side.

Trig point – a survey marker that marks the summit of a mountain.

Verglas – a thin coating of ice on rock.

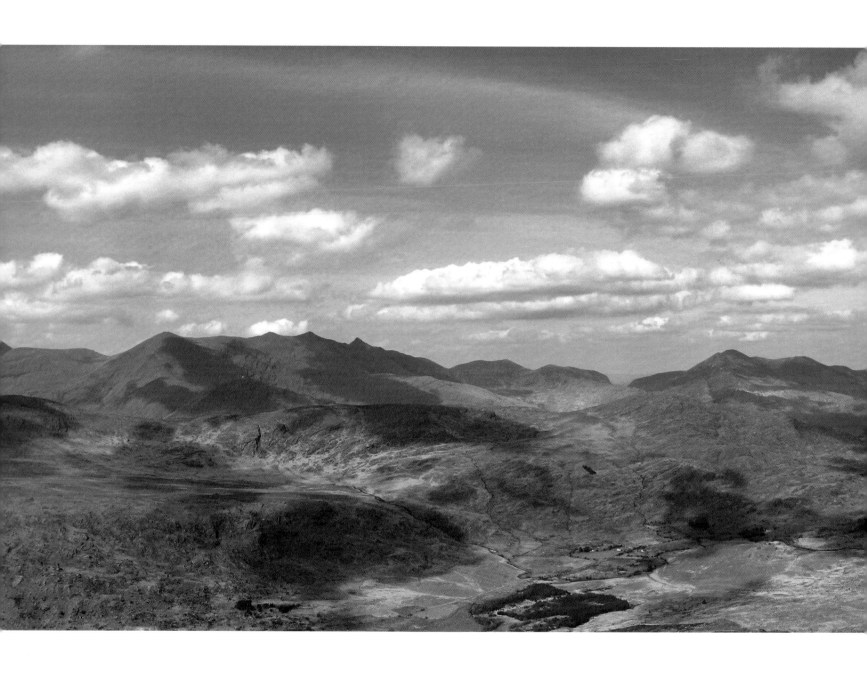

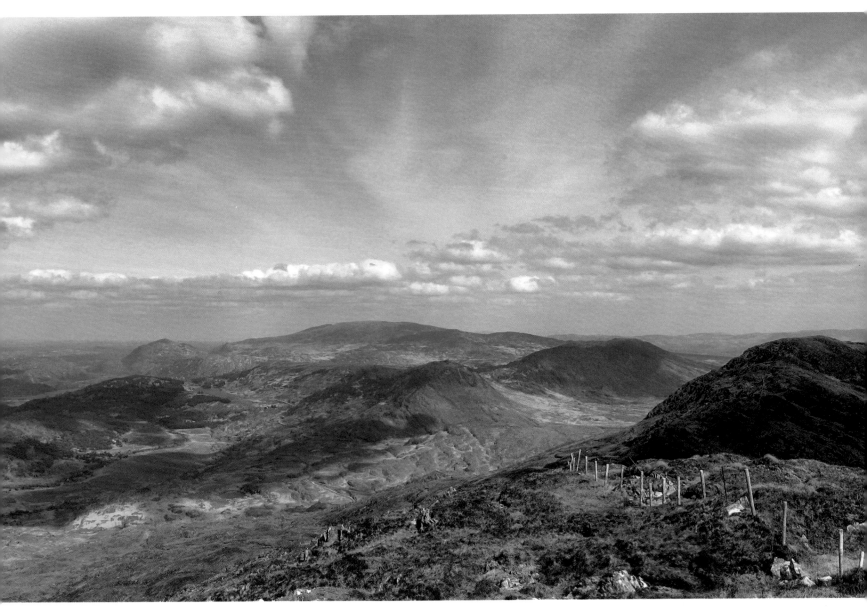

The panoramic view north and north-east from the
summit of Cnoc na gCapall, a mountain that rises
high above Moll's Gap in the Iveragh Peninsula.

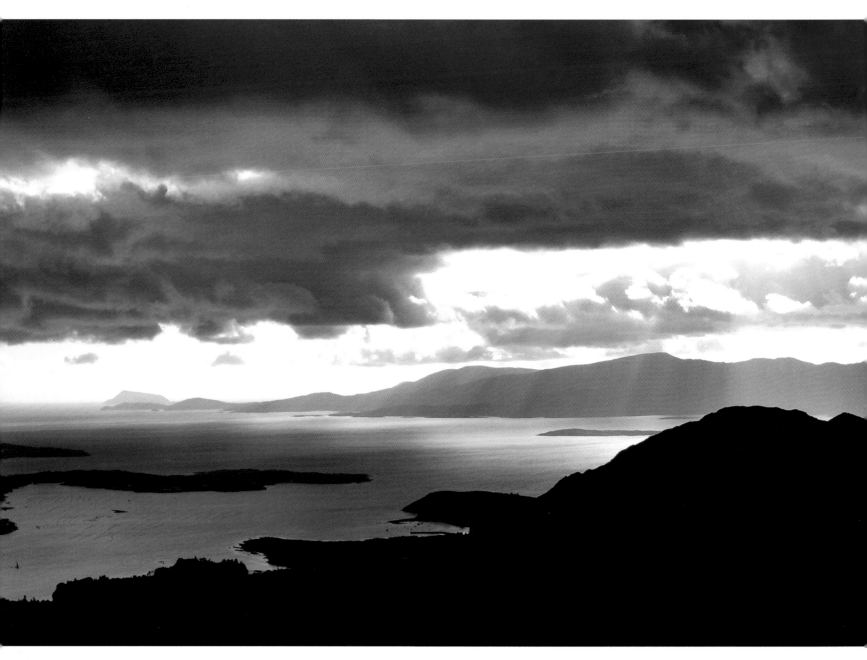

The spellbinding view out west across the
Kenmare River to the distant Iveragh Peninsula,
as seen from the summit of Knockanoughanish,
'the hill of solitude', in the Beara Peninsula.

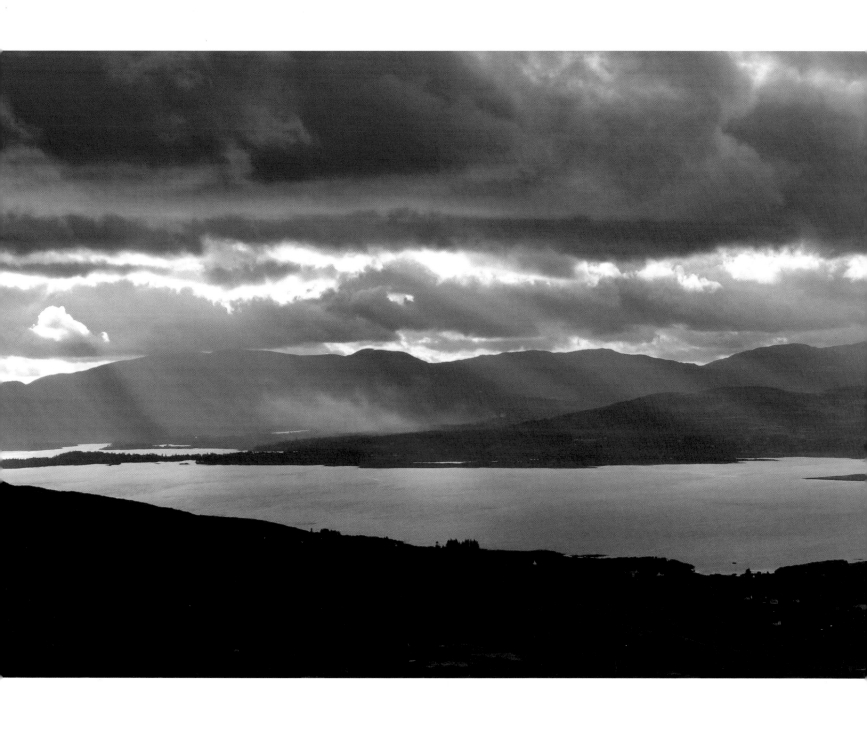